trans | plant

LIVING VEGETATION IN CONTEMPORARY ART

trans | plant

LIVING VEGETATION IN CONTEMPORARY ART

Barbara Nemitz

Hatje Cantz Publishers

LIVING VEGETATION IN CONTEMPORARY ART
ARTISTS REPRESENTED IN THIS BOOK

Vito Acconci Knut Åsdam Stefan Banz Lothar Baumgarten Joseph Beuys Michel Blazy Cosima von Bonin

Daniel Buren Maurizio Cattelan Mel Chin Agnes Denes Mark Dion Ian Hamilton Finlay Nina Fischer/Maroan el Sani

Peter Fischli/David Weiss Silvie Fleury Fortuyn/O'Brien Gloria Friedmann Paul-Armand Gette Avital Geva Dan Graham

Hans Haacke Henrik Håkansson Siobhán Hapaska Helen Mayer Harrison/Newton Harrison Paula Hayes Hirsch/Lorch/Wandel

Damien Hirst Carsten Höller Jenny Holzer Peter Hutchinson Fabrice Hybert Robert Irwin Dominique Kippelen Jeff Koons

Till Krause Samm Kunce Gordon Matta-Clark Mathieu Mercier Teresa Murak N55 David Nash Barbara Nemitz Olaf Nicolai

Nils-Udo Maria Nordman Brigitte Raabe Nikolaj Recke Tobias Rehberger Gary Rieveschl Erik Samakh Charles Simonds

Robert Smithson Alan Sonfist Daniel Spoerri Laura Stein Michael Stephan Didier Trenet Ingo Vetter/Annette Weisser

Sandra Voets Herman De Vries Shelagh Wakely Meg Webster Annette Wehrmann Lois Weinberger Luc Wolff

CONTENTS

AFFINITIES

The human mind has no logical answer to questions about our own existence. Have we not always looked into nature in order to discover something about ourselves? Work with living plants is both an intimate and a visionary endeavor.

As a component element of works of culture, living vegetation confronts us in the garden with secular, religious and mystical aspects of meaning. Do the works of art presented in this volume, almost none of which are gardens, have anything at all to do with these traditional objectives? The contemporary works with living vegetation featured here have been realized as independent works of art. Which qualities of the plants are used in these works? What connotations and metaphors are associated with them? What new questions are being addressed, what new perspectives opened? What positions are represented by the participating artists who employ living vegetation in their works?

There can be little doubt that the current phase of unrestricted pluralism in matters of style has promoted the inclusion of living plants into the mix. Other motivating factors are as diverse as the subjects that interest artists today. The essential difference we find in works with plants, as opposed to those using inanimate matter, is that the artist's ego encounters something that is alive. Works with plants are dynamic forms that develop within temporal dimensions. They are conceived in the progressive form and involve plans for life. Unlike "dead matter", plants exhibit relationships of dependence by virtue of the constant need for suitable living conditions.

Work with living plants is an interactive process of communication quite similar to the process of theatre direction. Stimuli and responses form links in a continuous chain. The artist's intervention is a manipulation of life processes which in turn provide feedback which imposes certain conditions relevant to the nature of the artist's work. Form is action. It is reflected in the life process of other organisms. Artists and viewers have an opportunity to experience themselves within the context of a living whole, and the roles of producer and recipient shift towards participation. In an age devoted to virtual reality, the "vital reality" embodied by a plant, with its interactive possibilities, now takes on entirely new meaning as a field of genuine nature experience. In many cases, however, nature is not approached in a comprehensive way but in discreet segments.

Vegetation as medium

Vegetation exudes an aura of ambivalent exoticism. It is both familiar and alien at the same time. In terms of geological history, plant life has existed for a very long time, and it has become a part of our idea of landscape. Vegetation gives the landscape a soft and supple appearance. The sight of vegetation often stimulates palpable responses on the skin. It is the fur that covers the body of landscape.

Plants are radical subjects. The original meaning of the word "radical" – from *radicalis*, something that is firmly rooted – is indicative of a perspective that is significant to our perception of plants. Plants are ordinarily rooted and firmly connected with the earth. Unlike humans and animals, they hardly move from place to place. Their movements are restricted to expansion and unfolding. The process of growth involves the metamorphoses of birth, development and death, which ordinarily take place slowly but in a continuous progression. Plants change in place, in their habitats. Thus vegetation, plants, appear dependable, despite their constantly changing form. Plants appear to be still. Rustling or other sounds of motion are noises caused by the wind and its resonance in the vegetation. Because of this stillness and the bonds that tie them to a particular place, plants tend to be perceived as passive and therefore inanimate. And that opens up the possibility of using them like a material.

Plants live in a close relationship with their locations. They inhabit regions suitable for them, and they reflect the characteristics of their habitats. They describe the conditions that prevail there and provide clear indications of the quality of life. Indeed, plants themselves are a sign of life.

A vital characteristic of vegetation is its capacity to stimulate the senses in a variety of ways. Scents, odors, colors, shapes and structures combine and merge with one another in a challenging appeal to the senses. Employed as a medium in the work of art, this capacity generates lasting and significant effects. Information broadcast by a work of art with plants gains in density and depth, as it presents not only what a human being has thought and produced but also, ultimately, the inexplicable, the other, as a component of the work. This living substance contains more than we know.

The capacity for expression is one of the fundamental characteristics of life. Reactions may become visible in species-specific "behavior", for example. This expressive competence is a fundamental part of work with living plants. With respect to the work of art, it means that the work cannot be perceived from the outside only. The dimension that distinguishes art with plants is the fact that parts of a work are capable of perception in their own right and of responding with a degree of sophistication commensurate with the complexity of living organisms. This is communicated to the viewer as well, either directly or indirectly.

The inclusion of living organisms enhances the presence of works of art. Awareness of the changeable nature of their inherent life processes increases the possibility of perceiving the formal relationships of artistic works not merely as static stimuli but in a much more comprehensive way. Interest in living processes is much more direct than that in inanimate materials. Works which incorporate living vegetation take advantage of this opportunity to establish contact by virtue of their ability to appeal for emotional closeness.

For the most part, plants are experienced in positive contexts – they provide nourishment, they serve as adornment and they delight. Generally speaking, vegetation manifests itself as peaceful. People enjoy natural green. Because of this popularity, vegetation is a "material" capable of

causing irritation within the context of art. The obvious visual appeal, the beauty of nature presented openly to view is rather unusual in 20th century art. The use of plants in contemporary art recalls long neglected fundamental questions about the field of tension between nature and beauty and thus paves the way for a new approach to a taboo subject. This subject matter has a determining influence upon my own art and motivates my work with the themes of landscape and vegetation.

It was in this context that I initiated the *KünstlerGärten Weimar* project, of which this book is a part, in 1993. I am interested in an undertaking in which the goal is not to complete or realize a work of art but to make itself visible in living forms. The work on *KünstlerGärten* is the experiment with a form of existence as a process of cognition. The term "*KünstlerGärten*" was selected as a working concept that designates an open field of activity. In this project I see my own art-work as an effort to initiate structures and basic conditions that will form the foundation for the presentation of the positions of contemporary artists who employ living vegetation in their work and to heighten awareness of its special qualities. The project as a whole is still in progress and, as is appropriate for a garden, is conceived for the future as well. In order to make this complex theme accessible from several different perspectives and to allow for different modes of reception at the same time, the *KünstlerGärten* project comprises not only works with living plants realized in areas within Weimar, where a total of 20 works have been installed since 1995. Several parallel, interrelated levels of work and activity exist as forums of exchange within the project as a whole: a lecture series for artists and scholars, the project journal *wachsen*, the teaching project in the Art Department of the Bauhaus-Universität Weimar, the print edition, the guided tours and, finally, the archive entitled "*trans* PLANT – Living Vegetation in Contemporary Art", from which this book has emerged.

In the course of my work, I have become aware of many more works of art on this particular theme than have been included in this volume. In many cases, it was the artists themselves who pointed me toward works by other artists. Apart from the artists to whom I am very grateful, a number of other people have also assisted me in my research. I would like to take this opportunity to express sincere thanks to my project staff and to the Bauhaus-Universität Weimar for their support. I also owe a debt of gratitude to the committed students who are now gathering experience in art within the context of the project. This complex theme continues to invite new enquiry, thought and practical experimentation.

GAINING GROUND: A RETROSPECTIVE VIEW OF ART IN NATURE AND NATURE AS ART

"The 'pastoral', it seems, is outmoded.
The gardens of history are being replaced by sites of time."[1]
Robert Smithson, 1968

Smithson was right and at the same time, wrong. Live vegetation was never much of an issue in the history of modern art, but it has since become a crucial concern of many artists. Agriculture, horticulture, and botany were not high on the agenda of avantguard revolutionaries intent on forging a radical new atomized art of urban, mechanistic, or abstract man-made forms. Early in the modern era, artists allied themselves with culture rather than nature: with scientific, technological, or spiritual investigations, with perceptual discoveries into the workings of the eye and psychological insights into the brain. And, for most of the 20th century, modern artists were involved one way or another with utopian visions that had to do with a new and improved society, and an ever more pure environment which tended to be mostly inorganic and wholly man-made. They were in thrall to the myth of progress.

And so it was hardly a paradox that at the same time early modern artists were envisioning a utopian future, they were also delving into the supposedly primitive past. Some were fascinated by the forms and energies of tribal art or folk arts. Others dug deep into repressed fantasies, regressive impulses, and other evidence of the untamed sources of creativity. They found inspiration in the childlike, the deranged, the criminal, and the unconscious mind. They envied the unmediated formal power of the so-called "primitive". Their investigations had to do not only with primal forms and spiritual content, but with the roots of human nature. Meanwhile the whole natural realm of trees, plants, grasses, vegetables, fruits, funguses, and flowers was largely ignored. Nature had become irrelevant. Looking back, we might call it hubris.

Looking back we might also wonder why nature more or less seemed to vanish from the history of art as well as from the modern consciousness early in the 20th century. There were exceptions, of course. But no one really noticed that Monet, in his late years, put at least as much effort and care into nurturing his garden at Giverny as he did into his vast canvases of waterlilies. No one cared that Mondrian's early watercolors of spider chrysanthemums – their thin petals delineated with almost hallucinatory precision – and his drawings of branching trees held the clues to the subsequent horizontals and verticals that he strung as tautly across the surface of his canvases as the quivering strings of an instrument. Obliterating all references to nature, Mondrian renounced the color green. And when he and other abstract artists and Surrealists crossed the Atlantic to America during World War II, art's reductive trajectory accelerated, with the help of a push from the critic Clement Greenberg.

By the 1960s, the sterile images and banal objects of Pop Art, and the gridded surfaces and industrial materials of Minimalism, left scant room for thoughts of nature. Warhol's flowers were far removed from any garden: a painted silkscreen of a photograph taken by someone else. Jackson Pollock was a major influence on the art of the '60s, but the implications

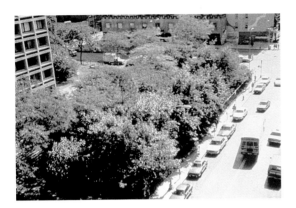

Alan Sonfist
Time Landscape ™, since 1965
Forest plants indigenous to Manhattan
14 x 61 m
Corner of La Guardia Place and West Houston Street,
New York City

of Abstract Expressionism – or Action Painting, as it was also called – led in other directions, materializing into Happenings and other performative gestures in the time and space of the real world. No one realized that Pollock's actions, as he dripped and swirled paint onto a canvas on the floor like an old-fashioned farmer planting grain in a field, unwittingly mimicked a pre-industrial European image: the figure of the Sower. Pollock's work opened art to all kinds of incursions and excursions into the real world, but it went unnoticed that his painting process also contained the accidental metaphor of seeds and soil. No one saw in his painterly dance that particular archetypal image. And although Pollock's splattered surface was an indeterminate unified field, none suspected that the ground itself would soon become fertile territory for artists.

Or did they? The ground did not lie fallow for long. By 1965 Alan Sonfist was at work replanting a block-long empty lot with native seeds, in order to recreate a pre-Colonial forest in the heart of New York City. Sonfist was somewhat ahead of his time. Other artists who soon began working in nature were not yet thinking organically. When Michael Heizer – who had conceived of an Earthwork in 1967 but didn't make his first one until 1968 – began digging the cubic hole in 1969 that would become the famous *Double Negative*, displacing 240,000 tons of earth on a desolate swath of land far from the art world, it was a Minimalist act of overweening reduction that had nothing to do with cultivation. When Walter De Maria carpeted the Galerie Heiner Friedrich in Munich with a layer of rich earth nearly one meter deep in 1968, he didn't intend to grow weeds or to sprout a single blade of grass. Recreated in 1977 as a permanent installation, the New York *Earth Room* – containing 140 tons of fertile earth – requires regular weeding. And when Smithson in 1970 created *Spiral Jetty* out of earth and rock in the Great Salt Lake, he was thinking about entropy and eons and the salt crystals that would eventually form, not about anything so prosaically organic as irrigation or farming.

Nevertheless, the ground was shifting. Though "landscape" was still a dirty word, these artists were working with the earth. The pivotal turning point was 1968: in the midst of student uprisings, political demonstrations, antiwar protests, and revelations of environmental pollution, the ideal of progress had begun to implode. Along with widespread disillusionments, the toxic side-effects of modernism became suddenly apparent. And so, in a context of social unrest, back-to-nature movements, countercultural communes of hippies retreating to rural areas, "flower-children" dropping out within cities, and astronauts on their way to the airless moon, Modernism collapsed. It was no longer possible to believe the utopian myths, nor to retain unswerving faith in the future. The future had arrived, for better and worse. Progress was no longer the issue: survival was. Beat poet Allen Ginsberg wasn't the only one who hailed a "return to nature and the revolt against the machine".

While some American artists, abandoning gallery spaces for inaccessible sites, returned to nature by imposing stark and grandiose Earthworks upon remote expanses of equally stark and sublime earth (desert, salt flats, or other arid ground), others were involved in related developments within exhibition spaces. Between 1967 and 1969, Richard Serra, Carl Andre,

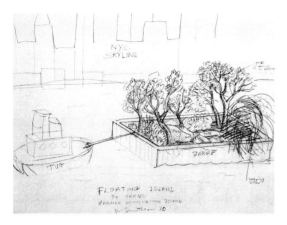

Robert Smithson
Floating Island: To Travel Around Manhattan Island, 1970
Pencil
47 x 60 cm
Collection of Joseph E. Seagram & Sons, Inc., New York City

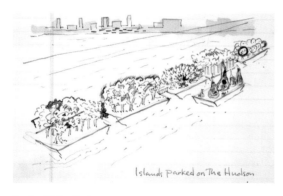

Gordon Matta-Clark
Islands Parked on the Hudson, 1970–71
Pencil, black ink and colored markers on yellow legal paper
13 x 20.2 cm

Barry Le Va, Robert Morris, and many others – taking up where Pollock left off – turned their attention to the floor, using flour, felt, and other materials that splattered, scattered, or lay flat. From one year to the next, the sensibility shifted from rigidity to pliability, from cubic form to random formlessness, from objects that were constructed or fabricated to substances that accumulated on the ground. At the same time, despite a paucity of art that had anything to do with nurturing nature, the terminology in esthetic discussions during those reductive days began to shift too. Metaphoric allusions to organic models of botanic evolution began to emerge. Indirectly, vegetation was being introduced into the discourse.

For example, in "Primary Structures" in the June 1966 issue of Arts Magazine, Conceptualist Mel Bochner remarked that "the entire language of botany in art can now be regarded as suspect". In the November/December 1966 issue of Art in America, in an essay titled "Is There Life on Earth?", English artist Peter Hutchinson, living in the United States, argued for the opposite position. Writing about works of Minimalist art, he stated "there is nothing human about them The works are about as inorganic and alien to life as can be imagined."

It is only in retrospect that it becomes obvious that in art, as in agriculture, digging up the earth was a prelude to planting. The same year Smithson made *Spiral Jetty*, he also made a simple pencil sketch for a future piece: *Floating Island to Travel Around Manhattan Island*. The island he envisioned was artificial: a flat rectangular barge pulled by a tugboat. But he pictured it covered with a layer of topsoil, planted with a weeping willow and other trees common to the New York region, and bifurcated by a winding path. Only two years earlier he had asked rhetorically: "Could one say that art degenerates as it approaches gardening?"[2] Gordon Matta-Clark whose work was in its formative stages, elaborated on Smithson's idea of a floating island in a group of related drawings, variously titled *Parked Island Barges on the Hudson* or *Islands Parked on the Hudson*, in which several barges similar to Smithson's are joined together by arched footbridges. The following year Matta-Clark, who had not yet begun deconstructing architectural structures, did a series of drawings of fanciful "arboreal forms" (see p. 91) and also a tree-house performance.

Meanwhile, the puny sprouts of Alan Sonfist's pre-Colonial forest, *Time Landscape*™ (see p. 118) were slowly but surely growing in New York City on a 45 foot by 200 foot plot of land extending along LaGuardia Place from the corner of Houston Street (at the edge of what in 1965 had not yet become the art district known as Soho) to the corner of Bleecker Street. Restoring a vacant city lot to its primeval forested state by planting native seeds and indigenous 17th century vegetation – oak, hickory, juniper, sassafras, milkweed – Sonfist dealt directly with the natural history of the site. *Time Landscape* continues to grow and flourish today, and Sonfist, who calls himself a "visual archaeologist," continues to work with nature and time unearthing the natural history of his sites. Two bronze cubes that he situated on the grounds of a Florida museum in 1991 are deceptively Minimalist time capsules containing encapsulated forests. Sealed within each are seeds native to the region – enough seeds so that when the metal decomposes a few hundred years hence, the seeds may spawn an archaic

forest. "Nature is not a gentle force", Sonfist has remarked.[3] Besides reconstruction, his work involves regression into lost ecosystems and historical strata, bringing back to life on urban sites the obliterated layers of the bucolic past.

Sonfist was not the only artist to work with the earth as a generative force-field that could be seeded. By 1968, Agnes Denes, working in a similar vein, made her first mature piece, *Rice/Tree/Burial*, which involved the sowing and harvesting of rice (and which she recreated in the late '70s at Artpark near Niagara Falls). Denes however wasn't dealing literally with planting and restoration. She was working with economic symbols, geographic differences, and poetic displacement in space: she not only grew an Asian crop in the northeastern United States but buried haiku in the soil.

In 1969, Dennis Oppenheim, who spoke of "the displacement from object to place"[4] and worked briefly with the environment and the ground, plowed an X measuring 825 feet in length across a Dutch field of grain. Titled *Directed Seeding – Cancelled Crop* his innovative if ambiguous Earthwork not only equated Minimalist reduction with environmental negation, but offered cultivation as a possibility. While Heizer carved into the earth's surface, De Maria gave earth cubic form, and Smithson sculpted the earth's surface with rocks, Oppenheim's maverick Earthworks were more like vast drawings – temporal and temporary. At the same time that he crossed out the crop of grain with an enormous X, he acknowledged the earth's fertility by making use of agriculture.

Peter Hutchinson also began working with plants and biological cycles in the late 1960s, and continues to do so today. In 1969, while on a trip to the West Indies with Oppenheim, the two artists collaborated on underwater works: bags of mold strung on rope and immersed in the sea. Hutchinson subsequently made other underwater works with oranges, calabashes, or roses strung along lines of rope, and then he began planting artworks in his garden in Massachusetts, and elsewhere. In his ongoing plantings, titled *Thrown Ropes* (see p. 78), he has planted yew, crocuses, tiny evergreens, and other plants in wavering rows that are determined by chance: a weighted rope thrown by the artist determines the planting line. Whether derived from Duchamp's *Three Stoppages*, John Cage's teachings, or a traditional English garden planting method in which the bulbs are thrown and planted where they land, Hutchinson's process allows chance to determine form, resulting in a work that blends into nature.

Thus art's return to nature in the '60s, at least in the United States, began with two opposing strategies. On one side were artists using heavy earth-moving equipment and dump trucks with the old modern hubris. On the other, as Sonfist once remarked, there were "artists pursuing the relatively new idea of cooperation with the environment, which they see as necessary because of the threat of its destruction".[5] While some American artists affected the methods of construction workers, using heavy machinery to create Earthworks, others turned to environmental work involving farming and gardening. Their counterparts in England at the same time had an even lighter touch. If American Earthworks were tough, literal, and pragmatic, the parallel development of English Land Art conveyed more

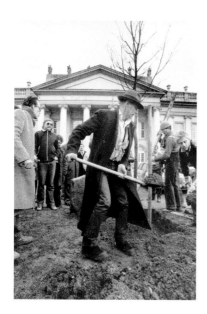

Joseph Beuys: *7000 Eichen* (7000 oaks)
(Joseph Beuys planting the first tree), 1982
documenta 7, Kassel (D)

Helen Mayer Harrison, Newton Harrison
Portable Orchard, 1972
University of California at Fullerton, California

romantic notions about the earth. This may be due to innate differences between the United States, a former colony with a pioneer myth of conquering a frontier and taming the land, and Britain, a former empire that, along with its intrepid explorers and conquests of ancient cultures, cultivated a heritage of gardens and nature walks. Or it may be due to a different discourse in the development of British contemporary art.

In any case, the sensibility was not the same. Around the same time that artists in the United States began to create Earthworks, artists in England, such as Richard Long and Hamish Fulton, began making Land Art. However, British artists tended to envision not final frontiers but lost Edens. Nature in itself was not alien but sublime or picturesque. Long's first piece of Land Art, *A Line Made by Walking*, dates to 1967. The "line" was simply the barest trace of the artist's presence on the earth's surface: the trajectory of his path, visible as a line of trampled flattened grass. "I was for art made on common land, by simple means, on a human scale. It was the antithesis of so-called American 'Land Art'", said Long later. "I prefer to be a custodian of nature, not an exploiter of it."[6]

While American artists carved into the earth, sculpted the terrain, or planted crops, British artists used the land more like an erasable surface for a solitary performance: the act of walking, and the passive perception of nature, is crucial to both Long and Fulton. Long continues to work with stones, mud and the earth itself in ways that document his solitary walks. "I like the idea of using land without possessing it", he stated in 1982.[7] Fulton sums up his marathon walking trips across remote parts of the planet with a single brooding photograph and a few lines of tersely poetic descriptive text.

Ian Hamilton Finlay's work is more stationary and territorial, and more specifically concerned with history and tradition. In 1967, near Edinburgh, he began work on an ongoing meditation on the French revolution and totalitarian power in the form of an Arcadian garden, *Little Sparta* (see pp. 48–49, 142). Drawing on the tradition of the informal English garden and the Victorian folly, and the connection between authoritarian structure and neoclassicist form, he turned landscaping into a vehicle for historicized and politicized memory. Along with plantings of vegetation, he implanted stone memorials and cryptic inscriptions on plaques, as well as a grotto, a hut, and a temple. "A garden is not an object but a process", Finlay has said. Imbued with classical, military, and ideological allusions, *Little Sparta* alludes to historical time, institutional power, revolutionary zeal, and cruelty, as well as an evolving process.

"The abysmal problem of gardens somehow involves a fall from somewhere or something. The certainty of the absolute garden will never be regained", wrote Smithson in 1968.[8] But by the early '70s, with issues of survival becoming paramount, nature had become a crucial issue for many artists. The dream of a man-made Utopia was supplanted by (and sometimes merged with) nostalgia for the Edenic garden as well as, in some cases, social or environmental intent. Gardening could be a process, a social model, a critique, or a metaphor. The shift in sensibility that propelled artists to work with living plants was not localized. Giuseppe Penone, who had begun working with living saplings and natural growing processes in

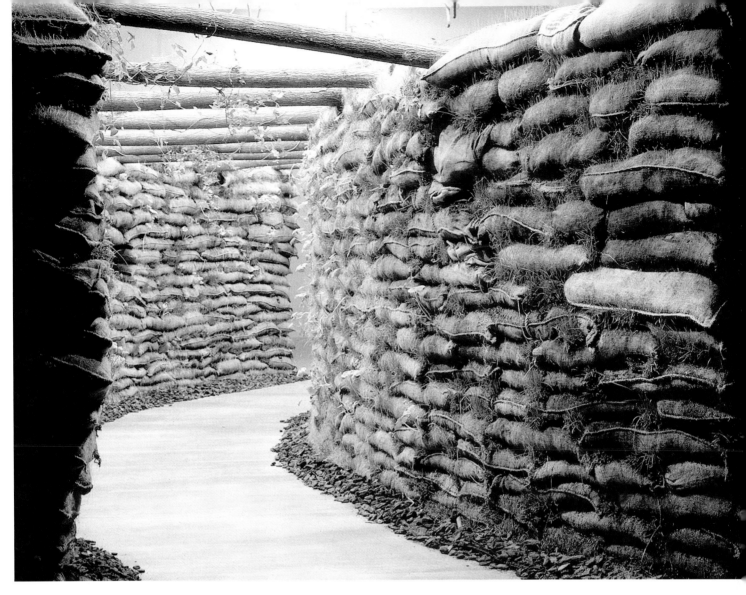

Charles Simonds
Growth House (detail), 1975/1994
Sacks, soil, seeds of edible plants
Exhibition view
Musée du Jeu de Paume, Paris 1994

Charles Simonds
Growth House, 1975
pen and ink on paper
65 x 75 cm

Italy in 1969, when he hollowed out a wooden beam to liberate a tree, anthropomorphized plants. Marcel Broodthaers's potted plants made a statement about sterile museum culture and the absence of nature.

In the early '70s, shortly before Beuys conceived of the collaborative planting of *7000 Oaks* as a social sculpture that would regenerate the earth, Helen and Newton Harrison in the western United States began their ecological work with a *Portable Orchard* and a self-sufficient fish farm that functioned as an enclosed ecosystem. Their work, like that of Beuys, was grounded in ecological and social issues rather than horticultural ones. Their visionary and poetic projects merge with social reformation and ecological concerns regarding specific bodies of water, land and urban reclamation. They propose Utopian yet pragmatic solutions to rescue endangered ecosystems – meadows and rivers, congested cities, polluted sites. Their conceptual framework raises politicized questions "... about who will command the land / and why and how. Seeing it as a metaphor / for yet another contest / as to who will shape the future / of this physical terrain."[9] Recently the Harrisons proposed an urban analog forest that would extend the length of Karl-Marx-Allee in Berlin, reducing four lanes of traffic to two.

By 1975, Charles Simonds, who in the early '70s became known for his anthropological art of miniaturized clay-brick dwellings and ruins, designed and built a full scale structure that involved vegetation. While his tiny settlements sprang up on urban windowsills, crevices, and stairwells, bearing narrative allusions to an imaginary civilization of little people who

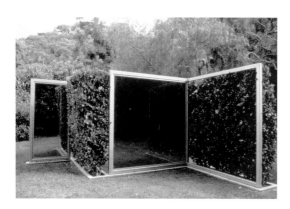

Dan Graham
Two-Way Mirror Hedge Labyrinth, 1989
Bob Orton Collection
La Jolla, California

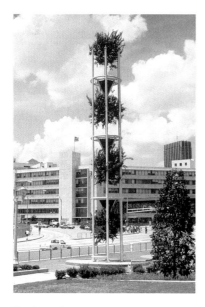

Vito Acconci
High-Rise of Trees, 1996
Trees, earth, plexiglass, painted steel
19.5 x 3 x 3 m
Olympic Games, Atlanta

had vanished, the large ovoid *Growth House* was a full scale fortress-like indoor construction that suggested not archeological remains but future habitation and growth. Its thick walls were constructed of stacked sacks of fertile earth from which unruly vegetation sprouted.

Despite the fact that in 1982 Agnes Denes planted a two-acre wheat-field in New York City (see p. 43) – on the battery Park Landfill near Wall Street and the World Trade Center, which was destined to become a luxury development – the prevailing sensibility in the art of the '80s did not lend itself to the use of living plants. Denes harvested a crop of nearly 1000 pounds of wheat, and said that she wanted to call attention to "misplaced priorities", but grain was not a hot issue in the New York artworld at that moment, and neither were environmental concerns.

Nevertheless, though vegetation was not a material or a metaphor that received much attention during the early 1980s, when corny neo-Expressionist figuration was in the spotlight, or in the late '80s, when sterile objects took center stage, established artists such as Vito Acconci and Dan Graham were designing outdoor structures and public projects that included living plants. For Acconci, plants are part of his elaborately disorienting psychological compositions involving the human body and expressing psychic displacements (see pp. 22–23). Most of his projects with plants and people, garden furniture and landscaped parks, remain unrealized. In Graham's work, trees and hedges are mirroring elements that relate to the illusory qualities and perceptual ambiguities of his semitransparent pavilions, which absorb and reflect the landscape (see pp. 60–61).

Looking back one might note that during the 1980s and '90s, the use of living plants in art ranged far afield from ecological matters or ideas of a lost paradise, having acquired ambiguous, problematic, even ominous social and antisocial connotations: in Acconci's work, plants contribute to a sense of physical and psychological disorientation. For Graham they add to the perceptual displacements. Other artists, such as Jenny Holzer, Damien Hirst, Robert Irwin, Jennifer Bartlett, or (as far back as 1961) Ed Kienholz, whose work is not usually associated with issues of nature or nurture, have also occasionally used vegetation in their work. Holzer in Nordhorn (Germany), used black and white blossoming plants as funeral elements in a war memorial (see pp. 76–77). Irwin, in Seattle, imprisoned nine trees in cubic frameworks (see pp. 80–81). Hirst surrounded a glass enclosure with monochrome paintings, butterflies and living plants and – referring perhaps to Marcel Broodthaers's museological ferns – called it "A Good Environment for Colored Monochrome Paintings". And Bartlett's proposal for a public park in lower Manhattan was rejected because her tall compartmentalized hedges could have encouraged crime.

Ever since the biblical Eden, the idea of the garden has carried connotations not only of primal innocence but of forbidden knowledge and corruption. And for many recent artists, the use of living plants has as much to do with modern evils – psychic and political dysfunctions, species endangerment or extinction, genetic mutation, or the toxic aftereffects of industrialization – as it has with lost innocence. One might almost say that all artists who now work with plants deal with an unstated postmodern metaphor: the tainted garden.

Mark Dion
The Tasting Garden, 1996
Harewood House, Leeds, (GB)

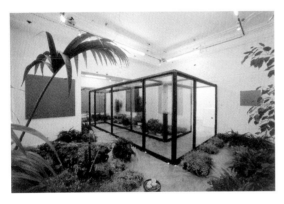

Damien Hirst
A Good Environment for Colored Monochrome Paintings, 1994
Glass, steel, plants, household paint on canvas, fruit, live
butterflies
DAAD Galerie, Berlin (D)

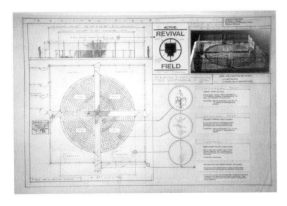

Mel Chin
Original plan and specifications for Revival Field, 1990
Ink, tape, black-and-white photograph and photocopy on paper
48 x 72 cm

In 1989, Mel Chin, whose metaphoric work ranges widely across social and environmental issues, conceived a formal garden for a toxic waste dump, titled *Revival Field* (see pp. 40–41), in which the idea of the tainted garden became literal. In cooperation with USDA (United States Department of Agriculture) soil agronomist Dr. Rufus L. Chaney and his laboratory, Chin made use of a newly discovered class of flowering plants known as hyperaccumulators, which thrive on heavy metals that they leech from the soil, to create an elegant ecological artwork that has by now successfully cleaned the toxins from three contaminated sites in the United States. The plants, occupying symmetrical beds and geometric borders in Chin's deceptively traditional garden, reap a recyclable harvest of poisonous metals such as cadmium, lead, and nickel. Says the Chinese-American artist, who is in the process of proposing a fourth version of *Revival Field* to clean thallium from a site in Germany, "It's an attempt to sculpt the ecology, to remove or chisel away the heavy metals. As Art, it's a conceptual sculpture. As Science, it's a field test."[10]

For Mark Dion, whose 1989 *Tropical Rainforest Preserves* flourished in a makeshift crate on wheels and whose semi-fictional narrative projects assume the methodology of the natural sciences (complete with botanical, zoological, or archeological specimens from his expeditions and excavations), the garden is tainted biogenetically. The garden that he designed in 1996, *Tasting Garden* on the Harewood Estate in England, is not only an actual garden but an elaborately metaphoric memorial to our planet's dwindling biological diversity, and an argument against agricultural monoculture. *Tasting Garden* alludes on several levels to phylogenetic evolution and devolution. With a network of paths branching from a central trunk, its ground plan is the symbolic evolutionary tree. Each path terminates in a memorial stone inscribed to a northern fruit tree (apple, pear, peach, cherry, plum, quince) and a monument topped by a monumental bronze specimen of that tree's fruit. A text describes its taste, and a single specimen of the fruit tree itself stands sentinel: a live sapling, an adult tree, or a withered bronze trunk, depending on whether the species is rare, endangered, or extinct. *Tasting Garden* also includes *The Arborculturist's Work Shed*, an installation that simulates an actual garden shed, and contains gardening tools, drawings, photographs, and documentation in tribute to the Estate's gardeners.

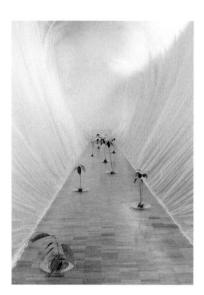

Michel Blazy
Plantes vertes (Green plants), 1997
Centre d'art Espace Jules Verne

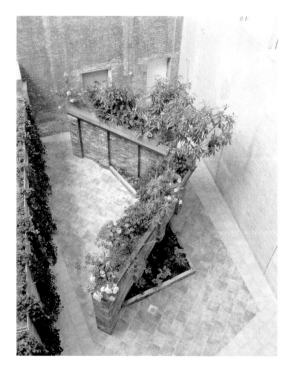

Paula Hayes: *429 Greenwich Street Atrium*, 1997 (begun)
New York City

The seeds sewn half a century ago by Pollock – whose gestures unconsciously echoed the swirling farmland paintings of his teacher, Thomas Hart Benton – are bearing strange fruit. In the past few years the number of artists working with live vegetation has proliferated exponentially. As the gaps between art and life continue to be patched and sealed by artists pushing the edge, living plants have become an accepted medium for art. There are now as many different uses of live vegetation as there are artists working with living plants, and as many reasons for making art that has roots, stems, blossoms, leaves, or branches. The issues today may be partly ecological, social, or historical, but they also have to do with new confusions and terrors regarding genetics, identity, and artificiality. Artists around the world, including Meg Webster, Henrik Håkansson, Olaf Nicolai, Michel Blazy, Didier Trenet, and Tobias Rehberger, are producing indoor and outdoor works, sculpture and installations, using agriculture, horticulture, hedges, molds, bonsai, or flowerbeds in ways that stress the manipulated, the unnatural, and the unreal.

Some, like Laura Stein, whose mutant cacti and anthropomorphic vegetables bear inescapable references to nuclear mutation and genetic engineering, work with horticultural techniques to graft, espalier, or hybridize Frankensteinian horticultural objects in works that comment indirectly on creation, responsibility, and the whole modernist experiment aimed at improving on nature (see pp. 122–124, cover). Others like Paula Hayes, who plants perfectly normal garden installations in abnormal places – in galleries, on fire escapes or rooftops – go to the opposite extreme of pure mundanity. Blurring the boundaries between her profession as horticulturist and landscape designer and her vocation as artist, Hayes turns the activity of gardening into an act of conceptual art by means of documentation, collaboration, and written contracts with the collectors who commission her work (see pp. 70–71). "I offer myself as a facilitator of possible interspecies influence", she states opaquely in a businesslike brochure that doubles as an artist's catalogue.[11]

Samm Kunce, whose nurturing work with vegetation exudes practicality, offers herself as a facilitator of natural plant growth in the absence of natural conditions. Her hydroponic environments, which have produced strawberries, lettuces, grasses, or moss in indoor environments lacking sun and soil, are dependent on highly artificial (and highly visual) life-support systems of pumps, hoses, nutrients, and mega-watt halide Gro-Lights (see pp. 88–89). Involving issues of control as well as of nurture, Kunce's installations raise questions about power as well as about the dissolving borders between the natural and the artificial.

Even Italian artist Maurizio Cattelan, whose usually surreptitious interventions tend to test exhibition support systems and issues of place and power (he once transported another artist's show from an Amsterdam gallery and reinstalled it at de Appel) has used living vegetation to impressive effect (see p. 39). In the summer of 1998, he trucked a single olive tree, rooted in an enormous cube of earth, from Italy to Luxembourg, installing it in a grand gallery at Manifesta 2, the European Biennale, where it almost touched the ceiling, an ascendant natural object transmogrified as art. Cattelan excises a tree from an olive grove and installs it as art, French

Samm Kunce: *Fort Laramee*, 1994
Strawberries, PVC, fans, pumps
fiberglass, aluminum, metal halide light
3.65 x 3.65 x 3.65 m
Installation, John Gibson Gallery, New York City

Avital Geva: *Greenhouse*, 1993
Kibbutz Ein Shemer (IL)

artist Fabrice Hybert, whose multivalent art lays claim to the color green, does the opposite. He insinuates his art blatantly into the economic, communication, and support systems of the real world. Having recently bought a valley near La Rochelle, he is sowing a forest of trees from all over the world. He is also at work on a public project conceived several years ago, which will be realized for the year 2000 in Cahors. The city of Cahors has agreed, beginning in 2000, to replace every municipal tree that dies with a tree that produces edible fruit – and to continue doing so forever after (see p. 79). In keeping with Hybert's all-encompassing multimedia approach, the project will begin with an advertisement for itself: a one-minute commercial that will precede films in cinemas all across France.

By accident as well as by design, politicized issues keep creeping into artists' gardens. When the late Kate Erikson and Mel Ziegler, known for their site-specific collaborations that took into account the social history of the sites, planted a vegetable garden on a flatbed truck in Warsaw in 1992, they were paralleling post-Communist Poland's fledgling efforts at private enterprise in a piece that also raised questions about cross cultural social critique. The rows of peppers, radishes, onions, and other vegetables (the first letters of the plant names spelled out the word "produce" in Polish and English) required local maintenance and support, weeding and watering, if they were to thrive. When Avital Geva's full-scale greenhouse installation was installed at the 1993 Venice Biennale, complete with irrigation spray system, it transplanted the social context of an Israeli kibbutz to the terrain of art. And when Lois Weinberger's eastern European weeds sprouted (see pp. 138–139) and bloomed despite all odds between the railroad tracks at documenta X, as out of context as immigrants on foreign soil, it was another use of vegetation to comment on socio-political issues.

By accident as well as by design, social and political issues also intrude upon art. Though Jeff Koons certainly could never have anticipated it, his monumental *Puppy* – perhaps the most superficially innocuous blossom-bedecked work (see pp. 84–85) of topiary pretensions and carnivalesque proportions ever – became tragically implicated in local Basque politics upon its installation in front of the Guggenheim Bilbao in 1997. Shortly before the museum's formal opening, three Basque terrorists disguised as gardeners attempted to deliver a truckload of potted replacement blossoms in which they had also planted grenades. When a policeman challenged them, thwarting their plot, they gunned him down in front of the museum.

But it has always been the gardener who did it. In fiction and in film, the gardener is often a mysterious or sinister figure. From the start, the garden in western civilization has been a mythic place of innocence, temptation, and guilt. If vegetation is suddenly relevant in art as a multipurpose material capable of carrying difficult messages about our planet, we should not be surprised. And if gardens created by artists are warning us not to meddle with mother nature, we might take note. In the wake of genetically altered soybeans and tomatoes into which have been spliced the genes of fish, it is the gardener, harboring the secrets of germination and decay, who is in some symbolic way still guilty of everything.

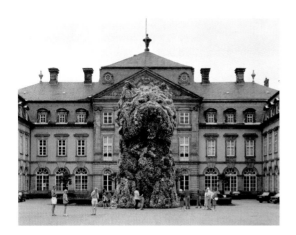

Jeff Koons: *Puppy*, 1992
Concrete base, wood/steel construction, living flowers
Height 11.50 m
Arolsen (D)

It may be useful, regarding the current diverse crop of gardening artists, to ask: Why? And why now? The '90s have been a decade in which art is given to modest gestures and private or inconspicuous acts. Artists graft branches, espalier trees, nurture moss, create mini-biosystems, or try to teach frogs to sing. They mimic the natural and behavioral sciences, or insert their work into the systems of the mundane world. They deal not with the old modern dichotomy of culture versus nature, but with postmodern dilemmas of survival, identity, and mutation in a world of germ-weapons, and cloned sheep. They reflect new confusions and uncertainties resulting from unprecedented mergers of animal, vegetable, and mineral. They express unforeseen ethical dilemmas about what is artificial and what is natural in a world in which the boundaries between the natural and the artificial are being rapidly erased. They pose new questions about where nature leaves off and post-human artificiality begins.

It is sometimes difficult to discern the motives of the new gardening artists, who merge ecological statements and social critique with new manifestations of the old urge to bend nature to human will. In one sense, the multitude of artists who are now using plants have little in common. In another, they share the crucial anxieties of our time. As the 20th century ends, poised on the brink of genetic breakthroughs and breakdowns and irreversible alterations, living plants with chlorophyll coursing through their veins have been integrated into the artistic vocabulary. They stand implicated by multiple layers of significance. Like us, they are part of the earth's old natural ecosystem on the verge of possible obsolescence. The gardens of recent art are far from trivial. Though he used the earth as a site of entropic incidents, Robert Smithson, back in 1968, couldn't possibly have predicted these developments. At the end of the modern century, we are all inhabitants of the tainted garden.

1 Robert Smithson, 'A Sedimentation of the Mind: Earth Projects', *Artforum*, September 1968. Reprinted in: *Robert Smithson. The Collected Writings*, ed. Jack Flam, Berkeley and Los Angeles 1996, p. 105.
2 Ibid., p. 105.
3 *Alan Sonfist* 1969–1989, exh. cat. Hillwood Art Museum 1990, Long Island University, p. 24.
4 *Conceptual Art and Conceptual Aspects*, New York Cultural Center, 1970, p. 30.
5 Alan Sonfist (ed.), *Art of the Land*, New York 1983, p. x1.
6 'Richard Long replies to a Critic', *Art Monthly*, July/August 1983, p. 20.
7 From 'Words After the Fact', in R. H. Fuchs, *Richard Long*, exh. cat. The Solomon R. Guggenheim Museum, New York, Thames & Hudson, 1986, p. 236.
8 Robert Smithson, op.cit.,p. 113.
9 H. Mayer Harrison and N. Harrison, 'Über die Dringlichkeit des Augenblicks', in *Green Heart Vision*, exh. cat. Kunstmuseum Bonn (D), 1997, p. 12.
10 From a conversation with the artist, March 24, 1999.
11 Paula Hayes, *Wild Friends*, artists book, New York 1995.

LIVING PLANTS IN
CONTEMPORARY ART – SURVEY

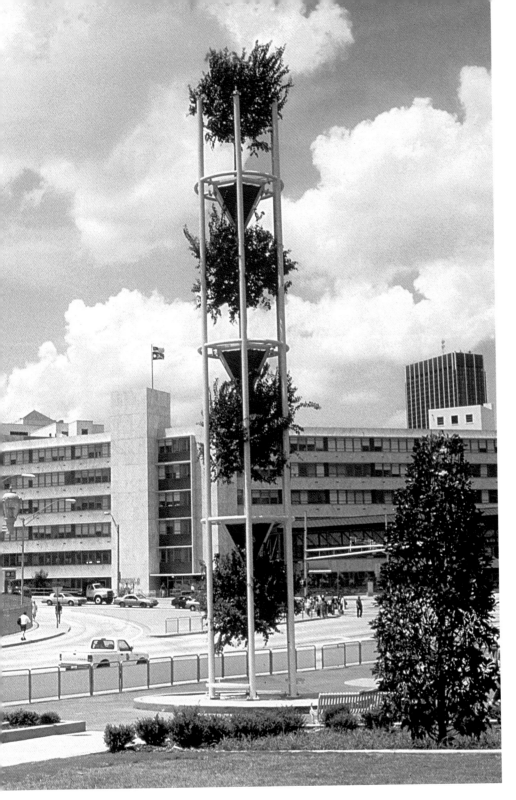

High-Rise of Trees, 1996
Trees, earth, plexiglass, painted steel
19.5 x 3 x 3 m
Olympic Games, Atlanta

Park up a Building, 1996
Aluminum, steel, trees, lights
different heights x 11 x 2.10 m
Centro Gallege de Arte Contemporánea,
Santiago de Compostela, Spain

Park up a Building, 1996

In a number of public art projects, Vito Acconci works with elements of the human environment such as architecture, furniture, parks, gardens and plants adapting them to new and unusual spatial and functional combinations and contexts.

Park up a Building transforms the traditional park bench in a natural setting into a portable system of vertical modules for building facades. Steel and aluminium components adjustable to the heights of different facades can be combined into a stepped sequence of seating units. Single trees packed in linen bags are incorporated into the regular structure of the suspended construction. Uprooted from the soil, the plants have the appearance of functionalised set pieces from nature adapted to a constructive-technical setting.

Thomas von Taschitzki

Psychasthenia: The Care of the Self, 1999
Architectural installation.
Glass enclosure, water filter, entry/exit corridor (7.2 m),
water spray, fade, trees bushes grass, soil, system of paths
and spaces, Gro-Lights (on at night)
Exhibition: Biennale di Venezia 1999, Venice

For the Venice installation (Psychasthenia: The Care of the Self) I used an organic environment with plants to make an architectural delineation of a particular social space, the night-time park – a space of the urban un-conscious and a space of fantasy as much as a space of withdrawal from the surrounding exhibition itself. The environment's sense of sound, smell, light and tactility and the relation to other bodies inside and outside the space were all integral to this.

Knut Åsdam, 1999

Psychasthenia: The Care of the Self, 1999
(at night)

Physis en différance

Der Anbau des Museums (Cultivating the museum), 1992 (detail)
Physis en différance
(Jacques Derrida)

The Kunsthalle Luzern was founded by the artists Stefan Banz, Bruno Müller-Meyer, Erwin Hofstetter and Stephane Huitmere in 1989. The most significant event hosted by the Kunsthalle to date was the exhibition entitled *Der Anbau des Museums* (Cultivating the museum), presented in April/May 1992. The show was devoted to the theme of the expanded intellectual spiritual space of art within the context of the museum and an effort to establish a new foundation from which to approach the question of the position and the possibilities of art, a foundation that takes into account the difficulties associated with attempts to draw clear lines of demarcation and illustrates their inherent variability.

The question arose as to whether the phenomena of visual art could still be usefully observed from the standpoint of classical definitions of the artist, indeed, whether it would not be more fruitful to approach creative works without reference to such categories or hierarchies. Accordingly, *Der Anbau des Museums* was a conglomerate of contributions that emerged on the fringes of art, a linking of various different open articulations which, in their joint presentation in visual space, qualified both their own conditions and those of art. Under the direction of Stefan Banz, *Der Anbau des Museums* was an ambitious art project, a *gesamtkunstwerk* that included contributions by Jaques Derrida, Wada Jossen, Theo Kneubühler and Harald Szeemann.

Stefan Banz, 1999

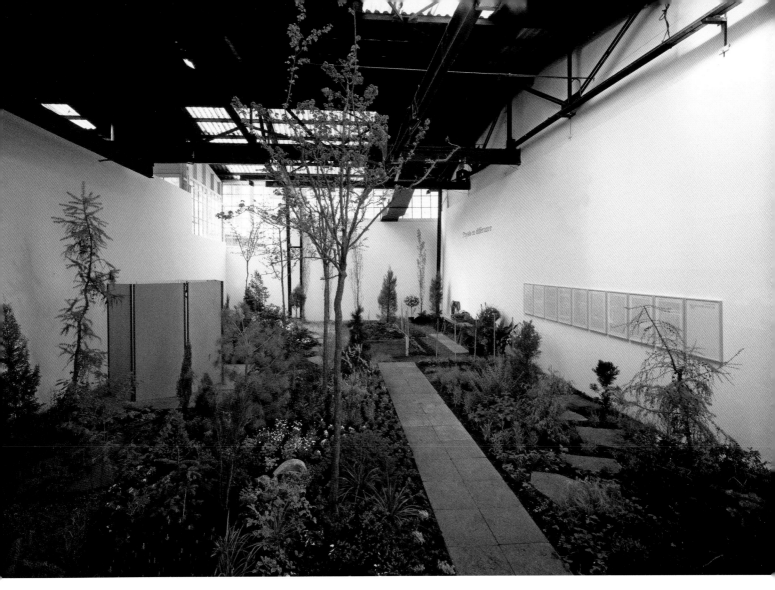

Der Anbau des Museums
With Jacques Derrida, Wada Jossen, Theo Kneubühler,
Harald Szeemann
Plants, soil and various materials
Kunsthalle Luzern (CH)

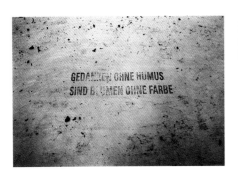

Der Anbau des Museums (detail)
Gedanken ohne Humus sind Blumen ohne Farbe
(Thoughts without humus are flowers without color),
Harald Szeemann

Theatrum Botanicum (detail)
Plants

From an early general interest in plants, their morphological appearance, biological structure, culture, historical significance and use, my work turned, considering all this, more and more to "plant life architecture" reflections. Developing concepts for gardens as a site-specific sculpture of different elements, the site and the architectural context became substantially important to me.

Lothar Baumgarten, 1999

Theatrum Botanicum, since 1992
Trees, plants, flowers, stone
Fondation Cartier pour l'art contemporain, Paris

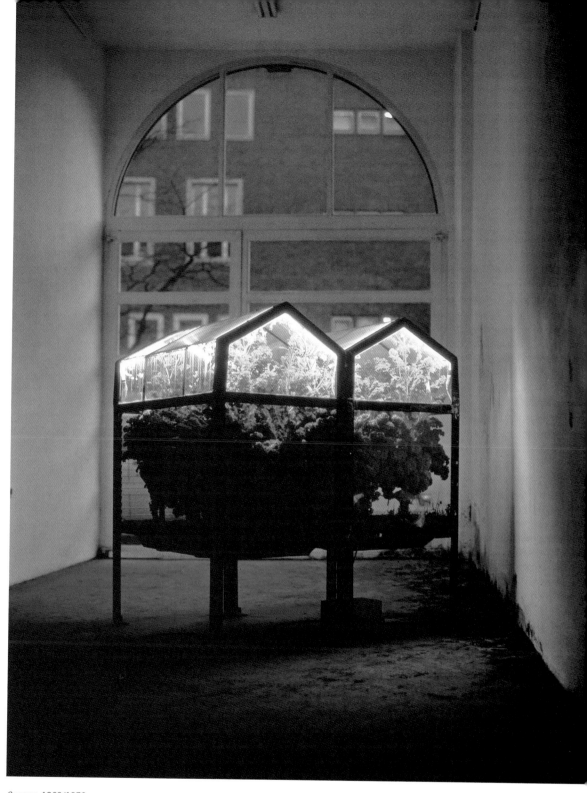

Guyana, 1969/1972
Hothouses, kale (*Brassica oloracea convar. acephala var. sabellica*),
tropical butterflies (live) (*Actias selene, Phil zyntia, Atacus atlas*),
pigment cobalt
Galerie Konrad Fischer, Dusseldorf (D)

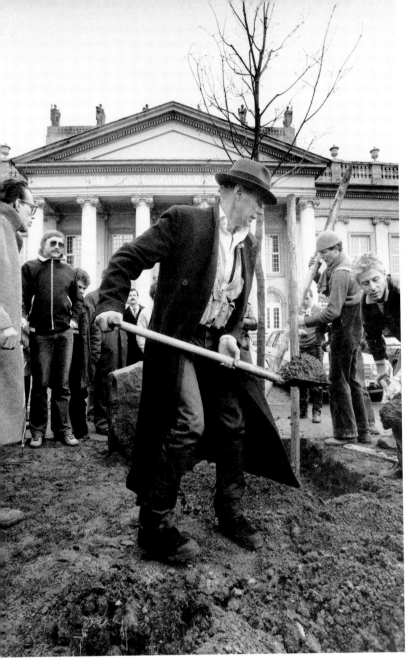

7000 Eichen (7000 oaks), since 1982
Joseph Beuys planting the first tree.
documenta 7, Kassel (D)

I wish to go more and more outside to be among the problems of nature and problems of human beings in their working places. This will be a regenerative activity; it will be a therapy for all of the problems we are standing before I wished to go completely outside and to make a symbolic start for my enterprise of regenerating the life of humankind within the body of society and to prepare a positive future in this context. I think the tree is an element of regeneration which in itself is a concept of time. The oak is especially so because it is a slowly growing tree with a kind of really solid heartwood. It has always been a form of sculpture, a symbol for this planet.

Joseph Beuys, in: Richard Demarco, 'Conversations with Artists', *Studio International* 195, No. 996, September 1982, p. 46

7000 Eichen (7000 oaks), state 1997 (detail)
Kassel (D)

Weeds

A weed is a small plant for which human beings have no use. Its foliage dies off each year. There are unconditional and conditional weeds.

Unconditional weeds

These are regarded as essentially bad. This is because they are often considered harmful to people or crops. One such weed is the nettle. Observed under a microscope, the surface of the leaf and the stem of a nettle is found to be bristling with hairs about two millimetres long, bulb-shaped, with a fragile tip. The slightest touch makes this tip break, and the unwary person who touches a nettle will immediately feel a burning pain. A raised rash appears at each point where the poison has penetrated. Another example is couch grass, a vigorous and invasive weed with a highly developed root-system and which is also harmful to crops. The relationship between this type of plant and humans is always of an aggressive nature. Plants can sting people, poison them and destroy their crops. Humans can eat plants, as they do nettles, hang them on the walls as decorations, as with thistles, or brew them to make teas, as in the case of couch grass.

Conditional weeds

These are plants that grow where they are not wanted and which, for a variety of reasons, are regarded as uninteresting. Any plant, however beautifully coloured, can be a potential conditional weed. All it takes is for it to have appeared without being selected. Thus even a crocus, planted by a gardener in a flower garden, may be ripped out by the same gardener the following year. Weeds of all categories (A.C.) can be found in towns, in flower gardens, in kitchen gardens, in public squares and in the pots of our house plants.

A.C. weeds in towns

Living conditions are harsh, and not all species adapt to them. Plants take advantage of the rain water that gathers in a broken, rusty gutter or of a little heap of soil that has gathered in a pothole in the road. Those that succeed in growing there are the ones that have no other choice than to put of these fundamental conditions of survival. They have limited space for growth. Like goldfish, whose size is proportional to the size of their bowl, the growth of these weeds is limited, frustrated, tortured. They develop slowly and do not look very beautiful, as they seem to show their eagerness to live while their existence is met with total indifference.

A.C. weeds in gardens

In the garden the gardener is the only master. He has the power to decide what will live, and where. A.C. weeds are persecuted here, yet if the gardener did not exist, the garden, with its regular watering, fertile soil, its essentials to life and its superfluity, would be an ideal place for them to thrive. Knowing that every weed will be immediately hoed up, their only chance of survival is to grow in a forgotten corner, abandoned or neglected by the gardener. While these nooks and crannies may be the natural

Plantes vertes (Green plants), 1997
Centre d'art Espace Jules Verne,
Brétigny-sur-Orge (F)

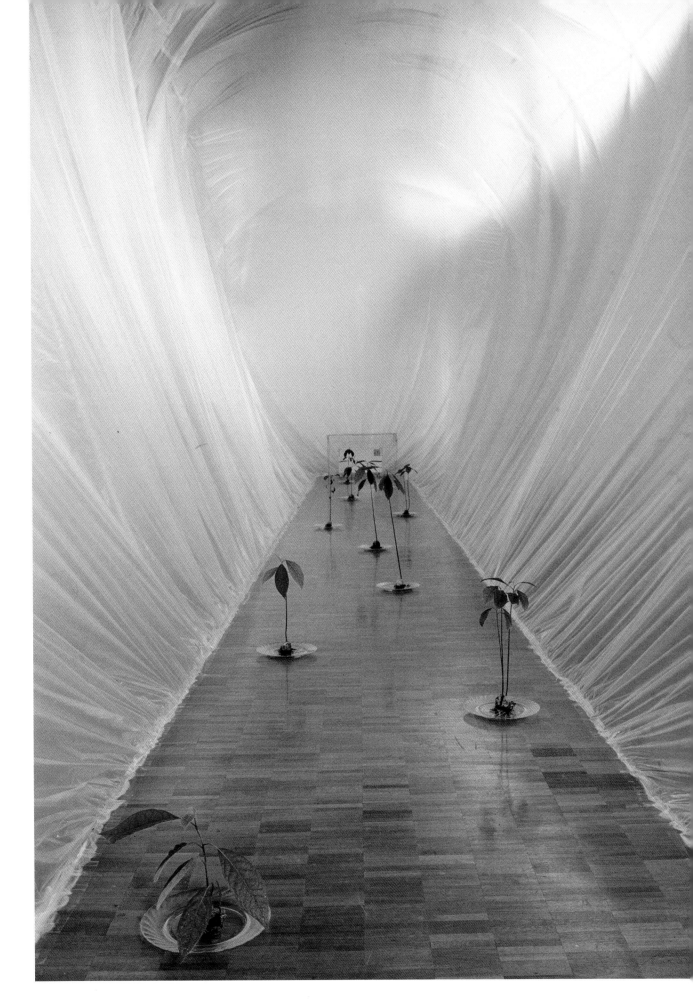

 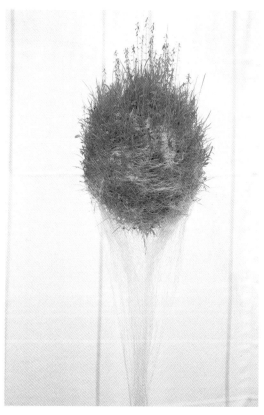

La vie des choses (details)

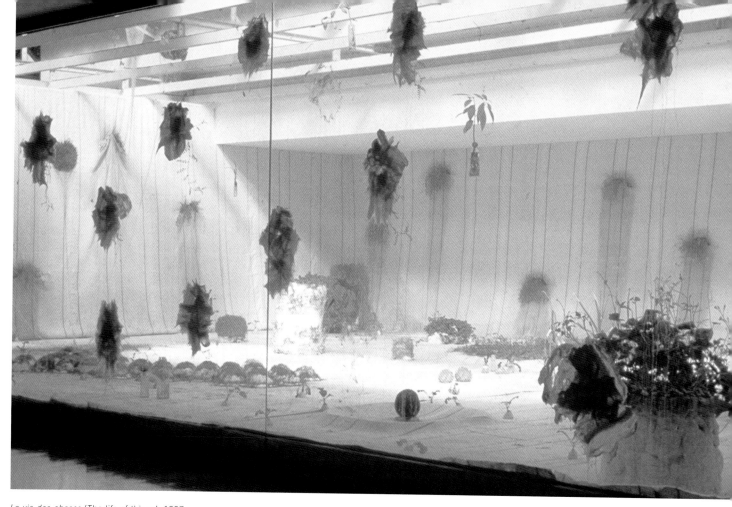

La vie des choses (The life of things), 1997
Radishes, chick-peas, lentils, beans, potatoes, onions, ginger, cabbage, avocados, bird seed
for exotic birds, bird seed for canaries, artichokes, water, floorcloths, cotton wool, adhesive
Exhibition: La vie des choses, Musée d' Art Moderne de la Ville de Paris

result of the topography, many have been created unknowingly by the gardener. Although found within a garden, such a niche offers the weed little more than a meagre existence.

Weeds in pot plants
Whatever the size of the plant growing in it, the pot will, by definition, be variable in size. Thus it is rare, and *a fortiori* for indoor plants, for a weed seed to arrive there by chance. On the other hand, soil that is often reused will, over time, acquire seeds, bulbs and roots. Conditional weeds are born of this kind of accident. Although some are unwanted, a number of plants coexist happily with the new arrival. A conditional weed will then flourish in this unanticipated biotope.

Michel Blazy, 1995

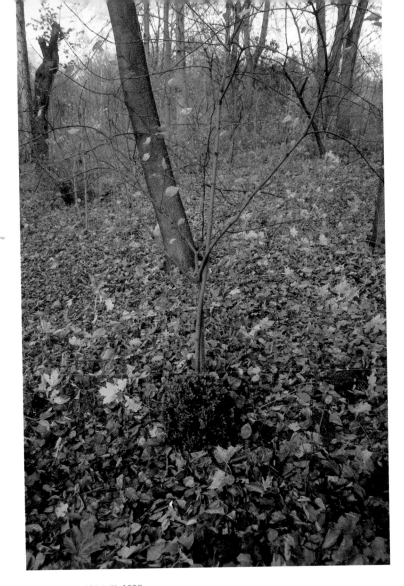

Mrs. Littlewood (detail), 1998
Cut boxwood
KünstlerGärten Weimar,
Bauhaus-Universität Weimar

At work on *Mrs. Littlewood*, 1998
The gardeners Gerald Schütze, Zawerio Kalusniak,
Roland Lorenz, Thomas Wendler and Cosima von Bonin
KünstlerGärten Weimar,
Bauhaus-Universität Weimar

The remains of a stairway have been preserved in a clearing in a wooded area of the park at the Villa Haar in Weimar. The steps are flanked asymmetrically by two young ash trees, which have been pruned, leaving only the strongest shoots. Their trunks are fastened to supporting stakes. A bed forming a gentle curve toward the left has been laid out on the gently rounded slope above the steps. Knee-high wooden stakes driven into the ground mark the corners. Planted in the bed are woodruff, elf flowers, blue-leaf plantain lilies, Solomon's seal, Chinese lantern, red and yellow dogwood, witch-hazel and pleated viburnum. Behind the bed is a heap of soil, horn and stone meal. Three nest yews grow in a dispersed pattern around it, one of them protruding from the bark of an old tree stump. Amongst the ragged brush and bushes behind it is a precisely pruned orb-shaped boxwood that looks almost like a ball that has come to rest there. This planted installation suggests a very personal, individual approach to gardening. Even the title, *Mrs. Littlewood*, seems to convey a similar message. The arrangement of garden fragments is a composition which establishes a fundamental atmospheric tone. In an open form, it offers stimulating "material" that can lead viewers to new ideas and speculations of their own.

Barbara Nemitz

Mrs. Littlewood (detail), 1998
Flower bed, plants, sticks
KünstlerGärten Weimar, Villa Haar
Bauhaus-Universität Weimar

My interest in architecture has been an important part of my work since it began, that is to say: 35 years ago!

If the word architecture is generally understood to denote something having to do with constructions created by human beings, it is also true that nature (all plants, flowers, etc.) has its own architecture.

It is also evident that plantations, fields and most of the entire countryside in Western Europe, for example, is the work of human hands. Landscape in these countries is the product of hundreds of years of what we may call human landscape architecture.

Since I have never had any personal interest in deserts or so-called wild fields, I have always been interested in working where humans have already transformed the site and/or are living within that space.

My interest in working directly with nature (growing flowers), within and around the given architecture of plants (trees along the avenue in Venice Giardini) or with nature products already transformed and shaped by human beings (hay ricks in the fields) complements and reinforces my interest in working with architecture in general and, in a broader sense, with any environment transformed by human beings – places in which they have lived and, in a more general sense, still live.

Daniel Buren, 1999

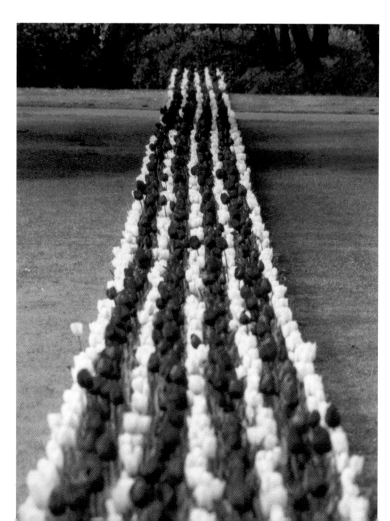

11,000 tulips (11,000 tulips), 1987
Work in situ
Keukenhof, Holland

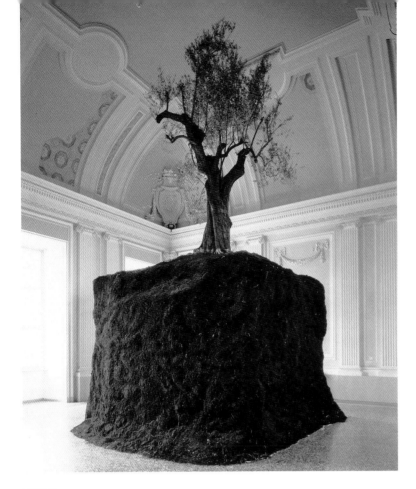

Untitled
Installation view, Castello di Rivoli, 1999
Olive tree, earth
8 x 5 x 5 m

Larger than Life

[...]

In the history of art there is a long tradition of moves and alienations, of objects that have found their way into the museum, not with the help of a Golem but thanks to an artistic, dadaistic gesture. Cattelan's olive tree, however, has none of the cold, calculated detachment nor the desecrating or cynical irony typical of the readymade. Above all, it betrays no speculative intention and does not question its status as a work of art. Cattelan's tree mysteriously seems to belong to the museum room; it could have no other location. As in any novel, we are not surprised by the presence of an ogre or a dwarf. We suspend our disbelief and we immerse ourselves in the pleasure of the text. This is not an escape from life, for literature and struggle to reproduce it in all its complexity. According to Cattelan, there is no way out of complexity. His tree doesn't talk about the primal, ideologised and political regression à la Beuys, nor of the genetic, posthuman play. Neither the desire to escape towards some Arcadia nor the leap into the future exists, because, as far as Cattelan is concerned, it's better not to choose, otherwise we would miss the richness of the world. That's what Cattelan's tree does: It unconceals a world. It imposes a world made of roots, earth, leaves, sap and perhaps even insects, weighed down by matter, by wood. Just like the world, Cattelan's tree is a slippery image, constantly saying something else, extending in a kind of infinite present, dilated with no breaks or fractures, always defying any interpretation. Cattelan's recourse to taxidermy or to an irrigation system must be seen in this context. It is a discrete means of defying the notion of closure (of life and death, we might end up saying). It's the systematic practice of the aperture and ambiguity of the world. Never-ending.

Massimiliano Gioni, 1999

Revival Field: Living Plants/Living Process

I had never tended a plant or gardened with great success in my life. When I learned, however, of the capacity of plants to remove heavy metal toxins from the soil, I was prepared to abandon all the familiar raw materials of art and add living plants as a major sculptural medium and tool. Such a commitment was predicated on a poetic promise and a pragmatic dedication: An ecology that is endangered or near death could be restored through an artwork.

Revival Field is a cross-pollination of ideas found in art and science which seeks to extend and transcend the desires and goals of both disciplines. As an artwork, it is envisioned as the sculpting of a site's ecology, where the material is contaminated soil, instead of marble, and the tools are hyperaccumulating plants and scientific process, instead of chisels. The full realization of the work will be a revitalized ecology that can sustain diverse plant and animal life. *Revival Field* seeks to expand the potential of public art by addressing an issue actively and by inviting multidisciplinary collaboration and community involvement into its creation.

As science, *Revival Field* catalyzed a scientific process that at the time was unfunded and dormant in the United States despite evidence of its promise. This project virtually introduced green remediation to an international community.

Revival Field began as a pioneering effort to test and introduce the use of hyperaccumulator plants for large-scale remediation of areas contaminated with toxic heavy metals. The plants have a cultural history as indicators of metal concentration for ancient metalsmiths (especially in Africa) thus serving as a tool for prospecting. These plants have adapted a natural capacity to pull metals out of the soil and store them in their leaves and stems. The concentration of heavy metals are so high that the plants can be harvested, safely incinerated and resold as high-grade ore to pay for the process. This form of green remediation is proposed as an on-site, low tech, self-sustaining alternative to current costly and unsatisfactory remediation methods.

Revival Field
Soil sampling, fall 1992
Plants, industrial fencing on a hazardous waste landfill
18.3 x 18.3 x 2.7 m
Pig's Eye Landfill, St. Paul, Minnesota

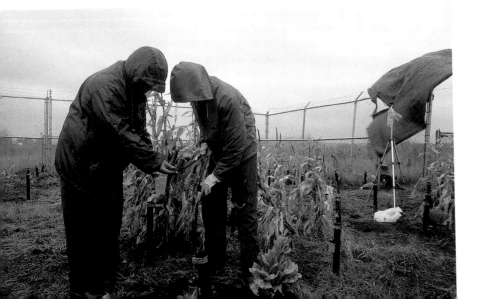

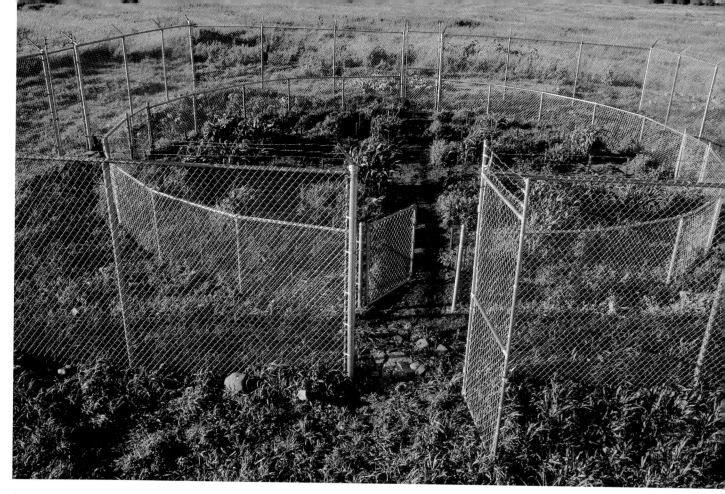

Revival Field, July 1991
Plants, industrial fencing
18.3 x 18.3 x 2.7 m
Pig's Eye Landfill, St. Paul, Minnesota

The project was first implemented in 1990 at Pig's Eye Landfill in St. Paul, Minnesota, a state Superfund site in an area with hazardously elevated levels of zinc and cadmium. Funded by the National Endowment for the Arts, this field represented a unique art/science collaboration between myself, an artist, and Dr. Rufus Chaney, a research agronomist at the United States Department of Agriculture. The initial experiment took the form of a three-year replicated field test, the first of its kind in the United States and one of only two such fields in the world. Previously, this form of bioremediation had been tested only under laboratory conditions.

Revival Field is not only about living plants. It is a living process deeply rooted in a progressive association of art and hard science interacting with the people in the fields of politics, law, and business. It originally compelled the areas in supposed opposition (art vs. science, polluters vs. environmental regulators) to share through action the production of knowledge. This knowledge has made green remediation an accepted technology.

Revival Field is not done.

As a living process, it will continue to be about the life of ideas and their continued application in the world. As a finished sculpture, it will be a place where flora and fauna interact and thrive under the threat of toxic presence.

Mel Chin, 1999

My work maps human evolution, creates social structures and metaphors for our time. It breaks through the boundaries of art, dealing with ecological, cultural and social issues. These works are philosophy- and science-based, large-scale environmental projects that range between individual creation and social consciousness.

[...]

I find it important to create these works all over the world as examples of what needs to be done – on destroyed, barren land where resource extraction has taken its toll; in the nervous tension of cities; on deforested soil – to stop erosion, purify the air, protect fresh groundwater, provide home for wildlife and afford people a chance to stay in touch with nature. It is also important that I make my work beautiful. The beauty carries the concept and the philosophy and makes this work different from any other reclamation project. This non-ego-based art form is a new visual language of communication that expands the boundaries of art. It speaks to people at all levels of life and reaches out to future generations, offering a legacy. These works question the status quo, elicit and initiate new thinking processes and offer provocative, meaningful communication.

Wheatfield – A Confrontation

In May 1982, after months of preparations, we planted a two-acre wheat field on a landfill in lower Manhattan, two blocks from Wall Street and the World Trade Center, facing the Statue of Liberty across the Hudson, on a landfill worth 4.5 billion dollars.

When I was invited to do a public sculpture in New York City, my decision to plant a wheatfield instead grew out of a long-standing concern and a need to call attention to our misplaced priorities and deteriorating human values. *Wheatfield* was a symbol, a universal concept, it represented food, energy, commerce, world trade, economics. It referred to mismanagement, waste, world hunger and ecological concerns and also to the future of megacities.

Two hundred truckloads of dirt were brought in, and we dug 285 furrows by hand, cleared of rocks and garbage. The seeds were sown by hand and the furrows covered with soil. We maintained the field for four months, cleared out wheat smut, weeded, fertilized, sprayed against mildew fungus and set up an irrigation system. We harvested the crop on August 16. It yielded over 1000 pounds of healthy, golden wheat.

Wheatfield wasn't just about making land fertile again. It created a powerful paradox due to its placing on land worth $4.5 billion for the planting and harvesting a field of wheat.

The harvested grain traveled to twenty-eight cities around the world in an exhibition called 'The International Art Show for the End of World Hunger', organized by the Minnesota Museum of Art. The seeds were eventually carried away by people who planted them in many parts of the globe.

Agnes Denes, 1999

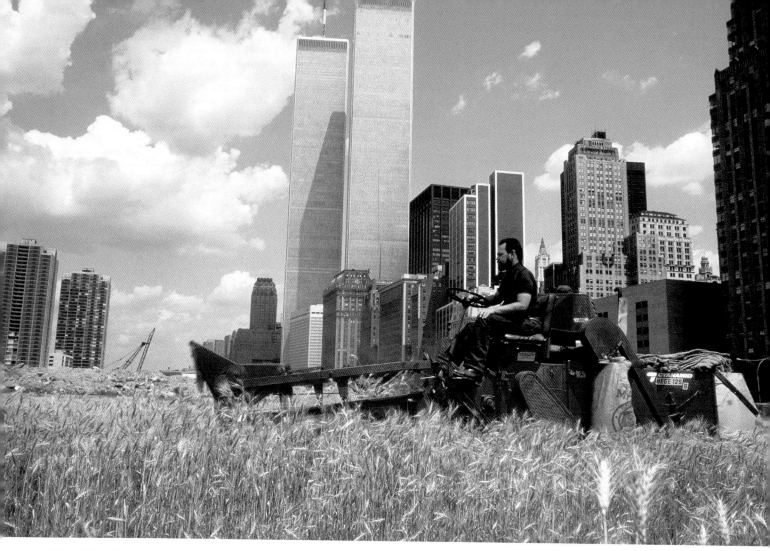

Wheatfield – A Confrontation, summer 1982
Two acres of wheat planted and harvested
Battery Park Landfill, Downtown Manhattan,
New York City

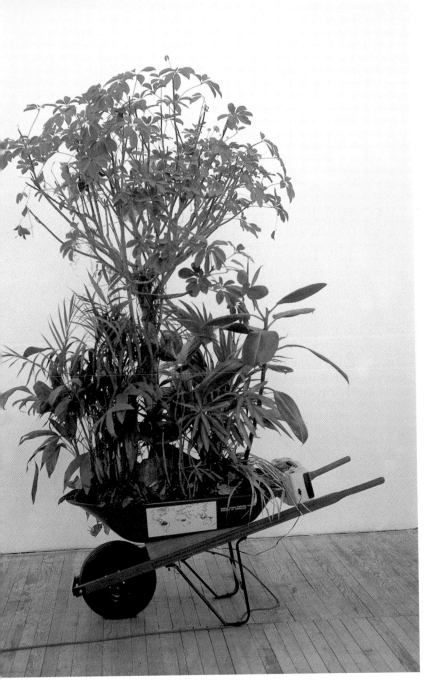

(with William Schefferine)
Tropical Rainforest Preserves (mobile version),
from: *Wheelbarrows of Progress*, 1990
Tropical vegetation, soil, stones, press type on red
enamel, wheelbarrow
63.5 x 68.5 x 141 cm
Installation, American Fine Arts, Co., New York

[...]

Mark Dion: During my travels in the Central American tropics, I became very concerned with the natural and cultural problems around tropical ecology. On my first visit to a tropical rainforest, I was overwhelmed by its complexity and beauty. The alienness of the jungle, its awesome vitality – I was so impressed. I remember taking a shit during a hike in the bush and having titanic dung beetles and a dozen different flying insects descending down on it before I could get my pants up. What a place!

Anyway, even though they make up only 6–7 per cent of the earth's land mass, tropical rainforests contain well over half of all living species. They are amazing laboratories of evolution, the greenhouses of biological diversity. At the same time, they are enormously affected by postcolonial politics, global economics, sovereignty issues and northern fantasies of paradise and greenhell. In the 1980s, tropical forest debates were like a microcosm of the deepening divide between countries of the northern and southern hemispheres. They were also a map of our assumptions, desires and projections about what constitutes nature.

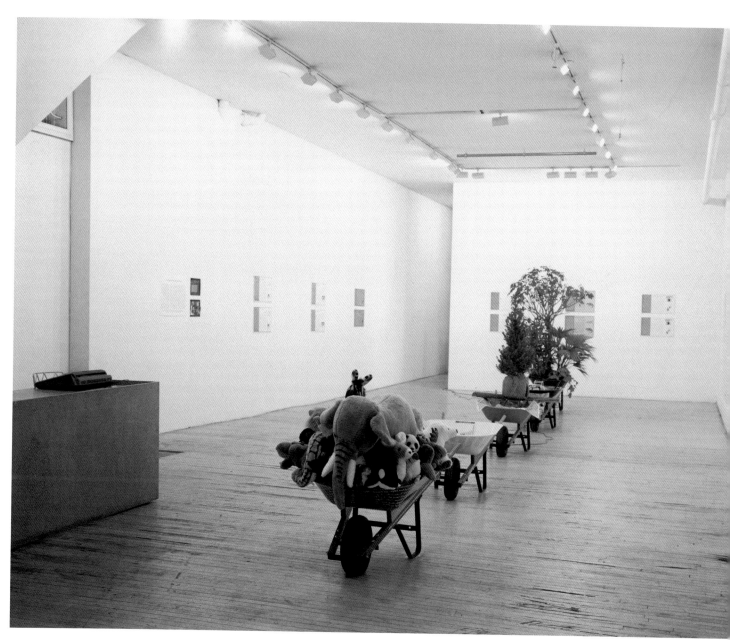

(with William Schefferine)
Wheelbarrows of Progress, 1990
Various materials
Installation, American Fine Arts, Co., New York

(with William Schefferine)
Under the Verdant Carpet: The Dreams of Mount Koch, 1990
Barrels and rubbish bins with text, potted plants, plastic bags, newspapers,
cardboard boxes, pie chart illustrations, colored photograph
Installation, Whitney Museum of American Art at Federal Plaza, New York

(with William Schefferine):
Tropical Rainforest Preserves, 1989
Terrarium with casters, plants, Gro-Lights, plywood,
notice-board, iguana, photographs, clipboards,
clippings, drawings, books, specimens, animal skin
Installation, Clocktower, New York

Miwon Kwon: What did you think an artist or an artwork could do in the face of such conditions?

Mark Dion: What a question! Well, one of the fundamental problems is that even if scientists are good at what they do, they're not necessarily adept in the field of representation. They don't have access to the rich set of tools, like irony, allegory and humour, which are the meat and potatoes of art and literature. So this became an area of exploration for Schefferine and me. Also, the ecological movement has huge blindspots in that it is extremely uncritical of its own discourse. At the time, it was evoking images of Eden and innocence, calling for a back-to-nature ethos. So part of what we did was critique these ideologically suspect, culturally entrenched ideas about nature.

The parade Schefferine and I made for American Fine Arts, Co. in New York, called the *Wheelbarrows of Progress*, was largely a response to the shockingly bone-headed ways of thinking which we witnessed around "green" issues. Each wheelbarrow carried a weighty folly – from Republican dismantlement of the renewable energy program to wildlife conservation groups pandering to the public with pandas.

Tropical Rainforest Preserves (1990) is a good example of a response to a double phenomena. On the one hand, zoos in North America were creating rainforests inside cities as special exhibits. On the other hand, ecological groups were trying to export notions of a national park – locking up natural resources in order to protect them. Our piece was meant to reflect on such conditions in a humorous way by making an absurdly small reserve that was "captured" and mobile, comically domesticated and reminiscent of the Victorian mania for ferns, aquariums and dioramas.
[...]

From: 'Miwon Kwon in conversation with Mark Dion', in: Corrin/Kwon/Bryson (eds.), *Mark Dion*, London, Phaidon Press, 1997, pp. 10–11

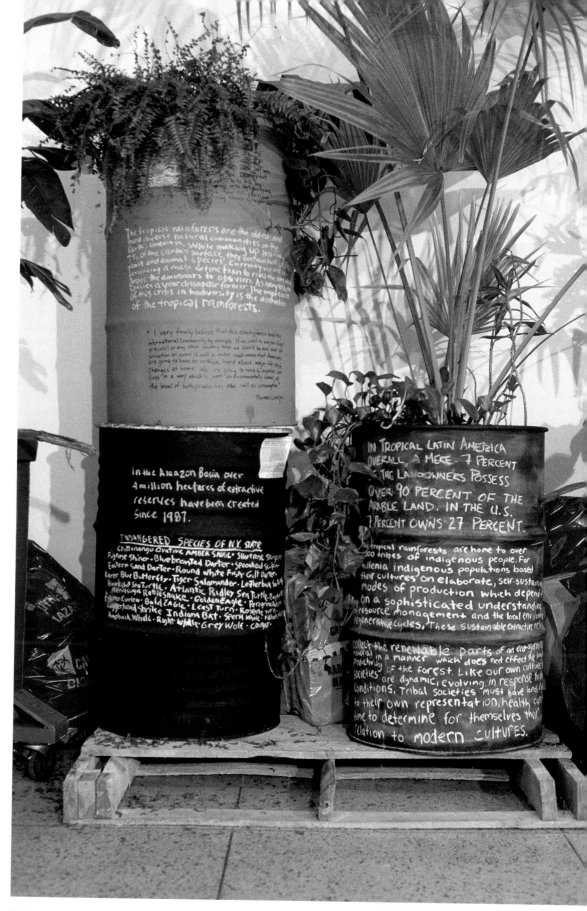

Under the Verdant Carpet: The Dreams of Mount Koch (detail), 1990

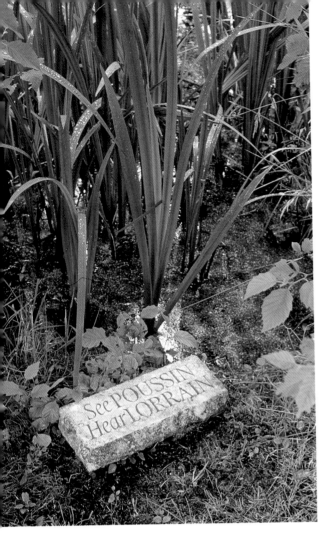

In my garden it is a mistake to suppose that the work of art is the stone (wood, bronze, or whatever) artifact; the work of art is the artifact together with the surrounding vegetation. In short, to garden is to compose using a variety of elements.

Ian Hamilton Finlay, 1999

See Poussin, Hear Lorrain, 1975
Stone with inscription, water plants
Little Sparta, Lanarkshire, Scotland

Apollo and Daphne, 1979
Metal, woodland
Little Sparta, Lanarkshire

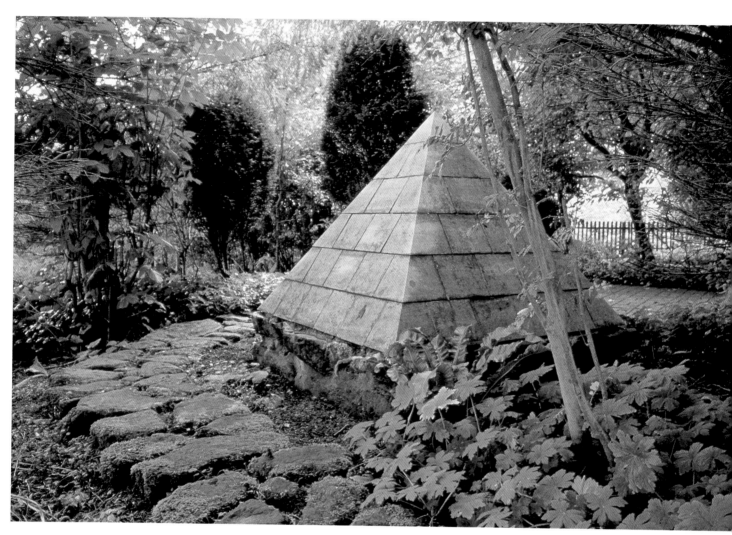

C. D. Friedrich Pyramid, 1975
Stone, plants
Little Sparta, Lanarkshire

One of the most remarkable things we observed during our stay in Japan in 1995 was an action in public space carried out by the Tokyo city government. The project was a response to a cardboard-box settlement in the subway tunnels. A 500-metre-long row of cardboard boxes had been erected by homeless people in a pedestrian underpass. The boxes were packing cartons for large household appliances such as television sets, washing machines and refrigerators: improvised dwellings resembling middle-class rowhouses in certain details, with doors and windows cut into the cardboard and adorned with curtains. Two weeks after the occupation of public space by the homeless, which the authorities tolerated, the city government had a number of large, easy-to-tend potted plants placed outside the cardboard-box settlement.

In a reversal of this government project, we installed small cardboard-box settlements behind existing groups of plants in public buildings in Kassel, including the Mövenpick Hotel and the Stadtsparkasse, within the context of the "Surfing Systems" exhibition organised by the Kasseler Kunstverein in 1996. Our conclusion was that the placement of plants in front of homeless settlements can just as easily be understood as an appeal to have such dwellings erected behind groups of plants as well.

Nina Fischer & Maroan el Sani, 1999

Centerpark, 1996
Potted plants, cardboard boxes, curtains, carpet, roller
Installation at Hotel Mövenpick and Stadtsparkasse Kassel
Exhibition: Surfing Systems, Kasseler Kunstverein, Fridericianum (D)

Garten (Garden), 1996/97
Garden design
Private garden, Münster (D)
Exhibition: Skulptur. Projekte in Münster (D)

[...]

The order imposed upon the garden of Fischli/Weiss differs only slightly from that of an ordinary farmer's garden. Two relatively large beds containing mixed cultures of local vegetables, fruits and berries hide the intimate centre in which, aside from glass-roofed spring beds and boards with seedlings, there are also a small tool shed and a place to sit. Pole beans are arranged along the wall, with a compost heap in a corner. Only on a patch of ground running to a sharp point on the right does the garden deviate with larger fields of corn and potatoes from the customary pattern of the farmer's garden. According to the artists' plans, their garden should be sufficient to feed at least a family of twelve. Important factors include structural concepts such as planting sequences and mixed cultures or "good" and "bad" neighbours, when it comes to the placement of different flowers and vegetables near one another; also important is the manner in which the "good" and "evil" of gardening are handled – in other words, an ecologically sound approach to the control of pests such as worms, snails,

Garten (Garden), 1996/97

various different caterpillars, ichneumon and fruit flies, and, above all, the hordes of rabbits that plague the region and the nets, mesh fences and other devices that must be erected to keep them out.... Because Fischli/Weiss proceed in neither a "romantic" nor a "Chinese" fashion, meaning that they make no attempt to imitate the lawlessness and disorder of "wild" nature but instead strive for a prosaic equilibrium between visual grace and productive yield by emphasising utility, the garden ultimately evokes – not least of all through the fictitious presence of the "imaginary gardener" – precisely the sense of model quality and fiction that typifies many of the most significant works of the two artists. This artfulness is concealed in perfect mimicry beneath the veils of organic-vegetable nature. Art develops as if from within itself in the flourishing growth of earthly life.

"The art of designing gardens", as the Chinese Lieou Tcheou is quoted as having stated in a missionary compendium published in 1782, "consists in combining points of view, diversity and solitude in such a way that the deluded eye gains the impression of simplicity and rural serenity, the ear hears the silence or that which penetrates it and all of the senses experience joy and peace..." [1].

"What we are looking for are the metalevels the garden creates on its own. What creates the metalevels is overripe, decayed, eaten." (Fischli/Weiss) That is why viewers who know little about the art of Fischli/Weiss, in particular, presumably see, hear and smell a simple garden when they first gaze at this work of art. However, upon entering the garden over the small wooden bridge past the romantic animal figures, certain viewers better-informed in matters of art will at first perhaps fail to perceive a garden at all but will see an exhibition object, an installation or something else resembling a work of art instead. These viewers should then, as the artists imagine it, be shown along a way that will take them to where they see "nothing but" a garden, to a place where their consciousness finally reaches ground level, where the lettuce grows, from which point the other "more abundant" world may perhaps become visible, the one with transparent horizons that encircle a garden on whose axis stands the Tree of Life" [2].

From: Patrick Frey, 'Es wächst', in: *Peter Fischli/David Weiss – Arbeiten im Dunkeln*, exhib. cat., Kunstmuseum Wolfsburg and Walker Art Center, Minneapolis, Stuttgart 1997

1 Quoted from Jurgis Baltrusaitis, *Imaginäre Realitäten*, Cologne 1984.
2 Quoted from Gerhard Meier, *Das dunkle Fest des Lebens, Amrainer Gespräche*, Cologne/Basle 1995.

Garten (Garden), 1996/97

The name "Versailles", which represents the epitome of the garden as art, the stylised luxury of the French Sun King Louis XIV, is associated metaphorically with an automobile in this work. Consumer goods as fetish, as status symbol, as the contemporary embodiment of luxury are Sylvie Fleury's theme in this piece. Accordingly, the massive, sleek Lincoln Versailles is completely covered by a teeming growth of climbing roses that prevent it from being driven and thus effectively negate its function as an automobile. The picture calls to mind the roses which overpower everything in Grimm's fairy tale *Sleeping Beauty*. The car now serves as an allegorical means of transportation into a dream world. The petals of the roses are pink. Pink, the colour of sugar-sweet, unrealistically positive "Think Pink" and naive girlishness, alludes to female dream projections, an association that is heightened by the fashion items on the seats inside the car.

Barbara Nemitz

Versailles (detail), 1994

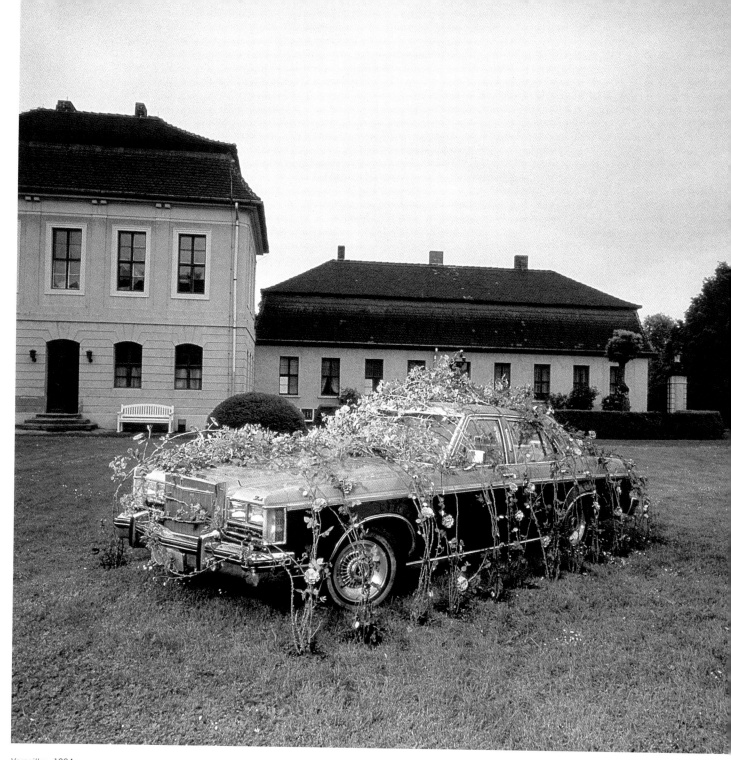

Versailles, 1994
Climbing roses, Ford Lincoln Versailles,
magazines, scarf, boutique carrier bags
Exhibition: East of Eden, Schloß Mosigkau, Dessau (D)

The house is a garden. Even in the heart of the inner city, in the residential flat, the city-dweller surrounded by his four walls has a close relationship to plants. His home is a puzzling conglomeration of garden elements, decorative forms, furnishings and installations, all of which contain unmistakable references. Indeed, aren't the expansive patches of decorative fabrics actually flower beds? And wallpaper and embroideries are landscapes. On the periphery, above the heads of guests, rows of hothouse ferns recall the traditional function of paintings – namely, to bring a bit of landscape or nature into the house. And the networks of cables and pipes – do they not spread throughout the house like parts of an organism. Are they not a root system in their own right?

The constructed garden synthesis shifts back and forth between over-exuberant splendour and puzzling, disruptive elements, the utensils of plumbers and electricians which inject an element of impurity into this image of shiny surfaces.

Barbara Nemitz

House and Garden, Undergrowth, 1996
Textiles, plumbing material, ferns, chairs
Snug Harbour Cultural Center, New York

[...]

Finally Paul-Armand Gette investigates a word which certainly merits considerable thought. What is landscape? Near our feet lie stones, between which grass and plantains sprout, with nettles growing a little further back. Time to consult Linnaeus: the plants, stones and even the black beetles scurrying between them have names. A little further off, though, they no longer have any names, the plants become 'greenery', the stones become hills and rocks; add a brook, houses and the sky above and we call it a landscape. Why landscape? Simply because we are short-sighted and can no longer distinguish the plants on the distant hill? Or do we jump to another level of perception, from that of the scientific collector to the geographic or even artistic level? At any rate, thinks Paul-Armand Gette, the transformation takes place somewhere, *Poa annua* and *Taraxacum officinale* do end somewhere and everything becomes landscape....

Obviously, the theme is nature. We are human beings, and nature has slipped away from us, we have become estranged from it. We have methods for approaching it, for bridging the gap, for trying to understand nature. One such method is science. It asks questions and answers them with names and models. However, it can only answer the questions which have been formulated. But where questions can no longer be formulated and answers are nonetheless given, we are in the domain of art. The scientist Paul-Armand Gette is an artist.

From: Lucius Burckhardt, 'Wissenschaft ohne Fragen' (Science without Questions), in: *Transect and some other attitudes towards landscapes*, exh. cat. European Visual Arts Center, Ipswich (GB), 1990, pp. 22–25

[...]

Insofar as it is perceived as a need, the exotic is a complement to our own one-dimensionality. As a wish machine, it offers the haves and the have-nots – both, although for different reasons, bound to their own particular patch of earth – a sense of ubiquity. The White Man brought his colonies to the city through botanical gardens and zoos and along with them tropical fashions, floral bouquets from far-off lands and ultimately the inner Orient. Exotic plants were introduced to indoor gardens, to public parks and even to city streets. They have long since become a part of our surroundings, everyday furnishings, despite their impressive Latin names whose promise is not fulfilled by their banal appearance.

It is this popularity of the exotic that Paul-Amand Gette exposes as a cliché when he locates trees and bushes from the two Americas, the Balkan region or China in Berlin's Tiergarten district, in Kreuzberg and Spandau or in Wedding, and isolates them in his cooly detached images. The foreign is mere fantasy; the exotic is what we attach to it, and what it does to us, so that the one qualifies the other. Just as we breed tropical plants in hothouses, our native plants are cultivated as rarities in cool-houses along the equator. We should be reminded that the first sights South Americans travelling through Europe tend to visit are the Norwegian fiords.

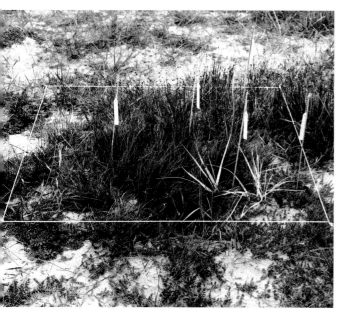

m² témoin
(Registered square meter), 1974
Elymus arenarius L.,
Potentilla Anserina L., etc. ...
Malmö (S)

Paul-Armand Gette's reverse approach leads him to seek out nature in the city – not in parks but at paved parking lots, the construction site at the Centre Pompidou, the Place de la Concorde and the canalised riverbeds in London, Paris, Rotterdam and Mannheim. Even as a student, he analysed recent entomological finds of beetles along the banks of the Rhone in Lyon, later pursing the track of a so-called weed on its way through Munich, as if it were a rare species of orchid.

From: Günter Metken, '*Ailanthus altissima* im Wedding', in: *Paul-Armand Gette – Exotik als Banalität*, exh. cat. DAAD Berlin, 1980

The Exotic as Banality (Robinia hispida), 1979
Photograph, paper, dry leaves
Paris

The Exotic as Banality (Pterocaria fraxinifolia), 1981
Photograph, paper, dry leaves
Paris

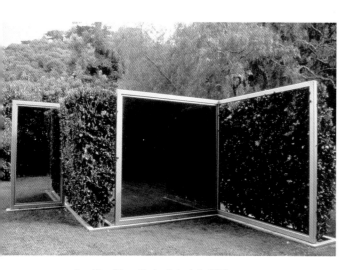

Two-Way Mirror Hedge Labyrinth, 1989
Bob Orton Collection
La Jolla, California

Two-Way Mirror Hedge Labyrinth, 1989

The hedge labyrinth alludes to the formal classical garden hedge maze and also to the labyrinth of modern downtown city of two-way mirror tower blocks. Simultaneously, the garden hedge alludes to the suburban house's hedge, which delimits property lines and private space for the individual homeowner. The work is a hybrid of these three allusions. The hedge is opaque from a distance, but transparent seen up close. While the two-way mirror panels shift between reflective transparency and mirror reflectiveness as the sunlight changes viewers' bodies and intersubjective gazes can be seen on all sides of the two-way mirror panels.

Dan Graham, 1992

Two-Way Mirror Pergola Bridge, 1988–1990

It is proposed to create a bridge sculpture. There are two possible ways to do the bridges – one has a wood or aluminium lattice from which ivy or any climbing plants could grow and the other has two-way mirror sides. As at least two of three surfaces should be reflective, the lattice version would only work if a very reflective area of the river was visible beneath the steel grid walkway. It was calculated that the best situation would be an equilateral triangular form whose three sides were about ten feet in length or width. The shorter the bridge the better. Ideally there will be an entire plane of two-way mirror glass, but if it must be broken in two lengths, the break should be in the middle of the bridge span, on the vertical.

Dan Graham, 1989

Two-Way Mirror Pergola Bridge, 1988
Clisson (F)

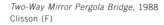

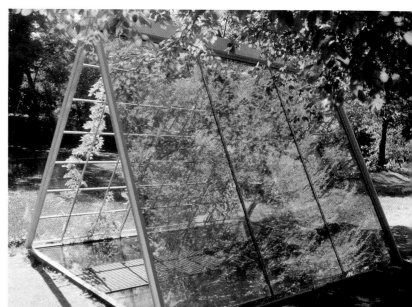

Two-Way Mirror Pergola Bridge, 1988
Clisson (F)

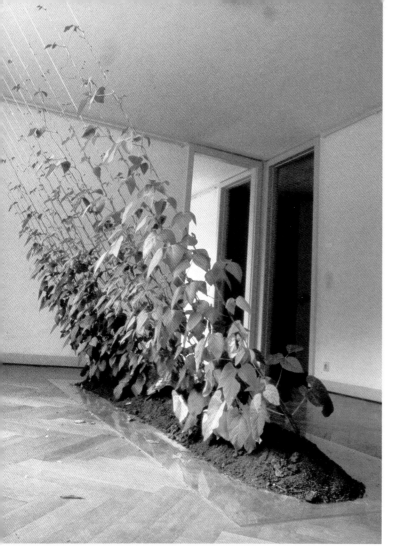

Gerichtetes Wachstum (Directed growth), 1972
Earth, beans
Museum Haus Lange, Krefeld (D)

Rye in the Tropics, 1971
(before cancellation of the show)
Guggenheim Museum,
New York City

Grass Grows, 1969
Earth, grass
Exhibition: Earth Art, Cornell University,
Ithaca, New York

… make something which experiences, reacts to its environment, changes,
is non-stable …

… make something indeterminate, which always looks different, the shape
of which cannot be predicted precisely …

… make something which cannot "perform" without the assistance of its
environment …

… make something which reacts to light and temperature changes, is sub-
ject to air currents and whose function depends on the forces of gravity …

… make something which the "viewer" handles, with which he plays and
thus animates …

… make something which lives in time and makes the "viewer" experience
time …

… articulate something natural …

Hans Haacke, Cologne, 1965

Out Of The Black Into The Blue, 1997
Site-related work, various butterflies, larvae, egg,
various plants, butterfly feeders, fruit, metal Hid light,
hanging cage, plastic box, video surveillance system
Nordic Pavilion, XLVII Biennale di Venezia

In a general sense, the work is, by personal interest, open research on bio-
logical behaviours in a social and cultural context. As a whole, it involves
investigation and observation of living matter, its limits and extensions.
The concept and strategy are to reflect and extend different aspects of
environmental and biodiverse structures – to develop and construct possi-
bilities for interspecies interaction and communication. In the end, living
matter itself is unpredictable, and this I find quite intriguing.

After Forever (ever all) is based on the process of building environ-
ments and on the extensions of plant physiology. The work is developed
further to be viewed and experienced as a painting of a forest, a reflective
state of mind and romantic view of a vanishing point in our coexistence.

Out of the Black into the Blue is based on the observation and regis-
tration of the metamorphosis of butterflies and moths and on strategies
involved in the development of new populations and habitats. The work
investigates possibilities for the generation of new animal populations on
open terrain. The project is designed to be flexible, as all units are portable
and can be moved to any other area of focus. The work stands in direct
relation to the environmental situation on site and proceeds from a foun-
dation in the natural history of butterflies and moths native to the region of
choice.

Henrik Håkansson, 1999

after forever (ever all), 1998
Plants, mixed media
Exhibition: Visions du Nord, Nuit Blanche
Musée d'Art Moderne de la Ville de Paris

after forever (ever all),
1998 (detail)

I have used plants rarely in the production of my work, but in the case of *Land*, I used them to construct a basic proposition where two supposedly opposing forces are at work. The enduring romanticisation of nature stems from a little feeling of insecurity with our modern world. There are many "irregularities" within nature which make a mockery of our projections on it. The romantic attraction to the life of a plant lies in a naive longing for its simple exchange with the earth's goodness and its rooted paradise of inertia.

Tillandsias, more commonly known as air plants, break free from this sentimental model. They do not fit in with our acceptable notion of nature as they have no functional root system, thus denying us the primary emotive essence of a plant. They use the remnants of a root system to attach themselves to a host, but they are not parasitic, as they use their host only as a means of physical support. They survive by absorbing nutrients through their leaves, from the dust dissolved in rainwater and oxygen from the atmosphere. Self sufficient and thoroughly modern in their approach to the task of living, they can survive in inhospitable sites, eliminating the problems of aggressive neighbours competing for water and light.

Land was once a machine, but now worn down and burnt out by the paradox of its own ambition for everything at once, speed and conclusion, it has surrendered to a more progressive ideology. Colonised by the air plants, the plant without roots becomes a metaphor for a new order of life where anti-genealogy and adaptability make it more powerful. In the relationship proposed by *Land* the modernity of this once potent machine is once more dissolved by the presence of the plants, surrendering to a more advanced proposition. Together they make a new future, an alliance in unsentimental terms between nature and machine where there is no need to battle against each other. Perhaps it is this co-operation which will safeguard the continuum of all living things.

Siobhán Hapaska, 1999

Land, 1998
Fiberglass, acrylic paint, two-pack acrylic lacquer,
magnets and air plants
1.32 x 2.38 x 0.94 m

Future Garden/The Endangered Meadows of Europe, 1996–1998
12,300 m² on the roof of the Kunst- und Ausstellungshalle der
Bundesrepublik Deutschland, Bonn (D)

Helen Mayer Harrison, Newton Harrison & Associates
On our work

When we first engaged the issue of survival, we considered experimenting with making earth for farming installations, growing food plants under lights for museum installations. Thus we did the *Survival Series*, 1970–73. These pieces varied from worm farms to strawberry patches – a strawberry wall made of wood with holes for the strawberry plants, a series of thin rectangular aluminium wall hangings that were planters with gro-lux lights inserted in the top. We invented upright pastures in redwood boxes under lights in order to grow beans and cucumbers, and we made flat pastures under lights that grew greens and root plants. We even constructed a citrus orchard indoors under lights for a work called *Portable Orchard*, an 18-tree citrus-and-avocado installation in which the bearing dwarf trees were planted in hexagonal boxes, each filled with a cubic meter of earth. It was an ironic response to the construction of local orchards by massive development.

Fish farms were created, with algal blooms as food for brine shrimp – food for fish which were food for us. We included feasts as part of almost all the projects since, of course, the purpose of growing food plants is to produce food and because harvest time is traditionally a time of feasting and celebration. We came to understand that farming under lights was energy-expensive and, if scaled up, would have some of the same problems as large scale industrial farming, and so we began to think more directly of reclamation and restitution at whatever scale opportunity offered. ...

In 1994, we began work on *Future Garden, Part 1: The Endangered Meadows of Europe*, opened in 1996 and still ongoing, in part, on the roof of the Kunst- und Ausstellungshalle der Bundesrepublik Deutschland in Bonn, where we rolled up half a hectare of meadow from the Eifel region that was to be destroyed by development and moved it to the roof garden. There we added a series of fencing structures that held plaques telling the story of the meadows and explaining why we valued them so highly. They are one of the few successful collaborations between man and nature, serving biodiversity and providing hay. The series of meadow works continues in Germany and Austria. The *Future Garden* series continues as well.

We have made many more proposals, most of them unbuilt, but which opened new conversations in their locales. Whether realized or in extended narrative such as *The Lagoon Cycle* or in proposal form, all our work is about the restoration of living systems. Finally, to show how the process works: When walking through the *KünstlerGärten* in Weimar, Newton looked at the ivy which was choking out the diversity of the plants. He asked how much you paid for an artist's work and then said, "Take that money and pay the gardeners to begin the process of freeing the ground and the trees from the ivy." That is as good an explanation of our work as any.

Helen Mayer Harrison, 1999

Future Garden/The Endangered Meadows of Europe, 1996–1998

HELEN MAYER HARRISON NEWTON HARRISON

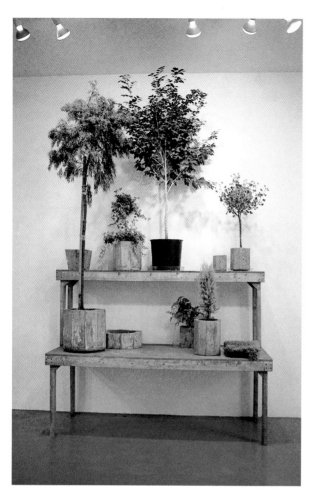

Exhibition View, 1997
AC Project Room, New York City

Apple Maze, 1996 (begun)
KünstlerGärten Weimar, Villa Haar
Bauhaus-Universität Weimar (D)

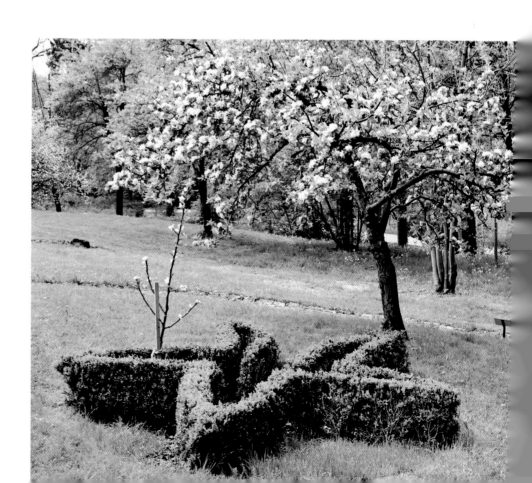

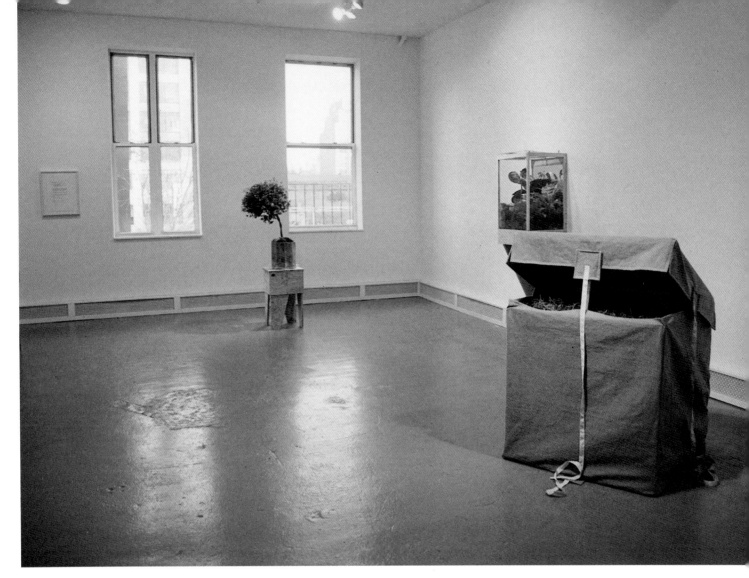

Exhibition View, 1997
AC Project Room, New York City

I have established a way of working as an artist which includes my profession as a horticulturist and landscape designer. Integrating these practices, I use the garden model as a focus for my content-based works. Projects begin with an exhibition then literally go on to unfold their meaning through time. They involve living plants, garden structures, collaborative and integrated systems with the intention of growing and developing. This distinction in my work encourages on-going communication about the boundaries of art and the ways that landscape work is evolving. Over the past thirty years, "Land Art" has been viewed as belonging to a history of monuments – observed from airplanes and existing in a form which strives to be whole and intact unto itself. As the core of my work is located in daily, close observation and consequential maintenance, the subject becomes animated and physical in a literal sense. I consistently work collaboratively with maintenance workers, architects, engineers and technicians, as well as other artists. My projects rework established notions of art-making but still belong to the historical tradition of gardening, an endeavor which has always crossed the boundaries of fine art and science. I view the accumulative and ephemeral activities of *gardening* as the deeper sculptural manifestation of the garden, not vice versa.

Paula Hayes, 1999

Akné's Friend, 1994
Exhibition: Summer Garden,
Galerie Air de Paris, Nice

Tragedy blossoms with enthusiasm. The artist has seen strangulation as fine art. A collection of flowers, placed here and there in an empty room, are made into the victims of their own natural destiny. The more they strive towards light and life, the closer they grow to their pitiful end. Helplessly rooted in the most meager of seed pots, they have become victims of a playful aesthetic urge. They permit themselves to be draped arbitrarily here and there, and so some of them have been tied to the metal shafts of everyday, white umbrellas, opened out and laid on their sides in the room. The plants hang almost horizontally in the exhibition room, now and then the plant soil trickles onto the stone floor, and every centimetre they grow means that the plants move further into the protective shade of the umbrellas. Until lack of light prevents anything more from growing. For one single specimen by the wall, the path to the light is not blocked, and the plant flourishes primly in the perpendicular. Meanwhile, a plumbline arranged as block and tackle – fastened at the very top of the stalk to stretch it – turns the increase in length of the blossom on its way upwards into inevitable destruction. It is prevented from growing to the side, and so a piece of cable between the indifferently graceful flower and a bamboo stick forcing it in the correct direction increasingly stretches, cutting into it. The natural way of things means that, stretching in space, it will permit its head to be severed by the cable. At the other side of this *Summer Garden*[1] another member of the family is sent to the devil as soon as its strapping size is adequate to trigger the firework motor of a small, hellish machine resembling a roller-skate and thus fling the flower and its planting pot into the air.

So is this murder or formalism? Carsten Höller would reject the latter, and so, initially, it is an experiment. In Nice, the artist presents one of many possible experimental constructions, and in these one never knows precisely who or what is the object of research: art, which in many cases has become accustomed to refusing form and experience, or perhaps its public, still eager to be stimulated and to consume? The fact that the flowers execute themselves in the service of aesthetics may certainly not be interpreted as a twee conjuring up of earthly transitoriness. What is presented here is damage through form, which would be met with justifiable indignation, were one to apply serious moral criteria: waste of resources, a lightly-taken unconditionalising of one's own play instinct, the perfidious setting of traps for defenceless vegetation, and finally the inconsiderate demonstration of a hierarchy of the species. The artist completely evil, the artist right on top. Admittedly, what harm is there in a ruined ornamental plant?

Höller's work persists on the brink of the threatening; perhaps it is more correct to compare it to a film idea, to the exposé of a bloodthirsty intention; it is the endlessly slowed-down, frozen slow-motion image of self-destruction. The merit of the work does not lie in the malice of its image, but in the refinement with which it remains harmless. Höller celebrates the edifying semblance, the naively stubborn systematics. The viewer sees a competition of ideas, delights in the floral ornament; its superficial brightness and a malice-provoking emulation almost make us forget that here the calculating artist is forcing the aesthetic into an admission of

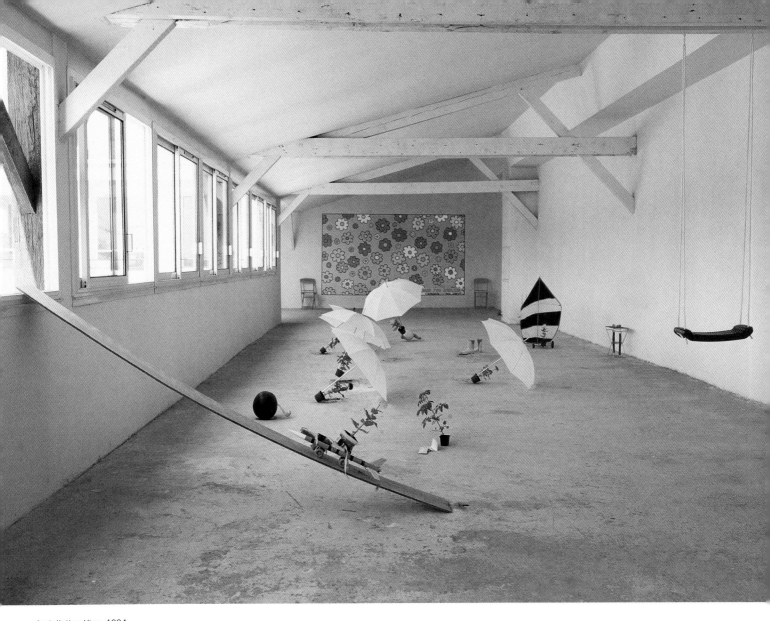

Installation View, 1994
Exhibition: Summer Garden
(with Lily v. d. Stokker),
Galerie Air de Paris, Nice

guilt: It accuses itself of a parasitic principle. Those who stroll in Höller's shameless, murderous little garden do not see symbols. With innocent eyes they see how the material which they, for lack of better ideas, begin to see as nature and reality, initiates a conflict with the aesthetic forms distilled from it. For Höller's flower pots and his plant soil are too clearly and tangibly what they are – we cannot declare them a further variation of the artistic ready-made. It is not that someone has plundered a garden centre and signed his name to the objects found. Instead, an artist has distilled perceptible values from that which evades the conventions of art. The ironically disturbing death struggle of some potted plants stubbornly refuses to fit in with the fund of common aesthetic means, it blurs the boundaries between play, frivolity and nature

From: Gerrit Gohlke, 'Pleasure and Truth – a process in the works of Carsten Höller', in: *Be Magazin*, May 1998, Künstlerhaus Bethanien, Berlin, pp. 62–71

1 Exhibition: Summer Garden, Galerie Air de Paris, Nice, 1994.

Suicide Plant, 1994
Exhibition: Summer Garden,
Galerie Air de Paris, Nice

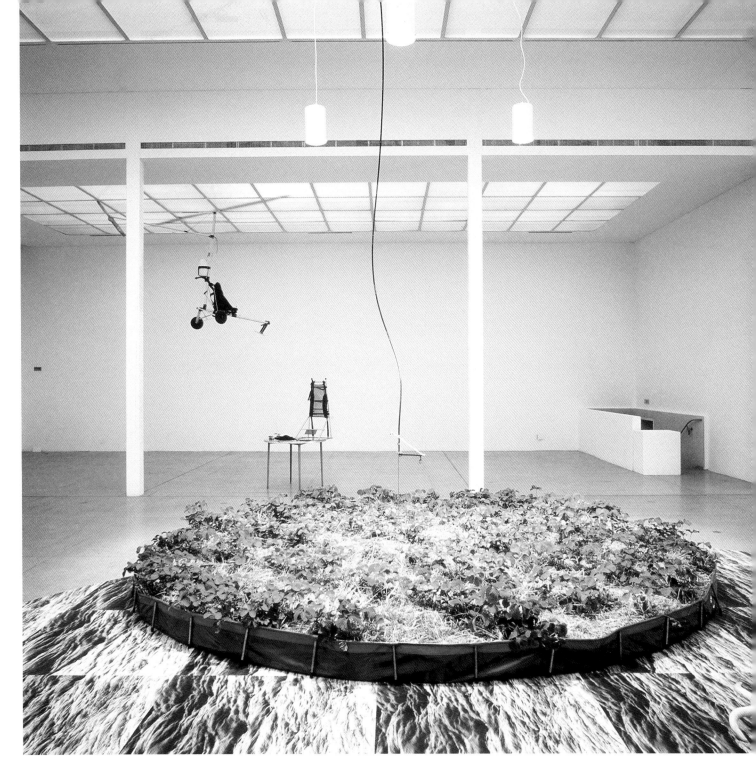

Installation View *SKOP* (detail), 1996
Transportable strawberryfield
Wiener Secession, Vienna

Black Garden (detail)

Jenny Holzer's *Black Garden* is a reinterpretation of a war memorial erected in the city of Nordhorn in 1929 in honour of soldiers killed during World War I and later expanded into a memorial also commemorating the victims of the War of 1870/71 and World War II.

Holzer transformed the war memorial into a site at which the subtle interactions of architectural, botanical and linguistic elements convey a sense of the cruelty of war. A network of red-gravel paths laid out in the shape of a target leads through beds full of extremely dark plants. The nearly black blossoms and leaves of the approximately 10,000 flowers, grasses and shrubs (including tulips, carnations, lilies, red berberis and, in the centre, an apple tree bearing black apples) are suggestive of a life devoid of all colour and overshadowed by death. In a very immediate, conceptual way, a number of stone benches forge a link between this atmospheric setting and the concrete horrors of war. Engraved texts offer fragmentary descriptions of the gruesome destructive effects of war upon human life.

A small bed containing 100 white-blossoming flowers sets a contrasting accent in front of the memorial plaques honouring victims of political and racial persecution during the period 1933–1945.

Thomas von Taschitzki

Black Garden (detail)

Black Garden, since 1994
Plants, paths, benches, text
3447 m²
Nordhorn (D)

Thrown Ropes, since 1996
Taxus baccata, Crocus flavus et ruscus
KünstlerGärten Weimar, Villa Haar
Bauhaus-Universität Weimar (D)

Peter Hutchinson throwing rope in Weimar, 1996

When I was three years old, I am told, I picked the flower heads from all my father's tulips. This may have led to the breakup of my parents' marriage! Since then, I have never lost my interest in growing plants. In 1968 I, during a crisis of creativity, started growing moss and molds in glass cigar tubes, carrying them around in my pocket, occasionally exposing them to sunlight. This led to maquettes containing molds, plants and chemical crystals, and further, to my undersea projects and land projects (1968 onwards). This was, of course, a unification of my love of botany, horticulture, science and art.

Peter Hutchinson, 1999

In 1989, when I did some photographs of fruit trees and other trees under board called *The insurer*, one question was very strong: "Why are there no fruit-trees in the city, only decorative trees?"

We might think of pollution as the answer, but during the last century there was much less pollution, and now genetic engineers have made stronger fruit-trees.

We might also think about the fruit market, but now grocery stores can sell fruits out of season, and seasonal fruits aren't an important part of one's annual budget.

The most important advantage fruit trees would offer in a city is that they would provide the homeless a source of food. I'm sure that the city budget for fruit-tree maintenance (which is not much different than the maintenance of decorative trees) would be offset by part of the budget dedicated to the homeless.

We can create a structure to support this need (foundation, association ...).

Fabrice Hybert, in: H. U. Obrist, G. Tortosa (ed.), *Unbuilt Roads – 107 Unrealized Projects*, Stuttgart, 1997

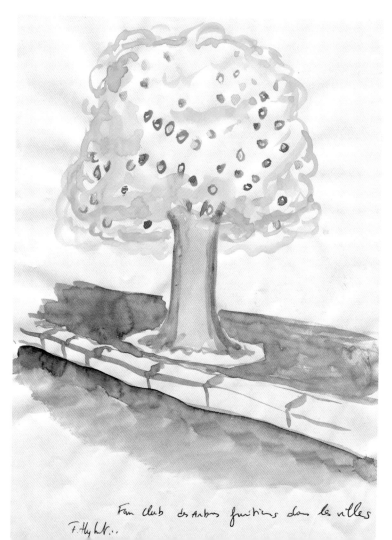

Fan club des arbres fruitiers dans les villes
(Fan club for fruit trees in towns), 1999
Water-color
20 x 30 cm

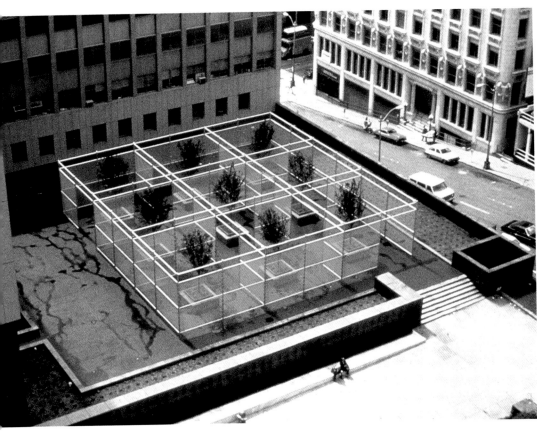

9 Spaces, 9 Trees, 1983
Cast concrete planters, asphalt, plastic-coated blue fencing,
visuvius plum trees, *sedum oreganicum*
Public Safety Building Plaza, Fourth Avenue and Cherry Street,
Seattle, Washington

In numerous site specific indoor and outdoor works done during the 1970s and 1980s, Robert Irwin made use of semitransparent gauze to mark out spatial areas and boundaries and to generate subtle interactions of light, space and sense perception. In *Nine Spaces, Nine Trees*, a work realised in Seattle, Irwin transformed a formerly empty square bounded by two public buildings and an intersection into a setting for a multifaceted aesthetic experience. Erecting shimmering light-blue plastic fences, he subdivided the square grounds of the complex into nine square spaces and planted a young plum tree in each of them. For viewers, who are free to sit on the containers holding the plants, the equally minimalistic and labyrinthine system consisting of semitransparent partitions, openings and trees offers a scarcely fathomable diversity of possible perspectives and interferences.

This architectural and sculptural approach to the medium of living plants also engenders painterly effects in detail, where, for example, the branches, leaves and blossoms of the trees are veiled, in a sense, by the blue net fences. While nature appears to be disciplined by geometry in this spatial construction, it also stands out in its manifestations as individual living trees in vivid contrast to the precise matrix of straight lines that structures the space.

Thomas von Taschitzki

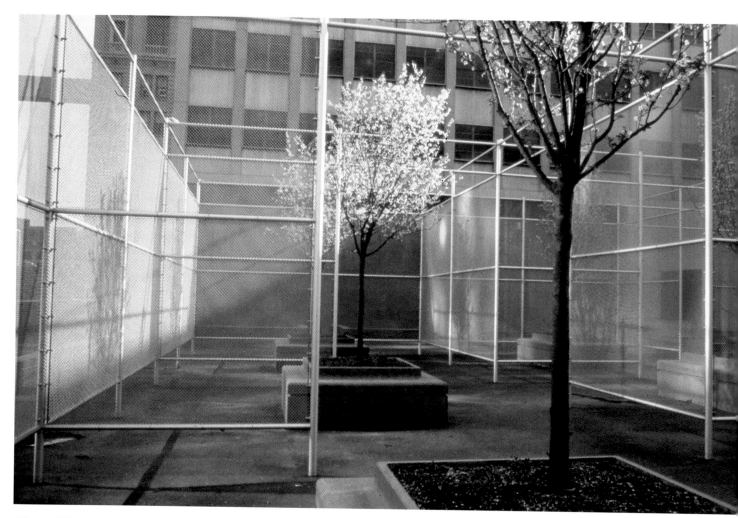

9 Spaces, 9 Trees (detail), 1983

Les gouttes de pluie dans la poussière
(Raindrops in the dust), 1995 (detail)
Wheat, earth, loudspeaker, tape
Port du Rhin, Strasbourg (F)

The harbour in Strasbourg is a huge complex of basins, docks and warehouses that is difficult to access. It is operated under the direction of the Autorité du Port in Paris. The more the volume of commercial traffic on the Rhine decreases, the more diligent the authority becomes in watching over its sole area of responsibility and especially in ensuring that no one notices how little use the harbour complex is to anyone anymore. And so a mysterious experimenter like Dominique Kippelen is just the right person to transform several of the decrepit warehouse halls into indoor gardens. Dominique's work is now in jeopardy, since the public had begun to develop an interest in it. If too many people learn the truth about the utilisation of the harbour complex, the port authority will grow uneasy and move to close the curtain even more tightly.

Dominique Kippelen lays out imaginary gardens in the multi-storey warehouses. Her regulating factor is the relatively sparse natural light that enters the buildings. She begins on the dark floors with inorganic elements – serial heaps of materials that create desertlike scenes, depending upon the amount of light that reaches them. Any surfaces exposed to light attract moss, which covers the remains of corrugated tiles, hollow blocks and cast-iron grates with a coat of green velvet. Finally, the artist brings in humus and sows grain. The grain sprouts and grows everywhere, but the green colour appears only where there is light. The whitish and pale yellow "fields" on the lower levels give way to the green ones on the top floor. The few visitors stumble over the "fields" as they move upward. The trampled stalks striving to right themselves again present a wild appearance in the flat bands of light.

Dominique Kippelen's works are speculative enquiries into the process of industrialisation. Whatever man has built, swept clean, poisoned and then abandoned, it is all swallowed up by invincible vegetation, the destroyer of the destroyed, the great healer.

From: Lucius Burckhardt, 'Künstlergärten – Kommt der Garten ins Haus?', in: *Basler Magazin*, No. 14, April 11, 1998, pp. 12–13

Les gouttes de pluie dans la poussière
(Raindrops in the dust), 1995

[...]

Anthony Haden-Guest: Your giant *Puppy* in Arolsen has elicited very different reactions. The review in the *New York Times* was positively glowing.

Jeff Koons: That's the first good review I've had in a long time. I'm not used to people enjoying my work so much. I felt that I had created a very generous work, but I was surprised so many people enjoyed it. I haven't had a recent history of that.

Anthony Haden-Guest: Tell me about the piece.

Jeff Koons: There are seventeen thousand flowers. They're live flowers, planted in twenty centimeters of earth. The flowers that I have chosen will grow for the specific length of time that the piece is up – four months. Then it has to be redone. But the next time that I redo the piece I can use spring flowers. The only thing that I am controlled by is the elements. It has to be able to stand the wind without flowers breaking off. And how much sun they can take. I choose flowers that are self-cleaning. It's a very articulated work.

Anthony Haden-Guest: Isn't this the first time that you have worked with living forms?

Jeff Koons: Well, I've worked with water in my tanks. And there are my wood sculptures. Wood is a living thing.

Anthony Haden-Guest: What was the train of thought that led you to work with flowers?

Jeff Koons: It was very organic. I like to just let things resonate within myself, and then I follow my intuition. So I started a while back thinking about flowers. I've had flowers in my work since 1979. So I was invited to this spot in Germany by Veit Loers and it occured to me to make this particular public piece.

I love baroque life, baroque architecture. My favorite sculpture in the world is in St. Peter's Church in Munich. It's a crucifixion with the silver Sacred Heart of Jesus. It's like my stainless steel pieces. It's absolutely beautiful. I decided I wanted to make an image that communicated warmth and love to people. A very spiritual piece. And it just came to me to make the *Puppy* out of live flowers.

Inside the *Puppy* is like a church. It has a shape like a belltower, going up. It's all wood, with a triangular cut. Absolutely beautiful and pristine. I wanted the piece to deal with the human condition, and this condition in relation to God. I wanted it to be a contemporary Sacred Heart of Jesus. The *Puppy* is a role model of God. Anyway, in some ways it plays as that. But it's also not that. It's not that here is God. It's more the human condition. Or maybe the desire for some form of union.

[...]

From: 'Interview: Jeff Koons – Anthony Haden-Guest', in: Angelika Muthesius (ed.), *Jeff Koons*, Cologne, 1992, pp. 32–33

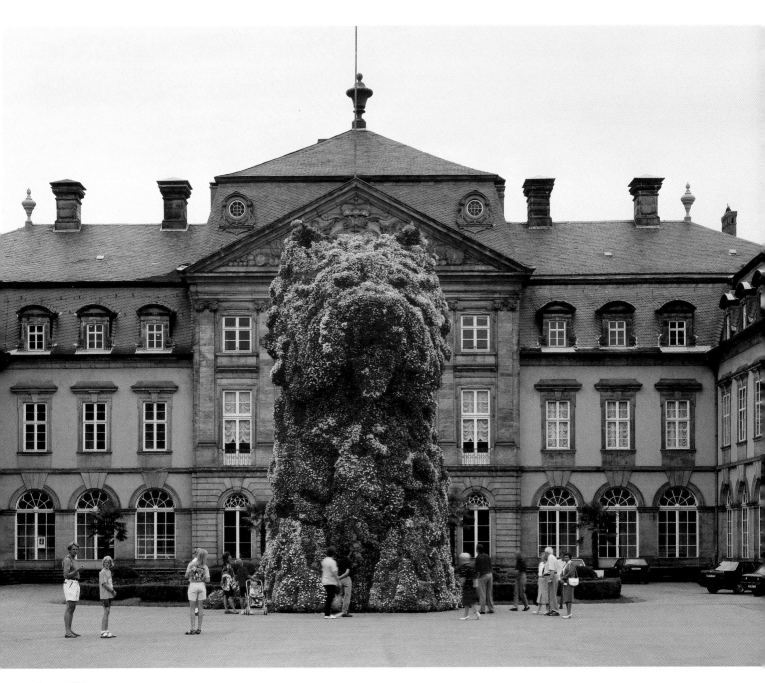

Puppy, 1992
Concrete base, wood/steel construction,
living flowers
Height 11.50 m
Arolsen (D)

Mygindscher Garten – Außenstelle Pflanzenwuchs
(Mygind garden – outpost plant growth), 1998
KünstlerGärten Weimar, Villa Haar,
Bauhaus-Universität Weimar, state January 1999

Mygindscher Garten – Außenstelle Pflanzenwuchs (detail),
state September 1999

Mygindscher Garten – Außenstelle Pflanzenwuchs
state July 1999

The Mygind Garden (Elements for an Artificial Nature). Outdoor vegetation, *KünstlerGärten Weimar*. Under the supervision of Brit Sömmering.

A patch of wood (a treetrunk and the space surrounding it) in the park of the Villa Haar in Weimar is kept under close observation and tended continuously. Approaches to maintenance and care are developed on the basis of observations of events and plant growth at the site. The central office of the Mygind Garden (and the "Experimental Brook Project") is located on the Falster Testing Grounds (Denmark) of the Hamburg Galerie für Landschaftskunst.

Till Krause, 1999

I grew up in the 60s and 70s, ten minutes from Disneyland. Most rights of passage took place there. Our tract house with garden and lawn existed where it shouldn't have – an artificial oasis in what is naturally a desert alongside dozens of others exactly like it.

Then, when I was 19, I went alone to Japan. And I saw the gardens of Kyoto.

One might say I have an exaggerated sensitivity to the artificial partly because I was raised to think it was natural.

The human drive/impulse to control nature points to our acute discomfort in our own skins – viewing ourselves as a part of nature. We have cultured ourselves. So much so that it is, in fact, barely apparent, as we have become so accustomed to our various (and increasingly less various) cultures that they have come to seem "natural". That tension between human consciousness and nature, how we have dealt with it and not, both externally and internally, is the juncture at which I have repeatedly found myself critically and creatively.

I hope that as I continue I will be able to make works which clearly present questions for the viewer. I have no desire to propose answers. I hope to make environments to be noticed, opportunities for isolated experience. I am interested in edges and contrast and what happens when they meet – when the controlled goes wild and the fungus dries up. How grass grows and how we cut it back.

Samm Kunce, 1999

right side:
Water Culture, 1994
Lettuce, water, PVC, wood, light
5 units, 46 x 46 x 380 cm
Installation Rotunda Gallery, New York City

Law of Desire, 1995
Grass, felt, PVC, liner, pumps, Gro-Lights
12.2 x 9.14 x 3.96 m

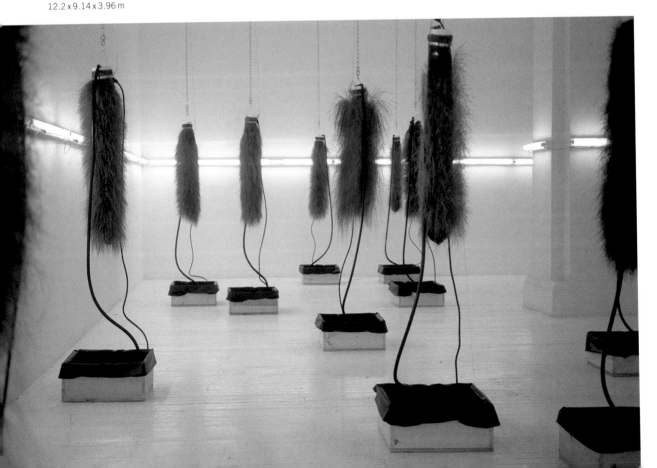

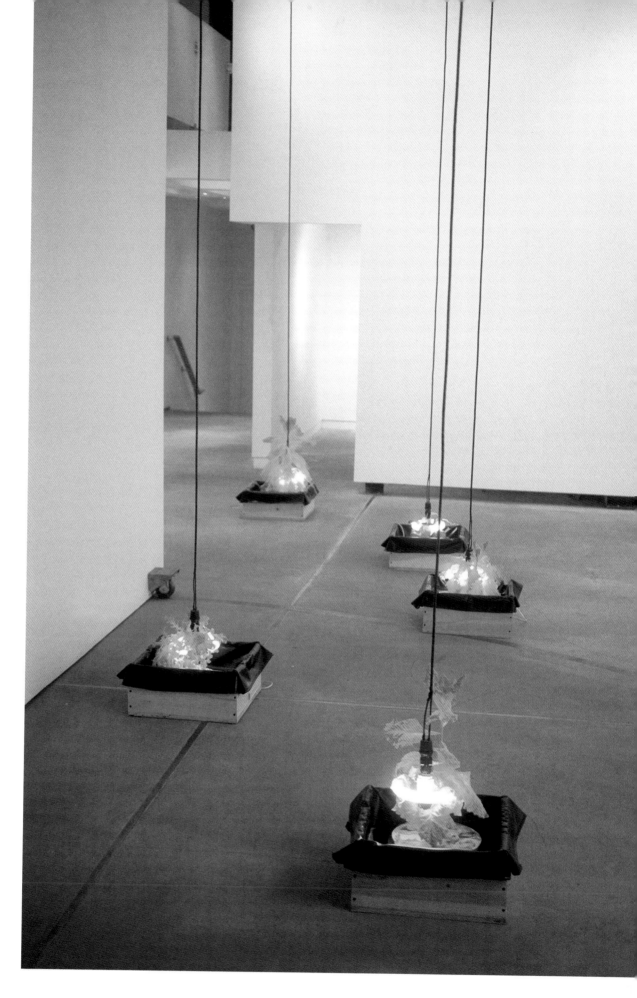

Cherry Tree, 1971
Earth, cherry tree, grass seeds, infrared lights
112 Greene Street, New York City

Processes of transformation in organic and living materials are the central focus of the early works of Gordon Matta-Clark done between 1968 and 1972. Drawing inspiration from his studies in alchemy and occult writings, the artist experimented in his studio with mixtures of such materials as agar, yeast and various nutrients, investigating the transformations they underwent during exposure to heat. During the same period, Matta-Clark was also interested in trees and the energies involved in their growth, to which he refers in a variety of different works and approaches. In a series of drawings, Matta-Clark depicted arboreal mutations and trees growing together to form fantastical shapes. In an unrealised project based upon an adaptation of an idea of Robert Smithson's, he conceived a barge with a growth of forest vegetation that was to be "parked" on the Hudson River. Matta-Clark has worked with living plants in a number of actions and installations relating to specific locales. The work entitled *Cherry Tree* was created in the basement of the exhibition gallery on 112 Green Street, a room he used as a laboratory for some time. He planted a cherry tree in a hole dug to a depth of two metres and sowed grass seed on the mound of earth beside it. This "garden studio" was illuminated with infrared light and remained in place for three months.

Thomas von Taschitzki

Untitled (tree forms), 1971
Pencil, black ink and colored markers on paper
48 x 61 cm

Untitled (tree forms), 1971
Pencil, black ink and colored markers on paper
48 x 61 cm

Plante tournante (Rotating plant), 1997
Exhibition: 504, Braunschweig (D)

Structure de mélaminé blanc pour plante (Structure in white melamine for a plant) is a piece carried out with a house plant of the type used to decorate the interiors of offices, hotels and other public spaces.

For the Berlin Biennale I used a *schefflera* plant because of its height and its large, widely-spaced leaves. Around the plant I built a platform and a sort of scaffolding in melamine to support the leaves. Melamine is a cheap material made of reconstituted wood chips of different types bound together with glue. This material is commonly used for kitchen and bathroom fittings. I particularly like the contrast between the gleaming white surfaces and the rough edges. The construction is like a piece of furniture for plants. From close up, too, with a change of scale, it suggests an architectural model, where the shelves can be understood as floors. The piece is conceived as something evolving, for the platform is pierced with a 5-cm grid so that the growth of the *schefflera* can be followed, as in a scientific experiment or a game.

The delicate construction is intended to be helpful to the plant, in one of two ways. If the plant is in a favourable environment (heat, humidity, and light) it will grow, making it necessary to change and adapt the structure. Alternatively, the plant will stop evolving. This will lead us to reflect on the metaphorical relationship of these two results from the point of view of politics (the opposition nature/culture), architecture, or ecology. Between the different sizes and heights of the shelves, a hierarchy emerges, opposing nature/culture, interior/exterior, furniture/building. A metaphorical relationship exists between the living green and the man-made construction, together with a more abstract relationship concerning something from the natural order linked to something artificially organised.

I first made this work at the Toxic Gallery in 1996 with a *sparrmannia* plant. A new meaning emerges from its presentation at the Berlin Biennale in the context of a capital in the process of reconstruction, with the added reference to the state of the city.

Mathieu Mercier, 1999

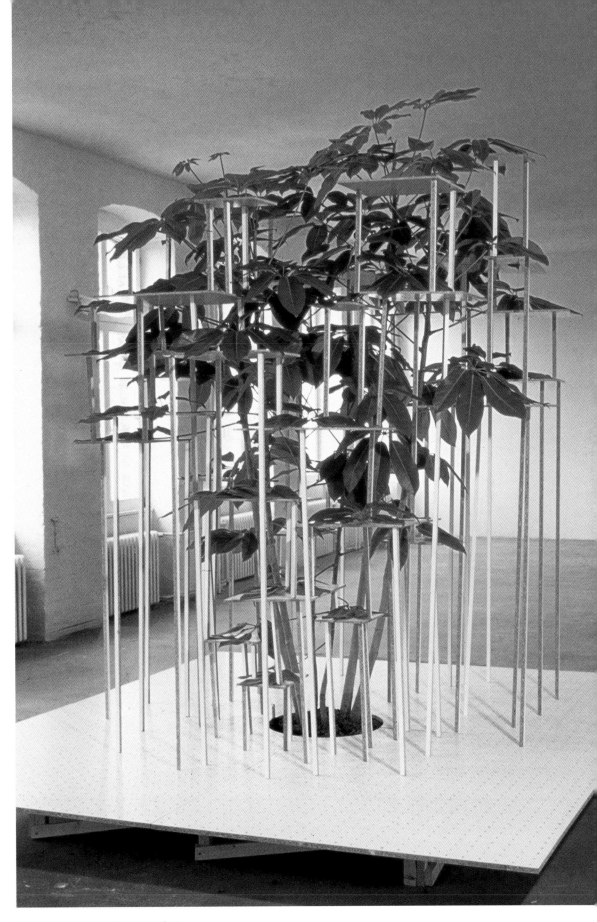

Structure de mélaminé blanc pour plante
(Structure in white melamine for a plant), 1998
Plant (*Schefflera*), wood
Exhibition: Berlin Biennale, Berlin

My seeds – the many seeds sown since 1972. They force me to work, to remain awake and attentive, to be sensitive to strong reciprocal bonds, to mutual interaction and to dependence as well ...

I planted cress seeds on a blouse. I tend them, watering them day and night. The seeds I have nudged into life begin to sprout ...

I lay the cress seeds on my wet blouse.

They sprout, swell and begin after a few hours to grow right on my body ...

I have been astonished for some time by the phenomenon of sourdough. The sourdough is a small amount of risen rye dough saved from the last batch of bread I baked ...

I have found a place where I can work with sourdough. I reach deep into a swamp, pull out the soft material and embed the sourdough inside ...

I watch over it, protect it, kindle a fire. I keep adding flour. The sourdough rises ...

Lost in thought, I gaze at the soft, moist matter; it awakens in me a powerful feeling of softness and vulnerability, prompts me to remember the beginning ...

I think about nature, and the thought becomes a part of nature. It all begins with self-recognition and an understanding of the essence of things. The desire to know the world begins to steer the mind once it has been awakened.

I lie in the bathtub with my soaked, swelling seeds. I am in direct contact with the softened matter whose interior pushes toward the surface.

I have realised this work in full knowledge of the power left in the slime by tiny beings as they die ...

... a conscious remembrance of former existence as a part of present life. Strength. Energy. Life.

WE.

Teresa Murak

Untitled, 1974
Cress, fabric
Warsaw (PL)

Seed, 1989
Bathtub, water, cress
Berlin

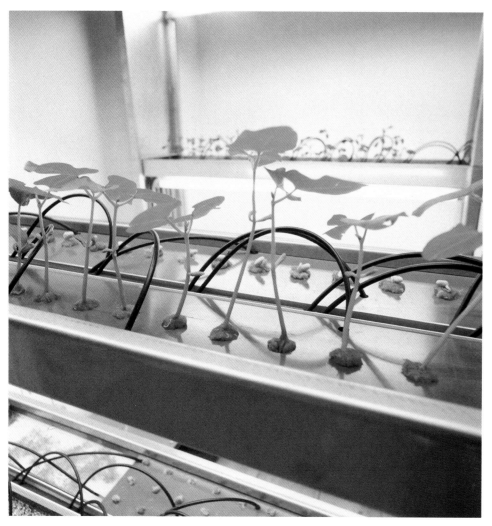

Home Hydroponic Unit (detail), 1998

Home Hydroponic Unit

The *Home Hydroponic Unit* enables people to produce their own food. It is especially designed for the continuous production of food in sufficient quantities to provide a considerable supplement to the daily household of 3–4 persons, and it can easily be extended.

The unit can be installed indoors, and it can easily be moved. One is therefore not dependent on access to land in order to produce food.

N55, 1999

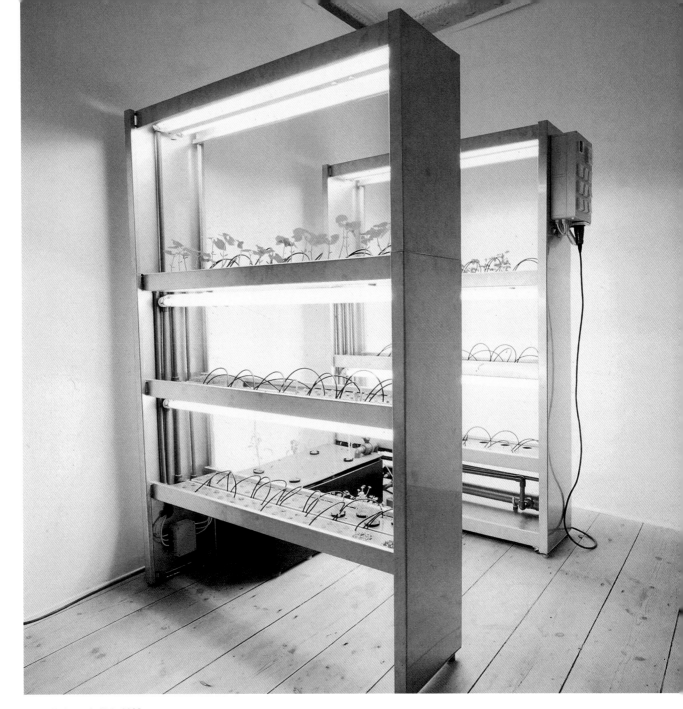

Home Hydroponic Unit, 1998
Stainless acid-resistant steel, buffer tank, rockwool biomat,
circulation pump, spray system, activated carbon, PVC,
daylight fluorescent tubes, automatic timer, UVC-filter,
PEL tubes, level control, cellulose filter, plants, nutrient solution,
water

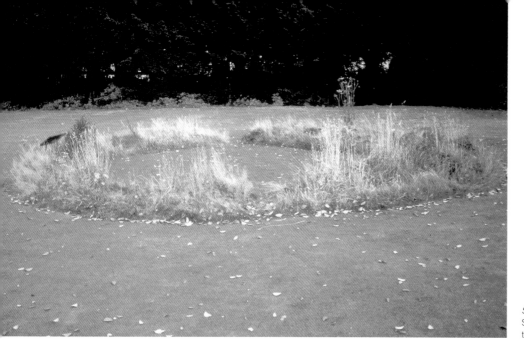

Sod Swap, 1983
Sods and turfs from Cae'n-y-Coed, North-Wales,
transplanted to Kensington Gardens, London

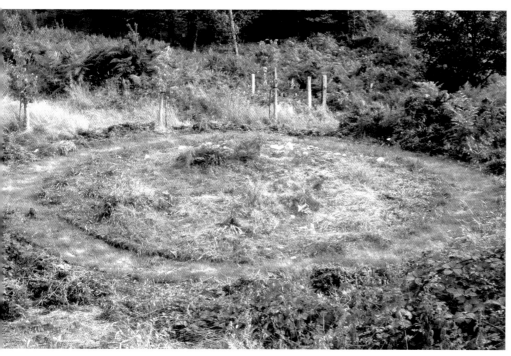

Sod Swap, 1983
Sods and turfs from Kensington Gardens, London,
transplanted to Cae'n-y-Coed, North-Wales

I look for ways to engage with real space. By "real space" I mean where
the elements are active. Inside buildings the elements are neutralised,
passive, controlled, time is paused. Outside, on and in and over the land,
they are active, making space alive and potent with the movement of time.
I look for ways of engaging with the life of this space. In each place this
activity is unique. To unite a healthy human presence with a place, this
uniqueness has to be learnt by observation. Observation eventually awak-
ens ideas. Planting trees is one way of making this engagement.

David Nash, Chapel Rhiw, 1999

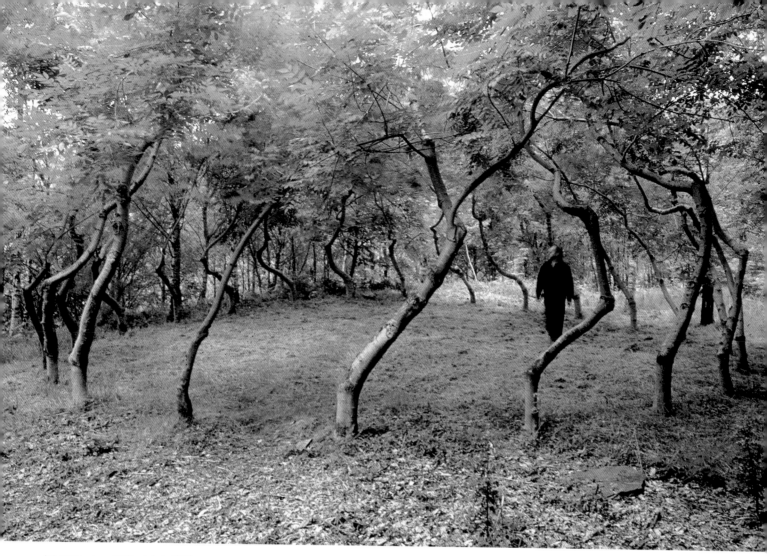

Ash Dome, since 1977, state in 1997
22 Ash trees
Cae'n-y-Coed, North-Wales

Ash Dome, 1977
Charcoal drawing

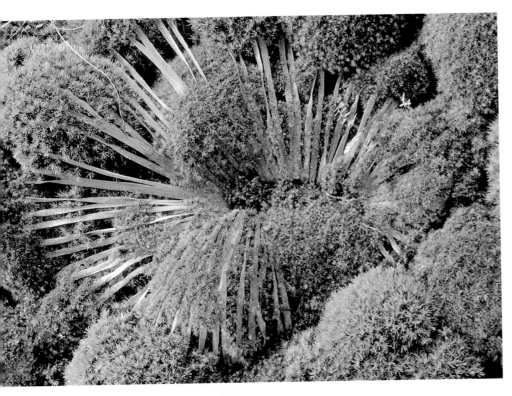

Embroidered in Moss (detail), state in 1997

Embroidered in Moss (detail), state in 1997

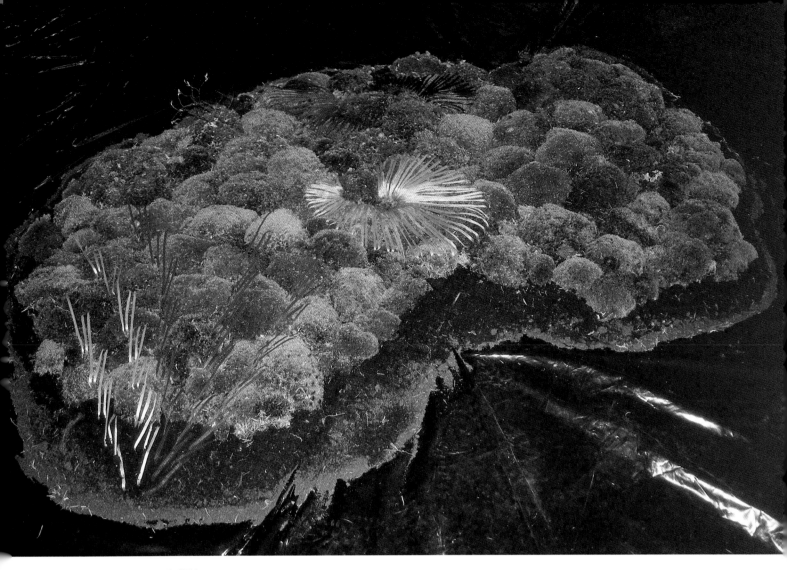

Embroidered in Moss, state in 1996
Moss, soil, polyamide
12 x 200 x 130 cm

I feel vegetation caresses my soul. Embroidering in moss is cultivating the field of the absurd.

Barbara Nemitz, 1999

Modul, 1998
Concrete, various plants, hydroponics
Galerie Eigen+Art, Berlin

Garden courtyard design by Paul Lester Winer
in association with S. J. Kessler & Sons, circa 1960
New York University, Bleekerstreet, West Village

[...]

Thomas Irmer: Has the artist become a medium of applied science?

Olaf Nicolai: Art is one way of responding reflectively to these processes. Beyond the level of the superficial analogy between the creativity of scientists and artists there is a traditional basis for a kind of art that makes use of scientific knowledge. In his early works, Joseph Kosuth joined modern linguistics with a striving for scientific precision. Today, social processes are interpreted with the aid of biological images. These are not metaphors but biological terms, and we have transposed the concept of nature to society – a concept of nature, of course, that already carries the results of its modification at the hands of society within itself.

Thomas Irmer: Your most recent example of that is *Landschaft. Ansichten nach der Natur* – a series of photos of an artificial miniature landscape that bears a striking resemblance to a real one.

Olaf Nicolai: That was a constructive "measure", a design product done in co-operation with a botanist as an answer to the question of how a landscape could emerge from such a situation. It is precisely here that we find the formative criteria one could describe as aesthetic. The important thing was that this process of design was carried out on a biological material. The design criteria were applied directly to that material. I actually see this process going on everywhere around me, but it has now come to be taken for granted to the extent that it is no longer perceived as the design of biological material: a perfect construct that demonstrates all of the problematical characteristics of our supposedly so stabile concept of nature. The quality of fiction – emphasised by the photographs of this miniature – is thus not only a process of delusion but a way of making this staged scene useful for ourselves as well. From E. A. Poe – American Romanticism: Nature is nothing compared to what we are capable of constructing – to Kelly: *Biosphere 2* is a radical construct in lieu of nature. Here, in this extension of American Romanticism, in contrast to German Romanticism, the construct is viewed as the more appropriate counterpart to the feelings, as the more beautiful, the "more natural" alternative. No more imitation of nature but rather construction in accordance with our needs. This perspective is very important. It could be one of the perspectives for my figures.

[...]

From: Thomas Irmer/Olaf Nicolai; 'Natur gestalten. Olaf Nicolai im Gespräch mit Thomas Irmer', *neue bildende kunst*, Berlin, February/March 1997, pp. 24–31

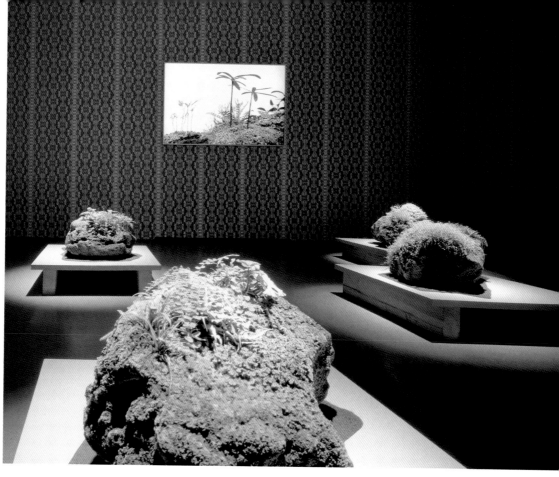

Interieur/Landschaft. Ein Kabinett
(Interior/Landscape. An Exhibit), 1996–97
Wallpaper, pedestals, stone, plants, photographs
Exhibition: documenta X, Kassel (D)

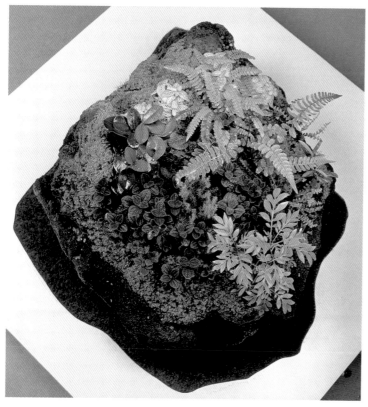

Interieur/Landschaft. Ein Kabinett (detail), 1996–97
Pedestal, stone, plants
Exhibition: documenta X, Kassel (D)

Plantings are a central focus of my work. In them I find the negation of the traditional separation of art and life that has become life-threatening today. My very first work in nature, realised in a mountain gorge in Chiemgau, Upper Bavaria, in 1972, consisted primarily of a plantation of firs and grasslands.

Plantations of trees, bushes and flowers on my seven parcels of land leased in Chiemgau followed during the 1970s.

Since then I have continued, even today, to integrate plantings into many of my other works. Thus my work becomes a part of nature. It is involved in the birth, growth and passing of its cycles.

Nils-Udo, 1999

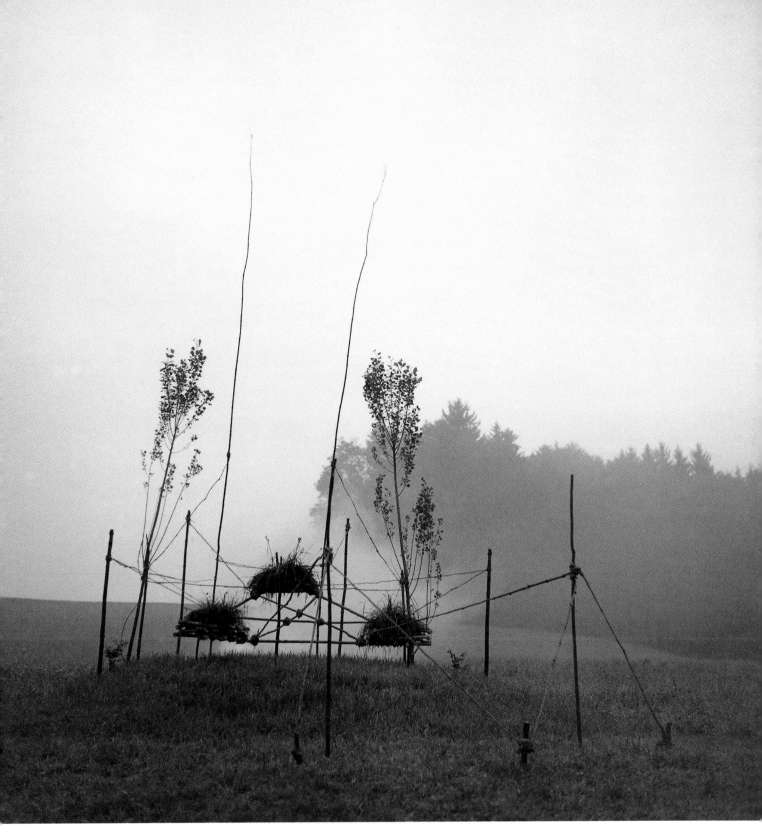

Hommage à Gustav Mahler, 1973
Earth mound, poplar grove, grass plot,
ash poles, forest vines, fire
Chiemgau/Oberbayern (D)

De Civitate, since 1991, state in 1997
Ginkgo biloba, Metasequoia glyptostroboides,
Thuja occidentalis
Wienburg-Park, Münster (D)

Maria Nordman has set up an extensive plantation complex in an open area of parks and fields on the outskirts of Münster. Running parallel to a path through the fields, the work is composed of three geometric sections comprising three different types of trees. In the northernmost section, Trees of Life (*Thuja occidentalis*) are grouped into a number of linear and rectangular formations. Whereas the clearing of forests was a historical prerequisite for settlement of land, Maria Nordman reverses the process, using trees to compose a geometric structure reminiscent of the foundation walls and squares of an imaginary city. Toward the South, two U-shaped double rows of *Metasequoia glyptostroboides* and *Ginkgo biloba* trees form a kind of avenue or promenade. Some 250 million years old and regarded as "living fossils", these species of tree exemplify the flora of the continents of America and Asia, while the *thuja* trees are representative of Europe.

In the midst of a semisuburban landscape shaped by random, irregular patches of vegetation, cultivated areas and isolated transport routes (a railroad line, a straight path through fields), the work entitled *De Civitate* stands out boldly with its clearly ordered geometry and, with its sequences of trees, enters into a rhythmic relationship with the viewer's movements and the perceptions that emerge during the act of walking.

The work is a complex field of temporal and spatial relationships. While the trees themselves reflect primarily aspects of time – their own lifetime and periods of growth, the seasons and the temporal dimensions of evolution – the geometric arrangement relates to the totality of surrounding space, to include even the cosmic space of the solar system. Thus, for example, the shadows cast by the trees lining the paths in the midday sun form long lines that run precisely along the north-south axis.

Thomas von Taschitzki

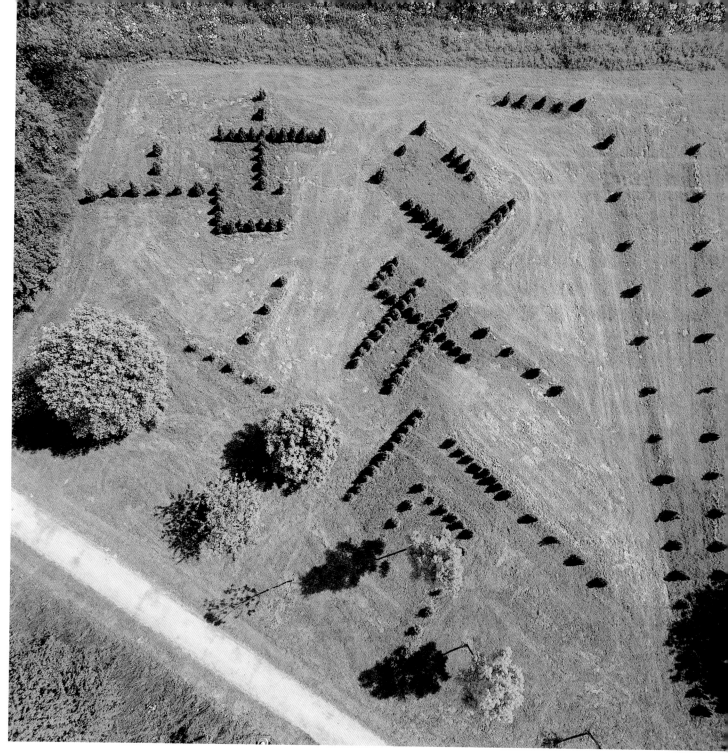

De Civitate (detail), state in 1997

Untitled, 1993
Approximately 500 potted plants,
none indigenous to Germany
Kunstverein Hannover (D)

[...]
Potted plants representing the full botanical spectrum: The artist transformed the long hall of the Kunstverein Hanover into an artificial paradise with clove bushes from South Africa, birch figs from India and tropical sword ferns In this extensive exhibition of natural artificiality, Brigitte Raabe bundles together the dialectical relationship between (second) nature – including our own – and its subjection to our dominion. The eye-opening simulation of a hothouse and its market-oriented presentation of living merchandise along with the structured "selected affinity" of art, reality and nature rule out "silence in the face of so many crimes". Indeed, in a manner that is pleasantly free of moral posturing, the artist's work bears temporal and spatial witness to our relationship to the post-modern world.

From: Raimar Stange, 'Biologische Schliessungen', in: *Brigitte Raabe*, exhib. cat., Kunstverein Hannover, 1993

Duftveilchenpflanzung (Fields of scented violets)
(detail), since 1996
250 *Viola odorata*
Distributed over the grounds of
*KünstlerGärten Weima*r, Villa Haar
Bauhaus-Universität Weimar (D)

The violet is an annual or biennial plant that develops linking underground root systems. The seeds of the scented violet (*Viola odorata*) are carried away by ants, which means that the plant's location will change over time and is thus not preordained for all time. Its movement is comparable to that of an odour in the wind.

In contrast to its modest appearance, the intensive scent of the violet (which blooms from March to April and sometimes a second time in September) is the point of departure for this project. The sense of presence evoked by the plants consists in their striking smell during the spring and the memory of and longing for it that remain during the rest of the year. 250 violets were planted at about ten different locations distributed over the grounds of the *KünstlerGärten Weimar*.

This scattering principle is crucial to the project statement. The pattern of broad distribution in small units establishes the palpable presence of the small flower. The essence of the violet spins its "invisible" web, and the existing violets weave themselves into it. The authorship – of nature, the gardener or the artist – is so closely interwoven that it becomes pointless to ask about it.

Brigitte Raabe, 1996

When I work with plants it is not for aesthetic reasons; it has nothing to do with "land art, naturalism, ecology", etc. I try to investigate how we use nature to define ourselves as human beings – how we use plants to tell us about our lives, our dreams and desires.

Why do these stories or narrative structures of "forget-me-nots" and "four-leaf clovers" exist all over the world, even in countries where they are very seldom to be found?

To me it's interesting to learn why and how these small plants can survive as a narrative and a "folk-faith".

Nikolaj Recke, 1999

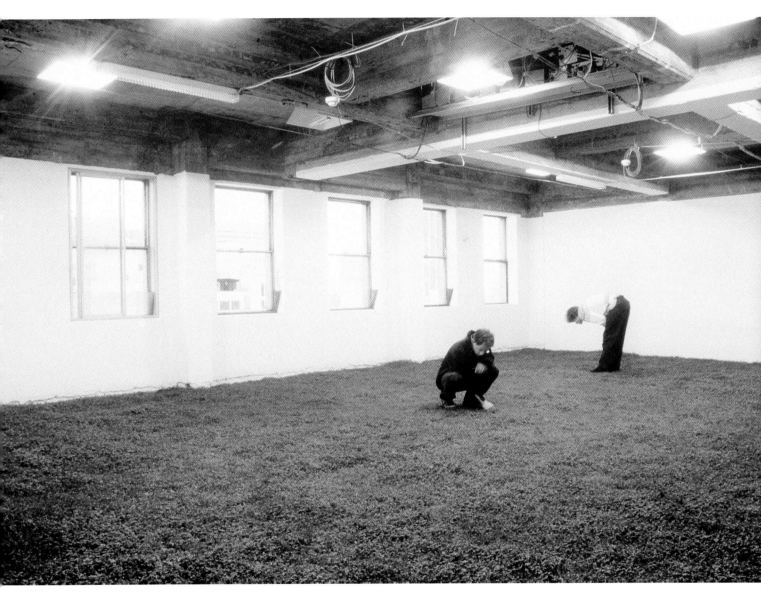

Cloverfield, 1999
Soil, clover
Melbourne International Biennial

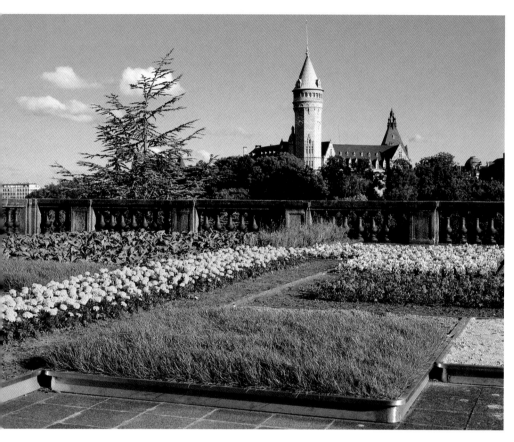

Within View of Seeing (Perspectives and the Prouvé), 1998
Various plants, soil, metal tubs
Exhibition: Manifesta 2, Luxembourg

Rehberger installed an extensive complex comprising a large number of beds for flowers and crop plants set in shallow rectangular aluminium tubs on a hillside terrace overlooking a valley in Luxembourg. Viewed from the glass pavilion across the street, the arrangement evoked the impression of a floral version of an abstract colour-field painting, and it derived much of its effect from a correlation – expressed through both form and perspective – with the pavillion erected by Jean Prouvé. Adapted from Prouvé's portable system for prefab houses, the flat tubs form a temporary garden that, in both a visual and spatial sense, clearly occupies a position between architecture and landscape.

Thomas von Taschitzki

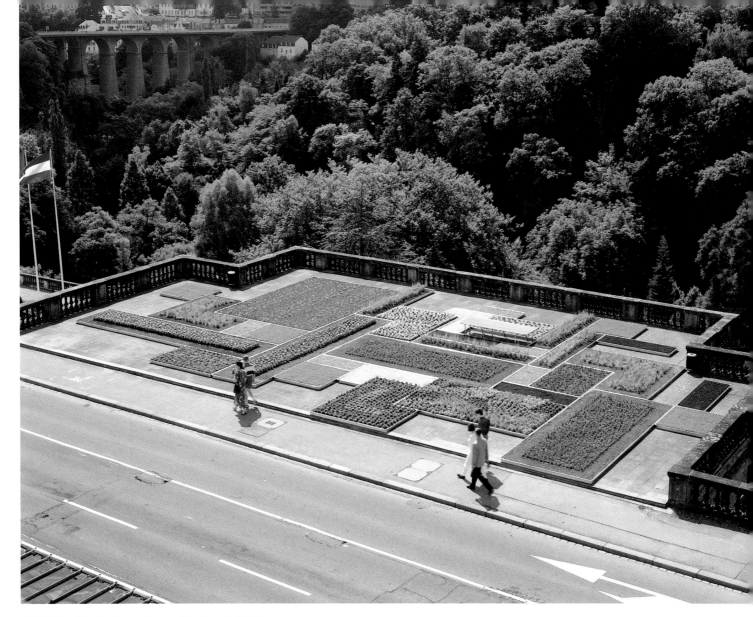

Within View of Seeing (Perspectives and the Prouvé), 1998

Working Statements

If art is about life, then it is sensible to realize living ideas with living materials.

My work is about finding forms that signify our connection with natural order. I do this by making landscape sculptures called Lifeforms.

Lifeforms are reference points for communications about the ideas they represent – signs along the way, attempts to provoke a closer relationship with the earth.

As human organization has become more abstracted from nature, so has our concept of growth. Now, the word "growth", denotes a political, technological or economic condition. This misunderstanding accelerates our misfortune. Badly conceived and mismanaged, "growth" increasingly threatens its host planet and obstructs our participation in a sustainable ecological reality.

Making artworks outside the certified context of gallery and museum spaces, making art in public places, particularly when enabled by public funding, creates both opportunities and responsibilities. If properly rooted in the democratic process, the placement of artworks in the common domain can flourish as a valuable public-scale identity-seeking process. We can employ art to ask and answer questions about who we are, where we come from, and where we are going in ways we can all share.

Therein lies the goal of public artworks – to be about the people they address and the spaces they occupy.

There is a curious quality of letting-go that permeates my experience of working with living vegetation. I imagine this stems from accepting natural processes as working partners. Surrendering to a limited sense of control over the materials and destiny of a project contradicts the customarily more aggressive approach to making art. And the energy otherwise lost in maintaining control can be used in working with things as they are.

Gary Rieveschl, 1999

Herzwelle (Heart wave), 1980
12,000 red tulips
Length 180 m
Planted in front of the "Urban Krankenhaus"
(hospital), Berlin

Pursuing a relationship with nature that is both playful and reflective, Erik Samakh likes to revive childhood experiences that are deeply significant for him, such as hunting for lizards or staring into the depths of a rock pool. He has grown duckweed in a large circular container, at the Galerie des archives, emphasising the pictorial appearance of the still surface. Earlier, in the same container, he exhibited – and, invited us to listen to the ampflied sounds of – thirty litres of live maggots whose continual movement made him think of pixels The vegetable and the animal kingdoms are merged, with the artist as explorer.

Colette Garraud, 1999

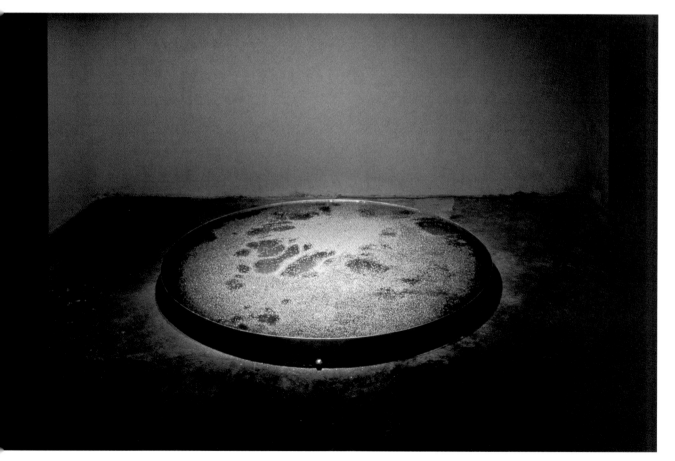

Lentilles – Installation silencieuse
(Duckweed – silent installation), 1992
Duck weed, water, stainless steel basin

Mangrove Ring, 1971
Summerland Key, Florida

In the land-art works he realised in the sparsely vegetated landscapes of the North American West and South, Robert Smithson concentrated primarily on inorganic nature, focusing upon long-term geological and cosmological processes that transcend the temporal boundaries of biological evolution. Thus in *Mangrove Ring* as well, his only realised work involving living plants, his interest in the element earth is the motivation for the use of living vegetation. Smithson was fascinated with the long-term "land-making" effect of the mangrove, a tree with submerged roots which flourishes along the Florida coast. "The *Mangrove Ring* was made by planting seedlings into sediment deposits in cracks in the rocky bottom of the lagoon. Mangrove seedlings are supposed to take root almost immediately. There's a story that Alexander the Great stopped his march through Asia to observe mangroves making land. Mangroves are called 'island makers' because they catch sediment in their spidery roots."[1]

Thomas von Taschitzki

1 From: '... The Earth, Subject to Cataclysms, is a Cruel Master', in: *Robert Smithson: The Collected Writings*, ed. Jack Flam, Berkeley and Los Angeles, 1996, p. 261.

Time Landscape™, since 1965
Forest plants indigenous to Manhattan
14 x 61 m
Corner of La Guardia Place and West Houston Street,
New York City

5 Time Enclosures with Forest Seeds, 1980
Metal, forest seeds
Ringling Museum, Sarasota, Florida

Circles of Time, since 1986
Etruscan herb garden surrounded by a wall of laurels,
a ring of stones (placed in order of their geological evolution)
and olive trees
Villa Celle, San Tomaso, Pistoia (I)

My life with nature began in the teeming jungles of the South Bronx. On the way to school, I passed smoldering fires and packs of dogs eating garbage. There were no trees anywhere – the few that had existed were long dead. The concrete streets and brick buildings were gathered and divided into local gangs and each gang controlled a section. Each day my walk was a passage through terror and my survival depended on reaching the safety of the school yard. This was "nature" as I experienced it. I escaped into the forest near my apartment almost daily.
[...]

In the forest, every animal knew its place, and every place was essential to the system's flow. The animals rushed along with instinctive purpose instead of wasting time standing on the streets day and night. High above, the trees formed a living cathedral. I worshiped nature's sublime balance. In that forest, I knew, without any doubt, my place in the puzzle.
[...]

As I aged, the adult world invaded and I stopped going to the forest. People crowded my mind with their concerns and anxieties. Slowly, my

connection with the nature began to give under their collective push, like Atlas under the weight of the globe. The city itself seemed unable to rest unless every speck of nature was annihilated from its boundaries. People surged into the forest, trampling it, covering it with bottles and cigarettes and smeared papers and suitcases and rags and umbrellas and condoms and needles.

[...]

Eventually someone drowned in the river. The city declared the forest dangerous. Swiftly destroyed with huge machines, the forest became just another part of concrete cemetery where I lived.

Like an animal sensing danger, I had sensed the beginning of this destruction and knew I had to respond. I collected as many seedlings from the forest as possible and brought them with me to my college in the Mid-West. There I replanted the last of my childhood forest on a farm where I stayed. The Hamils, whose farm it was, called it their "New York forest."

In my first plans to make a forest in NYC, I went back to the Hamil's farm. I needed to bring back some of the trees that I planted there to be part of the first Time Landscape (*Time Landscape™ NYC*), started in 1965. Like refugees from a war-ripped country returning home years later, the trees came back to the city.

The *Time Landscape™ New York City* still flourishes on La Guardia Place today. My influence for the project was my obsession with the idea of rebuilding the pre-colonial forest of New York City. In the mid-60s my window of opportunity came when city planners organized to construct a highway that connected the sides of Manhattan. In answer to the fierce protests of the community sprung the *Time Landscape™*. Seeking to reverse the stampede of "progress," the community members backed my radical idea to recreate the pre-colonial forest that once blanketed the city. The forest seemed to rise from the wellspring of my dreams, demanding to be remembered by all who had abandoned nature's harmonious presence.

The *Time Landscape™* required five years of rigorous research to ensure historical accuracy. It was necessary to use the same types of vegetation that had covered the city before the colonists arrived. After an Odyssey to find seeds and full grown trees and plants, I set about reshaping New York's past.

Like David standing against the monstrous Goliath, the delicate trees of the *Time Landscape™* stood up against the surging rivers of concrete.

From then on I dedicate my art to an understanding of my environment.

[...]

Alan Sonfist, 1999

Grassofa, 1985
Sofa, textile, grass
Exhibition: Berlin durch die Blume,
Schloß Charlottenburg, Berlin

I think it was Picasso who once said that, if he were in prison and had no paints, he would paint with his own shit. So if one can make art with dung, then why not with the product that emerges from the dung – with plants? I don't see any difference between the choice of marble, bronze, shit or plants, just as long as it suits the idea.

Daniel Spoerri, 1999

Liegewiese – Betreten verboten!
(Sun bathing lawn – keep off!), 1985/98
Metal structures, red paint, soil, grass, plate
Multiple, construction: Werkstatt Kollerschlag (A)
KünstlerGärten Weimar, Villa Haar
Bauhaus-Universität Weimar (D)

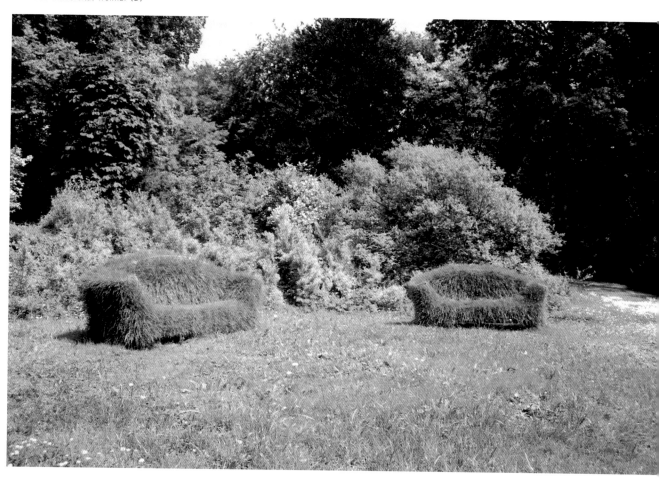

Green Pig and Smile on Vine, 1998
Tomatoes grown into vacu-formed molds
made by the artist
Color photograph
1 x 1.27 m

On working with life ... and the subject of nature and culture and their dueling influence on our existence.

Life as material – a way for me to create something that is both the object of discussion and a representation of a cultural thought. Expressing both is important to me and to be without either is to communicate only a fragment of what I am thinking. I have an interest in making the "thing" and the representation inseparable, a theoretical hybrid as well as a physical one. While preserving the classic culturally informed response to an art object, this also brings another level to the relationship, eliciting an experience one step less removed. It is the philosophy of minimalism, without giving up the cultural reference. I like to have my cake and eat it too. It is what it is and more.

On grafting ...

The grafted pieces are meant to demonstrate adaptive ability within an externally constructed situation. Structurally, each plant is composed of many separate types of plant; each plant maintains its own identity while growing in conjunction with the others. A single source feeds them all, yet each is nourished for its individual needs. It's a utopian construct. These time-based pieces improve with age; meaning they get fuller and bigger. Bigger in this context can also mean more valuable, creating a responsibility for maintaining both value and existence.

On animal-vegetable, the making of a cultured vegetable.

The animal-shaped molds are secured over baby vegetables in order to shape the vegetables' formal attributes. While growing, the vegetables exert their physical strength and frequently attempt to break out, they push the limits of the mold. Some are too strong to be contained, but most attempt to conform to the imposed shape. There is an intense will to grow, regardless of whether they submit to or resist their formal fate. I like the adaptability of these vegetables, it's similar to our observance of the impositions made upon us in daily life. Culture deals us a fictional norm, which gets filtered into individually aestheticized interpretations ... this process is at play in this project.

Laura Stein, 1999

Filled, 1996
Tomato growing into vacu-formed molds
made by the artist
Color photograph
1.27 x 1 m

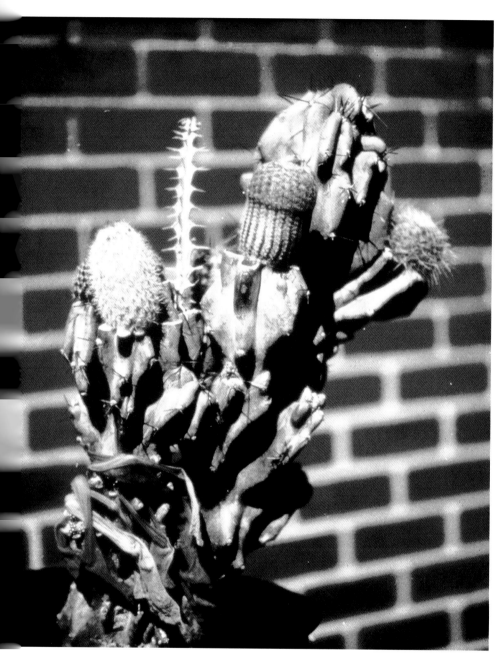

cereusmamillariaminisculacactaceananacactacea,
since 1994
Graft document, state in 1995
Work in progress
Color photograph
51 x 76 cm

Alles sieht bläulich aus – die blaue Blume
(Everything looks blue – the blue flower),
planted in 1997
Bethroot (*Trillium erectum*), plate
KünstlerGärten Weimar, Villa Haar,
Bauhaus-Universität Weimar (D)

Alles sieht bläulich aus – die blaue Blume, 1997
Homeopathic medication,
made from the bethroot flower

In the autumn of 1997, the artist Michael Stephan undertook a planting with *Trillium erectum* in the *KünstlerGärten Weimar* on the estate of the Villa Haar. The preparation made from this crimson (*T. erectum*) or white (*T. pendulum*) flowering plant is used in homeopathy and is available under the name "Trillium C30" at chemists' shops. One of the possible effects of the drug from the plant on healthy people is to make everything appear "bluish". Directly beside the plants, Michael Stephan has erected a sign which refers to these connections. The work is entitled *Everything looks blue – the blue flower*.

From: Bernd Dittrich, 'The Blue Flower has a Red Blossom', in: *wachsen*, ed. Barbara Nemitz, *KünstlerGärten Weimar*, No. 4, spring 1998, pp. 4–11

In their most recent works, Ingo Vetter and Annette Weisser are concerned primarily with the political and social significance of public parks and green areas. The work entitled *Tableau* relates to an area in the immediate vicinity of the exhibition venue in Münster, an urban settlement of homes and gardens established in 1937. The well-manicured front garden typical of German suburban residential developments is exposed to a subversive shift of meaning in this model installation. Conflict surrounding an explosive environmental issue – demonstrations against nuclear waste transports in northern Germany in the spring of 1998 – is translated in an adaptation of a video still into the seemingly innocuous form of a decorative rectangular tabletop garden. According to the artists the use of plants as pictorial elements derives from "tableaux" set up in baroque gardens – beds depicting such motifs as selected landscapes and battlefields, recreated in small-scale versions. By encoding their miniature garden with political elements, Vetter and Weisser undertake an ironic critical examination of the motives that led to the creation of front gardens as interfaces between private and public space.

Thomas von Taschitzki

Tableau, 1998
Various plants, wooden table, monitor,
video tape, photographs
Exhibition: Tableau, Förderverein für
Aktuelle Kunst e.V. Münster (D)

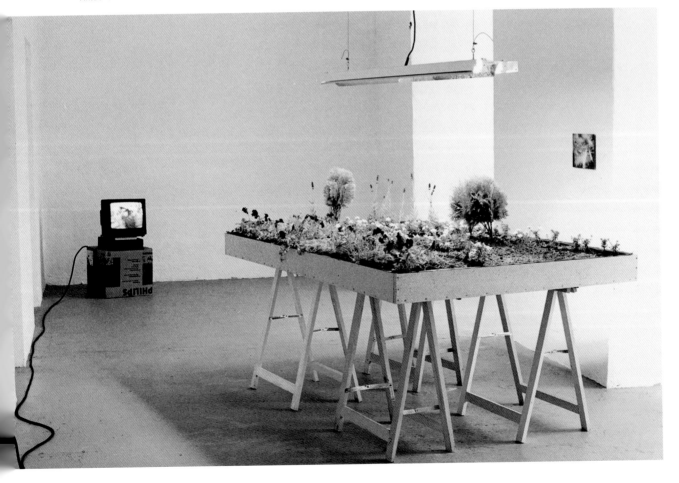

Untitled, 1995
Table, satin fabric, sprouts

Table, satin material with holes through which seedlings are growing. After they had dried out, they formed a fine net on the satin.

During this period I produced works involving processes of growth, works in which plants grew out of various materials. In this particular piece, shoots grew from out of the silky material, The "aliens" were white beans, the sprouts of which broke through a latex coating.

The dried-up stems of the seedlings settled in a ring around the holes through which they had grown.

Viewed from a distance, the work evokes associations with landscape and images of extinct volcanoes. Upon closer examination, one is re-minded of anatomical details in the microscopic field – synapses, cells, the smallest components of the body.

The satin material, lightly shot in pink, underlines the fragility of the work, also lending it a nostalgic element. Satin often makes us think of boudoirs, and the fact that the material is well-used, that the silk is worn, recalls past times.

Sandra Voets, 'Untitled', in: *wachsen*, No. 3, summer 1997, *KünstlerGärten Weimar*, ed. Barbara Nemitz, p. 17

Untitled, 1994
Foam rubber, latex, beans
20 x 15 x 7 cm

Forever Young, 1993
Plants, latex, showcase
Galerie Format, Basle

die wiese/paradiesfeld (the meadow/field of paradise),
since 1986
4000 m²
Eschenau (D)

die wiese/paradiesfeld (detail)

vegetation and art
10 theses

*living things should be treated with respect for their own message.

*nature is our primary reality. the experience of nature is a universal human value. vegetation is the basis of our existence.

*in art, nature becomes revolution.

**bonsai*, constricted and malformed trees or plants are not art. they are perversion.

*in dealing with vegetation or plants in art, the artist needs in-depth knowledge about what he is working with.

*to bring plants and art together is a challenge for art.

*art in nature is totally superfluous. art can add nothing of significance to nature. the statements of nature are perfect.

*the restoration of natural relationships can be an artistic act.

*in view of what we imagine nature would do without human intervention, a park is, generally speaking, culturally impoverished nature.

*the ideals of the zen garden – asymmetry, simplicity, spontaneity, the absence of formalism – are nowhere as clearly accessible to visual experience as in naturally flourishing vegetation.
 what wonderful things are "abandoned lots", terrain vague, where mugwort, blackberries, thistles and wasteland take over.

herman de vries, 1999

sanctuarium, 1997
Brick wall
Height 3 m, diameter 14 m, thickness 0.40 m
Skulptur. Projekte Münster 1997 (D)

sanctuarium, 1997

Five tables in a courtyard garden, since 1982
From top to bottom: 1982, 1986, 1995
20 x 26 m
St. George's Hospital, Tooting, London

Five tables in a courtyard garden is within a London hospital complex, St George's Hospital, Tooting. It was initiated in 1982 shortly after the hospital moved from Hyde Park Corner to these new premises. Five tables, copies of "real" tables, which could also themselves be used as tables, were placed in a paved garden in a large, bleak courtyard within the hospital. The emphasis was on varied greens and scented foliage rather than flowers. There were two *Catalpa Imperialis* trees with their large leaves, which will eventually shade most of the garden, making it into rather a secret place. There is also a collection of medicinal plants in the garden, as St George's has a long history of pharmacy. The garden can be entered but it is more usually viewed from the glazed corridors either on ground level or from above: It seems another place – separate from the busy hospital – a stage awaiting performers.

Apart from the element of change that growing plants make apparent, a garden was a way of introducing a very varied audience to a complex art work. People enjoyed the garden and were curious about the strange tables, gradually accepting them. As the plants grew and the garden developed, frogs and birds made it their home, and the original goldfish grew large and multiplied. Since then, inspired by *Five tables in a courtyard garden*, the hospital have employed a full time gardener and gardens have appeared in other areas in the hospital making it a much more pleasant place.

Shelagh Wakely, 1999

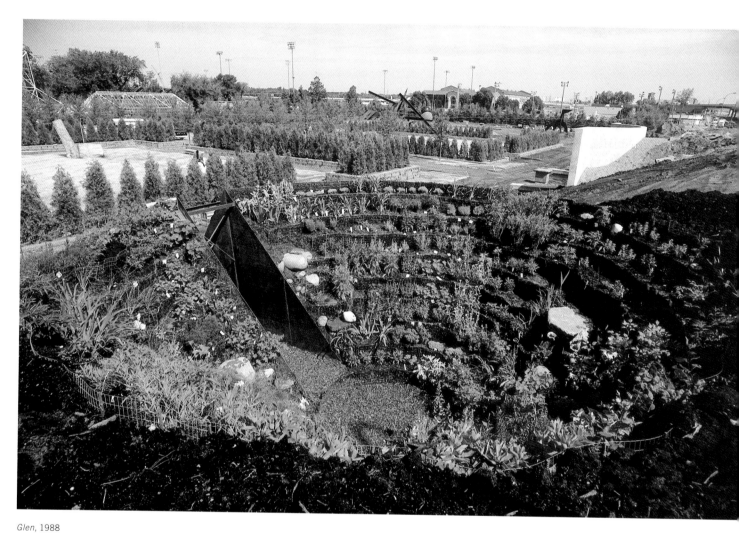

Glen, 1988
Earth, steel, plants, field stones
3.6 x 13 x 13 m
Minneapolis Sculpture Garden
Walker Art Center, Minneapolis

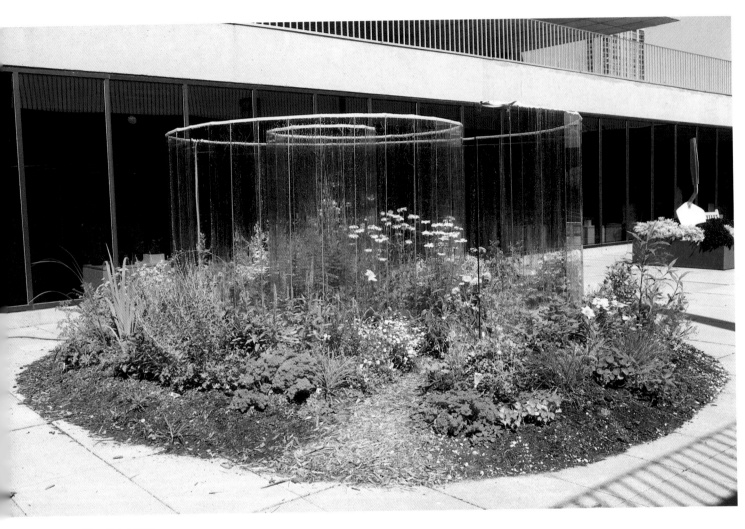

Glass Spiral, 1991
Glass, soil, flowering plants, water, soaker hose
3.7 x 4.6 x 2.4 m
Milwaukee Museum of Art
Milwaukee, Wisconsin

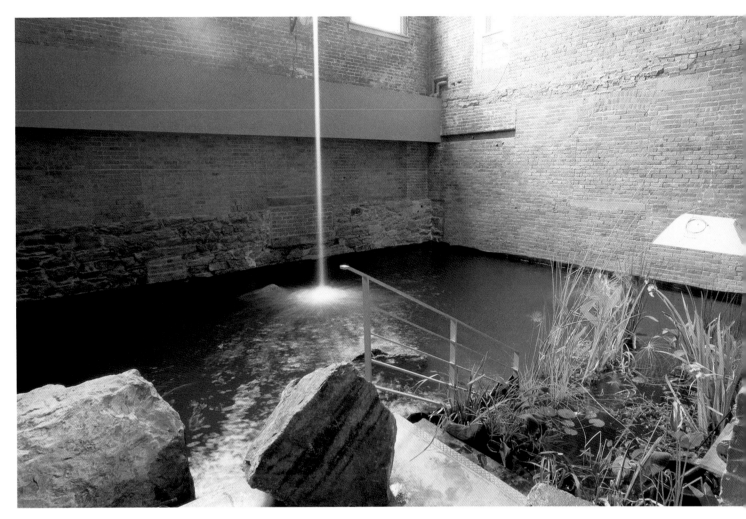

Pool, 1998
Water, fish, fish food, rubber liner, waterplants,
rocks, pumps, lights, fan, piping
9 x 12 x 9 m
P.S. 1 Contemporary Art Center,
Long Island City, New York

For some time I have made minimal art installations using natural materials, trying to create sequences to objects which reference the earth and nature through direct bodily feeling. Many early works were enterable objects. Plants were first used to hold soils in steep enclosures and provide living, textured, flowering walls. Stone, soil, sand, salt, hay, wood, glass and steel are some of the materials used in my sculptures. Minimal form and essential material provide a revolving perceptual context for the viewer. Water functions within the work as well. Pumps lift water into artifical falls and streams. Gardens are made in which special streams and ponds create cooling, warming or irrigating systems. In some cases the planting is very wild, making a contrast with the minimal works. I attempt to awaken within the viewer an emotional and intellectual awareness of environmental systems created both by man and by nature.

Meg Webster, 1999

Floral Blastings, Instructions:

The first order of business is to procure the explosives. The best time for this is at year's end, around New Year's Eve, so a little advanced planning is helpful. Class-D Chinese firecrackers, the biggest ones available in shops, are quite suitable. Trial runs with Class-C firecrackers and the bombs known as "cannon shots" produced unsatisfactory results. These fireworks put out a pleasing amount of smoke and noise, but they didn't have enough explosive punch.

Experiments with home-made solutions (home-made black powder, herbicide mixtures, etc.) should also be discouraged, as they can be dangerous and will require unnecessary work.

It may be necessary to lengthen the fuse on the firecrackers somewhat, but it is usually enough to pull out one end of the (double-ended) fuse a bit.

Appropriate targets for explosives are pansies, petunias, impatiens, tagetes – all perennials that are often found in public plantings. Freshly planted and not yet firmly rooted, these plants are launched wonderfully into the air by the thrust of a Class-D firecracker. The soil around the plants should be loose. This makes it easier to bury the firecracker (very important!) and simply makes the detonation look better. These ideal soil and planting conditions are found primarily in downtown urban areas, in decorative green fringes or in large flower pots placed in pedestrian zones or well-tended parking areas – in spots, that is, that make perfect sites for floral explosions in any case, for both aesthetic and substantive reasons.

I recommend the late afternoon or early evening as a fitting time of day. There are generally quite a lot of pedestrians out at these times to serve both as an audience and a photogenic backdrop, in the event that an explosion is to be captured on film. In this case, the early evening hours offer the best visual conditions for photos of fire and explosions.

Annette Wehrmann, 1999

Blumensprengung (Flower blasting), 1996
Hamburg

Brennen und Gehen (Burning and going), 1992–97
Broken asphalt, spontaneous vegetation, *Cichórium intybus*
Exhibition: documenta X, Kassel (D)

[...]

In an expression of opposition to the purity of species, Weinberger developed his Cultivated Steppe, a massive growth of therophytes, plants ideally adapted to rapid changes in environmental conditions and constant duress in the form of external factors such as trampling and frequent mowing. While his neighbours water their manicured lawns and crawl along their garden fences in panic at the thought of intrusions by ruderal vanguards, Lois Weinberger tends to pernicious toxic plants and reproductive strategists that expend a maximum of the resources made available to them for the purpose of optimising their reproductive output. Immigrants and niche-occupiers find him a willing helper dedicated to the care of wild, artless, natural vegetation in keeping with its own unique qualities in order to show that flora and fauna are representatives of a distinct value system and not a mere inert mass of organic material to be used or neglected according to the consumptive needs of the entertainment society.

This has nothing in common with the missionary zeal of a Saint Francis of Assisi. It has a great deal to do with serious doubts about the political and economic basis of western European democracies in light of the evolution of values in telesociety under the influence of global migration processes.

Weinberger is an unpretentious, lone-wolf educator. He digs his mole-hills in no-mans-land. He willingly accepts hardships in order to prepare the ground for the "appallingly beautiful" in the long run. Accordingly, his favourite plant is the crab thistle (*Onopordum acanthium*), the seeds of which are now known to remain viable in soil for some 550 years. He could hardly have chosen a more fitting symbol of his ability to single out the thorns and burrs and of realism as a corrective for feelings.

From: Christoph Tannert, 'Unkraut im Freizeitpark – über die Bemühungen des Gärtner-Künstlers Lois Weinberger', *neue bildende kunst*, Berlin, No. 6, 1997

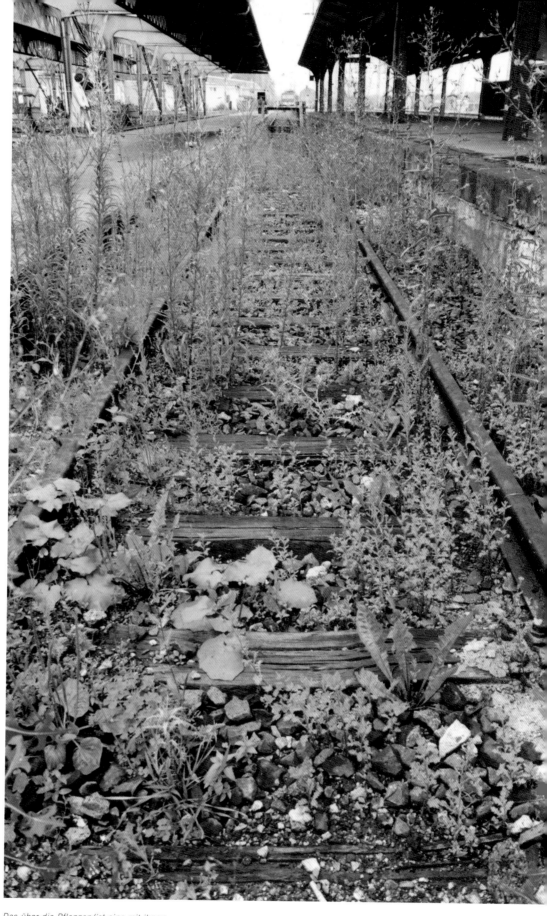

Das über die Pflanzen/ist eins mit ihnen
(That about the plants/is one with them), 1990–97
Rails, railway station Kassel
Exhibition: documenta X, Kassel (D)

an Stelle (in place), 1997
Various potted plants, wall paint, neon light
Galerie Erna Hécey, Luxemburg

an Stelle (in place), 1997

Rasen (Lawn), 1995
Lawn, fertilizer
Exhibition: oikos & Eigenbau, Berlin

The developed and enclosed space no longer derives its position of importance from its function of providing effective protection against the forces of nature. What makes it important now is the strategic role it plays in internal and external struggles for power and wealth. The occupied space is fortified to protect its own and to resist intrusion from without. What I articulate in my work is the desire to divest this stronghold of some of its power.

The aim is to make the resistant, fortified boundaries of the place passable. To the extent that this permits the excluded, the unfamiliar to manifest itself at the place itself, the autonomous value, the identity of the place will diminish considerably.

The trees in the forest and the animals in the zoo have long since become integral elements of our living space. Ironically, this makes them both endangered and worthy of protection. ... And the vegetation that flourishes under control inside and outside of our houses gives only a pale impression of the original nature that once even threatened our existence.

The horizon has shifted. Expansive parking areas and well-tended gardens are border regions, mediating, reconciling in-between places in the tension-filled relationship between our familiar homes and undefinable, unfamiliar surroundings. What interests me is the most extreme and most sensitive point along the boundary between the powerful, culturally defined place and the pure space that has not yet been appropriated.

Luc Wolff, 1999

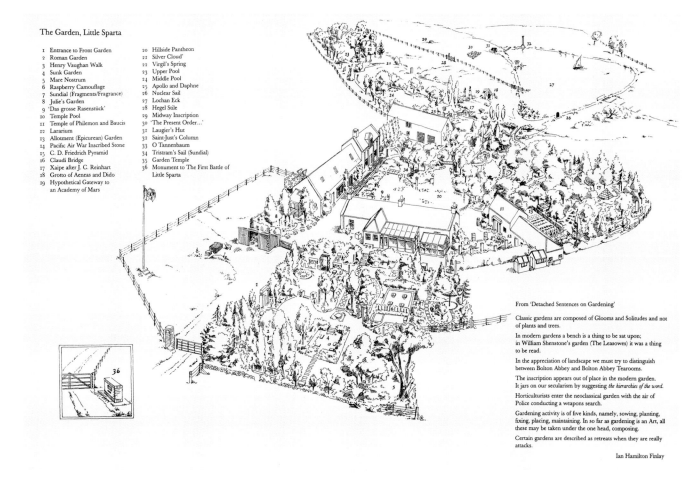

The Garden, Little Sparta

1 Entrance to Front Garden
2 Roman Garden
3 Henry Vaughan Walk
4 Sunk Garden
5 Mare Nostrum
6 Raspberry Camouflage
7 Sundial (Fragments/Fragrance)
8 Julie's Garden
9 'Das grosse Rasenstück'
10 Temple Pool
11 Temple of Philemon and Baucis
12 Lararium
13 Allotment (Epicurean) Garden
14 Pacific Air War Inscribed Stone
15 C. D. Friedrich Pyramid
16 Claudi Bridge
17 Xaipe after J. C. Reinhart
18 Grotto of Aeneas and Dido
19 Hypothetical Gateway to
 an Academy of Mars

20 Hillside Pantheon
21 Silver Cloud'
22 Virgil's Spring
23 Upper Pool
24 Middle Pool
25 Apollo and Daphne
26 Nuclear Sail
27 Lochan Eck
28 Hegel Stile
29 Midway Inscription
30 'The Present Order...'
31 Laugier's Hut
32 Saint-Just's Column
33 O Tannenbaum
34 Tristram's Sail (Sundial)
35 Garden Temple
36 Monument to The First Battle of
 Little Sparta

From 'Detached Sentences on Gardening'

Classic gardens are composed of Glooms and Solitudes and not of plants and trees.

In modern gardens a bench is a thing to be sat upon; in William Shenstone's garden (The Leasowes) it was a thing to be read.

In the appreciation of landscape we must try to distinguish between Bolton Abbey and Bolton Abbey Tearooms.

The inscription appears out of place in the modern garden. It jars on our secularism by suggesting *the hierarchies of the word.*

Horticulturists enter the neoclassical garden with the air of Police conducting a weapons search.

Gardening activity is of five kinds, namely, sowing, planting, fixing, placing, maintaining. In so far as gardening is an Art, all these may be taken under the one head, composing.

Certain gardens are described as retreats when they are really attacks.

Ian Hamilton Finlay

Ian Hamilton Finlay: *Little Sparta*, Lanarkshire
Garden plan
Drawing by Jack Sloan, 1999

Permanent Gardens

Ian Hamilton Finlay, Lothar Baumgarten, Lois Weinberger

The first artist's garden mentioned in Marie Luise Gothein's *Geschichte der Gartenkunst* was that of the painter Peter Paul Rubens. Gothein describes it as typical of the gardens maintained by upper-class citizens of Antwerp at the time. The artist's signature is missing – or cannot be confirmed, at any rate.

Until the 18th century, artist's contributions to gardens and parks were limited – with a very few exceptions – to sculptures. Artists provided figures that fit the plans of garden architects. They played their part in the creation of a total work of art shaped by men who had to "be a bit of a surveyor, understand architecture and be able to draw well, have a command of the ornamental arts and be familiar with the peculiarities and effects of all plants used in beautiful gardens".[1] This characterization offered by the architect Le Blond attributes universal skills to the garden architect. At about the same time, England witnessed a practical departure from the French garden model and the emergence of a theoretical discussion about the relationship between art and nature. In 1713, this debate culminated in a publication by the poet Alexander Pope which soon came to dominate public opinion. "I believe", he wrote, "that I cannot be wrong in observing that persons of genius, those who have the greatest talent for art, love nature; for they feel very strongly that all art consists in the imitation and study of nature."[2]

This idea can be traced to the ancient belief that the sacred groves did not fall from heaven but were established and safeguarded by heroes – by persons of outstanding talents. Like gardens, these sacred groves were clearly delineated areas to which only the elect had access. Their origins can be found in such specific natural phenomena as springs discovered in regions with rugged topography, grottoes in open terrain or trees that had survived from the dark, uncharted past. Only those with visionary skills could recognize the special qualities of a place and identify the local divinity. Such persons knew the rules by which such sites must be kept sacred. The groves survived as long as the gods were honored. Like the garden architect, the hero is a man of universal skills. He is acquainted with nature; he specifies the order and the rules that govern the terrain. And it is much the same with the artist, whose garden, like the sacred grove, can continue to exist only if a community or a team maintains it and ensures that its underlying relationships of meaning are preserved.

To a gardener, however, biological considerations are more important than semantic ones. It is here that we find the dividing line between an artist's garden and a mere decorative or utilitarian garden. The artist will always place meaning above utility or decorative appeal.

Ian Hamilton Finlay

Ian Hamilton Finlay is a poet who, upon his own admission, lacks the skills of a technician or craftsman but wants to express his ideas about the world and its order in a garden nevertheless. This concept of a total work of art

Lothar Baumgarten: *Theatrum Botanicum*
Ground plan

Paradiesgärtlein
Master of the Upper Rhineland, around 1420
Städelsches Kunstinstitut, Frankfurt/M. (D)
Leihgabe des Historischen Museums, Frankfurt/M.

Lothar Baumgarten: *Theatrum Botanicum*, since 1992
Trees, plants, flowers, stone
Fondation Cartier pour l'art contemporain, Paris

places him firmly within the neo-classical tradition. His 1.6-hectare land-scape park near Edinburgh is a poet's garden of the kind the philosopher Jean Jacques Rousseau might well have described (see pp. 48–49, 142). When Finlay took possession of the property in 1967, it was still called "Stoney Path". It comprised a small cluster of buildings, fields, pastures and a single tree. Finlay had paths, fields of flowers, small wooded areas and man-made ponds put in. Adding columns, reliefs and inscribed plaques which now appear surprisingly among patches of grass, near trees and beside ponds, he quotes 18th century ideas and employs a number of other, often contradictory citations in opposition to modernity.

Like every garden, Finlay's is also a refuge. In contrast to English land-scape gardens, however, Finlay incorporates political aspects into his garden of aphorisms. One of the most characteristic ambiguities is the amiable coexistence between the themes of power and death, on the one hand, and the world of classical mythology, on the other. Thus a walk through the garden past scattered aphorisms becomes a reading of Fin-lay's world.

Finlay regards his temples as symbols of an attempt to breathe life into religion. That is a serious matter to him. For years he has been wag-ing a legal battle with a higher government authority that wishes to tax one of his temples as a museum. Finlay insists that it is a temple. And that a temple is not a museum. Today, the property, which has taken on a kind of Arcadian aura with its many trees, shrubs and ponds, is called *Little Sparta*. The name itself is a declaration of war.

Lothar Baumgarten
Lothar Baumgarten names 161 plants as fellow actors in his *Theatrum Botanicum* (see pp. 28–29). In 1993, he was commissioned to design a garden for the Fondation Cartier in Paris which now forms an ensemble with the multi-storey glass building erected by the architect Jean Nouvel. The grounds behind the building are enclosed by a wall. There were already several trees on the grounds when Baumgarten began working on the project, and he incorporated them into his design. Discovering a rec-tangle, a triangle and a square inscribed in the lot ground plan, he decid-ed to augment this sequence of simple geometric forms as constructive elements by adding a circle and an ellipse. Thus he built a series of rising semicircular terraces outside the double-glass rear facade of the build-ing – positioned asymmetrically in the right-angle corner of the lot. They call to mind the form of a Greco-Roman theatre. The terraces are divided by stairs that lead in an opposing vertical movement to a fountain below. The fountain reflects only the sky, while the glass facade mirrors the whole garden as a large tableau.

Baumgarten's planting concept makes deliberate reference to large wall-hangings popular in the 15th century. The flowers, medicinal herbs and kitchen spices are meant to weave a kind of Gobelin carpet through all of the seasons; the floral decor should resemble a French gold brocade. The reflection of the real plants as an image in the mirror of the glass wall is the meeting point between the building and the garden, and it suggests two possible approaches to the discovery of meaning.

One approach leads to the client, to which Baumgarten refers in his work. The assets of the Fondation Cartier have been acquired through the conversion of leaves and blossoms into precious objects of jewels and gold. The other approach takes us farther back into history to the gardens on the Gobelin carpets – gardens of paradise in which every plant had its specific meaning. They were gardens of innocence.

And so the garden of the Fondation Cartier is also conceived as a garden of paradise, for, as Baumgarten says, "the filth, the noise and the pollution are kept out". The reality of the city is banished from the enclosed space, the *hortus conclusus*.

The artist sought to create a self-contained cosmos by selecting certain specific plants, all of which are associated in some way with European science and mythology. It was important to him that all of the plants he chose came from the area surrounding Paris. And only these plants from the region and "the seeds carried there by the wind", he writes, would be allowed to take root in this garden. The highly toxic jimsonweed grows here as well, however.

The Arcadia of mythology, in which death also has its place, and theology's Garden of Eden, where time is suspended and there is no evil, come together in Baumgarten's theatre. The coexistence of death and innocence becomes a precarious alliance.

With his design for a *Theatrum Botanicum* in the heart of Paris, Lothar Baumgarten has created an integral context, incorporating not only his client's new building and its immediate surroundings but European cultural and intellectual history as well.

Lois Weinberger

In 1988, Lois Weinberger laid out a garden intended to serve as a source of seeds for an indefinite number of unrelated species of plants. The plants in question are ruderal or "rubble" plants – grasses, vines and flowers that flourish without care on barren, nutrient-poor terrain. They may also grow in gardens with rich soil, but there they are ordinarily regarded as weeds and eliminated. Weinberger loves this group of plants, particularly the species native to southern and eastern Europe. The out-of-service section of track at the main railway station in Kassel he seeded during the documenta in 1997 has since become famous (see pp. 138–139). Local Kassel weeds were already growing there, but Weinberger made a point of having his own weeds displace them. Weinberger sees a correlation between weeds, which, according to a popular proverb, never die out but always survive, and migration. Weeds and migrants, he believes, have similar qualities.

This political interpretation of an overgrowth of vegetation on derelict railroad tracks, broken up streets, collapsing walls and abandoned trash dumps, also known as "ruin romanticism", is only one aspect of Weinberger's artistic objective. For in contrast to ruin romanticism, he does not use plants to call attention to the past but to the present by emphasizing the details of nature as the expression of a real life that will outlast history.

Weinberger has studied nature closely and concerned himself with past and present perceptions of it. Nature was regarded as threatening in ear-

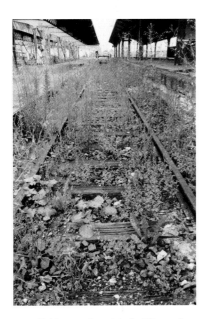

Louis Weinberger: *Das über die Pflanzen/ ist eins mit ihnen* (That about the plants/ is one with them), 1990–97
Rails, railway station Kassel
Exhibition: documenta X, Kassel (D)

lier times, and man sought to isolate pieces of it that could be controlled and cultivated. In Weinberger's art, it is culture itself that appears dangerous. He isolates a segment of culture – the railroad track, the path, the asphalt road – from the civilized world and proceeds to reintegrate it into nature, to naturalize it. He interprets the language of weeds in his own unique way. If he were to make his flowers speak, they would call their wildly flourishing garden "the survival of the fittest".

Unlike Finlay and Baumgarten, who compose their garden cosmos with regional plants, Weinberger lays out his plantings with exotic species, as if in passing, and leaves them to their own devices. While Finlay and Baumgarten shape vegetation into a protected, well-tended image, Weinberger allows only the most tenacious plants to thrive.

Valuation, Revaluation and Shifting Boundaries
Didier Trenet, Tobias Rehberger, Luc Wolff

Every garden is based upon a design. Gardens represent proposals for an ideal way of ordering the world on a large or small scale. Such concepts can be seen as counterproposals to the everyday world, and they reflect the yearnings and wish-images of the garden architects, architects, artists, farmers or hobby gardeners who conceive them. Frequently cited by scholars in many different places, the historical link between the garden and paradise is a special form; yet it shares with all gardens the aspect of separation from free nature, from wilderness, from fields and developed land. The isolation of a section of terrain dedicated to a design composed of plants as a world of its own is the hallmark of the garden. Thus a meadow in the open countryside covered with wildflowers is not a garden. If the same meadow were to be fenced in and the flowers ordered by human hands, then it might be called a garden.

Alpine farmers' gardens and coral gardens in the South Seas are enclosed and, although they serve primarily utilitarian purposes, referred to as gardens. Yet a grain field or a field of potatoes would not become a garden even if it were fenced in or marked out as a distinct territory by a ditch, since the aspect of deliberate, sense-giving design would still be missing. On the other hand, nicely decorated flower arrangements in pedestrian zones, shopping malls and squares are not gardens but simply beds, borders or planting pots.

The concept of the garden as a carefully tended, deliberately designed arrangement of plants has little to do with the concept of "landscape" – that is, as nature *viewed* in aesthetic terms in the broadest sense. "Landscape" depends upon the observer's point of view, whereas the garden is a *fait social*. What is known as a landscape garden is a response, realized in the real world, to the gaze of the observer who, from a privileged vantage point, has succeeded in grasping the immeasurable quality of nature as an image and appreciating it as a mental picture. Even the landscape garden presupposes an isolated terrain artfully composed with plants in a world apart, although the skill of architects and landscape gardeners lies in their ability to create the illusion of boundaries moved to

the horizon and to give the garden the appearance of nature, which in turn offers a view of "landscape".

In his treatise entitled *Der Englische Garten. Eine Reise durch seine Geschichte* (The English Garden. A Journey through its History), the garden historian Hans von Trotha discusses the ideal underlying the creation of gardens. "Gardens may well reflect social structures, but they are first and foremost works of art. They reveal a great deal about the concept of ideal beauty prevailing at a given time, about aesthetic fashions and about the relationship between mankind and nature. Nowhere else is the encounter between art and nature as immediate as in the garden, in the space between the house and the landscape."[3]

The idea that gardens contain only decorative plants and never useful ones is an often-heard misconception popular among city-dwellers. It derives from the majestic Italian, French and English gardens and their smallest offshoots in the front gardens of suburbia, yet it ignores the reality of gardens in Europe and the rest of the world.

Didier Trenet

In the copious abundance of his sketchbooks, Didier Trenet draws *after Montepulciano*, *after Barolo* and *after Bordeaux* – that is, under the influence of alcohol. The titles are cheerful clues to Didier Trenet's concept of time. There was something before, which still persists and has effect: perfect.

The titles parody the technical term used by art historians – "after Boullée", "after Watteau" – and at the same time the title variable of Elaine Sturtevant, who consistently introduces her appropriations with the preposition "after" – *after Marcel Duchamp*, *after Joseph Beuys*. Didier Trenet sees his work as an artist as following something or someone. He pursues a principle of dialogue and communicates with an imaginary counterpart.

For an entire summer in 1996, he planted a response in an existing garden setting at the Museum Boijmans Van Beuningen in Rotterdam for Manifesta 1. Along a gravel path encircling a round fountain with a bronze nymph, he placed a border of leeks, lettuce and tomatoes. On the surrounding grass he laid out a long, yellow hose arranged in an undulating pattern. The vegetables and the snakelike hose were a quotation. Thin fountains of water shot from the meandering hose in short intervals. They moistened the grass and also benefited the implanted vegetable garden in the long run. In the official photograph, however, the central gravel path and the surrounding contrasting yellow-and-green ornamentation dominated the image. Trenet favored this geometric dominance and gave an ironic turn to the idea of the Garden of Eden with its obligatory snake. The snake provides water. It is the life-giving element.

In his essay on Trenet, the art historian Gérard Lapalus writes that Trenet sees the garden as an ideal setting for a typically French kind of art.[4] Even in its domestic form and its function as a small vegetable garden, it offers space for all-encompassing revaluations that are not accommodated by the social contract. Trenet plants leeks, known in France as "poor-man's asparagus" and thus linguistically upgraded, in clearly visible spots alongside the mysterious mandrake. In doing so, he devalues the image of the mandrake while enhancing that of the leek.

Didier Trenet
Equlibre thermostatique des motivations, 1996
Hose, tomatoes, lettuce, leeks
Exhibition: Manifesta I,
Museum Boijmans Van
Beuningen, Rotterdam

Didier Trenet: *Pour quelques Poireaux*
(detail), 1992/98
Installation in the garden of the artist's
mother, Beaune, France

Didier Trenet: *Projet de Fontaine*, 1991
Ink on paper

Revaluation is his theme. His compost heaps are designed in such a way that weeds appear as a delicacy. This process of revaluation is applied to the chicken coop, the parasol and the shed, which are now presented as workshops, pavilions and rotundas. "The small, enclosed suburban garden", as Gérard Lapalus summarizes his description of this "transubstantiation", "expands into a ruin-strewn landscape".

Society's appraisal of utilitarian and decorative plants is shaped on the one hand by fashion trends and on the other by eating habits that can be traced back into the distant past. The idea of the leek as the "poor-man's asparagus" is the product of social rather than natural circumstances. A relationship between value judgement and cultural history also affects behavior in matters of taste. The question of how values emerge is as germane to Trenet's decision to dig up the grass in the museum park in Rotterdam in order to plant leeks and lettuce as it is to the plays on words from titles or quotations from the works of the Marquis de Sade, who sought to teach art (erotic excess as a set of cruel, fantastic rules) to nature (sexuality).

Tobias Rehberger

Tobias Rehberger is also concerned with revaluations and asks "how aesthetic values originate". Unlike Trenet, he does not use living plants as references but instead as tools for translation. His 1998 work for Manifesta 2 in Luxembourg entitled *Within view of seeing (perspectives and the Prouvé)* deals with the "impossible translation between gardening and Color Field Painting", as Rehberger commented on the work in an article in the journal *artforum*.[5] On the basis of Rehberger's design, gardeners planted decorative and utility plants in shallow tubs (see pp. 112–113). Thus the plants were not firmly rooted in the ground of the terrain but lay on the stone tiles of an overlook terrace like a painting on a wall.

The rectangular beds along the road formed a complex that covered most of the enclosed space. They were separated from the road by the foundation of the terrace, which presented no major obstacle. The boundary was reinforced by the gray strip of the path that ran around the beds, creating a frame that composed the complex into a picture in the eyes of viewers looking down from the upper floors of the museum on the opposite side. The reverse view from the picture toward the pavilion of the architect Jean Prouvé shows the garden as a vague mirror image.

Rehberger designed the garden as a form of interplay between function and decor, providing a demonstration of the impossibility of establishing a clear distinction in the definition of these two concepts in practice. Conceptual interpretation depends upon perspective, the viewer's interest and the practical approach taken; for every thing is capable of assuming several different functions. If the food plants cabbage, lettuce and basil planted on the overlook terrace are picked and eaten, the decorative character of the garden is negated. If these plants are not harvested, however, they will go decoratively to seed.

"What interests me is the difference between what I wanted to do and what someone has done with it", he remarked in an interview.[6] The result was a sculptural idea that incorporates the unpredictable contribution of the viewer to the creative process. Rehberger can suggest meanings through formal arrangements, but he cannot dictate them definitively. Thus the work becomes open to appropriation, and the artist can neither assume responsibility for the meaning it produces nor be identified with the work once it is completed. He is a provider of ideas; he creates works that establish a basis for further use. In this way, however, he becomes dependent upon a work's reception. In the case of the small garden in Luxembourg, an unforeseen situation arose: The garden was not immediately removed after the close of the exhibition but left intact for some time as consideration was given to making it a permanent part of the public space. In such cases, Rehberger considers whether the original situation is appropriate to the new temporal standard and makes changes as needed.

Luc Wolff

Luc Wolff emphasizes the boundaries that define his temporary works. In Berlin, he placed a rough-finished white wall abruptly in a garden (*Wand* [Wall], 1995) and filled an empty exhibition room so full of potted shrubs and trees that it could no longer be entered (*Parkhaus* [Parking Garage], 1997). Living plants offer him a means of highlighting boundaries and thresholds. In some cases a garden is enclosed by walls, in others the reverse is true. Before presenting these unspectacular interventions to the public, however, Luc Wolff makes careful preparations. He clears and cleans the terrain, sweeps the ground and offers the eye an open space. The presentation consists of a demonstration of the possible in the condition of its possibility: as terrain kept free.

In his contribution to the Biennale in Venice in the Giudecca district (*Magazzino*, 1997), he emptied an entire warehouse hall. To call attention to the existence of this unused space he blocked the entrance area with an array of some sixty tall potted plants leading out to the wall of the quay along the edge of the lagoon. Each evening after the exhibition closed, he carried the plants into the empty room, only to take them back out into the light the next morning, like a merchant displaying goods outside a shop. In a text accompanying *Magazzino*, Wolff emphasized this repetitive activity. "The silent presence of a caretaker should be evident at all times in the *Magazzino*. This impression should be created in a credible way through regular cleaning inside the warehouse."[7]

Luc Wolff: *Magazzino*, 1997
Installation; various materials, potted plants, drawings
Biennale di Venezia, Venice

Luc Wolff: *Magazzino*, 1997
Installation; various materials, potted plants, drawings
Biennale di Venezia, Venice

Luc Wolff's works focus on concern for empty spaces. In keeping with each specific concept, he keeps them in order and tends the plants. Yet it would be wrong to say that he cultivates gardens. His efforts are not directed toward their growth or change but toward maintaining the established status quo. This process of conservation is clearly underscored by his use of plants.

Wolff's concern for the preservation of terrain is both the link and the distinction between his work and that of the gardener. He does not sow seeds but instead uses such portable finished products from garden centers as rolled sod and potted plants; he stakes out a terrain at different locations and keeps it open as a free zone. The act of greening is viewed as one possibility among many between the poles of movement and immobility. Yet between the occupied and the open fields, between growth and arrested motion, Wolff fixes his gaze upon the boundaries (see pp. 140–141). It is these that he enlivens and maintains as thresholds – as the difference between one field and the other that is sometimes as imperceptible as the constant growth of plants.

In the course of their lives, plants continually occupy different spaces. Their growth and death cause borders to move, making them a symbol of constantly shifting boundaries.

Monuments and Memorials
Gloria Friedmann, Jenny Holzer, Hirsch/Lorch/Wandel

Lidice
After the assassination of Reinhard Heydrich, Deputy "Reichsprotektor" of Bohemia and Moravia, in the summer of 1942, the "Gestapo" targeted Lidice in their search for the organizers of the attack. SS troops combed the Bohemian village. Unable to find their suspects, they evacuated the women and children, executed all of the men, burnt the town to the ground, blew up the houses and the church, cleared away the rubble, plowed the remains of the village under, filled in the village pond, leveled the cemetery and eliminated every trace of the settlement. All that remained where the village had once stood was a vast, empty plain of desolate, scorched earth.

Seeds were sown again after the war. Wheat fields began to grow anew. Years later, farmers noticed an unusual discoloration of the stalks in their grain fields. And thus were the traces of Lidice discovered. Some of the new grain grew over a mass grave. Today, a monument stands as a reminder of the destruction. Several areas have been excavated and exposed. Surviving fragments of walls bear witness to the devastation.

Nature never forgets, and it was nature that brought the evidence to light. What the farmers on the plains discovered accidentally – that past history is written on the ground's surface – has long been a part of archaeological methodology. When they suspect that the ground in a given area conceals the remains of old settlements, archaeologists first survey the terrain from the air. Wherever they discover plants growing in irregular patterns, they begin to dig, and they usually find something. Even after

the passage of centuries, plants grow differently than in places where no settlements lie buried. The ground preserves an image that can be read like an archive on the surface.

What the alert farmers found in the wheat field would seem impossible to improve upon as an image of the massacre. What they discovered cannot be expressed in a visual image, but it can be told. And what they told became a legend – an image of the human imagination that strains the limits of language: not as a picture but transformed into a different medium.

Nor do the following examples of approaches to the facts and events of the years between 1933 and 1945 represent depictions of the horror. The artists did not seek out images with which to illustrate the suffering of the victims of injustice, of those persecuted on political or racial grounds, of the fallen soldiers or the deported. Instead, they turned to the resources of analogy, atmosphere, symbolism and documentary record to encourage a behavior in those born afterwards that would evoke the memory fifty years later, but not without a recollection of injustice, torture, murder and struggle. And living plants play an essential role in the process – as mediators between the present and the past.

Gloria Friedmann

Gloria Friedmann's memorial *Hier + Jetzt* (Here and now) was dedicated in Hamburg on October 1, 1997. It commemorates the victims of National Socialist injustice in Hamburg. People leaving the Oberlandesgericht (Higher Regional Court) in the Hanseatic city find themselves confronted by a barrier. The once open view into the park across the way is now blocked by a concrete wall more than two meters high that runs horizontally in front of the building portico. The number 1933 is engraved in the wall, recalling the year the National Socialist Party took power in Germany. There is no reference to any other year.

On the rear surface of the wall facing the grounds of the park, a panoramic view of Hamburg covering the entire breadth of the wall provides a backdrop for ninety pedestals set in the ground. The tops of the pedestals form containers in which Gloria Friedmann planted ninety different kinds of plants. All of the plants are exposed to the same light and shadows, although at differing heights. As Friedmann commented in her description of *Hier + Jetzt*, "They present 90 different potted plants to visitors. Nettles grow alongside a rosebush. Potatoes grow as neighbors of lavender. Medicinal herbs flourish next to a poison plant. The exotic cactus stands beside native leek stalks, awaiting the sun. The plants are symbols of biodiversity. They represent the population of Hamburg, with its many different social classes and regions of origin. This model of a world of differences, all with an equal right to be cared for, also serves as a metaphor for the entitlement to equal rights under the law."[8]

In his accompanying text, Günther Engelhard speaks of an "architecture of consciousness" and interprets the work as an allegory on justice. The plants represent a "multicultural society that grows together and is guaranteed equal justice for all in this place".[9]

Friedmann does not mark an end to the period following the caesura of 1933 with another date. Thus the existence of the memorial itself, its

Gloria Friedmann: *Hier + Jetzt* (Here and now), 1997
View of the memorial and the "Hanseatisches
Oberlandesgericht", Hamburg

presence as ordained by the city, is the only conclusive warning symbol.
The monument accomplishes its purpose as long as people give equal
care to all of the plants. In this sense, however, the work means more
than it intends to be.

Gloria Friedmann erected an immovable and unalterable wall as a
symbol of accusation in the form of a free-standing, inscribed monument.
On its reverse side, she sets the manifold movements of the Here and Now
in the cyclical blossoming and withering plants in opposition to fixation
upon the past. Potted plants require care. With the date 1933, the artist
reminds us of the abolition of equal rights for all citizens; with the plants,
she appeals year in and year out for the democratic right of equal treat-
ment under the law. Conscious action becomes an element of meaning
underlying the intention that informs the work of art.

Jenny Holzer

The memorial *Black Garden*, a work by the American artist Jenny Holzer,
was dedicated in downtown Nordhorn on October 28, 1994 (see
pp. 76–77). It is a revised version of existing memorials to the victims of
three wars (1870/71, 1914–1918 and 1939–1945) and is also devoted in
part to the memory of the victims of political and racial persecution. The
"Memorial at the Langemarckplatz", named after a World-War-I battlefield
in Belgium, underwent revision within the context of a reassessment of the
historical events during the 1980s. The discussion also gave birth to the
idea of a memorial that would go beyond the already existing monuments.
In her 'Gedanken zu einem Kunstwerk gegen den Krieg' (Thoughts on a
Work of Anti-War Art), Sabine Dylla, director of the Städtische Galerie,
described Jenny Holzer's 1994 work: "In a pattern that echoes the memo-
rial to those killed in World War I (a closed, round area consisting of
sandstone segments), a system of beds and paths arranged in concentric
circles was introduced. A number of different black-leafed and black-
blooming plants were planted in the beds and around the fringes of the
World-War-I memorial. Sandstone benches bearing texts by the artist were
placed in five previously existing bench areas."[10]

The color black is unknown in the natural environment. Many types of
wood, grasses and flowers look almost black, however. Jenny Holzer had
plants of this kind set around the concentric circles. From the air, the
complex has the appearance of a target.

In his analytical essay 'Garten in Schwarz' (A Garden in Black), the
art historian Justin Hoffmann focuses upon the symbolism of the color
black – the symbol of death, mourning and suffering.[11] Yet we should
perhaps avoid overemphasizing this popular approach to interpretation
in our assessment of the 36 dark-leafed plant species in this work. Viewed

Gloria Friedmann: *Hier + Jetzt* (Here and now), 1997
View of the plant ensemble and the botanical garden
Planten un Blomen

as an ensemble, their most striking effect is the evocation of a mood, and they clearly establish a centre of calm in the midst of a busy urban setting. The plants stand out in contrast to the stone benches with their engraved descriptions of human agony, which awaken compassion in those who read them.

Justin Hoffmann sees "two forms of representing death" linked here in an apparently paradoxical manner. "For, on the one hand, flowers, though not black ones, are customarily associated with the rites of death. On the other, black is regarded as a symbol of death, albeit not in the form of plants. A black flower … appears to deny the flower its function as an expression of love for the dead soldier, while emphasizing at the same time the significance of the color black as a sign of violence or impending danger."[12] Because Holzer creates a natural, living image rather than a static one, her statement can be related to painting only if we view the space as surface from the air. We then see the area covered with vegetation in much the same way that the painter Arnulf Rainer applies a coat of black to the surfaces of previously painted pictures.

Yet what cannot be determined on the basis of a view from the air is why the plants should overgrow the entire area, or whether they should do so at all. Things look different from ground level. The pedestrian viewer walks along the fixed paths on the target. Twelve rings spread out around a centre and are surrounded by a circle of trees like the court circle in the open field in medieval times. The gaze is drawn to the centre. Those who enter these rings find themselves within range of the spell of a monument to those caught long ago in the field of fire. Symbolically, at least, this means danger.

Turning our attention to the flowers, we recognize dark carnations, gray fennel, blue speedwell and crimson bells. Were we to attempt to interpret them, we would recognize in their names a catalogue of male virtues. In the German tradition, blue is seen as the color of fidelity, purple as the

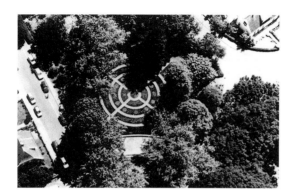

Jenny Holzer: *Black Garden* (aerial view), since 1994
Plants, paths, benches, text
3447 m²
Nordhorn (D)

color of majesty but of battle and love as well. Grey would represent the uniforms of fallen combatants. The consistently dark coloration is a lasting expression of tribute to the soldiers. At the memorial to the victims of racial and political persecution from 1933 to 1945, white chrysanthemums, irises, pansies and heather grow in small beds. These particular species are commonly found in cemeteries in Germany, Holland and Belgium. Jenny Holzer also uses white as a color of mourning.

A closer look at the trees and shrubs reveals the presence of red beeches, red plum trees, castor-oil trees, Judas trees, weeping red plum trees and red berberis. These species do not change significantly with the seasons. Their leaves remain dark. Walkers can stop here. They will find it hard to sit on the benches and thus display apparent disregard for the texts inscribed on them. Like all gardens, this one also influences behavior. People walk in circles, confined to narrow paths. The benches acquire the status of lecterns. Lightness never comes. The park remains dark; the few white and multicolored beds lend it a silvery, anthracite hue.

Hirsch/Lorch/Wandel
The *Gleis 17* (Track 17) memorial erected by the architects Hirsch, Lorch and Wandel was dedicated 27 January 1998 in Berlin Grunewald. It commemorates the deportation of more than fifty thousand Jews to Treblinka, Theresienstadt, Riga, Lodz and Auschwitz between October 1941 and April 1945.

The site is still located in the midst of everyday bustle. As successor to the Deutsche Reichsbahn, which carried out the transports as ordered by the Nazi government, the Deutsche Bahn AG commissioned the Saarbrücken architects to design the memorial to *Gleis 17* in 1995. "Our aim was not to interpret", says Wolfgang Lorch, "but to bring facts to light".

The railroad authority had already ceased using this end section of track. Beech and birch trees had grown up between the rails. Only a small plaque mounted on a nearby shed served as a reminder of the long-departed transports trains. A scholar was appointed to research the accounts of the Deutsche Reichsbahn, which had billed the Nazi government disbursing office for the transports. He was able to document 183 transport operations. In commemoration of these 183 transports, the architects had 183 corresponding perforated, inscribed cast-steel plates laid in a seamless arrangement along both sides of Track 17. The relief at the top of each plate gives the date, the number of persons transported and the respective departure and arrival stations. "26.02.1943/1095 Juden/ Berlin – Auschwitz". Those who walk along the row of plaques, forced to bow their heads to read them, gradually find themselves reciting a litany that turns the deportation schedule into an invocation. The facts become a prayer, each plaque a reminder of a mass grave.

The architects left the trees that had grown up over the years as they were. They renovated the stairway leading from the underground access tunnel to the platform, mounted a plaque there and added a sign pointing the direction to *Gleis 17* to the many other signs in the station.

A memorial whose forms derive their expressive power from the aesthetics of precision because they respect the unspeakable character of the

Hirsch/Lorch/Wandel
Gleis 17 (Track 17), 1997
Bahnhof Grunewald, Berlin

Gleis 17 (Track 17), 1997

site would be incomplete without reference to the future. Should the site remain unfrequented and fall into disremembrance, grass will grow up through the gridlike steel plates. The height of the grass will serve as record of visits.

Used as a means of creating meaning, living vegetation is the key to an interpretation of the memorial. While the record of facts gives clear evidence of the time of the crime, the growth of the trees between the tracks tells of the time that has since passed and is, together with the flourishing or trampled grass, a gauge of the passage of past and present time.

In contrast to the previously cited examples, this memorial requires no care. Every form it assumes lends more or less weight to one of its possible meanings. Yet each serves as an indicator of the behavior of those born later. Living plants alone make it possible to keep this record. The idea that nature never forgets has been inscribed through art in this work and will remain evident even after decades have passed.

Eros and Body
Paul-Armand Gette, Teresa Murak, Sandra Voets

Many artists link their use of plants to symbolic actions presumed to express a genuine inner bond. They are forms of empathy. In the following discussion of the forms used by artists in dealing with plants, no attempt will be made to determine whether the public feels obliged to accept these signs of expression. No examination of Weltanschauung is intended, as the objective is merely to explore the phenomenon of the transformation of pleasure, fear and pain into metaphors and images of plants as objects of representation. The artists respond to literature and systems of order, to myth and magic, to sex and Eros, focusing upon the human body through an aesthetic association with plants. The artists in question represent different generations.

Paul-Armand Gette
In the mid-1970s, Paul-Armand Gette had the plant names from Carl von Linné's encyclopedic *Species plantarum* read aloud in Nanterre for six

straight hours. His objective was to enrapture himself and his listeners with the names and the associations they evoked. Linné compiled a list of all known plants in the 18th century, classified them according to sex characteristics (pistils and pollen receptacles) and assigned them all Latin names. Thus Aaron's rod was henceforth known to all scientists definitively as *arum*, and the waterlily as *nymphea*. Gette's reading drew an element of eroticism from this scientific language – a language which must not deliberately delude – which he intended to present as a fountain of stimulating ideas through the act of reading aloud. When the French-speaking Gette hears the word "nymphea", he thinks of waterlilies but also of the loins of one or several women (French: nymphe/s) and of course of Claude Monet's waterlily paintings as well. Since these meaning intertwine in Gette's view, waterlilies appear in the horizon of women's laps and Monet's *nympheas* as sublimated obsession.

He finds allusions to the female sex wherever he looks. As in Linné's classification system, however, what fascinates him is the lack of intention behind the erotic connotation. "I like the coast, the edge of the forest, the bank of a lake and the places where a dress or a stocking stops", he once stated in an interview.[13] It is the hem of things that interests him, the edge at which something touches something else. Gette does not distinguish categorically between landscape and body. And that is why he discovers with his attentive, wandering gaze the same stimulating details in both landscapes and bodies that prompt him to flights of fancy based on sudden leaps of imagination.

Gette is interested primarily in plant names rather than plants themselves. His approach is communicated in literary form. Plants enter his field of vision only when they are named; they belong entirely to culture. Nature – growing, unpredictable, dangerous, overflowing nature – does not interest Gette. He admires the orderly structure of botanical gardens and French parks. His gardens of pleasure are geometric and precisely mapped out. Only on clearly defined ground does he find the freedom of ambiguity and vagueness; here, on this terrain, the proper names are the true actors (see pp. 58–59). "There are no botanical gardens without labels", he writes. "Labels, even more than the plants, which disappear over the winter, are the most important element – the absolute and permanent common denominator."[14]

Teresa Murak

While Paul-Armand Gette focuses upon natural symbols with arrangements of sophisticated artificiality, taking advantage of any and every slippery anthropomorphism to evoke the idea of innocence through the power of an imagination schooled in the exquisite, Teresa Murak works with rites of fertility, seeking direct contact with matter in the process of coming to life, and even makes her naked body available to these fundamental natural forces. She plays the part of the earth mother, demonstrating the process of plant growth as a cyclical event and submitting to nature's own concept of time. In a 1974 action, she lay in a bathtub, covered from head to toe with cress seeds (see pp. 94–95). She allowed the slimy, sprouting seeds to grow on her skin and later arose from the water resembling a hybrid

being reminiscent some of the figures depicted in paintings by the Belgian artist Paul Delvaux: half plant, half woman, her hair and skin barely distinguishable from the plant growth. That same spring, she sowed cress seeds on wet linen, let the thriving vegetation grow uncontrolled, pulled the fabric like a dress over her shoulders, let down her hair and strode through the streets of Warsaw like a wandering embodiment of Sandro Botticelli's goddess of spring.

Nonetheless, her allusion to the love goddess Venus is less important than the reference to Demeter, the goddess of fertility. Murak calls our attention to the maternal forces of nature. Her work is a continuous attempt to make what is no longer taken for granted – the cycle of the seasons and the corresponding patterns of plant growth – seem remarkable. "A miracle we have grown accustomed to remains the most wondrous thing there is"[15], she writes, emphasizing that she is not concerned with the perception of superficial stimuli or the distinct gazes of individual viewers of art but with making a statement to society. Murak does not make art that satisfies the eyes or seeks to stimulate pleasant thoughts. Her actions in memory of past rites consist of references to the "wonder of nature" that now finds itself in a precarious position, and this she accomplishes by demonstrating growth processes as actions involving her own body.

Although Murak prefers to work with cress for practical reasons, she is not interested in cress per se. The medicinal plant simply offers a useful means of illustrating the processes of sowing, sprouting and growth in the plant world. Cress stands for nature, Murak's body for a nourishing mother. The two elements merge to form the symbol of "Mother Nature" and demonstrate Murak's artistic intentions: to express the naturalness of nature in such a way that it affects her audience in a lasting way. The green dress Murak wore in the streets of Warsaw is an archaic image that evokes a lasting effect.

"My way of thinking about nature is based upon the understanding that thinking itself is a part of nature", Murak explained in 1989.[16] There is no gap between the two. Murak respects the natural and seeks to respond to it appropriately through symbolic action. "I base what I do on knowledge of my own substance and of the substance of things. The need to turn and face the world is an integral part of an impassioned consciousness." And the element of passion is indeed a prerequisite for an artist who insistently advocates "the natural aspect" of nature in the midst of an industrialized landscape with its methods of artificial insemination and cultivation and who performs her actions in the cities of Warsaw, Danzig, Stockholm, Cologne and Paris. She willingly accepts the anachronism, knowing that it is a fitting complement to the archaic aspect of her work, of which she wishes to remind us.

In 1985, she had a mustard seed sprout on a stone in an allusion to a parable of the mystic Gurdjieff about a prisoner held in a dungeon who finds a seed between the pages of a book and places it in a moist crack in the wall to sprout. Although the parable can be interpreted in a number of ways, and Paul-Armand Gette would probably have employed it to remind us of the fertility of the world of words, Murak does not read the story metaphorically with respect to the place of discovery but pragmati-

Teresa Murak: *Untitled*, 1974
Cress, fabric
Warsaw (PL)

Sandra Voets: *Forever Young*, 1993
Plants, latex, showcase
Galerie Format, Basle

cally, in terms of a real potential. "The seed can be to a prisoner like a source of fresh air to a suffocating person."[17]

Action and representation are a dynamic duo in her work. The meaning of art becomes evident in the meaning of the action. And that is why she appears as a performer in the art world, although her goal is ritual. The manner in which she sows the seeds herself and fosters their growth as "Mother Nature" leads some to suspect heathen roots. Murak often schedules her "actions" on high Catholic feast days, most notably Easter and Pentecost. In her home town of Kielczewice (Poland), she cultivated a seventy-meter-long cress carpet and rolled it out from the church entrance to the altar for mass on Easter Saturday. Her actions are quests for community and faith.

Sandra Voets
In 1993, Sandra Voets placed narcissus bulbs coated with a tight second skin of bright green rubber in a glass showcase under neon light. The roots absorbed a nutrient-bearing liquid that had been dyed green. Several of the bulbs burst their rubber skins, grew rapidly on the rich fertilizer concentrate and then abruptly died. Aside from the title *forever young*, only a video and photo documentation remain from this experimental set-up focused upon ecstasy which rapidly, silently and brutally produced an event like a laboratory test. Events cannot be conserved; as variables, however, they can be repeated.

In a 1995 work entitled *Dripping Flowers*, she exhibited a three-part arrangement of cut flowers. Two tailflowers and a woman's shoe were laid out on three satin-covered pillows. The stems were inserted in test tubes. Water dripped onto each of the flowers from a drip-cock funnel, wetting and discoloring the satin and falling with a loud splash into a metal basin. The water caused the fabric to form dark folds. The drumming sounds made by the water drops heightened the tension in the otherwise already highly-charged field of tension. By virtue of their resemblance to sexual features, the swollen lips of the cup-shaped woman's shoe, with genitals located on the upper surface, and the two stalks of the tail flowers that protruded like horns suggested a sexual meaning. The woman's shoe was not meant as a woman's shoe, nor were the tailflowers intended to represent tailflowers. The arrangement's striking allusions referred to an equally morbid and erotic moist climate in which even the flowers at the focus of attention were drained of their strength. They were hooked up to infusions like invalids in an intensive care unit. Viewers clearly recognized that nothing but technology was keeping the flowers alive.

Voets relies on an audience that regards flowers in purity and innocence as natural organisms but is also well aware that they are no more natural than they are erotic, that both are phenomena of the imagination. Because Voets makes an event of both the natural and the erotic as constructions, the distance which separates us from the natural part of nature becomes as obvious as the chasm between us and the erotic side of sexuality.

She stages scenes with flowers as industrial products and renders ideas about the beauty of plants as wonders of nature with detached objec-

Sandra Voets: *Dripping Flowers* (detail), 1995
Orchid, satin on strechers, watering system

tivity. Her flowers are isolated from nature. The bulbs are uprooted and grow under laboratory conditions. The plants stand for no natural substance. Whereas Teresa Murak dramatizes the experience of nature as ritualized memory, demonstrating growth and development as processes, the most significant constituent element of Voets' work is the artificial character of natural phenomena: an artificial paradise of technoide fantasies.

Nature is a grotesque quotation torn from its context; it has no natural substance, and the flowers in the showcase look like wounds both inflicted and suffered by technology. Yet Voets arranges her flowers in such a way that they can also be understood as metaphors for sexuality. That sexuality is not associated with promises of happiness, however, but with tidings of death. To gaze upon nature in horror is to entertain an intimation of mortality at the same time. What remains is a product of the aesthetic stimulus triggered by the event through a break in continuity outside the confines of a gallery room.

Both Voets and Murak stage repeatable processes that are subject to temporal restrictions. Murak emphasizes the driving forces of nature, Voets the technology of conservation (see pp. 127–129). Whereas Murak and Voets, despite their diametrically opposing messages, establish a direct connection between plants and the human body, Gette demonstrates his appreciation of the imaginative power of language, in which the contemplation of nature survives as idea.

From the German by John S. Southard

1 A. Le Blond, *Theorie et Pratique du Jardinage*, Paris 1709, p. 16; quoted from: Marie Luise Gothein, *Geschichte der Gartenkunst*, Vol. II, 3rd ed. Munich, 1994, p. 191.
2 Alexander Pope, in: *The Guardian*, September 1713, no. 173; quoted from: Marie Luise Gothein, *Geschichte der Gartenkunst*, Vol. II, 3rd ed. Munich, 1994, p. 369.
3 Hans von Trotha, *Der Englische Garten. Eine Reise durch seine Geschichte*, Berlin 1999, p. 12.
4 Gérard Lapalus, 'Heureux, comme Ulysse...', in: *Didier Trenet. Le jardin de ma mère – Études et Ruines*, exh. cat. Centre Georges Pompidou, Paris, 1997.
5 Daniel Birnbaum, 'A thousand words, Tobias Rehberger talks about his garden' *Artforum*, November 1998, p. 100.
6 'Tobias Rehberger – Garten als Skulptur oder Garten meets Schneekanone. Ein Gespräch von Brigitte Franzen', *Kunstforum International*, no. 145, May/June 1999, p. 119.
7 *Magazzino*, exh. cat. on occasion of Biennale di Venezia 1997, ed. Ministry for Culture Luxembourg, Luxembourg, 1997.
8 Gloria Friedmann, 'Hier + Jetzt', in: exh. cat. *Hier + Jetzt*, ed. Achim Könneke, Hamburg 1998, p. 4.
9 Ibid., p. 30.
10 Sabine Dylla, 'Gedanken zu einem Kunstwerk gegen den Krieg', in: exh. cat. *Jenny Holzer – Black Garden*, ed. Sabine Dylla, Städtische Galerie Nordhorn, 1994, p. 4.
11 Justin Hoffmann, 'Jenny Holzer – Black Garden', in: exh. cat. *Jenny Holzer – Black Garden*, ed. Sabine Dylla, Städtische Galerie Nordhorn, 1994, p. 70.
12 Ibid., p. 72.
13 'Paul-Armand Gette, 'Le Retour de L'Imaginaire', Interview of Catherine Francblin, *art press*, no. 174, November 1992.
14 Paul-Armand Gette, 'Von der Berührung des Modells zum Vulkanismus der Leidenschaft', in: Gerhard Fischer ed., *Dädalus – Die Erfindung der Gegenwart*, Vienna, 1990, pp. 389 ff.
15 Jaromir Jedlinski, 'Les semailles et la glane', exh. cat. *Teresa Murak*, Galerie Faust Rosa Turetsky, Genf, 1992.
16 Ibid.
17 Ibid.

TEXTS IN GERMAN/
TEXTE IN DEUTSCHER SPRACHE

NÄHE

.

Auf die Frage nach der eigenen Existenz gibt es im menschlichen Denken keine logische Antwort. Haben wir nicht immer in die Natur hineingesehen, um etwas über uns herauszubekommen? Mit lebenden Pflanzen zu arbeiten, hat etwas Intimes und zugleich Visionäres.

Lebende Vegetation als Bestandteil kultureller Werke begegnet uns in Gärten mit profanen, religiösen und mystischen Bedeutungen. Haben die in diesem Buch gezeigten künstlerischen Arbeiten, die bis auf wenige keine Gartenanlagen sind, mit den bisherigen traditionellen Zielsetzungen etwas zu tun? Die hier präsentierten zeitgenössischen Werke mit lebender Vegetation sind im Kontext Freie Kunst entstanden. Welche Qualitäten der Pflanzen werden eingesetzt? Welche Konnotationen und Metaphern werden damit verbunden? Welche neuen Fragen und Perspektiven werden eröffnet? Welche Positionen vertreten die Künstlerinnen und Künstler, die lebende Pflanzen in ihren Werken verwenden?

Sicherlich hat die gegenwärtige Phase des offenen Stilpluralismus den Einsatz von lebenden Pflanzen befördert. Weitere Beweggründe sind so unterschiedlich wie das, was heute in der Kunst thematisiert wird. Das Gemeinsame und gegenüber der Arbeit mit toter Materie grundlegend Andere der Arbeiten mit Pflanzen ist, daß dem Ego des Künstlers etwas Lebendes gegenüber steht. Werke mit Pflanzen sind sich entwickelnde, prozessuale Formen innerhalb zeitlicher Dimensionen. Sie werden in der Verlaufsform konzipiert und enthalten Lebensplanungen. Im Gegensatz zur Arbeit mit »toter Materie« zeigen Pflanzen durch die ständigen Anforderungen an die Erfüllung ihrer Lebensbedürfnisse Abhängigkeiten.

Mit lebenden Pflanzen zu arbeiten, gleicht einer Regiearbeit und ist ein interaktiver Kommunikationsprozeß. Reize und Reaktionen ketten sich aneinander. Der künstlerische Eingriff manipuliert an lebenden Vorgängen, die ihrerseits – als Feedback – wieder bestimmte Bedingungen an die Art der künstlerischen Arbeit stellen. Die Form ist die Handlung. Sie spiegelt sich im Lebensprozeß anderer Organismen. Künstler und Betrachter können sich selbst innerhalb einer lebenden Gesamtheit erfahren, und die Rollen vom Produzenten und Rezipienten verschieben sich hin zum Teilnehmer. Die »Vitale Realität« Pflanze mit ihren interaktiven Möglichkeiten bekommt heute als Feld der echten Naturerlebnisse angesichts der »Virtuellen Realität« eine neue Bedeutung. Dabei wird vielfach nicht von Natur in einem umfassenden Sinne ausgegangen, sondern von einer Natur, die in Ausschnitten interessiert.

Medium Vegetation

Von Vegetation geht eine ambivalente Exotik aus. Sie ist gleichzeitig fremd und vertraut. Sie existiert erdgeschichtlich schon lange. Sie ist außerdem ein Bestandteil unserer Vorstellung von Landschaft. Vegetation läßt die Landschaft weich und anschmiegsam erscheinen. Ihr Anblick evoziert spürbare Empfindungen auf der Haut. Vegetation ist der Pelz des Körpers Landschaft.

Pflanzen sind ein radikales Gegenüber. Der Wortsinn von radikal, radicalis: an die Wurzeln gehend, weist in eine Richtung, die für unsere Wahrnehmung von Pflanzen bedeutsam ist. Pflanzen sind meist eingewurzelt und fest mit der Erde verbunden. Im Unterschied zu Mensch und Tier bewegen sie sich kaum von Ort zu Ort. Ihre Bewegung ist eher ein Ausdehnen und Entfalten. Der Prozeß des Wachstums ist ein metamorphes Werden und Vergehen, meist langsam, jedoch kontinuierlich voranschreitend. Pflanzen verändern sich am Ort, im Biotop. Das läßt Vegetation, läßt Pflanzen trotz ihrer sich im fließenden Wandel befindlichen Gestalt verläßlich erscheinen. Pflanzen erscheinen still. Wenn wir ein Rascheln oder Rauschen hören, dann ist es ein vom Wind verursachtes Geräusch, das durch die Resonanz der Vegetation erklingt. Die Lautlosigkeit und die Bindung an den spezifischen Standort mögen dazu führen, daß Pflanzen eher passiv und deshalb dinghaft wahrgenommen werden. Das kommt der Möglichkeit entgegen, sie wie ein Material zu verwenden.

Pflanzen existieren standortbezogen. Sie besiedeln die zu ihnen passenden Gebiete, und die Eigenheiten der Orte werden durch sie weiter ausformuliert. Sie teilen mit, welche Verhältnisse dort herrschen und sind ein Indikator für die Lebensqualität. Pflanzen sind überhaupt: Lebenszeichen.

Die Ausstrahlung vielfältiger Sinnesreize ist eine vitale Charakteristik von Vegetation. Düfte, Gerüche, Farben, Formen, Strukturen überlagern und verbinden sich und sind herausfordernde Angebote an das Empfindungsvermögen. Als Medium im Kunstwerk verwendet, hat dies nachhaltige Bedeutungen. Die von der Arbeit ausgehenden Informationen gewinnen eine größere Dichte und Tiefe, da nicht nur das vom Menschen Erdachte und Hergestellte präsentiert, sondern auch das vom Menschen letztlich nicht Erklärbare, das Andere, Bestandteil des Werkes ist. In dieser lebenden Substanz ist mehr enthalten, als wir wissen. Die Fähigkeit sich zu äußern, gehört zu den fundamentalen Charakteristika des Lebens. Beispielsweise können Reaktionen in artspezifischen »Verhaltensweisen« sichtbar werden. Diese expressive Kompetenz wohnt auch den Arbeiten mit lebenden Pflanzen inne. Sie bedeutet für die künstlerische Arbeit, daß das Werk nicht nur von außen wahrgenommen werden kann. Die hinzukommende Dimension ist: Bestandteile des Kunstwerkes

besitzen die Fähigkeit, selbst etwas wahrzunehmen und darauf mit der Komplexität des lebenden Organismus differenziert zu reagieren. Dies teilt sich direkt oder indirekt auch dem Betrachter mit.

Durch das Einbeziehen von lebenden Organismen wird die Präsenz der Kunstwerke gesteigert. Das Bewußtsein um die Veränderlichkeit der ihnen innewohnenden Lebensprozesse erhöht die Möglichkeit, die formalen Zusammenhänge der künstlerischen Arbeiten nicht nur als statischen Reiz wahrzunehmen, sondern in einer umfassenden Weise zu erleben. Das Interesse an lebenden Vorgängen ist ein direkteres als an toten Materialien. Werke mit lebender Vegetation nutzen diese Möglichkeit, zu berühren, indem sie zusätzlich eine emotionale Nähe herausfordern können.

Pflanzen werden vor allem in positiven Zusammenhängen erlebt. Sie sind Nahrung, und darüber hinaus schmücken und erfreuen sie. Durch die friedliche Vielseitigkeit im Alltag und die breite öffentliche Akzeptanz, die sich in der Beliebtheit von Grünem zeigt, erscheint Vegetation in der Kunst als populäres Medium. Pflanzen sind ein »Material«, das im Kunstkontext irritiert. Die offensichtliche Attraktivität, die Schönheit der Natur, die unverdeckt zur Schau gestellt wird, ist ungewohnt in Werken des 20. Jahrhunderts. Mit dem Einsatz von Pflanzen werden in der zeitgenössischen Kunst auch lange vernachlässigte Fragen aus dem Spannungsfeld Natur und Schönheit von grundsätzlicher Bedeutung aufgeworfen und damit die Neubearbeitung eines Tabuthemas eröffnet. Dieser Inhalt bestimmt meine künstlerische Arbeit und führte mich dazu, mit Landschaft und Vegetation zu arbeiten.

In diesem Zusammenhang begann ich 1993 das Projekt *KünstlerGärten Weimar*, dessen Bestandteil auch dieses Buch ist. Ich bin an einer Arbeit interessiert, bei der nicht die Fertigstellung oder Ausführung eines Werkes das Ziel ist, sondern die in Lebensformen sichtbar wird. Die Arbeit an den *KünstlerGärten* ist das Experiment der Seinsweise als Erkenntnisprozeß. Der Titel *KünstlerGärten* ist als Arbeitsbegriff gewählt worden, der ein offenes Handlungsfeld bezeichnet. Meine künstlerische Arbeit sehe ich hier darin, Strukturen und Rahmenbedingungen zu initiieren, die die Grundlagen dafür bilden, Positionen zeitgenössischer Künstler, die lebende Vegetation in ihrem Werk einsetzen, zu präsentieren und ihre besonderen Qualitäten bewußt werden zu lassen. Das gesamte Vorhaben dauert noch an und ist, für einen Garten angemessen, in die Zukunft gedacht. Um die Thematik von mehreren Seiten anzugehen und mit verschiedenen Rezeptionsmöglichkeiten zu operieren, besteht das Projekt *KünstlerGärten* nicht nur aus den Werken mit Pflanzen in Weimarer Arealen, wo seit 1995 zwanzig Arbeiten realisiert wurden. Mehrere miteinander verbundene Arbeits- und Handlungsebenen als Foren des Austausches existieren parallel:

die Vortragsreihe für Künstler und Wissenschaftler, die projektbegleitende Zeitschrift *wachsen*, das Lehrprojekt im Studiengang Freie Kunst an der Bauhaus-Universität Weimar, die Grafikedition, die Führungen und schließlich das Archiv, »*trans* PLANT – Lebende Vegetation in der zeitgenössischen Kunst«, aus dem dieses Buch entstanden ist.

Im Laufe meiner Arbeit bin ich auf wesentlich mehr künstlerische Werke zu diesem Thema aufmerksam geworden, als in dieses Buch Eingang finden konnten. Oft waren es die Künstler selbst, die mir Hinweise auf entsprechende Arbeiten von anderen Künstlern gegeben haben. Außer den Künstlern, denen ich großen Dank ausspreche, haben mir viele andere bei meinen Recherchen geholfen. An dieser Stelle möchte ich mich sehr herzlich bei den Mitarbeitern meines Projektes und der Bauhaus-Universität Weimar für ihre Unterstützung bedanken. Außerdem gilt mein Dank den engagierten Studierenden, die künstlerische Erfahrungen unter diesem Vorzeichen sammeln. Der Themenkomplex lädt weiterhin zu Fragen, Überlegungen und zur experimentellen Praxis ein.

BODEN GEWINNEN: EIN RÜCKBLICK AUF DIE KUNST IN DER NATUR UND DIE NATUR ALS KUNST

»Das ›Pastorale‹, so scheint es, ist antiquiert.
Die Gärten der Geschichte werden durch Orte
der Zeit ersetzt.«[1]
Robert Smithson, 1968

Smithson hatte recht und unrecht zugleich. Lebende Vegetation war nie ein großes Thema in der Geschichte der modernen Kunst, sie hat jedoch inzwischen für viele Künstler eine zentrale Bedeutung. Landwirtschaft, Gartenbaukunst und Botanik besaßen für die Revolutionäre der Avantgarde keine Priorität, als es darum ging, eine radikale, neue, atomisierte Kunst mit urbanen, mechanischen oder abstrakten künstlichen Formen zu schmieden. Zu Beginn der Moderne verbündeten sich die Künstler eher mit der Kultur als mit der Natur: mit naturwissenschaftlichen, technologischen oder spirituellen Untersuchungen, mit perzeptorischen Entdeckungen hinsichtlich der Funktionsweise des Auges und mit psychologischen Einsichten in das Gehirn. Und während eines Großteils des 20. Jahrhunderts beschäftigten sich moderne Künstler auf die eine oder andere Weise mit utopischen Visionen, bei denen es um eine neue und bessere Gesellschaft und eine immer »reinere« Umwelt ging, die größtenteils unorganisch und ganz und gar menschlichen Ursprungs sein sollte. Sie standen völlig im Bann des Fortschrittsmythos.

Daher war es kaum ein Widerspruch, daß sich die frühen modernen Künstler zur gleichen Zeit, in der ihnen eine utopische Zukunft vorschwebte, in die angeblich primitive Vergangenheit versenkten. Einige von ihnen waren von den Formen und Energien der Stammes- oder Volkskunst fasziniert. Andere vertieften sich in verdrängte Phantasien, regressive Impulse und andere Zeugnisse für ungezähmte Quellen der Kreativität. Sie ließen sich von kindlichen, geisteskranken, kriminellen und unbewußten Geisteszuständen inspirieren. Sie beneideten die sogenannten »Primitiven« um ihre unmittelbare formale Kraft. Ihre Untersuchungen befaßten sich nicht nur mit Urformen und spirituellen Inhalten, sondern auch mit den Wurzeln der menschlichen Natur. Zugleich wurde das gesamte natürliche Reich der Bäume, Pflanzen, Gräser, Gemüse, Früchte, Pilze und Blumen weitgehend ignoriert. Die Natur war irrelevant geworden. Im Rückblick kann man durchaus von einer Art Hybris sprechen.

Und im Rückblick kann man sich auch fragen, warum die Natur zu Beginn des 20. Jahrhunderts mehr oder weniger aus der Kunstgeschichte und dem modernen Bewußtsein zu verschwinden schien. Natürlich gab es Ausnahmen. Aber niemand nahm zur Kenntnis, daß Monet in seinen späten Jahren mindestens so viel Energie und Sorgfalt auf die Pflege seines Gartens in Giverny verwendete wie auf seine riesigen Wasserlilienbilder.

Niemand interessierte sich dafür, daß Mondrians frühe Aquarelle von spinnenartigen Chrysanthemen, deren dünne Blütenblätter mit fast halluzinatorischer Präzision gemalt sind, und seine Zeichnungen von sich verzweigenden Bäumen, den Schlüssel zu den nachfolgenden Horizontalen und Vertikalen enthielt, die er so straff wie die zitternden Saiten eines Musikinstruments über die Oberflächen seiner Leinwände spannte. Jeglichen Bezug zur Natur auslöschend, entsagte Mondrian der Farbe Grün. Und als er und andere abstrakte Künstler und Surrealisten während des Zweiten Weltkriegs über den Atlantik nach Amerika fuhren, beschleunigte sich die reduktive Verlaufsbahn der Kunst, wozu auch der Kunstkritiker Clement Greenberg das Seine beitrug.

In den sechziger Jahren ließen die sterilen Bilder und banalen Objekte der Pop Art sowie die gerasterten Oberflächen und industriellen Materialien des Minimalismus wenig Raum für Gedanken an die Natur. Warhols Blumen waren von jeglichem Garten weit entfernt: ein bemalter Siebdruck einer Fotografie, die ein anderer gemacht hatte. Jackson Pollock übte einen maßgeblichen Einfluß auf die Kunst der sechziger Jahre aus, aber das, was der Abstrakte Expressionismus – oder das Action Painting, wie man diese Kunst auch bezeichnete – implizierte, führte in andere Richtungen, verkörpert durch Happenings und andere performative Gesten in der Zeit und im Raum der realen Welt. Niemand bemerkte, daß Pollocks »Aktionen«, bei denen er Farbe auf die am Boden liegende Leinwand träufelte und wirbelte, gleich einem altmodischen Bauer, der auf einem Acker Getreide sät, unwissentlich ein vorindustrielles europäisches Bild – die Figur des Sämanns – nachahmten. Pollocks Œuvre öffnete die Kunst für alle Arten von In- und Exkursionen in die reale Welt, aber es blieb unbemerkt, daß sein Malverfahren auch die Zufallsmetapher von Samen und Scholle enthielt. Niemand sah in diesem Malerei-Tanz das besondere archetypische Bild. Und obwohl Pollocks bespritzte Oberfläche ein unbestimmtes vereinheitlichtes Feld war, vermutete niemand, daß der Erdboden selbst für Künstler bald zu einem fruchtbaren Territorium werden würde.

Oder vielleicht doch? Der Boden sollte jedenfalls nicht lange brachliegen. 1965 machte sich Alan Sonfist daran, ein leeres Grundstück von der Länge eines Blocks mit einheimischen Samen zu bepflanzen, um im Herzen New Yorks einen vorkolonialen Wald zu rekonstruieren. Sonfist war seiner Zeit voraus. Andere Künstler, die bald in der Natur zu arbeiten begannen, dachten noch nicht an die belebte Natur. Michael Heizer konzipierte 1967 ein Earthwork und realisierte sein erstes im Jahr darauf. Als er 1969 damit begann, das kubische Loch zu graben, aus dem das berühmte *Double Negative* wurde, bei dem auf einem öden Landstrich fern der Kunstwelt 240 000 Tonnen Erde verlagert wurden, war dies ein minimalistischer Akt über-

triebener Reduktion, der nichts mit Kultivierung zu tun hatte. Als Walter de Maria 1968 in München die Galerie Heiner Friedrich mit einer fast ein Meter dicken Schicht aus fruchtbarer Erde auffüllte, hatte er nicht die Absicht, Unkraut anzupflanzen oder auch nur einen einzigen Grashalm keimen zu lassen. Der 1977 als Dauerinstallation rekonstruierte New Yorker *Earth Room*, der 140 Tonnen fruchtbarer Erde enthält, muß regelmäßig von Unkraut befreit werden. Und als Smithson 1970 im Great Salt Lake aus Erde und Steinen das Werk *Spiral Jetty* schuf, dachte er dabei an Entropie und Äonen und die Salzkristalle, die sich mit der Zeit bilden würden, aber nicht an so etwas prosaisch Organisches wie Bewässerung oder Ackerbau.

Doch immerhin, der Boden war in Bewegung geraten. Obwohl »Landschaft« noch immer ein Schimpfwort war, arbeiteten diese Künstler mit der Erde. Der entscheidende Wendepunkt war das Jahr 1968: Inmitten von Studentenunruhen, politischen Demonstrationen, Antikriegsprotesten und der Aufdeckung von Umweltskandalen begann das Fortschrittsideal in sich zusammenzubrechen. Zusätzlich zu einer weitverbreiteten Desillusionierung kamen plötzlich die giftigen Nebenwirkungen des Modernismus zum Vorschein. Und so kollabierte der Modernismus im Kontext sozialer Unruhen, Zurück-zur-Natur-Bewegungen, Hippiekommunen der Gegenkultur, die sich aufs Land zurückzogen, »Blumenkindern«, die in den Städten »ausstiegen«, und Astronauten auf ihrem Weg zum sauerstofflosen Mond. Es war weder möglich, weiterhin an utopische Mythen zu glauben, noch konnte man an einem ungebrochenen Glauben an die Zukunft festhalten. Mit einem Mal war die Zukunft da, im Guten wie im Schlechten, und das Thema lautete nicht mehr Fortschritt, sondern Überleben. Allen Ginsberg, der Dichter der Beat Generation, war nicht der einzige, der »die Rückkehr zur Natur und den Aufstand gegen die Maschine« begrüßte.

Während einige amerikanische Künstler sich aus den Galerieräumen an schwer zugängliche Orte zurückzogen und zur Natur zurückkehrten, indem sie entlegenen kargen und erhabenen Landstrichen (Wüsten, Salzebenen oder anderen trockenen Böden) nicht minder strenge und grandiose Earthworks aufdrängten, befaßten sich andere mit ähnlichen Entwicklungen in Ausstellungsräumen. Zwischen 1967 und 1969 machten Richard Serra, Carl Andre, Barry Le Va, Robert Morris und viele andere Künstler da weiter, wo Pollock aufgehört hatte, und wendeten ihre Aufmerksamkeit dem Boden zu; dabei benutzten sie Mehl, Filz und andere Materialien, die sich verspritzen, verstreuen oder flach hinlegen ließen. Von einem Jahr auf das andere schwenkte die Sensibilität von Starrheit auf Biegsamkeit um, von kubischen Formen auf die Formlosigkeit des Zufalls, von Objekten, die konstruiert oder fabriziert wurden, auf Substanzen, die sich auf dem Erdboden aufhäuften. Zur gleichen Zeit begann sich in jenen reduktiven Tagen – trotz einer Kargheit

der Kunst, die nichts mit der Pflege der Natur zu tun hatte – in ästhetischen Diskussionen auch die Begrifflichkeit zu wandeln. Metaphorische Anspielungen auf organische Modelle botanischer Evolution tauchten auf. Indirekt wurde die Vegetation in den Diskurs eingeführt.

So konstatierte beispielsweise der Konzeptkünstler Mel Bochner 1966 in seinem Artikel »Primary Structures«, daß »die gesamte Sprache der Botanik in der Kunst jetzt als suspekt gelten«[2] könne. In einem Essay mit dem Titel »Is There Life on Earth?« vertrat der englische, in Amerika lebende Künstler Peter Hutchinson noch im selben Jahr die gegenteilige Position. Im Hinblick auf Werke der Minimal Art erklärte er, »sie haben nichts Menschliches an sich … Die Werke sind dem Leben gegenüber so unorganisch und fremd, wie man es sich nur vorstellen kann.«[3]

Erst im Rückblick wird deutlich, daß in der Kunst genau wie in der Landwirtschaft das Umgraben von Erde nur ein Vorspiel für das Anpflanzen war. Aus dem selben Jahr, in dem Smithson *Spiral Jetty* schuf, stammt auch eine einfache Bleistiftskizze von ihm für ein Projekt: *Floating Island to Travel Around Manhattan Island* (Abb. S. 12). Die Insel, die er mit dieser Zeichnung entwarf, war künstlich: ein flacher rechteckiger Schleppkahn, der von einem Dampfer gezogen wurde. Doch in seiner Skizze war die Barke mit einer Lage Muttererde bedeckt, auf der sich ein gewundener Pfad gabelte und eine Trauerweide und andere für die New Yorker Region typische Bäume wuchsen. Nur zwei Jahre zuvor hatte er noch rhetorisch gefragt: »Könnte man sagen, daß die Kunst degeneriert, wenn sie sich dem Gartenbau annähert?«[4] Gordon Matta-Clark, dessen Werk damals noch in den Kinderschuhen steckte, entwickelte Smithsons Idee einer schwimmenden Insel in einer Gruppe damit zusammenhängender Zeichnungen weiter; sie tragen Titel wie *Parked Island Barges on the Hudson* oder *Islands Parked on the Hudson* (Abb. S. 12) und zeigen mehrere Kähne, die denen von Smithson ähneln und durch gewölbte Fußstege miteinander verbunden sind. Im folgenden Jahr schuf Matta-Clark, der damals noch nicht mit der Dekonstruktion architektonischer Strukturen begonnen hatte, eine Reihe von Zeichnungen phantastischer »baumartiger Formen« (Abb. S. 91) und machte eine Baumhaus-Performance.

In der Zwischenzeit wuchsen in New York City die winzigen Sprößlinge von Alan Sonfists vorkolonialem Wald, seine *Time Landscape™* (Abb. S. 11, 118), langsam, aber sicher heran: auf einem 45 mal 200 Fuß großen Terrain, das sich von der Ecke der Houston Street (am Rande des Terrains, das 1965 noch nicht der als Soho bekannte Kunstbezirk war) entlang dem LaGuardia Place bis zur Ecke der Bleecker Street erstreckt. Indem er ein unbebautes Stadtgrundstück in seinen ursprünglichen bewaldeten Zustand zurückversetzte, durch Anzucht ein-

heimischer Samen und der lokalen Vegetation des 17. Jahrhunderts – Eiche, Hickory, Wacholder, Zederzypressen Sassafras und andere – bezog sich Sonfist direkt auf die Naturgeschichte des Ortes. *Time Landscape™* wächst und gedeiht bis heute, und Sonfist, der sich selbst als »visuellen Archäologen« bezeichnet, arbeitet auch weiterhin mit der Natur und der Zeit, indem er die Naturgeschichte seiner Orte sichtbar macht. Bei zwei Bronzewürfeln, die er 1991 auf dem Gelände des Florida Museum aufstellte, handelt es sich um täuschend minimalistisch wirkende Zeitkapseln, in denen eingekapselte Wälder stecken. Im Inneren der beiden verbergen sich in dieser Region vorkommende Samen, die ausreichen, um einen archaischen Wald hervorzubringen, wenn das Metall in einigen hundert Jahren zerfallen sein wird. »Die Natur«, so Sonfist, »ist keine sanfte Kraft.«[5] Neben der Rekonstruktion geht es in seinen Werken auch um die Rückentwicklung verlorengegangener Ökosysteme und historischer Schichten: an urbanen Orten erwecken sie in Vergessenheit geratene Aspekte der bukolischen Vergangenheit zu neuem Leben.

Sonfist war nicht der einzige Künstler, der mit der Erde als einem generativen Kraftfeld arbeitete, in das gesät werden konnte. 1968 schuf Agnes Denes, die einen ähnlichen Ansatz verfolgte, ihre erste ausgereifte Arbeit *Rice/Tree/Burial*, die auch das Aussäen und Ernten von Reis beinhaltete (und die sie in den späten siebziger Jahren im Artpark in der Nähe der Niagarafälle wiederholte). Freilich setzte sich Denes nicht buchstäblich mit dem Anpflanzen und Wiederherstellen auseinander, sondern arbeitete mit ökonomischen Symbolen, geografischen Unterschieden und der poetischen Verschiebung im Raum: Sie pflanzte nicht nur asiatische Pflanzen im Nordosten der USA an, sondern vergrub auch Haikus in der Erde.

1969 pflügte Dennis Oppenheim, der von einer »Verschiebung vom Objekt zum Raum«[6] sprach und kurze Zeit mit der Umwelt und dem Erdboden arbeitete, ein 255 Meter langes X in ein niederländisches Kornfeld. Sein ebenso innovatives wie zweideutiges Earthwork, das den Titel *Directed Seeding – Cancelled Crop* trug, setzte nicht nur die minimalistische Reduktion mit der Vernichtung der Umwelt gleich, sondern präsentierte Kultivierung als eine Möglichkeit. Während Heizer in die Erdoberfläche hineinschnitt, De Maria der Erde kubische Gestalt verlieh und Smithson die Erdoberfläche mit Felssteinen skulptural bearbeitete, ähnelten Oppenheims höchst eigenwillige Earthworks in ihrer Zeitlichkeit und Zeitweiligkeit eher riesigen Zeichnungen. Indem er die Kornernte mit einem gewaltigen X auskreuzte, erkannte er zugleich die Fruchtbarkeit der Erde an, indem er sich die Landwirtschaft zunutze machte.

Auch Peter Hutchinson begann in den späten sechziger Jahren mit Pflanzen und biologischen Kreisläufen zu arbeiten und tut dies noch heute. 1969 unternahm er mit Oppenheim eine Reise zu den Westindischen Inseln und realisierte dort mit ihm zusammen Unterwasserarbeiten, bei denen mit Geschimmeltem gefüllte Tüten an einem Seil befestigt und ins Meer hinabgelassen wurden. In der Folge schuf Hutchinson weitere Unterwasserarbeiten mit Orangen, Kalebassen oder Rosen, die ebenfalls an einem Seil befestigt waren; später begann er in seinem Garten in Massachusetts und anderenorts Kunstwerke anzupflanzen. Bei seinen fortlaufenden Pflanzungen mit dem Titel *Thrown Ropes* (Abb. S. 78) hat er Eiben, Krokusse, kleines Immergrün und andere Pflanzen in unregelmäßig gewellten, vom Zufall bestimmten Reihen angepflanzt: Ein mit Gewichten beschwertes Seil, das vom Künstler ausgeworfen wird, bestimmt die Anordnung der Pflanzen. Ob es sich um Duchamps Arbeit *Trois Stoppages-Étalon*, John Cages Lehren oder eine traditionelle englische Gartenbaumethode handelt, bei der Zwiebeln geworfen und dort gepflanzt wurden, wo sie landeten – Hutchinsons Verfahren erlaubt es dem Zufall, die Form zu bestimmen; das Ergebnis ist eine Arbeit, die mit der Natur verschmilzt.

Die Rückkehr der Kunst zur Natur in den sechziger Jahren begann, zumindest in den USA, mit zwei gegensätzlichen Strategien. Auf der einen Seite standen Künstler, die mit der bekannten Hybris der Moderne gewaltige Gerätschaften zur Landerschließung sowie Lastwagen benutzten. Und auf der anderen gab es, wie Sonfist einmal anmerkte, »Künstler, die die relativ neue Idee der Zusammenarbeit mit der Umwelt verfolgen, die sie wegen deren drohender Zerstörung als notwendig ansehen«.[7] Während einige amerikanische Künstler die Arbeitsweise von Bauarbeitern bevorzugten und schwere Maschinen benutzten, um Earthworks zu schaffen, wandten sich andere umweltbezogenen Werken zu, zu denen Acker- und Gartenbau zählten. Ihre Kollegen in England wählten eine leichtere Art des Umgangs mit der Natur. Während amerikanische Earthworks hart, sachlich und pragmatisch waren, vermittelte die sich parallel dazu entwickelnde englische Land Art romantischere Vorstellungen von der Erde. Das mag mit den tief verwurzelten Unterschieden zwischen den Vereinigten Staaten – einer ehemaligen Kolonie mit dem Pioniermythos der Grenzeroberung und Landbezwingung – und Großbritannien – einem ehemaligen Weltreich, das neben seinen unerschrockenen Forschungsreisenden und Eroberungen alter Kulturen auch ein Erbe von Gärten und natürlichen Wegen kultivierte – zu tun haben. Vielleicht lag es aber auch an einem anderen Diskurs innerhalb der Entwicklung der zeitgenössischen britischen Kunst.

Auf jeden Fall war das Empfinden ein anderes. Um dieselbe Zeit, als Künstler in den Vereinigten Staaten anfingen, Earthworks zu realisieren, schufen Künstler in England wie etwa Richard Long und Hamish Fulton, Land Art. Doch die britischen Künstler neigten weniger zu Visionen ultimativer Grenzen als zu

solchen eines verlorengegangenen Paradieses. Natur an sich war nicht fremd, sondern erhaben oder malerisch. Longs erste Land-Art-Arbeit, *A Line Made by Walking*, stammt aus dem Jahr 1967. Die »Linie« war einfach nur die bloße Spur der Präsenz des Künstlers auf der Oberfläche der Erde – die Verlaufsbahn seines Wegs, die als eine Linie niedergetretenen, abgeflachten Grases sichtbar war: »Ich war für eine Kunst auf gewöhnlichem Land, mit einfachen Mitteln, im menschlichen Maßstab. Es war die Antithese zur sogenannten amerikanischen ›Land Art‹«, sagte Long später. »Ich bin lieber ein Behüter der Natur, als ihr Ausbeuter.«[8]

Während amerikanische Künstler in die Erde hineinschnitten, das Gelände plastisch formten oder Getreidefelder anpflanzten, benutzten britische Künstler das Land eher wie eine ausradierbare Oberfläche für eine einsame Performance: Für Long wie für Fulton ist der Akt des Laufens und die passive Wahrnehmung der Natur von zentraler Bedeutung. Long arbeitet mit Steinen, Schlamm und Erde in einer Weise, daß sie seine einsamen Spaziergänge dokumentieren. »Mir gefällt die Idee, Land zu benutzen, ohne es zu besitzen«,[9] erklärte er 1982. Fulton faßt seine Marathonwanderungen durch entlegene Teile des Planeten in einer einzigen tiefgründigen Fotografie und einigen wenigen Zeilen einer prägnanten poetischen Beschreibung zusammen.

Ian Hamilton Finlays Werk ist stationärer und ortsgebundener und setzt sich auf spezifischere Weise mit Geschichte und Tradition auseinander. 1967 begann er in Form eines arkadischen Gartens *Little Sparta* in der Nähe von Edinburgh mit einer bis heute fortgesetzten Meditation über die Französische Revolution und totalitäre Macht. Im Rückgriff auf die Tradition des unregelmäßigen englischen Gartens und der viktorianischen »folly« sowie der Verbindung zwischen autoritärer Struktur und neoklassizistischer Form, hat er die Landschaftsgestaltung in ein Vehikel für historisch und politisch aufgeladene Erinnerung verwandelt. Neben vegetabilen Anpflanzungen implantierte er steinerne Mahnmale und kryptische Inschriften auf Tafeln neben einer Grotte, einer Hütte und einem Tempel (Abb. S. 48–49, 142). »Ein Garten ist kein Objekt, sondern ein Prozeß«, hat Finlay gesagt. Durchsetzt mit klassischen, militärischen und ideologischen Anspielungen, verweist *Little Sparta* auf historische Zeit, institutionelle Macht, revolutionären Eifer und Grausamkeit, aber auch auf den laufenden Entwicklungsprozeß.

»Die abgründige Problematik von Gärten impliziert manchmal den Sturz von irgendwo oder von irgend etwas. Die Gewißheit des vollkommenen Gartens wird sich nie wiedererlangen lassen«,[10] schrieb Smithson 1968. Doch in den frühen siebziger Jahren, als Überlebensfragen im Vordergrund des Interesses standen, war die Natur für viele Künstler zu einem entscheidenden Thema geworden. Der Traum eines von Menschen geschaf-

fenen Utopia wurde von der Nostalgie nach dem Garten Eden sowie in manchen Fällen von gesellschaftlichen oder umweltbezogenen Intentionen abgelöst (und verschmolz mitunter mit diesen). Der Gartenbau konnte ein Prozeß, ein gesellschaftliches Modell, eine Kritik oder eine Metapher sein. Der Sinneswandel, der Künstler dazu bewog, mit lebenden Pflanzen zu arbeiten, war nicht auf einzelne Orte beschränkt. Giuseppe Penone, der 1969 in Italien mit lebenden Setzlingen und natürlichen Wachstumsprozessen zu arbeiten begonnen hatte, anthropomorphisierte Pflanzen, als er einen Holzbalken schälte, um daraus einen Baum zu befreien. Und Marcel Broodthaers' Topfpflanzen waren ein Statement über die sterile Museumskultur und die Abwesenheit von Natur.

In den frühen siebziger Jahren, kurz bevor Beuys sein Konzept des gemeinschaftlichen Anpflanzens von 7000 Eichen als soziale Plastik entwickelte, begannen Helen und Newton Harrison im Westen der USA ihre ökologische Arbeit mit einem *Portable Orchard* (Abb. S. 14) und einer autarken Fischfarm, die als geschlossenes Ökosystem funktionierten. Ihre Arbeit wie auch die von Beuys beruhten eher auf ökologischen und gesellschaftlichen Fragestellungen als auf gärtnerischen. Ihre visionären und poetischen Projekte sind mit gesellschaftlichen Reformbemühungen und ökologischen Anliegen verbunden, in denen es um spezifische Fälle der Rückgewinnung von Wasser, Land und urbanen Räumen geht. Sie präsentieren utopische, doch zugleich pragmatische Lösungen zur Rettung bedrohter Ökosysteme – Wiesen und Flüsse, verstopfte Städte, verseuchte Standorte. Ihr Konzept wirft politische Fragen dazu auf, »... wer das Land beherrschen würde/und warum und wie./Sie (die Landkarte) als Metapher sehen/für einen weiteren Kampf/darum wer die Zukunft/dieses konkreten Terrains gestalten wird.«[11]

1975 entwarf und baute Charles Simonds, der in den frühen Siebzigern für seine anthropologische Kunst mit Miniaturen von Backsteinbehausungen und -ruinen bekannt wurde, einen großformatigen Komplex, in dem auch die Vegetation eine Rolle spielte. Während seine kleinen Siedlungen auf städtischen Fenstersimsen, aus Spalten und Treppenschächten hervorlugten und narrative Anspielungen auf eine imaginäre, mittlerweile verschwundene Zivilisation kleiner Menschen enthielten, war das große *Growth House* (Abb. S. 15) eine festungsartige Innenraumkonstruktion in Originalgröße, die nicht an archäologische Relikte appellierte, sondern an Wachstum und ein zukünftiges Heim. Seine dicken Wände bestanden aus übereinandergestapelten Säcken mit fruchtbarer Erde, aus der ungebändigte Vegetation hervorsproß.

Abgesehen von der Tatsache, daß Agnes Denes 1982 in New York City – auf dem Battery Park Landfill unweit der Wall Street und des World Trade Center, auf dem Luxussiedlungen errichtet

werden sollten – ein zwei Morgen großes Weizenfeld anlegte (Abb. S. 43), war das in der Kunst der achtziger Jahre vorherrschende Verständnis nicht dazu geeignet, lebende Pflanzen zu verwenden. Denes erntete fast 1000 Pfund Weizen und sagte, sie habe die Aufmerksamkeit auf »falsch gesetzte Prioritäten« lenken wollen, doch Getreide war in der New Yorker Kunstwelt in jener Zeit kein Thema und die Anliegen des Umweltschutzes ebensowenig.

Aber auch wenn der Vegetation in den frühen Achtzigern, als die grobschlächtige neoexpressionistische Gegenständlichkeit im Rampenlicht stand, oder in den späten Achtzigern, als sterile Objekte das Zentrum des Interesses bildeten, weder als Material noch als Metapher große Aufmerksamkeit geschenkt wurde, entwarfen etablierte Künstler wie Vito Acconci und Dan Graham Strukturen im Außenraum und öffentliche Projekte, zu denen auch lebende Pflanzen zählten. Für Acconci sind Pflanzen Teil seiner auf komplexe Weise desorientierenden psychologischen Kompositionen, die den menschlichen Körper mit einbeziehen und psychische Verschiebungen zum Ausdruck bringen (Abb. S. 22–23). Die meisten seiner Projekte mit Pflanzen und Menschen, Gartenmöbeln und Landschaftsparks sind nicht realisiert worden. In Grahams Arbeiten sind Bäume und Hecken Spiegelelemente, die sich auf die illusionären Eigenschaften und mehrdeutigen Wahrnehmungen seiner halbtransparenten Pavillons beziehen, die die Landschaft absorbieren und reflektieren (Abb. S. 60–61).

Im Rückblick könnte man feststellen, daß in den Achtzigern und Neunzigern die Verwendung lebender Pflanzen in der Kunst von ökologischen Fragen oder Ideen eines verlorenen Paradieses weit entfernt war und statt dessen zweideutige, problematische, ja selbst bedrohliche soziale und antisoziale Konnotationen beinhaltete: In Acconcis Arbeiten tragen Pflanzen zu einem Gefühl physischer und psychologischer Desorientierung bei. Für Graham implizieren sie Verschiebungen der Wahrnehmung. Andere Künstler wie Jenny Holzer, Damien Hirst, Robert Irwin, Jennifer Bartlett oder (bereits 1961) Ed Kienholz, deren Werk man normalerweise nicht mit den Themen Natur und (Pflanzen-)Kultur in Zusammenhang bringt, haben mitunter ebenfalls Vegetation in ihren Arbeiten benutzt. In Nordhorn (Niedersachsen) verwendete Holzer schwarz und weiß blühende Pflanzen als Trauerelemente in einem Kriegerdenkmal (Abb. S. 76–77). In Seattle sperrte Irwin neun Bäume in ein kubisches Rahmengefüge (Abb. S. 80–81). Hirst umgab einen verglasten Gang mit monochromen Gemälden, lebenden Pflanzen und Schmetterlingen und nannte die Arbeit – vielleicht in Anspielung auf Marcel Broodthaers museologische Farne – *A Good Environment for Colored Monochrome Paintings* (Abb. S. 17). Und Bartletts Vorschlag für einen öffentlichen Park in Lower Manhattan wurde abgelehnt, weil die hohen, in verschiedene Abschnitte unterteilten Hecken der Kriminalität Vorschub geleistet hätten.

Seit den Tagen des biblischen Eden ruft die Idee des Gartens nicht nur die Assoziation ursprünglicher Unschuld hervor, sondern auch die von verbotenem Wissen und Korruption. Und für viele zeitgenössische Künstler hat die Verwendung lebender Pflanzen ebensoviel mit modernen Übeln zu tun – psychischen und politischen Funktionsstörungen, Gefährdung und Auslöschung biologischer Arten, genetischer Manipulation oder den toxischen Spätfolgen der Industrialisierung – wie mit verlorener Unschuld. Man könnte fast sagen, daß sich Künstler, die heute mit Pflanzen arbeiten, implizit mit einer unbenannten postmodernen Metapher auseinandersetzen: dem verdorbenen Garten.

1989 konzipierte Mel Chin, dessen metaphorische Arbeiten zahlreiche soziale und umweltbezogene Themen umfassen, mit *Revival Field* einen formstrengen Garten für eine Giftmülldeponie, der der Idee des verdorbenen Gartens im wörtlichen Sinne entspricht (Abb. S. 40–41). In Zusammenarbeit mit dem Agronom Dr. Rufus L. Chaney vom USDA (United States Department of Agriculture) und seinem Labor verwendete er eine neu entdeckte, als Hyperakkumulator bekannte blühende Pflanzensorte, die mit Hilfe von Schwermetallen gedeiht, die sie aus der Erde absorbiert. Es entstand ein elegantes ökologisches Kunstwerk, das inzwischen drei verseuchte Standorte in den Vereinigten Staaten erfolgreich von den Giften gereinigt hat. Die Pflanzen, die in Chins täuschend traditionell wirkendem Garten in symmetrischen Beeten und geometrischen Rändern angeordnet sind, produzieren aus Kadmium, Blei und anderen giftigen Schwermetallen eine recycelbare Ernte. Der chinesisch-amerikanische Künstler, der gerade dabei ist, eine vierte Version des *Revival Field* vorzustellen, die einen Ort in Deutschland von Thallium reinigen soll, erklärt: »Es ist ein Versuch, die Ökologie plastisch zu formen, die Schwermetalle zu entfernen oder wegzumeißeln. Als Kunst ist es eine konzeptuelle Skulptur. Als Wissenschaft ist es ein Feldtest.«[12]

Für Mark Dion, dessen *Tropical Rainforest Preserves* (1989) in einem improvisierten Container auf Rädern gedieh und dessen halb fiktive erzählerische Projekte sich der Arbeitsweise der Naturwissenschaften bedienen (zusammen mit botanischen, zoologischen oder archäologischen Proben von seinen Expeditionen und Ausgrabungen), ist der Garten biogenetisch verdorben (Abb. S. 17). Der *Tasting Garden*, den er 1996 auf dem Harewood Estate in England gestaltete, ist nicht nur ein wirklicher Garten, sondern ein komplexes metaphorisches Denkmal für die dahinschwindende biologische Vielfalt unseres Planeten und eine Kritik an der landwirtschaftlichen Monokultur. *Tasting Garden* spielt auf mehreren Ebenen auf die phylogenetische Evolution und Degeneration an. Der Grundriß, der aus einem Netz von Pfaden besteht, die von einem zentralen Baumstamm

abzweigen, ist der symbolische evolutionäre Baum. Jeder Pfad endet in einem Gedenkstein, auf den der Name eines nördlichen Obstbaumes eingraviert ist (Apfel, Pfirsich, Kirsche, Pflaume, Quitte) und einem Denkmal, auf dem sich ein monumentales bronzenes Exemplar der Frucht dieses Baumes befindet. Ein Text beschreibt ihren Geschmack, und ein einzelnes Exemplar dieses Obstbaums steht Wache: ein lebender Setzling, ein erwachsener Baum oder ein verwitterter Bronzestamm, je nachdem, ob die Spezies selten, gefährdet oder ausgestorben ist. Zu *Tasting Garden* zählt auch *The Arborculturist's Work Shed*, eine Installation, die einen echten Gartenschuppen simuliert und Gartenwerkzeuge, Zeichnungen, Fotografien und eine Dokumentation zu Ehren der Gärtner des Anwesens enthält.

Die Samen, die Pollock – dessen Gesten unbewußt die wirbelnden Ackerlandbilder seines Lehrers Thomas Hart Benton wiedergeben – vor einem halben Jahrhundert säte, tragen eigenartige Früchte. In den letzten Jahren hat sich die Anzahl der Künstler, die mit lebender Vegetation arbeiten, deutlich vervielfacht. Da die Lücken zwischen Kunst und Leben weiterhin von Künstlern gekittet werden, die bis an die äußerste Grenze vorstoßen, sind lebende Pflanzen zu einem akzeptierten Medium für die Kunst geworden. Es gibt inzwischen genauso viele Verwendungsweisen für lebende Vegetation, wie es Künstler gibt, die mit lebenden Pflanzen arbeiten, und ebenso viele Gründe dafür, Kunst zu schaffen, die Wurzeln, Stämme, Blüten, Blätter oder Zweige hat. Die Themen von heute mögen teilweise ökologisch, sozial oder historisch sein, doch zugleich haben sie etwas mit den neuen Irritationen und Schrecknissen im Hinblick auf Themen wie Genetik, Identität und Künstlichkeit zu tun. In der ganzen Welt schaffen Künstler, darunter Meg Webster, Henrik Håkansson, Olaf Nicolai, Michel Blazy, Didier Trenet und Tobias Rehberger, Arbeiten im Innen- und im Außenraum, Skulpturen und Installationen, bei denen sie Landwirtschaft, Gartenbaukunst, Hecken, Gräben, Bonsai und Blumenbeete so einsetzen, daß das Manipulierte, Unnatürliche und Unwirkliche betont wird.

Einige wie Laura Stein, deren Kakteenmutationen und anthropomorphe Gemüse unübersehbare Hinweise auf radioaktiv ausgelöste Veränderungen im Erbgut und genetische Manipulation enthalten, arbeiten mit gärtnerischen Techniken des Pfropfens, der Aufzucht an Spalieren oder des Kreuzens frankensteinhafter Gartenerzeugnisse (Abb. S. 122–124, Cover). Ihre Werke kommentieren indirekt die Themen Erschaffung, Verantwortung und das gesamte modernistische, auf die Verbesserung der Natur abzielende Experiment. Andere, wie Paula Hayes, die ganz gewöhnliche Garteninstallationen an ungewöhnlichen Orten anpflanzt – in Galerien, auf Feuerleitern oder Dächern – verfolgen das entgegengesetzte Extrem reiner Profanität. Indem sie die Grenzen zwischen ihrem Beruf der Landschaftsgärtnerin und

-designerin und ihrer Berufung als Künstlerin verwischt, verwandelt Hayes die Tätigkeit des Gärtnerns mit Hilfe von Dokumentation, Kooperation und schriftlichen Verträgen mit den Sammlern, die die Arbeiten bei ihr in Auftrag geben, in einen Akt der konzeptuellen Kunst. »Ich biete mich als Person zur wechselseitigen Beeinflussung zwischen den Arten an«, erklärt sie undurchsichtig in einer geschäftsmäßig aussehenden Broschüre, die zugleich als Künstlerkatalog fungiert (Abb. S. 18, 70–71).[13]

Samm Kunce, deren Arbeit mit Vegetation von praktischer Anwendbarkeit geprägt ist, präsentiert sich selbst als jemand, die natürliches Pflanzenwachstum bei fehlenden natürlichen Bedingungen möglich macht. Ihre Environments mit Hydrokulturen, die in Innenräumen, in denen es keine Sonne und keinen Erdboden gab, Erdbeeren, Kopfsalat, Gräser oder Moos hervorgebracht haben, beruhen auf extrem künstlichen (und höchst anschaulichen) lebenserhaltenden Konstruktionen aus Pumpen, Schläuchen, Nährlösungen und megawattstarken Pflanzenleuchten (Abb. S. 19, 88–89). Kunces Installationen, in denen es um Themen wie Kontrolle und Ernährung geht, werfen sowohl Fragen über die Macht als auch über die sich auflösenden Grenzen zwischen Natürlichem und Künstlichem auf.

Selbst der italienische Künstler Maurizio Cattelan, dessen in der Regel heimliche Interventionen dazu tendieren, Systeme zu testen, die die Ausstellungen unterstützen, und Fragen nach Ort und Macht zu stellen (einmal verfrachtete er die Ausstellung eines anderen Künstlers von einer Galerie in Amsterdam in die De Appel Foundation und installierte sie dort neu), hat lebende Vegetation auf eindrucksvolle Weise eingesetzt (Abb. S. 39). Im Sommer 1998 fuhr er mit dem Lastwagen einen einzigen, in einem gewaltigen Erdkubus verwurzelten Olivenbaum von Italien nach Luxemburg und stellte ihn dort in einen großen Ausstellungssaal auf der Manifesta 2, der europäischen Biennale, wo er fast die Decke berührte – ein aufragendes, zu Kunst transponiertes natürliches Objekt. Während Cattelan einen Baum aus einem Olivenhain herausschneidet und ihn als Kunst installiert, geht der französische Künstler Fabrice Hybert, dessen vielgestaltiges Werk auf die Farbe Grün Anspruch erhebt, umgekehrt vor. Er schmuggelt seine Kunst auf unverfrorene Weise in die Wirtschafts-, Kommunikations- und Versorgungssysteme der realen Welt. Vor kurzem hat er ein Tal in der Nähe von La Rochelle erworben und legt dort einen Wald mit Bäumen aus der ganzen Welt an. Außerdem arbeitet er an einem öffentlichen, bereits vor mehreren Jahren konzipierten Projekt, das ab dem Jahr 2000 in Cahors realisiert werden wird. Die Stadt Cahors hat ihre Zustimmung dazu gegeben, von diesem Zeitpunkt an dauerhaft jeden städtischen Baum, der abstirbt, durch einen Baum zu ersetzen, der eßbare Früchte hervorbringt (Abb. S. 79). Im Einklang mit Hyberts umfassendem multimedialen Ansatz wird das Projekt mit einer Eigenwerbung begin-

nen, einem einminütigen Werbespot, der überall in Frankreich in Kinos vor dem Hauptfilm gezeigt werden soll.

Zufällig oder absichtlich schleichen sich politisch relevante Themen in die Künstlergärten ein. Als die verstorbene Kate Erikson und Mel Ziegler, bekannt für ihre ortsspezifischen Kooperationen, die auf die Sozialgeschichte der jeweiligen Orte eingehen, in Warschau 1992 einen Gemüsegarten auf einen Tieflader pflanzten, zogen sie damit in einer Arbeit, die zugleich Fragen zur interkulturellen Gesellschaftskritik aufwarf, eine Parallele zu den ersten Gehversuchen des privaten Unternehmertums im nachkommunistischen Polen. Damit die aufgereihten Pfefferfrüchte, Radieschen, Zwiebeln und anderen Gemüsearten (die ersten Buchstaben der Pflanzennamen bildeten auf polnisch und englisch das Wort »produzieren«) gedeihen konnten, mußten sie vor Ort gehegt und gepflegt, von Unkraut befreit und bewässert werden. Als Avital Gevas Gewächshausinstallation 1993 (Abb. S. 19) in Originalgröße auf der Biennale von Venedig installiert wurde, komplett, einschließlich eines Sprinklersystems für die Bewässerung, transplantierte er damit den gesellschaftlichen Kontext eines israelischen Kibbuz in das Gebiet der Kunst. Und als Lois Weinbergers osteuropäisches Unkraut auf der Documenta X (Abb. S. 138–139) allen Unkenrufen zum Trotz zwischen den Eisenbahngleisen hervorsproß und blühte, aus seinem Kontext gerissen wie Immigranten auf fremdem Boden, lieferte auch hier die Vegetation einen Kommentar zu sozialpolitischen Themen.

Zufällig oder absichtlich kommt es auch zum Hereindrängen politischer und sozialer Probleme in die Kunst. Auch wenn Jeff Koons es mit Sicherheit niemals hätte voraussehen können, wurde seine monumentale Arbeit *Puppy* – vielleicht die oberflächlichste und harmloseste, blütenübersäte figurative Pflanzenskulptur mit karnevalesken Ausmaßen, die je geschaffen wurde – bei ihrer Installation vor dem Guggenheim Museum in Bilbao auf tragische Weise in die lokale baskische Politik verwickelt. Kurz vor der offiziellen Eröffnung des Museums versuchten drei baskische, als Gärtner verkleidete Terroristen eine Lastwagenladung mit Ersatz-Topfpflanzen zu liefern, in die sie auch Granaten eingepflanzt hatten. Als ihnen ein Polizist in die Quere kam und so ihren Anschlag verhinderte, schossen sie ihn vor dem Museum nieder.

Doch der Täter war schon immer der Gärtner. In Romanen und Filmen ist der Gärtner häufig eine mysteriöse oder finstere Gestalt. Von Anfang an war der Garten in der westlichen Zivilisation ein mythischer Ort der Unschuld, Versuchung und Schuld. Wenn Vegetation in der Kunst plötzlich als ein vielfältigen Zwecken dienendes Material relevant ist, das schwierige Botschaften über unseren Planeten vermitteln kann, sollte uns das nicht überraschen. Und wenn von Künstlern geschaffene Gärten uns warnen, uns nicht in Mutter Natur einzumischen,

dann sollten wir aufmerksam werden. In der Folge geklonter Schafe, genetisch veränderter Sojabohnen und mit Fischgenen manipulierter Tomaten ist der Gärtner – der Hüter der Geheimnisse der Keimung und des Zerfalls – derjenige, der auf eine symbolische Weise immer noch Schuld an allem ist.

Hinsichtlich der gegenwärtigen vielfältigen Ernte der gärtnernden Künstler scheint die Frage nach dem »Warum?« und nach dem »Warum gerade jetzt?« angebracht. Die Neunziger sind ein Jahrzehnt, in dem die Künstler zu zurückhaltenden Gesten und privaten oder unspektakulären Handlungen neigen. Künstler pfropfen Zweige, spalieren Bäume, pflegen Moos, schaffen kleine Biosysteme oder bringen Fröschen das Singen bei. Sie imitieren die Natur- und Verhaltenswissenschaften oder integrieren ihre Arbeiten in die Systeme der Alltagswelt. Sie setzen sich nicht mit der alten modernen Dichotomie von Kultur versus Natur auseinander, sondern mit postmodernen Sorgen wie Überleben, Identität und Mutation in einer Welt genetisch veränderter Sojabohnen, biologischer Waffen und geklonter Schafe. In der Folge beispielloser Verschmelzungen von Tieren, Gemüse und Mineralien reflektieren sie neue Irritationen und Ungewißheiten. Sie bringen unvorhergesehene ethische Dilemmas zum Ausdruck bezüglich der Frage, was in einer Welt – in der die Grenzen zwischen dem Natürlichen und dem Künstlichen rapide ausgelöscht werden – künstlich und was natürlich ist. Sie stellen neue Fragen danach, wo die Natur aufhört und die posthumane Künstlichkeit beginnt.

Es ist manchmal schwierig, die Motive der zeitgenössischen gärtnernden Künstler zu erkennen, die ökologische Stellungnahmen und Gesellschaftskritik mit neuen Manifestationen des alten Dranges, die Natur dem menschlichen Willen zu unterwerfen, verschmelzen. Einerseits haben die vielen Künstlerinnen und Künstler, die jetzt mit Pflanzen arbeiten, wenig miteinander gemein, andererseits werden sie alle von den zentralen Ängsten unserer Zeit umgetrieben. Am Ende des 20. Jahrhunderts, am Rande genetischer Durch- und Zusammenbrüche und irreversibler Veränderungen, sind lebende Pflanzen, durch deren Adern Chlorophyll fließt, Bestandteil des künstlerischen Vokabulars geworden. Dabei sind sie in zahlreiche Schichten der Bedeutung verwickelt. Wie wir sind sie Teil des alten natürlichen Ökosystems der Erde, das sich möglicherweise schon bald überlebt haben wird. Die Gärten der aktuellen Kunst sind alles andere als trivial. Obwohl er die Erde damals als Schauplatz entropischer Ereignisse benutzte, hätte Robert Smithson diese Entwicklungen 1968 schwerlich vorhersagen können. Am Ende des modernen Jahrhunderts sind wir alle zu Bewohnern des verdorbenen Gartens geworden.

Aus dem Englischen von Nikolaus G. Schneider, Thomas von Taschitzki

1 Robert Smithson, »A Sedimentation of the Mind: Earth Projects«, *Artforum*, September 1968, wiederabgedruckt in: *Robert Smithson. The Collected Writings*, hrsg. v. Jack Flam, Berkeley and Los Angeles 1996, S. 105

2 Mel Bochner, »Primary Structures«, *Arts Magazine*, Juni 1966, S. 33

3 Peter Hutchinson, »Is There Life on Earth«, *Art in America*, November/ Dezember 1966, S. 68–69

4 Robert Smithson, a.a.O., S. 105

5 *Alan Sonfist 1969–1989*, Ausst.-Kat. Hillwood Art Museum 1990, Long Island University, S. 24

6 *Conceptual Art and Conceptual Aspects*, New York Cultural Center, 1970, S. 30

7 Alan Sonfist (Hg.), *Art of the Land*, New York 1983, S. x1

8 »Richard Long replies to a Critic«, *Art Monthly*, Juli/August 1983, S. 20

9 »Words After the Fact«, in: R. H. Fuchs, *Richard Long*, Ausst.-Kat. The Solomon R. Guggenheim Museum, New York 1986, S. 236

10 Robert Smithson, a.a.O., S. 113

11 H. Mayer Harrison, Newton Harrison, »Über die Dringlichkeit des Augenblicks«, in: *Green Heart Vision*, Ausst.-Kat. Kunstmuseum Bonn, 1997, S. 12

12 Aus einem Gespräch der Autorin mit dem Künstler am 24. März 1999

13 Paula Hayes, *Wild Friends*, Broschüre, New York 1995

Permanente Gärten
Ian Hamilton Finlay, Lothar Baumgarten, Lois Weinberger

Der erste Künstlergarten, von dem die *Geschichte der Gartenkunst* von Marie Luise Gothein zu berichten weiß, stammt von dem Maler Peter Paul Rubens. Gothein beschreibt ihn als eine Anlage, die für vornehme Bürgerhäuser Antwerpens jener Zeit typisch war. Die Handschrift des Künstlers fehlt – oder ist zumindest nicht nachweisbar.

Bis ins 18. Jahrhundert war der Beitrag von Künstlern in Gärten und Parks – von wenigen Ausnahmen abgesehen – auf Skulpturen beschränkt. Künstler lieferten die Figuren, die in das Konzept von Gartenbaumeistern paßten. Sie nahmen an einem Gesamtkunstwerk teil, das von Männern bestimmt war, die »ein wenig Geometer sein, die Architektur verstehen und gut zeichnen können müssen, die Ornamentik meistern, die Eigenheit und Wirkung aller Pflanzen, deren man sich in schönen Gärten bedient, kennen«.[1] Diese Charakterisierung des Architekten Le Blond weist dem Gartenbaumeister universale Kenntnisse zu. Zur gleichen Zeit gab es in England eine praktische Abkehr vom französischen Gartenvorbild und eine theoretische Auseinandersetzung über den Zusammenhang von Kunst und Natur. Diese mündete 1713 in eine Veröffentlichung des Schriftstellers Alexander Pope, die rasch die öffentliche Meinung beherrschte. »Ich glaube«, schrieb er, »es ist keine falsche Beobachtung, daß Menschen von Genie, die in der Kunst Begabtesten, die Natur lieben; denn diese empfinden besonders stark, daß alle Kunst Nachahmung und Studium der Natur ist.«[2]

Dieser Gedanke wurzelt in der antiken Vorstellung, daß die heiligen Haine nicht vom Himmel gefallen sind, sondern von Heroen, also besonders begabten Menschen, angelegt und geschützt wurden. Diese heiligen Haine waren wie Gärten ein abgegrenztes Terrain, zu dem nur Auserwählte Zugang hatten. Ihrer Entstehungsgeschichte liegen besondere Gegebenheiten in der Natur zugrunde, etwa Quellen in unwegsamen Gebieten, Grotten in freiem Gelände oder Bäume aus unvordenklicher Zeit. Nur ein Mensch mit seherischen Fähigkeiten konnte den Ort als besonderen Ort erkennen und die lokale Gottheit benennen. Er wußte, in welchen Regeln der Ort heilig gehalten werden mußte. Diese Haine hatten Bestand, solange die Götter verehrt wurden. Der Heros ist wie der Gartenbaumeister ein Mann universaler Kenntnisse. Er kennt die Natur, legt die Ordnung und die Regeln des Terrains fest. So auch ein Künstler, dessen Gärten wie ein heiliger Hain nur dann weiterexistieren, wenn sich eine Gemeinschaft oder ein Team um den Bestand kümmert und die Bedeutungszusammenhänge erhält.

Einem Gärtner hingegen sind die biologischen Zusammenhänge wesentlicher als die semantischen. Hier ist auch die Scheidelinie zwischen einem Künstlergarten und einem bloßen Zier- und Nutzgarten. Ein Künstler wird die Bedeutung immer über die Nutzung oder Ansehnlichkeit stellen.

Ian Hamilton Finlay
Ian Hamilton Finlay ist ein Dichter, dem es, wie er sagt, an technisch-handwerklichen Fähigkeiten mangele und dennoch seine Vorstellung von Welt und Ordnung in einem Garten zum Ausdruck bringen wolle. Diese Idee eines Gesamtkunstwerks stellt ihn in die Tradition des Klassizismus. Sein 1,6 Hektar großer Landschaftspark bei Edinburgh ist ein Dichtergarten wie er von dem Philosophen Jean Jacques Rousseau hätte beschrieben werden können (Abb. S. 48–49, 142). Als Finlay das Grundstück 1967 übernahm, hieß es »Stoney Path«. Es bestand aus einer kleinen Gruppe von Häusern, Feldern, Weideland und einem einzigen Baum. In Finlays Auftrag wurden Wege, Blumenfelder, Boskette und künstliche Teiche angelegt. Mit Säulen, Reliefs und Inschriftenplatten, die sich verstreut und überraschend zwischen Gräsern, an Bäumen, am Teich finden, zitiert er aus der Ideenwelt des 18. Jahrhunderts und wendet eine Vielzahl auch einander widersprechender Zitate gegen die Moderne.

Wie jeder Garten ist auch der Finlays ein Refugium. Doch anders als die englischen Landschaftsgärten nimmt Finlay das Politische in seine Gartensentenzen auf. Einer der kennzeichnenden Widersprüche besteht darin, sowohl die Themen Macht und Tod wie auch antike mythologische Welt im freundlichen Nebeneinander gelten zu lassen. Dadurch wird der Gang vorbei an den verstreuten Sentenzen im Garten zu einer Lektüre von Finlays Welt.

Finlay hält seine Tempeleinrichtungen für einen Versuch, Religion zu beleben. Damit ist ihm ernst. Seit Jahren führt er einen Rechtsstreit mit der übergeordneten Behörde, die eine seiner Tempelanlagen als Museum besteuern möchte. Für Finlay bleibt sie ein Tempel. Und ein Tempel ist kein Museum. Heute heißt das Grundstück, das mit zahlreichen Bäumen, Büschen und Seen nunmehr arkadische Anmutung hat, *Little Sparta*. Es ist eine Kampfansage.

Lothar Baumgarten
161 Pflanzen nennt Lothar Baumgarten als Mitspieler für sein *Theatrum Botanicum* (Abb. S. 28–29, 144). 1993 erhielt er den Auftrag, einen Garten für die Fondation Cartier in Paris zu entwerfen, der zusammen mit dem mehrgeschossigen Glasbau des Architekten Jean Nouvel ein Ensemble bildet. Das Gelände ist hinter dem Gebäude ummauert. Als Baumgarten mit der Arbeit begann, standen bereits einige Bäume auf dem Gelände, die er in seinen Plan einbezog. Da er dem Plan des Grundstücks ein Rechteck, ein Dreieck und ein Quadrat eingeschrieben fand, entschloß er sich, diese Reihe einfacher geometrischer Formen als Konstruktionselemente mit Kreis und Ellipse fortzusetzen. So

entstanden vor der rückwärtigen doppelten Glaswand des Gebäudes – in den rechten Winkel des Grundstücks asymmetrisch eingefügt – halbkreisförmig aufsteigende Terrassen, die an die Form des antiken Theaters erinnern. Sie werden von einer Treppe geteilt, die in einer Gegenbewegung zu einem Brunnen in die Tiefe führt. Der Brunnen spiegelt allein den Himmel, die Glasfassade den ganzen Garten zum großen Tableau.

Baumgarten beabsichtigt mit seinem Pflanzkonzept die Referenz an große Wandbehänge des 15. Jahrhunderts. Die Blumen, Medizin- und Küchenkräuter sollen durch die Jahreszeiten hindurch einen gobelinartigen Teppich weben und in ihrem Blütenschmuck einem französischen Goldbrokat gleichen. Die Widerspiegelung der realen Pflanzen als Bild an der Glaswand ist der Berührungspunkt des Gebäudes mit dem Garten und eröffnet zwei Wege der Bedeutungsproduktion.

Ein Weg führt zum Auftraggeber, dem Baumgarten mit seinem Werk Referenz erweist. Das Vermögen der Stiftung Cartier stammt aus der Verwandlung von Blättern und Blüten in kostbare Bilder aus Juwelen und Gold. Ein anderer Weg führt tiefer in die Geschichte, nämlich zu den Gärten auf den Gobelins, die Paradiesgärten waren und in denen jede Pflanze eine Bedeutung hatte. Es waren Gärten der Unschuld.

So soll auch der Garten der Fondation Cartier ein Paradiesgarten sein, denn, so Baumgarten, »der Dreck, der Lärm und die Verschmutzung bleiben draußen«. Die Wirklichkeit der Stadt ist aus der Umfriedung, dem hortus conclusus, verbannt.

Der Künstler möchte mit den ausgewählten Pflanzen, die alle mit der europäischen Wissenschaft und Mythologie verbunden sind, einen geschlossenen Kosmos bauen. Er legt Wert darauf, daß alle Pflanzen, die er ausgewählt hat, aus der Gegend um Paris stammen. Und nur diese Pflanzen aus der Region und »jene Samen, die der Wind dorthin trägt«, wie er schreibt, sollen in diesem Garten wurzeln. Hier wächst jedoch auch der tödliche Stechapfel.

Das Arkadien der Mythologie, in dem auch der Tod ist, und der Paradiesgarten der Theologie, in dem die Zeit aufgehoben ist und in dem es kein Vergehen gibt, fallen in diesem Theater ineinander. Das gleichzeitige Nebeneinander von Tod und Unschuld verbindet sich zu einer prekären Allianz.

Lothar Baumgarten schafft mit seinem Entwurf für ein *Theatrum Botanicum* im Zentrum von Paris einen integralen Kontext nicht nur zum Neubau seines Auftraggebers und zur unmittelbaren Umgebung, sondern auch zur europäischen Kultur- und Geistesgeschichte.

Lois Weinberger

Lois Weinberger hatte sich 1988 einen eigenen Garten angelegt, der ihm als Samenquelle für eine unbekannte Zahl artfremder Pflanzen dient. Es sind Ruderalpflanzen, also Trümmerpflanzen, – Gräser, Ranken und Blumen, die ohne Pflege auf kargen, nährstoffarmen Böden gedeihen. In Gärten mit reicher Erde wachsen sie vielleicht auch. Doch da werden sie als Unkraut entfernt. Weinberger liebt diese Pflanzengruppe; und besonders jene Arten, die aus Süd- und Osteuropa stammen. Berühmt geworden ist das stillgelegte Gleis am Kasseler Hauptbahnhof, das er zur documenta 1997 übersäte (Abb. S. 138–139). Dort wuchs bereits Kasseler Unkraut. Doch Weinberger legte es darauf an, daß sein Unkraut das heimische verdrängte. Denn Unkraut, das, wie der Volksmund meint, nicht vergeht, sondern sich durchsetzt, habe, so Weinberger, etwas mit Migration zu tun. Unkraut und Migranten hätten miteinander vergleichbare Eigenschaften.

Diese politische Wendung einer auch als Ruinenromantik bekannten Überwachsung stillgelegter Gleise, aufgebrochener Straßen, verfallener Mauern, aufgelassener Müllhalden ist nur ein Aspekt seiner gestalterischen Absichten. Denn anders als in der Ruinenromantik lenkt er mit seinen Pflanzen die Aufmerksamkeit nicht auf das Vergangene, sondern auf die Gegenwart, indem er Details der Natur als das eigentlich Lebendige und die Geschichte Überdauernde hervorhebt.

Er hat sich mit der Natur in ihrer historischen und in ihrer gegenwärtigen Wahrnehmung beschäftigt. Galt in früheren Zeiten die Natur als gefährlich, so daß man sich ein Stück aus ihr herauslöste, um es zu beherrschen und zu kultivieren, erscheint bei Weinberger die Kultur gefährlich. Er löst ein Stück Kultur – das Gleis, den Weg, die Asphaltstraße – aus der zivilen Welt heraus, um es der Natur wiedereinzugliedern und zu naturieren. Die Sprache des Unkrauts versteht er auf sehr eigene Weise. Ließe er seine Blumen sprechen, würden sie ihrem wild wuchernden Garten den Namen »the survival of the fittest« geben.

Im Gegensatz zu Finlay und Baumgarten, die den Kosmos des Gartens aus Pflanzen der Region entwerfen, legt Weinberger die Pflanzungen gleichsam im Vorübergehen mit Pflanzen aus der Fremde an und überläßt sie sich selbst. Während Finlay und Baumgarten die Vegetation zu einem geschützten und gepflegten Bild formen, läßt Weinberger allein die zählebigsten Exemplare wuchern.

Wertsetzungen, Umwertungen und Grenzverschiebungen
Didier Trenet, Tobias Rehberger, Luc Wolff

Jedem Garten liegt ein Entwurf zugrunde. Gärten sind ein Vorschlag, wie die Welt im Großen oder im Kleinen ideal geordnet werden könnte. Dieser Vorschlag kann als Gegenentwurf zur alltäglichen Welt verstanden werden und spiegelt Sehnsüchte und Wunschvorstellungen jener Gartenbaumeister, Architekten,

Künstler, Bauern oder Kleingärtner wider, die ihn vorgebracht haben. Die historische Verbindung des Gartens mit dem Paradies, die von Interpreten allerorten immer wieder angeführt wird, ist eine Sonderform. Sie hat jedoch mit allen Gärten die Trennung von freier Natur, von Wildnis, von Feldern und von bebautem Land gemein. Die Absonderung eines mit Pflanzen gestalteten Terrains als eine Welt für sich ist das Kennzeichen eines Gartens. Deshalb ist eine blumenübersäte Wiese in freier Natur kein Garten. Würde dieselbe Wiese jedoch umhegt und die Blumen von einem Menschen angeordnet, dürfte man von einem Garten sprechen.

Bauerngärten in den Alpen wie auch Korallengärten in der Südsee sind umzäunt und werden, obwohl sie in erster Linie zu Nutzzwecken angelegt sind, als Gärten bezeichnet. Ein Kornfeld oder ein Kartoffelacker würden jedoch auch dann nicht zu einem Garten, wenn sie umzäunt oder durch einen Graben als Territorium markiert wären, da ihnen die absichtsvolle und bedeutungsstiftende Gestaltung fehlt. Umgekehrt sind hübsch dekorierte Blumenanordnungen in Fußgängerzonen, Einkaufszentren und auf Plätzen keine Gärten, sondern Beete, Rabatten, Pflanzenkübel.

Mit der Vorstellung einer »Landschaft«, das heißt nach ästhetischen Gesichtspunkten *betrachteter* Natur im weitesten Sinne hat der Begriff des Gartens als umhegte und gestaltete Pflanzenordnung wenig zu tun. Denn »Landschaft« hängt vom Blick des Betrachters ab; der Garten aber ist ein »fait social«. Spricht man von einem Landschaftsgarten, so handelt es sich um die in der realen Welt verwirklichte Antwort auf den Blick des Betrachters, der dem Unermeßlichen der Natur von einem privilegierten Standpunkt aus als Bild inne zu werden wußte und es auch als Vorstellungsbild zu genießen vermochte. Auch der Landschaftsgarten bedarf der Absonderung des kunstvoll mit Pflanzen geordneten Terrains in eine Welt à part, obwohl es im Geschick der Architekten und Landschaftsgärtner liegt, die sichtbaren Grenzen scheinbar an den Horizont zu verschieben und den Garten als Natur erscheinen zu lassen, die wiederum einen Blick auf »Landschaft« verspricht.

In der Abhandlung *Der Englische Garten. Eine Reise durch seine Geschichte* weist der Gartenhistoriker Hans von Trotha auf das Ideal hin, das die Anlagen von Gärten beflügelt. »Gärten mögen Gesellschaftsordnungen widerspiegeln, vor allem aber sind sie Kunstwerke. Sie verraten viel über das Schönheitsideal einer Zeit, über ästhetische Moden und über das Verhältnis der Menschen zur Natur. Nirgends treffen Kunst und Natur so unmittelbar aufeinander wie im Garten, in dem Raum zwischen Haus und Landschaft.«[3]

Daß Gärten nur Zier-, keine Nutzpflanzen enthalten, ist ein oft wiederholtes Mißverständnis von Städtern. Es läßt sich von den herrscherlichen italienischen, französischen und englischen Gärten und ihren kleinsten Ablegern in den Vorgärten der Vorstädte herleiten, verkennt aber die Wirklichkeit der Gärten in Europa und der Welt.

Didier Trenet

Didier Trenet zeichnet in die wuchernde Fülle seiner Zeichenhefte *nach Montepulciano*, *nach Barolo*, *nach Bordeaux*, also in trunkenem Zustand. Die Titel deuten auf heitere Weise auf Didier Trenets Zeitkonzeption. Es war etwas davor, das noch immer anhält und Wirkungen zeitigt: Perfekt.

Die Titel verballhornen einerseits den terminus technicus von Kunsthistorikern »nach Boullée«, »nach Watteau«, andererseits die Titelvariable von Elaine Sturtevant, die ihre Nachbildungen stets mit der Präposition »nach…« einleitet: *nach Marcel Duchamp*, *nach Joseph Beuys*. Didier Trenet sieht seine künstlerische Tätigkeit in der Folge von etwas oder jemandem. Er folgt einem dialogischen Prinzip und kommuniziert mit einem imaginären Gegenüber.

Im Garten des Museums Boijmans Van Beuningen in Rotterdam pflanzte er 1996 zur Manifesta 1 in eine gegebene Gartensituation für einen Sommer lang eine Antwort (Abb. S. 147). Er säumte einen Kiesweg, der einen kreisförmigen Brunnen mit einer bronzenen Nymphe umfaßte, mit Porree, Salat und Tomaten. Rundum auf den Rasen legte er einen langen gelben Schlauch und rollte ihn in Schlangenlinien aus. Das Gemüse und der Schlauch in Form einer Schlange sind als Zitat gesetzt. Aus dem mäandernden Schlauch schossen in kurzen Abständen dünne Fontänen. Sie näßten den Rasen und kamen dem implantierten Nutzgarten auf Zeit zugute. Doch auf dem offiziellen Foto blieb der zentralisierende weiße Kiesweg und das umgebende gelb-grün kontrastierende Ornament bildbestimmend. Trenet bevorzugte die Dominanz des Geometrischen und ironisierte die Idee des Paradiesgartens, in dem keine Schlange fehlen darf. Die Schlange spendet Wasser. Sie ist das belebende Element.

Der Garten sei für Trenet der ideale Ort für eine typisch französische Kunst, schreibt der Kunsthistoriker Gérard Lapalus in seiner Studie zu Trenet.[4] Schon in der häuslichen Variante und in seiner Bestimmung als kleiner Nutzgarten bietet er Raum für allumfassende Umwertungen, die von der gesellschaftlichen Übereinkunft nicht gedeckt werden. Trenet pflanzt den Porree, der in Frankreich »Spargel der armen Leute« genannt und mithin sprachlich aufgewertet wird, deutlich sichtbar neben die alte, geheimnisumwitterte Alraune. Damit wertet er die Alraune ab und den Porree nochmals auf.

Umwertungen sind sein Thema. Den Komposthaufen entwirft er auf eine Weise, daß das Unkraut als Delikatesse erscheint. Diese Umwertungen erstrecken sich über Hühnerstall, Sonnenschirm und Schuppen, die nunmehr als Werkstätten,

Pavillons und Rotunden erscheinen sollen. »Der kleine, abgegrenzte Vorstadtgarten«, faßt Gérard Lapalus die Beschreibung dieser »Transsubstantiation« zusammen, »weitet sich zu einer Landschaft mit Ruinen«.

Das gesellschaftliche Ansehen von Nutz- und Zierpflanzen unterliegt einerseits Moden, andererseits Eßgewohnheiten, die weit in die Geschichte zurückreichen. Daß Porree zum »Spargel der armen Leute« werden konnte ist gesellschafts-, nicht naturbedingt. Dieser kulturgeschichtlichen Abhängigkeit im Werturteil berührt auch das Geschmacksverhalten. Die Frage, wie Wertschätzungen entstehen, stellt sich ebenso bei Trenets Entscheidung, den Rasen des Museumsparks von Rotterdam umzugraben, damit Porree und Salat wachsen können, wie auch bei seinen Sprachspielen mit Titeln oder Zitaten aus dem Werk des Marquis de Sade, der die Natur (Sexualität) die Kunst (erotischen Exzeß als phantastisch-grausames Regelwerk) lehren wollte.

Tobias Rehberger

Auch Tobias Rehberger beschäftigt sich mit Umwertungen und fragt, »wie ästhetische Werte entstehen«. Lebende Pflanzen dienen ihm nicht wie bei Trenet als Zitat, sondern als Mittel innerhalb eines Übersetzungsprozesses. Seine Arbeit von 1998 während der Manifesta 2 in Luxemburg, *Within View of Seeing (Perspectives and the Prouvé)*, handelte »von der unmöglichen Übersetzung eines Gartens in Farbfeldmalerei«, kommentierte Rehberger das Werk in einem Beitrag in der Zeitschrift *Artforum*.[5] Zier- und Nutzpflanzen wurden von Gärtnern entsprechend Rehbergers Entwurf in flachen Wannen angelegt (Abb. S. 112–113). Dadurch waren die Blumen nicht in der Erde des Territoriums verankert, sondern lagerten auf den Steinfliesen einer Aussichtsterrasse wie ein Tafelbild auf der Wand.

Die rechteckigen Beete bildeten neben der Straße ein Gefüge, das die dreiseitig umschlossene Fläche weitgehend besetzte. Von der Straße her waren sie durch den leicht überwindbaren Sockel der Terrasse abgegrenzt. Die Grenze wurde durch den grauen Streifen des Gehwegs entlang der Beete verstärkt. Es entstand ein Rahmen, der für den Blick aus den Obergeschossen des gegenüberliegenden Museums die Anlage zu einem Bild faßte. Der Blick aus dem Bild heraus, hinüber zum Pavillon des Architekten Jean Prouvé, erkennt umgekehrt vage den Garten als Spiegelbild.

Rehberger konstruierte den Garten als Spiel zwischen Funktion und Dekor und führte die Unmöglichkeit einer trennscharfen Definition dieser beiden Begriffe in der Praxis vor. Die begriffliche Erfassung hängt von der Perspektive, dem Interesse des Betrachters und dem praktischen Umgang ab. Denn jedes Ding kann mehrere Funktionen erfüllen. Wenn die eingesetzten Nutzpflanzen Kohl, Salat, Basilikum von der Aussichtsterrasse geerntet und gegessen werden, wird der schmückende Charakter negiert. Wenn diese Nutzpflanzen nicht geerntet werden, schießen sie dekorativ ins Kraut.

»Mich interessiert die Differenz zwischen dem, was ich gewollt habe und dem, was einer daraus gemacht hat«, sagte er in einem Interview.[6] Daraus resultiert eine skulpturale Idee, die den unwägbaren Anteil der Betrachter in den Werkprozeß einbezieht. Rehberger kann Bedeutungen durch formale Anordnung lancieren, eindeutig festlegen nicht. Damit wird das Werk eine Frage der Aneignung, für deren Bedeutungsproduktion der Künstler keine Verantwortung übernimmt; er kann mit dem Werk dann auch nicht mehr identifiziert werden. Er ist Ideengeber, veranlaßt Werke, die eine Ausgangssituation für den weiteren Gebrauch schaffen. Damit macht er sich allerdings von der Rezeption abhängig. Im Falle des kleinen Gartens in Luxemburg stellte sich die unvorhergesehene Situation ein, daß er nach Ausstellungsende nicht abgebaut, sondern bleibender Teil des öffentlichen Raums werden sollte. In solchen Fällen überlegt Rehberger, ob sich die Ausgangslage für das neue Zeitmaß eignet und verändert, sofern nötig.

Luc Wolff

Luc Wolff bringt die Grenzen zur Geltung, die seine auf Zeit angelegte Arbeit bedingen. In Berlin stellte er eine grobverputzte weiße Wand unvermittelt in einen Garten (*Wand*, 1995) oder füllte mit getopften Büschen und Bäumen einen leergeräumten Ausstellungsraum bis zur Unzugänglichkeit auf (*Parkhaus*, 1997). Lebende Pflanzen dienen als Mittel, um Grenzen und Schwellen zu verdeutlichen. Mal ist der Garten von Wänden umstellt, mal ist es umgekehrt. Bevor Luc Wolff jedoch diese unspektakulären Interventionen dem Publikum öffnet, trifft er sorgfältige Vorbereitungen. Er entrümpelt und säubert das Terrain, fegt den Boden und bietet den Augen eine offene Fläche. Die Präsentation besteht darin, das Mögliche im Zustand des Möglichen zu zeigen: als freigehaltenes Terrain.

In seinem Beitrag zur Biennale in Venedig im Stadtteil Giudecca (*Magazzino*, 1997) räumte er eine Halle frei. Zum Zeichen, daß es diesen ungenutzten Raum gibt, verstellte er mit einer Ansammlung von etwa sechzig hochgewachsenen Topfpflanzen den Eingangsbereich bis hinaus zur Kaimauer der Lagune. Sobald die Ausstellung am Abend schloß, trug er die Pflanzen in den leeren Raum, um sie am Morgen – wie ein Händler die Auslagen – wieder hinaus ans Licht zu stellen. In einem Begleittext zu *Magazzino* (Abb. S. 149) betont Wolff die wiederkehrende Tätigkeit. »Die stille Präsenz einer pflegenden Kraft sollte im Magazzino konstant spürbar sein. Durch Umräumen sowie durch regelmäßiges Saubermachen im Lager soll dieser Eindruck glaubwürdig erzeugt werden.«[7]

Luc Wolffs Werke stellen die Sorge um leere Räume in den

Vordergrund. Er hält sie gemäß der jeweiligen Konzeption in Form und pflegt die Pflanzenbestände. Doch kann man nicht sagen, daß er Gärten kultiviert. Sein Streben konzentriert sich nicht auf den Wuchs und die Veränderung, sondern auf die Aufrechterhaltung des einmal hergestellten Status quo. Die Konservierung wird durch den Einsatz von Pflanzen deutlich hervorgehoben.

Die Sorge um die Bewahrung des Terrains verbindet seine Arbeit mit der Tätigkeit der Gärtner und unterscheidet sie gleichzeitig davon. Er sät nicht, sondern nutzt transportable Fertigprodukte der Gartencenter wie Rollrasen und Topfpflanzen, steckt an wechselnden Orten ein Terrain ab und hält es als Zone frei. Zwischen Bewegung und Starre wird die Begrünung zur Möglichkeit unter vielen. Doch Wolff hat sich zwischen den besetzten und offenen Feldern, zwischen Wachsen und Arretierung auf die Grenzen dazwischen fixiert. Diese werden als Schwellen belebt und gepflegt: als Unterschied zwischen dem einen und dem anderen Feld, der bisweilen so unmerklich ist wie das stete Wachsen der Pflanzen (Abb. S. 140–141).

Eine Pflanze nimmt im Laufe ihres Lebens einen immer anderen Raum ein. Sie verschiebt durch ihr Wachsen und Absterben die Grenzen. Dadurch wird sie zu einem Symbol für permanente Grenzverschiebung.

Mahnmale und Gedächtnisstätten
Gloria Friedmann, Jenny Holzer, Hirsch/Lorch/Wandel

Lidice

Nach dem Attentat auf den stellvertretenden Reichsprotektor von Böhmen und Mähren, Reinhard Heydrich, im Sommer 1942 vermutete die Gestapo die Organisatoren des Anschlags in Lidice. Einsatztruppen der SS durchsuchten ergebnislos das böhmische Dorf, ließen Frauen und Kinder abtransportieren, erschossen alle Männer, brannten das Dorf nieder, sprengten die Häuser und die Kirche, schafften die Trümmer weg, ebneten die Überreste ein, schütteten den Dorfteich zu, leiteten den Bach um, machten den Friedhof dem Erdboden gleich und verwischten alle Spuren. An der Stelle, wo das Dorf lag, war nun weite Ebene. Die Erde war wüst und verbrannt.

Nach dem Krieg wurde wieder gesät. Die Weizenfelder wuchsen. Jahre später bemerkten Bauern eine ungewöhnliche Verfärbung der Halme in den Feldern. So wurden die Spuren von Lidice entdeckt. Ein Teil des frischen Weizens wuchs auf einem Massengrab. Heute weist ein Mahnmal auf die Vernichtung hin. Einige Stellen wurden freigelegt. Mauerreste im Feld zeugen von der Verheerung.

Die Natur vergißt nichts und hat selbst die Spur gelegt. Was den Bauern in der Ebene unverhofft aufgefallen war, nämlich die

Lesbarkeit der Vorgeschichte an der Oberfläche, ist Archäologen seit langem Methode. Wenn sie annehmen, daß in einem Gebiet der Boden die Überreste von Siedlungsanlagen verbirgt, wird das Gelände aus größerer Höhe betrachtet. Dort, wo die Pflanzen unregelmäßig wachsen, beginnen sie zu graben und werden meist fündig. Noch nach Jahrhunderten treibt der Boden die Pflanzen anders aus dem Erdreich als dort, wo keine Siedlungen verschüttet sind. Der Boden bleibt Zeuge. Das Erdreich bewahrt ein Bild, das an der Oberfläche als Archiv gelesen werden kann.

Was die aufmerksamen Bauern im Weizenfeld sahen, scheint als Nachbild des Massakers nicht steigerbar. Was die Bauern sahen, läßt sich nicht abbilden, aber erzählen. Und was sie erzählten, wurde Legende: zum Bild der Vorstellungskraft soweit die Sprache reicht; kein Abbild, sondern Verwandlung in ein anderes Medium.

Auch die folgenden Beispiele vom Umgang mit Tatbeständen der Zeit zwischen 1933 und 1945 in Europa bilden das Grauen nicht ab. Die Künstler suchten keine Bilder, um das Leid der Opfer der Justiz, der politisch und rassisch Verfolgten, der gefallenen Soldaten, der Deportierten zu illustrieren. Sie suchten vielmehr mit den Mitteln der Analogie, der Stimmung, der Symbolik und der Registratur ein Verhalten der Nachgeborenen zu ermöglichen, das die Erinnerung ein halbes Jahrhundert nach den Taten nicht ohne den Gedanken an Unrecht, Folter, Mord und Kampf hervorruft. Dabei spielen lebende Pflanzen eine elementare Rolle. Sie werden als Vermittler zum Vergangenen eingesetzt.

Gloria Friedmann

Am 1. Oktober 1997 wurde in Hamburg das Mahnmal *Hier + Jetzt* am Sievekingplatz von Gloria Friedmann eingeweiht. Es ist den Opfern nationalsozialistischer Justiz in Hamburg gewidmet (Abb. S. 152–153). Wer aus dem Hanseatischen Oberlandesgericht tritt, steht vor einer Barriere. Quer zum gewaltigen Portikus des Gebäudes blockiert eine übermannshohe Betonmauer den einst freien Blick hinaus in den Park. Auf der Wand ist die Jahreszahl 1933 eingeprägt, das Jahr der Machtübernahme durch die Nationalsozialistische Partei Deutschlands. Eine weitere Jahreszahl findet man nicht.

An der Rückseite der Wand zum Parkgelände hin dient ein über die ganze Breitseite montiertes Panorama Hamburgs als Szenenbild für neunzig im Boden verankerte Sockel. Sie gehen in Kübel über, in die Gloria Friedmann neunzig verschiedene Gewächse pflanzte. Auf unterschiedlichen Höhen stehen alle Pflanzen im gleichen Licht und Schatten. »Sie präsentieren dem Besucher«, notiert Friedmann in ihrer Werkbeschreibung, »90 verschiedene Topfpflanzen. Neben dem Rosenstock sprießt die Brennessel. Die Kartoffel ist die Nachbarin des Lavendel. Heilkräuter siedeln neben der Giftpflanze. Der exotische Kaktus

wartet neben dem heimischen Lauchgemüse auf Sonne. Die Pflanzen sind Symbolträger der Biodiversität. Sie stehen für die verschiedenen sozialen Schichten und Herkunftsgebiete der Hamburger Bevölkerung. Dieser Entwurf für eine Welt der Verschiedenheit mit gleichem Pflegeanspruch gilt zugleich als Metapher für gleichen Rechtsanspruch.«[8]

Günther Engelhard spricht in seinem Begleittext »Neunzig Personen finden ihren Topf« von einer »Besinnungsarchitektur« und deutet das Werk als Allegorie des Rechts. Die Pflanzen vertreten »eine multikulturelle Gesellschaft, die nebeneinander wächst und sich darauf verlassen darf, daß an dieser Stätte gleiches Recht für alle gilt.«[9]

Da Friedmann die Zeit nach der Zäsur 1933 mit keiner weiteren Jahreszahl schließt, erscheint nur die Existenz des Mahnmals selbst, sein Vorhandensein im Auftrag der Stadt, als mahnender Abschluß. Das Mahnmal erfüllt seine Bestimmung, solange sich Menschen um die gleichmäßige Pflege aller Pflanzen kümmern. In dieser Hinsicht bedeutet das Werk jedoch mehr, als es sein will.

Gloria Friedmann errichtete ein Zeichen der Anklage als unverrückbare und unwandelbare Mauer und nimmt auf diese Weise die Form des freistehenden, beschrifteten Denkmals auf. An der Kehrseite setzt sie der Fixierung auf das Damals mit den zyklisch aufblühenden und welkenden Pflanzen mannigfache Bewegung im Hier und Jetzt entgegen. Topfpflanzen bedürfen der pflegenden Hand. Mit der Jahreszahl ruft die Künstlerin die Aufhebung gleichen Rechts für alle Staatsbürger in Erinnerung; mit den Pflanzen fordert sie Jahr um Jahr das demokratische Recht auf Gleichbehandlung. Handeln wird zum bedeutungsstiftenden Element der Werkabsicht.

Jenny Holzer

Am 28. Oktober 1994 wurde in der Innenstadt Nordhorns das Mahnmal *Black Garden* der amerikanischen Künstlerin Jenny Holzer eingeweiht (Abb. S. 76–77, 154). Es ist eine Neufassung eines schon bestehenden Denkmals, das an die Gefallenen dreier Kriege (1870/71, 1914–1918 und 1939–1945) erinnert und in einem Teil den zwischen 1933 und 1945 politisch und rassisch Verfolgten gewidmet ist. Das »Mahnmal am Langemarckplatz«, benannt nach einer Schlacht in Belgien im Ersten Weltkriegs, wurde im Verlauf einer Umbewertung der historischen Ereignisse in den achtziger Jahren einer Revision unterzogen. Dieser Diskussion entsprang auch die Idee eines Denkmals über die bereits vorhandenen Denkmale. Die Leiterin der Städtischen Galerie Sabine Dylla beschreibt in ihren »Gedanken zu einem Kunstwerk gegen den Krieg« Jenny Holzers Werk von 1994. »In Korrespondenz zu dem Denkmal der Gefallenen des Ersten Weltkrieges (eine geschlossene runde Fläche aus Sandsteinsegment) wurde auf der sich anschließenden Rasenfläche ein Beete- und Wegesystem in konzentrischen Kreisen angelegt. In den Beeten sowie in den Randbereichen um das Mahnmal des Ersten Weltkrieges wurden verschiedene schwarzlaubige/schwarzblühende Pflanzen gesetzt. In fünf bereits vorhandenen Bankzonen wurden Sandsteinbänke mit Texten der Künstlerin aufgestellt.«[10]

Die Farbe Schwarz kommt in der belebten Natur nicht vor. Doch es gibt schwarz anmutende Hölzer, Gräser und Blumen. Diese läßt Jenny Holzer im Kontrast mit wenigen weißen Blumen und Gräsern entlang der konzentrischen Kreise pflanzen. Die Anlage sieht aus der Flugzeugperspektive wie eine Zielscheibe aus.

Der Kunsthistoriker Justin Hoffmann hebt in seiner Analyse »Garten in Schwarz« die Symbolik des Schwarz hervor. Es sei das Symbol des Todes, der Trauer, des Leidens.[11] Doch vielleicht sollte man diese populäre Lesart angesichts der 36 dunkelblättrigen Pflanzenarten nicht überbewerten. Im Ensemble wirken sie vor allem als Stimmungsbild und schaffen einen beruhigten Ort inmitten des verkehrsreichen Stadtraums. Die Pflanzen bilden einen Kontrast zu den Bänken aus Stein, in die Schilderungen menschlicher Qualen eingemeißelt sind. Sie wecken das Mitleiden des Lesenden.

Justin Hoffmann sieht »zwei Repräsentationsformen von Tod« auf paradoxe Weise verknüpft. »Denn einerseits sind Blumen in Totenriten gebräuchlich, aber keine schwarzen. Andererseits gilt Schwarz als Symbol des Todes, jedoch nicht in Form von Pflanzen. Mit einer schwarzen Blume … wird scheinbar die Funktion der Blume als Liebesbezeugung für die toten Soldaten verweigert, dagegen die Bedeutung der Farbe Schwarz als Zeichen für Gewalt oder Bedrohung betont.«[12] Indem Holzer kein statisches Bild erstellt, sondern ein naturgemäß lebendes, läßt sich ihr Kommentar nur auf Tafelbildmalerei beziehen, wenn man aus dem Flugzeug den Raum als Fläche betrachtet. Dann sieht man den Platz vegetabil überdeckt wie etwa der Maler Arnulf Rainer bereits bemalte Bildflächen mit schwarzer Farbe überstreicht.

Doch es bleibt dem Blick aus der Luft verschlossen, weshalb und ob überhaupt die Pflanzen das ganze Gelände überwuchern sollen. Aus der Perspektive eines Spaziergängers sieht es anders aus. Er geht auf den festgelegten Wegen der Zielscheibe. Zwölf Kreise spannen sich um ein Zentrum und werden von einem Kreis von Bäumen umstellt wie im Mittelalter auf freiem Feld der Kreis des Gerichts. Der Blick geht in die Mitte. Wer in diese Kreise tritt, bewegt sich im Bannkreis des Denkmals der ins Schußfeld Geratenen. Zumindest als Zeichen bedeutet dieser Gang Gefahr.

Achtet man auf die Blumen, so sieht man dunkle Nelken, grauen Fenchel, blaues Männertreu und Purpurglöckchen. Würde man diese symbolisch deuten, ergäbe die Sprache der Blumen ein Bild männlicher Tugenden. Blau wird in deutscher

Tradition als Farbe der Treue gelesen, Purpur als Farbe der Herrschaft, aber auch des Kampfes und der Liebe. Grau waren die Uniformen der Gefallenen. Die durchgehend ins Dunkle gewendete farbliche Ordnung erweist den Soldaten anhaltende Ehre. Am Mahnmal der von 1933 bis 1945 rassisch und politisch Verfolgten wachsen in kleinen Beeten weißblühende Chrysanthemen, Schwertlilien, Stiefmütterchen und Heide. Es sind Friedhofsblumen wie sie in Deutschland, Holland, Belgien üblich sind. Die Farbe Weiß wird auch von Jenny Holzer als Trauerfarbe eingesetzt.

Achtet man auf die Bäume und Sträucher, so findet man Blutbuche, Blutpflaume, Wunderbaum, Judasbaum, Trauerblutbuche und Blutberberitze. Sie verändern sich wenig über das Jahr. Ihre Blätter bleiben dunkel. Der Spaziergänger kann sich hier aufhalten. Es wird ihm schwerfallen, sich auf die Bänke zu setzen und damit seine Ignoranz den Texten gegenüber zu zeigen. Wie alle Gärten steuert auch dieser das Verhalten. Man geht im Kreis auf engen Bahnen. Die Bänke gewinnen den Status von Lesepulten. Hell wird es nie. Der Park bleibt finster und wirkt durch die wenigen weißen und farbigen Beete silberglänzend anthrazit.

Hirsch/Lorch/Wandel

Am 27. Januar 1998 wurde in Berlin-Grunewald die Gedenkstätte *Gleis 17* (Abb. S. 155) des Architekturbüros, Hirsch, Lorch, Wandel eingeweiht. Es erinnert an die Transporte von mehr als fünfzigtausend Juden nach Treblinka, Theresienstadt, Riga, Lodz und Auschwitz zwischen Oktober 1941 und April 1945.

Der Ort liegt auch heute mitten im Alltag. Als Nachfolgeunternehmen der Deutschen Reichsbahn, die die Transporte im Auftrag der NS-Regierung durchführte, hatte die Deutsche Bahn AG 1995 den Auftrag für die Gestaltung zur Gedenkstätte des *Gleis 17* dem Architektenbüro aus Saarbrücken übergeben. »Wir wollten nicht interpretieren«, sagt Wolfgang Lorch. »Wir wollten Fakten sichtbar machen.«

Die Bahn hatte das Gleis an seinem Endstück bereits aufgegeben. Zwischen den Schienen wachsen Buchen und Birken. An einem nahen Schuppen erinnerte bislang nur eine kleine Tafel an die Transporte von einst. Ein Wissenschaftler wurde beauftragt, die Buchhaltung der Deutschen Reichsbahn zu studieren, die die Transporte der Kostenstelle der NS-Regierung in Rechnung stellte. Er konnte 183 Transporte belegen. Diesen 183 Transporten entsprechen 183 perforierte und beschriftete Stahlgußplatten, die die Architekten nahtlos und beidseitig von Gleis 17 einlegen ließen. Am Kopfende der Platten sind Datum, Anzahl der Personen, Start- und Zielbahnhof als Relief lesbar. »26.02.1943/1095 Juden/Berlin – Auschwitz«. Wer auf den Platten entlanggeht und gezwungenermaßen mit gesenktem Kopf

liest, stimmt sich allmählich in eine Litanei ein, die den Fahrplan der Deportation zu einer Anrufung macht. Die Fakten werden zum Gebet. Jede Platte erinnert an ein Massengrab.

Die Architekten beließen den Wuchs der Bäume der vorangegangenen Jahre, renovierten den Aufgang zum Gleis vom Zugangstunnel, brachten an dessen Treppe eine Tafel an, fügten zu den Hinweisschildern des Bahnhofs ein weiteres zu *Gleis 17* hinzu.

Die Einrichtung einer Gedenkstätte, deren Gestalter durch eine Ästhetik des Exakten bestechen, weil sie den historischen Ort in seiner unsäglichen Dimension respektieren, wäre ohne den Gedanken an Zukunft nur halb. Durch die gitterartigen Stahlgußplatten wird Gras wachsen, falls der Ort nicht frequentiert werden und dem Vergessen anheim fallen sollte. Der Graswuchs ist die Registratur der Besuche.

Die Interpretation der Gedenkstätte liegt in der Verwendung lebender Pflanzen als bedeutungsstiftendes Moment. Während die Registratur der Fakten die Tatzeit lesbar macht, veranschaulicht der Wuchs der vorgefundenen Bäume die Zeit seither und ist zusammen mit dem aufsprießenden oder niedergetretenen Gras ein Gradmesser der vergangenen und noch vergehenden Zeit.

Im Gegensatz zu den vorgenannten Beispielen braucht diese Stätte keine Pflege. Jede Gestalt, die sie annimmt, gibt einer der möglichen Bedeutungen mehr oder weniger Gewicht. Doch alle lassen ein Verhalten der Nachgeborenen zu diesem Ort ablesbar werden. Diese Schrift ist allein durch die Verwendung lebender Pflanzen möglich. Der Gedanke, daß die Natur nichts vergißt, wurde hier künstlich ins Werk gesetzt und wird noch nach Jahrzehnten feststellbar sein.

Eros und Körper
Paul-Armand Gette, Teresa Murak, Sandra Voets

Viele Künstler binden ihren Umgang mit Pflanzen an symbolische Handlungen, von denen angenommen wird, daß sie reale innere Bindungen zum Ausdruck bringen sollen. Es sind Formen der Empathie. Wenn es im folgenden darum geht, welche Formen der Umgang von Künstlern mit Pflanzen annimmt, soll offen bleiben, ob das Publikum sich den Zeichen des Ausdrucks verpflichtet fühlt. Eine weltanschauliche Betrachtung ist nicht beabsichtigt, vielmehr die Klärung der Frage nach der Verwandlung von Lust, Sorge, Schmerz in Metaphern und Bilder von Pflanzen als Gegenstand der Darstellung. Die Künstler beziehen sich auf Literatur und Ordnungssysteme, Mythos und Magie, Sex und Eros und bringen den menschlichen Körper ästhetisch in Verbindung mit Pflanzen zur Geltung. Es handelt sich um Künstler aus verschiedenen Generationen.

Paul-Armand Gette

Mitte der siebziger Jahre hat Paul-Armand Gette in Nanterre sechs Stunden lang die Pflanzennamen aus Carl von Linnés Enzyklopädie »Species plantarum« vorlesen lassen, um sich und die Zuhörer an den Namen und ihren entfachten Assoziationen zu berauschen. Linné hatte im 18. Jahrhundert alle bekannten Pflanzen erfaßt, sie nach Sexualmerkmalen (Stempel und Staubgefäße) eingeteilt und ihnen lateinische Namen gegeben. Der Aronstab hieß nun für alle Wissenschaftler verbindlich Arum und die Seerose hieß Nymphea. Gettes Lesart gewann der Wissenschaftssprache, die nicht bewußt täuschen darf, eine erotisierende Seite ab, die er durch den Akt des lauten Lesens als Fundus erregender Vorstellungen demonstrieren wollte. Hört der französischsprachige Gette Nymphea, so denkt er an Seerosen, aber auch an den Schoß einer oder mehrerer Frauen (französisch: nymphe/s) und selbstverständlich an Claude Monets Seerosenbilder. Da sich für Gette die Bedeutungen berühren, erscheinen Seerosen im Horizont von Frauenschößen und die Nympheas Monets als sublimierte Obsession.

Er wähnt, wohin er schaut, Anspielungen auf das weibliche Geschlecht. Doch wie bei Linnés Klassifikationssystem fasziniert ihn die Absichtslosigkeit der erotisierenden Konnotation. »Ich mag die Küste, den Waldrand, das Seeufer und die Stellen, wo ein Kleid oder ein Strumpf aufhört,« sagt er in einem Interview. [13] Es ist der Saum der Dinge, der ihn interessiert, der Rand, an dem etwas ein anderes berührt. Gette macht keinen prinzipiellen Unterschied zwischen Landschaft und Körper. Deshalb entdeckt er mit aufmerksam umherstreifendem Blick in Landschaft und Körper dieselben anregenden Details, die ihn durch einen plötzlichen imaginativen Übersprung zu Gedankenfluchten erregen.

Gette widmet sich den Eigennamen der Pflanzen, weniger den Pflanzen selbst. Sein Bezug ist literarisch vermittelt. Erst durch ihre Benennung werden Pflanzen Teil seiner Wahrnehmung; sie gehören ganz der Kultur. Natur – wachsend, unberechenbar, gefahrvoll, überbordend – interessiert Gette nicht. Er schätzt die Ordnung botanischer Gärten und französischer Parks. Sein Garten der Lüste ist geometrisch und kartographiert. Nur auf festgelegtem Terrain entdeckt er die Freiheit des Vieldeutigen, Vagen; auf diesen Terrains sind die Eigennamen die wahren Akteure (Abb. S. 58–59). »Es gibt keinen Botanischen Garten ohne Etiketten«, schreibt er. »Mehr noch als die Pflanzen, die im Winter verschwinden, bilden die Etiketten das Hauptelement – das absolute und permanente gemeinsame Moment.« [14]

Teresa Murak

Während Paul-Armand Gette sich auf Naturzeichen mit Arrangements ausgesuchter Künstlichkeit bezieht und keinen schlüpfrigen Anthropomorphismus ausläßt, um durch seine am Exquisiten geschulte Phantasie die Idee der Unschuld zu evozieren, setzt Teresa Murak Fruchtbarkeitsriten ins Werk, sucht den unmittelbaren Kontakt mit der zum Leben erwachenden Materie und stellt den treibenden Kräften auch ihren nackten Körper als Boden zur Verfügung. Sie tritt als Erdmutter auf, demonstriert den Vorgang vegetabilen Wachsens als zyklisches Ereignis und unterwirft sich der Zeit der Natur. 1974 legte sie sich über und über mit Kressesamen bedeckt in eine Badewanne (Abb. S. 94–95), ließ die schleimig keimenden Samen auf ihrer Haut wachsen und entstieg dem Wasser wie eines der Zwischenwesen aus Bildern des belgischen Malers Paul Delvaux: halb Pflanze, halb Weib, Haar und Haut vom Krautwuchs kaum noch zu scheiden. Im Frühling desselben Jahres säte sie Kressesamen auf feuchtes Leinen, ließ das aufsprießende Kraut verwachsen, zog das Gewebe wie ein Kleid über ihre Schultern und schritt mit aufgelöstem Haar durch die Straßen von Warschau wie eine erratische Verkörperung der Frühlingsgöttin Sandro Botticellis.

Gleichwohl spielt der Bezug auf die Liebesgöttin Venus gegenüber dem Bezug auf die Fruchtbarkeitsgöttin Demeter nur eine untergeordnete Rolle. Murak ruft die Kraft der gebärenden Natur ins Bewußtsein. Ihr Werk ist ein anhaltender Versuch, das nicht mehr Selbstverständliche – den Zyklus der Jahreszeiten und die entsprechend wachsenden Pflanzen – merkwürdig erscheinen zu lassen. »Ein Wunder, an das wir uns gewöhnt haben, bleibt dennoch das Wunderbarste, das es gibt«, [15] schreibt sie und betont damit, daß es ihr nicht um die Wahrnehmung von Oberflächenreizen und den individuellen Blick von einzelnen Kunstbetrachtern geht, sondern um eine Botschaft an die Gesellschaft. Murak macht keine Kunst, die den Augen genügen und zu angenehmen Gedanken animieren will. Ihre Aktionen in Erinnerung an vergangene Riten bestehen darin, auf das prekär gewordene »Wunder der Natur« hinzuweisen, indem sie Wachstumsprozesse unter Einsatz ihres Körpers als Handlung verdeutlicht.

Aus pragmatischen Gründen bevorzugt sie Kresse. Doch Murak geht es nicht um die Kresse als solche. Das Heilkraut ist lediglich ein probates Mittel, das Säen, Keimen, Wachsen der Pflanzenwelt darzustellen. Kresse steht für Natur, Muraks Körper für die Nährmutter. Beides verbindet sich zum Symbol »Mutter Natur« und veranschaulicht Muraks künstlerische Absichten: das Naturhafte der Natur so zur Geltung zu bringen, daß es das Publikum nachhaltig berührt. Das grüne Kleid, das Murak in den Straßen Warschaus trug, ist ein nachhaltig wirkendes archaisches Bild.

»Meine Art an die Natur zu denken, beruht darauf, daß das Denken selbst Teil der Natur ist«,[16] erklärte Murak 1989. Eine Trennung gibt es nicht. Murak achtet Naturhaftes und versucht, ihm durch symbolisches Handeln zu entsprechen. »Ich gehe von der Kenntnis meiner eigenen Substanz und der Substanz der Dinge aus. Das Bedürfnis, sich der Welt zuzuwenden, gehört zu einem begeisterten Bewußtseins.« Und es bedarf tatsächlich des Leidenschaftlichen, um inmitten industrialisierter Landwirtschaft mit künstlichen Befruchtungs- und Anbaumethoden auf »das Natürliche« der Natur zu pochen, wenn sie ihre Aktionen in den Städten Warschau, Danzig, Stockholm, Köln, Paris durchführt. Sie nimmt den Anachronismus in Kauf, paßt er doch zum Vorzeitlichen ihrer Arbeit, an das sie erinnern will.

1985 ließ sie ein Senfkorn auf einem Stein keimen, um an eine Parabel des Mystikers Gurdjeff zu erinnern, die von einem Gefangenen in einem Verließ handelt, der ein Saatkorn zwischen den Seiten eines Buches fand und es in einem feuchten Mauerriß keimen ließ. Obgleich die Parabel verschiedene Deutungsmöglichkeiten zuläßt und Paul-Armand Gette wohl an die Fruchtbarkeit der Wörterwelt erinnert hätte, interpretiert Murak das Beispiel nicht in bezug auf den Fundort metaphorisch, sondern in bezug auf das reale Potential pragmatisch. »Das Saatkorn kann für einen Gefangenen wie die Luftzufuhr für einen Erstickenden sein.«[17]

In ihren Arbeiten sind Handlung und Darstellung ein dynamisches Paar. Der Sinn der Kunst zeigt sich im Sinn der Handlung. Deshalb erscheint sie in der Kunstwelt als Performerin, doch ihr Ziel ist das Ritual. In der Art wie sie selbst die Samen setzt und als Mutter Natur zum Wachsen bringt, vermutet man heidnische Wurzeln. Murak läßt ihre »Aktionen« oft an hohen Feiertagen der katholischen Kirche stattfinden, vor allem an Ostern und Pfingsten. Für den Ostersamstagsgottesdienst kultivierte sie in ihrem Geburtsort Kielczewice (Polen) einen 70 Meter langen Kresseteppich und rollte ihn durch das Kirchenportal bis zum Altar. Ihre Handlungen suchen die Gemeinschaft und den Glauben.

Sandra Voets

1993 legte Sandra Voets in eine neonbeleuchtete Vitrine Narzissenzwiebeln, die sie mit grellgrünem Gummi enganliegend wie eine weitere Haut überzogen hatte. Die Wurzeln saugten an einer grüngefärbten Nährflüssigkeit. Einige Zwiebeln sprengten das Gummi, wuchsen mit Hilfe einer hohen Düngerkonzentration schnell und gingen dann abrupt ein. Von dieser auf Ekstase getrimmten Versuchsanordnung, die schnell, stumm, brutal ein Ereignis wie einen Labortest produzierte, bleiben neben dem Titel *forever young* (Abb. S. 129) eine Video- und Fotodokumentation. Ereignisse lassen sich nicht konservieren; doch als Variable sind sie wiederholbar.

1995 zeigte sie unter dem Titel *Dripping Flowers* (Abb. S. 159) ein dreiteiliges Arrangement mit Schnittblumen. Auf drei satinbespannten Kissen lagen zwei Anthurien und ein Frauenschuh. Die Stengel waren in Reagenzgläser eingeführt. Aus einem Tropfhahntrichter tröpfelte auf jede Blume Wasser, näßte und verfärbte den Satin und fiel laut auf ein blechernes Bassin. Der Stoff warf unter dem Wasser dunkle Falten. Das Trommeln der Tropfen erhöhte die Spannung des visuell ohnehin hochcodierten Spannungsfeldes. Die aufgeblähten Lippen des kelchartigen Frauenschuhs, dessen Geschlechtsorgane sich an der Oberseite befinden, und die beiden wie Hörner aufragenden Stäbe der Anthurien wiesen durch Ähnlichkeit mit Geschlechtsmerkmalen auf eine sexuelle Bedeutung. Der Frauenschuh war nicht als Frauenschuh und die Anthurien nicht als Anthurien gemeint. Das Arrangement wies mit seinen starken Anspielungen auf ein ebenso kränkelndes wie erotisierendes Feuchtklima, in dem die zentral präsentierten Blumen selbst keine Kraft mehr hatten. Sie wurden wie Invaliden in einer Intensivstation am Tropf gehalten. Das Publikum wußte, daß das Wohlergehen der Blumen nur von der Technik abhing.

Voets rechnet mit einem Publikum, das Blumen in Reinheit und Unschuld für ein Naturgewächs hält, aber gleichwohl weiß, daß sie ebensowenig natürlich wie erotisch sind; beides sind Phänomene der Einbildungskraft. Da Voets das Natürliche und das Erotische als Konstruktion zum Ereignis macht, wird der Abstand zum Natürlichen der Natur ebenso deutlich wie umgekehrt zum Erotischen der Sexualität.

Sie inszeniert Blumen als Industrieprodukt und versachlicht Vorstellungen von der Schönheit der Pflanzen als Wunder der Natur. Die Blumen sind von der Natur abgeschnitten. Die Zwiebeln sind entwurzelt und wachsen unter Laborbedingungen. Die Pflanzen bürgen für keine Natursubstanz. Während Teresa Murak Naturerfahrung als ritualisierte Erinnerung theatralisiert und dabei das Wachsen und Gedeihen als Vorgang vorführt, ist bei Voets die Künstlichkeit der Naturerscheinungen konstitutiv: ein artifizielles Paradies technoider Phantasien.

Natur ist ein aus dem Zusammenhang gerissenes groteskes Zitat ohne Natursubstanz, und die Blumen in der Vitrine erscheinen wie Wunden, die die Technik ebenso schlug wie erhält. Und doch arrangiert Voets die Blumen solcherart, daß sie auch als Metaphern für Sexualität aufgefaßt werden können; sie wird jedoch von keinem Glücksversprechen begleitet, sondern von einer Todesbotschaft. Der entsetzte Blick auf die Natur schließt den Gedanken an Endlichkeit ein. Was bleibt, stiftet der ästhetische Reiz des Ereignisses durch den Bruch der Kontinuität im Abseits eines Galerieraums.

Voets wie Murak inszenieren wiederholbare zeitlich begrenzte Vorgänge. Murak betont die natürlichen Triebkräfte, Voets die konservierende Technik. Während aber Murak und Voets trotz

der diametral entgegengesetzten Botschaften den menschlichen Körper und die Pflanze direkt aufeinander beziehen, genießt Gette die imaginative Kraft der Sprache, in der die Naturanschauung als Idee überlebt.

1 A. Le Blond, *Theorie et Pratique du Jardinage*, Paris 1709, S. 16; zitiert nach: Marie Luise Gothein, *Geschichte der Gartenkunst*, Bd. 2, 3. Aufl., München 1994, S. 191

2 Alexander Pope, in: *The Guardian*, September 1713, Nr. 173 ; zitiert nach: Marie Luise Gothein, *Geschichte der Gartenkunst*, Bd. 2, 3. Aufl., München 1994, S. 396

3 Hans von Trotha, *Der Englische Garten. Eine Reise durch seine Geschichte*, Berlin 1999, S. 12

4 Gérard Lapalus, »Heureux, comme Ulysse...«, in: *Didier Trenet. Le jardin de ma mère – Études et Ruines*, Ausst.-Kat. Centre Georges Pompidou, Paris 1997

5 Daniel Birnbaum, »A thousand words, Tobias Rehberger talks about his garden«, *Artforum*, November 1998, S. 100

6 »Tobias Rehberger – Garten als Skulptur oder Garten meets Schneekanone. Ein Gespräch von Brigitte Franzen«, *Kunstforum International*, Band 145, Mai/Juni 1999, S. 119

7 *Magazzino*, Ausst.-Kat. anläßl. der Biennale Venedig 1997, hrsg. v. Ministerium f. Kultur Luxemburg, Luxemburg 1997

8 Gloria Friedmann, »Hier + Jetzt«, in: Ausst.-Kat. *Hier + Jetzt*, hrsg. v. Achim Könneke, Hamburg 1998, S. 4

9 Ebd., S. 30

10 Sabine Dylla, »Gedanken zu einem Kunstwerk gegen den Krieg«, in: Ausst.-Kat. *Jenny Holzer – Black Garden*, hrsg. v. Sabine Dylla, Städtische Galerie Nordhorn, 1994, S. 4

11 Justin Hoffmann, »Jenny Holzer – Garten in Schwarz«, in: Ausst.-Kat. *Jenny Holzer – Black Garden*, hrsg. v. Sabine Dylla, Städtische Galerie Nordhorn, 1994, S. 71

12 Ebd., S. 73

13 »Paul-Armand Gette, Le Retour de L'Imaginaire«, Interview von Catherine Francblin, *art press*, no. 174, November 1992

14 Paul-Armand Gette, »Von der Berührung des Modells zum Vulkanismus der Leidenschaft«, in: Gerhard Fischer (Hg.), *Dädalus – Die Erfindung der Gegenwart*, Wien 1990, S. 389 ff.

15 Jaromir Jedlinski, »Les semailles et la glane«, in: Ausst.-Kat. *Teresa Murak*, Galerie Faust Rosa Turetsky, Genf 1992

16 Ebd.

17 Ebd.

BIOGRAPHIES, EXHIBITIONS, BIBLIOGRAPHIES

Vito Acconci
* 1940, New York
Lives in New York

Selected Solo Exhibitions
1998 Barbara Gladstone Gallery, New York
1997 Ota Fine Arts, Tokyo
1996 Galerie Monika Sprüth, Cologne
Living off the Museum, Centro Galego de Arte Contemporánea,
Santiago de Compostela, Spain
Public Spaces, Klosterfelde Gallery, Berlin
1993 Österreichisches Museum für Angewandte Kunst, Vienna
1988 *Vito Acconci: Public Places*, The Museum of Modern Art,
New York

Selected Group Exhibitions
1997 *In Site 97*, San Diego, Tijuana, New Projects in Public Spaces
by Artists of the Americas
documenta X, Kassel, Germany
1996 *NowHere*, Louisiana Museum of Modern Art, Humlebaek,
Denmark
1994 *Tradition and Invention – Contemporary Artists Interpret the
Japanese Garden*, Sogetsu Plaza, Sogetsu Kaikan, Japan
1992 *Allocations/Art for a Natural and Artificial Environment*, Floriade,
Zoetermeer, The Netherlands

Selected Site Projects
1994 *Personal Island*, Zwolle, The Netherlands
1993 *Personal River*, Tyne, Newcastle, United Kingdom
1991 *Land of Boats* – Project for St. Aubin Park, Detroit

Selected Bibliography
Philip Nobel, 'As Always, Please Touch', *New York Times*, April 8,
1999
Melanie Marino, 'Vito Acconci at Barbara Gladstone', *Art in America*,
Nov. 1998
Hans-Ulrich Obrist, 'Interview with Vito Acconci', in: exh. cat. *Kün-
stlerInnen*, Kunsthaus Bregenz, 1997
José Luis Brea, 'Vito Acconci – Centro Galego de Arte Contempo-
ránea', *Artforum*, September 1996, p. 117.
Maria Linda and Sina Najafi, 'Vito Acconci', *Index*, January 1996,
pp. 24–27
Suzanne Lazy, 'Mapping the Terrain', in: *New Genre Public Art*,
Seattle, Washington, 1995, pp. 193–194
Kate Linker, *Vito Acconci*, New York, 1994
Vito Acconci Making Public, exh. cat. Stroom, The Hague's Center for
Visual Arts, Netherlands, 1993
Vito Acconci: The City Inside Us, exh. cat. Museum für Angewandte
Kunst, Vienna, 1993
Vito Acconci: Public Places, exh. cat. Museum of Modern Art,
New York, 1988

Selected Writings by the Artist
'Bodies of Land', *Transcript*, Volume 1, Issue 2, 1998, pp. 5–33
'Parks, Streets, and Vehicles', *Grand Street*, No. 54, Fall 1995,
pp. 24–33

Knut Åsdam
* 1968 Trondheim, Norway
Lives in New York City and Son, Norway

Selected Solo Exhibitions
1998 Contemporary Art Center, Vilnius, Lithuania
1994 Galleri Riis, Oslo, Norway

Selected Group Exhibitions
1999 *Biennale di Venezia*, Venice, Italy
The Melbourne International Biennal, Melbourne, Australia
1998 *Nordic Nornacis*, White Columns, New York
Nuit Blanche, Musee d'Art Moderne de la Ville de Paris, Paris
1996 *Departure Lounge*, P.S. 1 Contemporary Art Center, New York
Museum Clocktower Gallery, New York
1995 *Nord in America*, Thomas Nordanstad Gallery, New York

Selected Bibliography
Gregory Williams, 'Nordic Nomads', *Frieze*, No. 45, 1999
Benedict Borthwick, 'D/Y Mapping and Instruction', *Index*, No. 1, 1998
Benedict Borthwick, 'Queering Space', (Interview), *Index*, No. 3–4,
1996

Stefan Banz
* 1961 Sursee, Switzerland
Lives and works in Lucerne, Switzerland

Selected Solo Exhibitions
2000 *Gulliver*, Migros Museum, Museum für Gegenwartskunst, Zurich
1999 *Dewil's Guest & Cave's Loverman*, Stadtgalerie, Bern (with Erik
Dettwiler)
Ars Futura Galerie, Zurich
A Shot Away Some Flowers, MAMCO, Geneva
1996 *Dive – Give the people what they want*, OK, Linz
1995 *Gras*, Sponsored Booth, Art 26/95, Basel (Ars Futura Galerie,
Zurich)
1992 *Der Anbau des Museums*, (with Jaques Derrida, Wada Jossen,
Theo Kneubühler, Harald Szeemann), Kunsthalle Luzern

Selected Group Exhibitions
1999 Stalke Galleri, Kopenhagen
D. A. CH., Galerie Krinzinger, Vienna
1998 *Nonchalance*, Akademie der Künste, Berlin
Freie Sicht aufs Mittelmeer, Kunsthaus Zürich, Zurich

Selected Bibliography
Christoph Doswald, 'The Origin of the World', in: Stefan Banz, 'I Built
This Garden For Us', Zurich, 1999
Christoph Doswald, 'Stefan Banz? Wirkliche Wirklichkeit', in: Stefan
Banz, 'A Shot Away Some Flowers', Zurich, 1999
Paolo Bianchi, 'Ästhetik der Existenz', *neue bildende Kunst*, Berlin,
June 1996
Stefan Banz, 'Der Anbau des Museums' Kunsthalle Luzern, *Artis –
Zeitschrift für Neue Kunst*, No. 5, 1992

Lothar Baumgarten
*1944 Rheinsberg, Germany
Lives in Dusseldorf, Germany

Selected Solo Exhibitions
1998, 1991, 1988, 1987, 1985 Marian Goodman Gallery, New York
1995 *Theatrum Botanicum*, Fondation Cartier pour l'art contemporain, Paris
1994 *Silencium*, Transmission Gallery, Glasgow
1993 *Eklipse*, Portikus, 52. Ausstellung, Frankfurt/M., Germany
AMERICA Invention, The Solomon R. Guggenheim Museum, New York
1986 *Accès aux Quais* Tableaux Parisiens, ARC Musée d'Art Moderne de la Ville de Paris
1985 *Tierra de los Perros Mudos*, Stedelijk Museum, Amsterdam
1984 German Pavilion, with A.R. Penck, Biennale di Venezia
1972 *Guyana*, Konrad Fischer Gallery, Dusseldorf

Selected Group Exhibitions
1999 *The Museum as Muse*, The Museum of Modern Art, New York
1997, 1992, 1982, 1972 *documenta*, Kassel
1996 *Project for Survival*, The National Museum of Modern Art, Kyoto, traveling to the National Museum of Modern Art, Tokyo
1991 *Carnegie International*, Duquesne University, Pittsburgh
1990 *Life-Size, A Sense of the Real in Recent Art ...*, The Israel Museum, Jerusalem
1987 *Skulptur. Projekte*, Münster
1983 Internationale Filmfestspiele Berlin 'Forum'. *Der Ursprung der Nacht (Amazonas Kosmos)*, 1978
1974 *Project '74*, Kunsthalle Köln, Tropenhaus, Botanical Garden, Cologne

Selected Bibliography
Thomas Wagner, 'Schrift an der Wand', in: *Eklipse*, Richter Verlag, Dusseldorf, 1997
Lothar Baumgarten, 'Theatrum Botanicum', *Pages paysages*, Contacts, Paris, 1996–97, pp.40–48
Lothar Baumgarten, 'Theatrum Botanicum', Fondation Cartier pour l'art contemporain, May 1994
Günter Metken, 'Botanisches Theater', *Frankfurter Allgemeine Zeitung*, July 23, 1994, p. 26
Hal Foster, 'The Writing on the Wall' *AMERICA Invention*, in: exh. cat. Solomon R. Guggenheim Museum, New York, 1993, pp. 6–14,
Friedrich W. Heubach, 'Kultur und Natur oder die Natur ist ziemlich komisch geworden', in: *Interfunktionen* 9, 1972, pp. 42–56
Craig Owens, 'Improper Names', *Art in America*, New York, October 1986, pp. 126–135, 187
Christopher Knight, 'Carbon', *Los Angeles Times*, 13 April 1990
Jürgen Hohmeyer, 'Auf dem Amazonas wandeln', *Der Spiegel*, Hamburg, 4 June 1984, pp. 187–189
Günter Metken, 'Der Regenwald – Tanzplatz der Bäume', *Frankfurter Allgemeine Zeitung*, Frankfurt/M., January 17, 1983, p. 19
Peter Steinhart, 'Tropenhaus', *Rheinische Post*, July 19, 1974, Dusseldorf

Selected Artist's Publications
AMERICA Invention, Solomon R. Guggenheim Museum, New York, 1993
Carbon, Museum of Contemporary Art, Los Angeles/Pentti Kouri, 1991
Makunaima, Marian Goodman Gallery, New York, 1987
Tierra de los Perros Mudos, Stedelijk Museum, Amsterdam, 1985
Die Namen der Bäume, Van Abbemuseum, Eindhoven, 1982

Joseph Beuys
*1921 Krefeld, Germany
Died 1986 in Dusseldorf, Germany

Selected Exhibitions and Performances
1997 Opening of the Museum Castle Moyland, Germany, with Beuys works from the Brothers van der Grinten Collection
1985–86 *Project Rieselfelder/Münster*, Münster, Germany, unfinished project
1982, 1977, 1972, 1968, 1964 *documenta*, Kassel
1980 *Retrospective*, Solomon Guggenheim Museum, New York
1974 *Coyote*, Galerie René Block, New York
1965 *Wie man dem toten Hasen die Bilder erklärt*, (performance), Galerie Schmela, Dusseldorf , Germany

Selected Site Project
since 1982 *7000 Eichen*, initiated at documenta 7, Kassel, Germany

Selected Bibliography
Armin Zweite (ed.), *Joseph Beuys – Natur Materie Form*, exh. cat. Kunstsammlung Nordrhein-Westfalen, Dusseldorf, Munich, 1992
Carin Kuoni (ed.), *Energy Plan for the Western Man: Writings by and Interviews with the Artist*, New York, 1990
Stephan von Borstel (ed.), *Die unsichtbare Skulptur: Zum erweiterten Kunstbegriff von Joseph Beuys*, Free International University, Kassel, Stuttgart, 1989
Fernando Groener and Rose-Maria Kandler (ed.), *7000 Eichen: Joseph Beuys*, Essays by Joseph Beuys, Richard Demarco, Johannes Stüttgen, Rhea Thönges-Stringaris, Cologne, 1987
Karl Heinrich Hülbusch and Norbert Scholz, *Joseph Beuys, 7000 Eichen: Zur documenta 7 in Kassel*, Kassel, 1984
Theodora Vischer, *Beuys und die Romantik: Individuelle Ikonographie, individuelle Mythologie*, Cologne, 1983
Richard Demarco, 'Conversations with Artists: Richard Demarco interviews Joseph Beuys, London (March 1982)' *Studio international* (London), vol. 195, September 1982, pp. 46–47
Donald B. Kuspit, 'Beuys: Fat, Felt and Alchemy', *Art in America*, vol. 68 (May 1980), pp. 78–89
Kim Levin, 'Joseph Beuys: New Order', *Arts Magazine*, vol. 54 (April 1980), pp. 154–57

Michel Blazy
*1966 Monaco
Lives in Paris

Selected Solo Exhibitions
1998 *Le Multivers*, Galerie Art:Concept, Paris
The Life of Things, Correct Contemporary Exhibitions, New York
Bulb (with Hugues Reip), MIRE Art Contemporain, Geneva
1997 *La vie des choses*, ARC, Musée d'Art Moderne de la ville de Paris, Paris
1995 Art Cologne, Förderprogramm, Galerie Art:Concept, Cologne
1992 *L'escargorium n°1*, Art:Concept, Nice

Selected Group Exhibitions
1999 *I never promised you a Rosegarden*, Kunsthalle Bern
Paris en création, Sétagaya Museum, Tokyo; Museum of the City of Nagoya, Hokkaido Museum of Modern Art, Hiroshima Museum of Modern Art
1998 *Organic*, Espace d'art moderne et contemporain, Toulouse
1997 *Coincidences*, Fondation Cartier pour l'art contemporain, Paris

1996 *L'art du plastique*, Ecole Nationale Supérieur des Beaux-Arts, Paris
1995 *Making Out*, Transmission Gallery, Glasgow

Selected Site Project
since 1999 *Chateau de terre*, KünstlerGärten Weimar, Bauhaus-Universität Weimar

Selected Bibliography
Philippe Regnier, 'Organiquement votre', *Journal des Arts*, No. 74, January 1999
Anne Dagbert, 'Review: Michel Blazy', *Artforum*, No. 37, Nov. 1998, p. 123
Lucius Burkhardt, 'Kommt der Garten ins Haus?', *Basler Magazin*, No. 14, April 1998, p. 12
Francoise Nyffenegger-Ninghetto, 'Michel Blazy et Hugues Reip', *Kunst Bulletin*, (Zurich), April 1998
Armelle Leturcq, 'Le Crestet', *Blocnotes* No. 13, 1996, p. 107

Cosima von Bonin
* 1962 Mombasa, Kenya
Lives in Cologne, Germany

Selected Solo Exhibitions
1999 Kunsthalle St. Gallen, St. Gallen
1997 *Löwe im Bonsaiwald*, Galerie Christian Nagel, Cologne
1996 *Heetz, Nowak, Rehberger*, Museum Abteiberg Mönchengladbach (with Kai Althoff and Tobias Rehberger)
1993 American Fine Arts, New York
1991 Andrea Rosen Gallery, New York

Selected Group Exhibitions
1997 *Home Sweet Home*, Deichtorhallen, Hamburg
1996 *NowHere (Incandescent)*, Louisiana Museum of Modern Art, Humlebaek/Denmark
nach Weimar, Kunstsammlungen zu Weimar
1993 *Kontext Kunst*, Neue Galerie am Landesmuseum Joanneum & Künstlerhaus Graz

Selected Site Project
since 1998 *Mrs. Littlewood*, KünstlerGärten Weimar, Bauhaus-Universität Weimar

Selected Bibliography
Thomas Eggerer, 'Spurensuche im Bonsaiwald. Einige Aspekte in den neueren Arbeiten von Cosima von Bonin', *Texte zur Kunst*, Cologne, No. 29, March 1998, pp. 68–76
Zdenek Felix (ed.), *Home Sweet Home*, Oktagon Verlag, Cologne, 1997
D. Buchholz, C.v. Bonin, C. Müller, *Glockengeschrei nach Deutz – Das beste aller Seiten*, Cologne, 1997
Isabelle Graw: 'Cosima von Bonin. Warum hat die es geschafft? Der Bürgertraum vom Adelsschloß', *Artis* No. 5, 1995, pp. 48–55
Joshua Decter: 'Cosima von Bonin', *Arts Magazine* No. 10/1991, p. 99

Daniel Buren
* 1938 Boulogne-Billancourt, France
Lives in Paris

Selected Bibliography
Au sujet de … Daniel Buren, entretien avec Jérôme Sans, Flammarion, Paris, 1998
A force de descendre dans la rue, l'art peut-il enfin y monter?, ed. Sens & Tonka, Paris, 1998
Daniel Buren, Erscheinen Scheinen Verschwinden, exh. cat. Kunstsammlung Nordrhein-Westfalen, Dusseldorf, 1996
Jean-Marc Poinsot (ed.), *Daniel Buren. Les Ecrits (1965–1990)*, vol. 1–3, CAPC, Musée d'art contemporain de Bordeaux, Bordeaux, 1991
Daniel Buren. Hier und da. Arbeiten vor Ort, exh. cat. Staatsgalerie Stuttgart, 1990
Daniel Buren, 'Les images volées', in: *Les magiciens de la terre*, exh. cat. Musée National d'Art Moderne, Centre Georges Pompidou, Paris, 1989, pp. 111–112

Maurizio Cattelan
* 1960 Padova, Italy
Lives in Milan, Italy

Selected Solo Exhibitions
1997 Castello di Rivoli, Turin
Moment Ginza, Le Magasin, Centre National d'Art Contemporain, Grenoble
Espace Jules Verne, Bretigny-Sur-Orge
1996 Laure Genillard Gallery, London
Ars Futura, Zurich

Selected Group Exhibitions
1998 *Manifesta 2*, Luxembourg
Artificial, Museo de Arte Contemporáneo, Barcelona
Wounds, Moderna Museet, Stockholm
1997 *Skulptur. Projekte in Münster*, Münster
Delta, Arc Musée d'Art Moderne de la Ville de Paris, Paris

Selected Bibliography
Pierre Leguillon. 'Maurizio Cattelan', *Art Press*, February 1999
'Maurizio Cattelan', *Flash Art*, Dec. 1998/Jan. 1999
Projects 65. Maurizio Cattelan, exh. cat. The Museum of Modern Art, New York, 1998
Maurizio Cattelan, exh. cat. Wiener Secession, 1997
Elizabeth Janus, 'M. Cattelan', *Frieze*, No. 34, May 1997

Mel Chin
* 1951 Houston, Texas
Lives in Burnsville, North Carolina, and New York

Selected Solo Exhibitions
1991 Menil Collection, Houston/Texas
1990 *Viewpoints*: Mel Chin, Walker Art Center, Minneapolis
1989 *Directions*: Mel Chin, Hirshhorn Museum and Sculpture Garden, Washington, D.C.
1988 *Selected Weapons*, Frumkin/Adams Gallery, New York

Selected Group Exhibitions
1997 *In the Name of the Place*, Museum of Contemporary Art, Los Angeles

1996 *Art at the End of the 20th Century*, Whitney Museum, New York
1994 *Black Male – Representations of Masculinity in Contemporary American Art*, Whitney Museum of American Art, New York
Landscape As Metaphor, Denver Art Museum
1993 *Differentes Natures*, La Defense, Paris
1992 *Fragile Ecologies*, The Queens Museum of Art, New York
1992 *Allocations: Art for a Natural and Artificial Environment*, Floriadepark, Zoetermeer, Netherlands

Selected Site Projects
1996–1998 *Houston Sesquicentennial Park Monument*, Houston/ Texas
1995 *Landmind*, West Queens High School, Percent for Arts Commission, New York
1992 *Revival Field*/Netherlands: Simultaneous Replicated Field Test, initiated spring 1992
1989–1993 *Revival Field*, Pig's Eye Landfill, St. Paul/Minnesota, Pennsylvania

Selected Bibliography
Joshua Decter, 'Prime Time: In the Name of the Place of Art and Television', in: exh. cat. *In the Name of the Place*, Grands Arts, Kansas City, 1998
Christopher Knight, 'The Socio-Art Genre', *Los Angeles Times*, Section F, March 18, 1997, p. 1
John Beardsley, 'Mel Chin', in: *Visions of America: Landscape as Metaphor in the Late Twentieth Century*, Denver Art Museum And Columbus Art Museum, 1994
Eleanor Heartney, 'Skeptics in Utopia', *Art in America*, July 1992, pp. 76–81
Marcia Tanner, 'A Conversation with Mel Chin', *Artweek*, June 18, 1992, p. 5
Kim Levin, 'Eco-Offensive Art', *The Village Voice*, Vol. 36, No. 1, January 1, 1991, p. 33
Peter Boswell, *Viewpoints: Mel Chin*, Walker Art Center, Minneapolis, 1990

Agnes Denes
* 1938 Budapest, Hungary
Lives in New York

Selected Solo Exhibitions
1992 Herbert F. Johnson Museum, Cornell University, New York
1975 Corcoran Gallery of Art, Washington, D.C.

Selected Group Exhibitions
1978, 1980 *Biennale di Venezia*, Venice, Italy
1977 *documenta 6*, Kassel, Germany

Selected Environmental Sculptures
1998 *A Forest for Australia*, Altona Treatment Plant, Melbourne
1995 *On the Edge*, commissioned by the Artists Museum, Mitzpe Ramon, Israel
1992–1996 *Tree Mountain – A Living Time Capsule*, Pinzio gravel pits, Ylöjärvi, Finland
1982 *Wheatfield – A Confrontation*, Battery Park landfill, Downtown Manhattan
1968 *Rice/Tree/Burial*, Sullivan County, New York

Selected Bibliography
Agnes Denes, 'Wheatfield – A Confrontation', and 'Tree Mountain – A Living Time Capsule', in: Jeffrey Kastner (ed.), *Land and Environ-*

mental Art, Phaidon Press, London, 1998, pp. 261–262, pp. 160–161
Agnes Denes, 'Notes on Eco-Logic: Environmental Artwork, Visual Philosophy and Global Perspective', *Leonardo*, Vol. 26, No. 5, 1993, pp. 387–395
Agnes Denes, exh. cat. Herbert F. Johnson Museum, Cornell University, Ithaca, N.Y., 1992

Mark Dion
* 1961 New Bedford, Massachusetts
Lives in Pennsylvania

Selected Solo Exhibitions
1999 *Tate Thames Dig*, Tate Gallery of Modern Art, London
Private Property, Galerie für Landschaftskunst, Hamburg
1998 *Adventures in Comparative Neuroanatomy*, Deutsches Museum, Bonn, Germany
1996 *A Tale of Two Seas ...*, Galerie Christian Nagel, Cologne
Two Trees, American Fine Arts Co., New York
1990 *Biodiversity: An Installation for the Wexner Center*, Wexner Center for Visual Arts, Columbus/Ohio, (with William Schefferine)

Selected Group Exhibitions
1999 *Natural Reality. Künstlerische Positionen zwischen Natur und Kultur*, Ludwig Forum, Aachen, Germany
La Ville, le Jardin, la Mémoire, Villa Medici, Rome
1998 *post naturam – nach der Natur*, Geologisch-Paläontologisches Museum Münster/Hessisches Landesmuseum Darmstadt, Germany
1997 Scandinavian Pavilion, Biennale di Venezia, Venice, Italy
Skulptur. Projekte in Münster, Münster, Germany
1996 *Hybrids*, De Appel, Amsterdam

Selected Site Project
1996 *The Tasting Garden*, Harewood House, Leeds, England

Selected Bibliography
Mark Dion, eds. L.G. Corrin, M. Kwon, N. Bryson, Phaidon Press, London, 1997
Mark Dion: The Museum of Natural History and Other Fictions, exh. cat. Ikon Gallery, Birmingham; Kunstverein Hamburg, 1997
Gerhard Theewen, 'Mark Dion, Where are You Now?: The Attempt to Correspond with a Travelling Artist', Künstlerhaus Bethanien, Berlin, 1996
Mark Dion, ' Füllung des Naturhistorischen Museums', *Texte zur Kunst*, Cologne, November 1995
Jean Fisher, in: *Cocido y Crudo*, exh. cat. Museo Nacional Centro de Arte Reina Sofia, Madrid, 1994
Die Wunderkammer, exh. cat. K-Raum Daxer, Munich, 1993
Bruce Ferguson, in: *On taking a normal situation ...*, exh. cat. Museum van Heedendaagse Kunst, Antwerp, 1993
Joshua Decter, 'Mark Dion at American Fine Arts Co.', *Flash Art*, Milan, Summer 1992

Ian Hamilton Finlay

* 1925 Nassau, Bahamas
Lives in Dunsyre, Scotland

Selcted Solo Exhibitions
1999 Nolan/Eckman Gallery, New York
1995 *Stones & Leaves*, The Houghton Library, Harvard University, Boston
1993 *Wildwachsende Blumen*, Lenbachhaus Munich, Germany
A Wartime Garden, Tate Gallery, London
1992 *Instruments of Revolution and other Works*, Institute of Contemporary Art, London
1990 Kunsthalle Basel, Basle
Idylls, Victoria Miro Gallery, London
1987 *Inter Artes et Naturam*, Musée d'Art Moderne de la Ville de Paris
1980 *Nature Over Again After Poussin*, Collins Exhibition Hall, University of Strathclyde, Glasgow
1977 Serpentine Gallery, London

Selected Group Exhibitions
1997 *The Pleasure of Reading*, John Gibson Gallery, New York
1996 *Public Works*, Peninsula & Van Abbemuseum, Eindhoven, Netherlands
1990 *Von der Natur in der Kunst*, Exhibition of Wiener Festwochen 1990, Messepalast Halle E, Vienna
1987 *documenta 8*, Kassel

Selected Site Projects
1999 Wallraf-Richartz-Museum, Cologne, Germany
1994 Laumeier Sculpture Park, St.Louis, USA
1992 Floriadepark, Zoetermeer, Netherlands
1989 Forest of Dean, England
1987 Furka Pass, Switzerland
Skulptur. Projekte in Münster, Münster, Germany
1982 Kröller-Müller Sculpture Garden, Otterlo, Netherlands
Since 1966 Stonypath Garden, Little Sparta, Scotland

Selected Bibliography
Ian Hamilton Finlay, Pia Maria Simig, Werner J. Hannapel, *Little Sparta – Der Garten/The Garden*, Wild Hawthorn Press, Stonypath 1998
Udo Weilacher, 'Lyrik in ungebändigter Wildnis – Ian Hamilton Finlay', in: Udo Weilacher, Zwischen *Landschaftsarchitektur und Land Art*, Birkhäuser Verlag, Basel, 1996
Works in Europe 1972–1975, ed. Zdenik Felix & Pia Simig, Stuttgart, 1995
Karl Schawelka, 'Ian Hamilton Finlay and Garden Art', *wachsen – Work at the Artists' Gardens Weimar*, No. 1, 1995, ed. Barbara Nemitz, Bauhaus-Universität Weimar, pp. 36–37
Wildwachsende Blumen, Städtische Galerie im Lenbachhaus München, Munich, 1993
A Wartime Garden, Graeme Murray Gallery, Edinburgh, 1990
The Garden on the Hill, Christine Burgin Gallery, New York, 1990
Un Paysage, ou 9 vues du jardin de Ian Hamilton Finlay, ed. Daniel Boudinetin, Fondation Cartier pour l'Art Contemporain, Jouy-en-Josas, 1987

Nina Fischer/Maroan El Sani

Nina Fischer
* 1965 Emden, Germany
Lives in Berlin
Maroan El Sani
* 1966 Duisburg, Germany
Lives in Berlin

Selected Solo Exhibitions
1999 Städtische Galerie für Gegenwartskunst, Dresden
1998 Tokyo Metropolitan Museum of Photography, Tokyo
Galerie Eigen + Art, Berlin
Galerie Meile, Lucerne
1996 Galerie P-House, Tokyo
Grenzenlos – Berlin in Moskau, Galerie L, Moscow

Selected Group Exhibitions
1998 *Berlin Biennale*, Plattform, Berlin
ISEA, Liverpool, Manchester
art club berlin, Mies van der Rohe Pavilion, Barcelona
1997 *Correspondences: Berlin – Scotland*, National Galleries of Scotland, Edinburgh/Berlinische Galerie, Berlin
1996 *After dark*, Stichting de Appel, Amsterdam
Surfing Systems, Kasseler Kunstverein, Fridericianum, Kassel
1995 *Beyond the Borders*, Kwangju Biennale 95, South Korea
1994 Independant Art Space, London

Selected Films
1998 *Klub 2000 – Rom, Paris, Marzahn*, feature film
1996 *Familyland*, feature film
1995 *Be supernatural*, infomercial

Selected Bibliography
Revolution 98, Ninth international Symposium on Electronic Art, ISEA 98, FACT, Liverpool, 1998
'Berlin 97 – Surge to the Mitte', *Art in America* , No. 1, 1997, p. 60
Krystian Woznicki, *Don't trust technology*, Gallery P-House, Tokyo, 1996
Surfing Systems, exh. cat. Kasseler Kunstverein, Kassel, 1996
Urbane Legenden – Berlin, exh. cat. Staatliche Kunsthalle Baden-Baden, 1995

Peter Fischli/David Weiss

Peter Fischli
* 1952 Zurich, Switzerland
Lives in Zurich
David Weiss
* 1946 Zurich, Switzerland
Lives in Zurich

Selected Solo Exhibitions
1999 Matthew Marks Gallery, New York
Musée d'Art Moderne de la Ville de Paris
1998 *Arbeiten im Dunkeln*, Kunstmuseum Wolfsburg
1997 *In a Restless World*, Institute of Contemporary Art, University of Pennsylvania, Philadelphia; Wexner Center for the Arts, The Ohio State University, Columbus; San Francisco Museum of Modern Art; Institute of Contemporary Art, Boston; Serpentine Gallery, London; Kunsthaus Zürich, Zurich
1995 *XLVI Biennale di Venezia*, Swiss Pavilion
1994 Sonnabend Gallery, New York

1992 Musée National d'Art Moderne, Centre George Pompidou, Paris
1988 Institute of Contemporary Art, London
1983, 1985, 1987, 1989, 1995, 1998 Monika Sprüth Galerie, Cologne

Selected Group Exhibitions
1998 *11th Biennale of Sidney*
Freie Sicht aufs Mittelmeer, Kunsthaus Zürich, Zurich
1997 *Skulptur.Projekte*, Münster
documenta X, Kassel
1992 *Double Take*, Hayward Gallery, London
1987 *documenta 8*, Kassel
1986 *Swiss Pralinés*, Forum Stadtpark, Graz

Site Project
1997 *Garten* (Garden), Private garden, Münster

Selected Bibliography
Peter Fischli/David Weiss – Gärten, ed. Florian Matzner, Cologne, 1998
Peter Fischli/David Weiss – Arbeiten im Dunkeln, exh. cat. Kunstmuseum Wolfsburg and Walker Art Center, Minneapolis; Ostfildern, 1997
Peter Fischli et David Weiss, exh. cat. Musée national d'art moderne, Centre George Pompidou, Paris, 1992
Boris Groys, 'Peter Fischli/David Weiss', in: *Parkett*, No. 40/41, 1994

Sylvie Fleury
* 1961 Geneva, Switzerland
Lives in Geneva

Selected Solo Exhibitions
1999 Villa Merkel, Galerien der Stadt Esslingen am Neckar, Esslingen
Sylvie Fleury, ACE Contemporary Exhibitons, Los Angeles
1998 *Hot Heels*, Migros Museum, Museum für Gegenwartskunst, Zurich,
1997 *Is Your Makeup Crashproof?*, Postmasters Gallery, New York,
1996 *First Spaceship on Venus*, Musée d'art moderne et contemporain, Geneva

Selected Group Exhibitions
1999 *Heaven*, Kunsthalle Düsseldorf; Tate Gallery, Liverpool
Auffrischender Wind aus wechselnden Richtungen – Internationale Avantgarde seit 1960/Sammlung Paul Maenz, Neues Museum Weimar, Weimar, Germany
1998 *Freie Sicht aufs Mittelmeer*, Kunsthaus Zürich; Schirn Kunsthalle, Frankfurt/M.
1996 *Shopping*, Deitch Projects, New York
1995 *Fémininmasculin*, Musée National d'Art Moderne, Centre Georges Pompidou, Paris,
1994 *East of Eden*, Museum Schloss Mosigkau, Dessau, Germany

Selected Bibliography
Sylvie Fleury, Villa Merkel, Galerie der Stadt Esslingen, Esslingen, 1999
First Spaceship on Venus and Other Vehicles, Office Fédéral de la Culture, Bern, 1998
Stilleben – Nature morte – Natura morta – Still life, Helmhaus Zürich, Zurich, 1996
Exotik Erotik, Ursula Blickle Stiftung, Kraichtal, 1996

Fortuyn/O'Brien
Currently lives in Amsterdam, Netherlands

Selected Solo Exhibitions
1998 The Showroom, London
1997 *Cityscapes, Landscapes, Peoplescapes*, Galerie Rüdiger Schöttle, Munich
1996 *The Gardener*, Noord Brabants Museum 's, Hertogenbosch
1991 Galerie Roger Pailhas, Paris
1984 Artist Space, New York

Selected Group Exhibitions
1997 *Dopopaesaggio, figure e misure dal Giardino*, Certaldo Castello di Santa Maria Novella, Italy
1996 *Making a place*, Snug Harbour Cultural Center, Staten Island, New York
One Nature, Arti et Amicitiae, Amsterdam
1994 *East of Eden*, Museum Schloß Mosigkau, Dessau, Germany
1992 *documenta IX*, Kassel
1989 P.S. 1 Contemporary Art Center, The Clocktower, New York
1988 *Aperto 88*, Biennale di Venezia, Venice

Selected Bibliography
Catherine Grout, 'Fortuyn/O' Brien – Die Preisgabe des Himmels', in: exh. catalogue *East of Eden*, Museum Schloß Mosigkau, Dessau, 1994, pp. 45–50
M. Bloem, 'Fortuyn/O'Brien', in: exh. cat. *A Century in Sculpture*, Amsterdam, 1992, pp. 218–219
M. Brouwer, 'Images of absence', in: exh. cat. *Shirazeh Houshiary – Lili Dujouri – Anish Kapoor – Fortuyn/O'Brien*, Rijksmuseum Kröller–Müller, Otterlo, 1990, pp. 9–27
P. Groot, 'F for Fortuyn/O'Brien', in: exh. cat. *International Projects: Holland – Fortuyn/O' Brien*, Artists' Space, New York, 1984
C. French, T. Sultan, 'Report from the Netherlands', *Art in America*, July 1992, pp. 42–50
W. Beeren, 'Fortuyn/O'Brien', in: *Fortuyn/O'Brien – Marble Public'*, Amsterdam, 1991, pp. 33–40
C. Dubois, 'The materialisation of intimacy' in: *Parachute*, Nr. 56, 1989, pp. 43–44, and in exh. cat. *Bestiarium Jardin-Theatre*, Entrepot-Galerie du Confort Moderne, Poitiers
E. Hearthey, 'Fortuyn/O' Brien', in: *Art News*, December 1987, pp. 159–160

Gloria Friedmann
* 1950 Kronach, Germany
Lives in Paris

Selected Solo Exhibitions
1998 108 Galerie, Paris
Galerie Academia, Salzburg
1997 Annely Juda Fine Art, London
1995 *Pour qui, contre qui*, Musée d'Art Moderne, Paris
1994 Centre d'Art Contemporain de Vassivière Villa Arson, Nice

Selected Group Exhibitions
1998 *Genwelten*, Kunst- und Ausstellungshalle der Bundesrepublik Deutschland, Bonn
Le Sentiment de la Montagne, Musée de Grenoble, Grenoble
1996 *De la Nature*, Le Parvis, Pau
1994 *Privatgrün*, Kunstraum Fuhrwerkswaage, Cologne

Selected Site Project
since 1999 *Gartenparty*, KünstlerGärten Weimar, Villa Haar, Bauhaus-Universität Weimar

Selected Bibliography
Gloria Friedmann – Hier + Jetzt, ed. Achim Könneke, Hamburg 1998
Günter Engelhard, 'Bilder vom Werden und Vergehen – Künstlerporträt', *ART*, No. 4, 1998
Maiten Bouisset, 'Gloria Friedmann, de la nature des êtres et des choses', *Artpress*, No. 200, 1995
Karl Heinz Schmidt, 'Spiegel der Natur', *Artis*, November 1990

Paul-Armand Gette
* 1927 Lyon, France
Lives in Paris

Selected Solo Exhibitions
1997 *Paul-Armand Gette*, Centre d'art contemporain de Castres, France
1989 *Nymphe, Nymphea et voisinages*, Centre National d'Art Contemporain, Le Magasin, Grenoble, France
1983 *Paul-Armand Gette – Perturbation*, ARC Musée d'Art Moderne de la Ville de Paris ARC
1980 *P.-A. Gette*, Malmö Konsthall, Malmö, Sweden
Exotik als Banalität, DAAD Galerie, Berlin
1978 *Le Jardin Botanique*, Le Coin du Miroir, Dijon, France

Selected Group Exhibitions
1997 *Skulptur. Projekte Münster*, Münster, Germany
1989 *Landschaft in der Erfahrung*, Kölnischer Kunstverein, Cologne, Germany
1978 *Biennale di Venezia*, Venice
1977 *documenta 6*, Kassel

Selected Bibliography
Guy Tortosa, 'Minimale Gärten – Minimalist gardens', *Topos*, June 1995, Munich
Transect – and some other attitudes towards Landscapes, exh. cat. European Visual Arts Centre, Ipswich, England, 1990
Annemarie and Lucius Burckhardt, 'Kassel: ein botanischer Garten', *Der Alltag*, (Zurich), No. 5, 1982
Günter Metken, 'Ailanthus altissima im Wedding', in: *Exotik als Banalität*, exh. cat. DAAD Galerie, Berlin, 1980
'Die Landschaft zwischen Bild und Erinnerung', in: *Was ist Landschaft* (Meissner), Edition Gesamthochschule Kassel, No. 14, 1980
Hans Gercke, 'Paul-Armand Gette', *Das Kunstwerk*, vol. 27, No. 2, 1974

Artist's Publications
Migrateurs – Lucius Burkhardt & Paul-Armand Gette, Musée d'Art Moderne de la Ville de Paris, 1995
Exotik als Banalität, Edition Zweitschrift, Hanover & DAAD, Berlin, 1980
Jardins Botaniques, é. Sellem, Lund, 1974
Paris – Flore rudérale, Malva rotundifolia L., rue des Ecluses St. Martin, 1971

Avital Geva
* 1941 Kibbutz Ein Shemer, Israel
Lives in Ein Shemer, Israel

Selected Exhibitions and Projects
1996 *Aquakultur*, Kunsthalle Düsseldorf, Germany (cat.)
1993 *Biennale di Venezia*, Venice, Italy
since 1980 Research and development at the greenhouse in Ein Shemer, in collaboration with scientists and youth
1977 Inception of work in the greenhouse of Ein Shemer

Dan Graham
* 1942 Urbana, Illinois
Lives in New York

Selected Solo Exhibitions
1997 *Models to Projects 1989–1997*, Marian Goodman Gallery, Paris
Dan Graham – Pavilions, Galerie für Zeitgenössische Kunst, Leipzig
1993 *Children's Pavilion, Dan Graham and Jeff Wall*, Museum Boijmans Van Beuningen, Rotterdam
1992/93 *House and Garden*, Marian Goodman Gallery, New York
1991 *New York Roof Project*, Dia Center for the Arts, New York
1980 Museum of Modern Art, New York
1977 Stedelijk Van Abbemuseum, Eindhoven

Selected Group Exhibitions
1997 *Whitney Biennial*, Whitney Museum of American Art, New York
Skulptur. Projekte, Münster
documenta X, Kassel
P.S.1 Contemporary Art Center, Queens, N.Y.
1994 *East of Eden*, Museum Schloß Mosigkau, Dessau, Germany
1986 *Sonsbeek '86 Internationale Beelddententoonstelling*, Park Sonsbeek, Arnhem, Netherlands

Selected Bibliography
Rainer Metzger, *Kunst in der Postmoderne: Dan Graham*, Cologne, 1996
Dan Graham. Pavilions 1989–96, eds. Martin Köttering/Roland Nachtigäller, Städtische Galerie Nordhorn, 1996
Dan Graham – Ausgewählte Schriften, ed. Ulrich Wilmes, Oktagon Verlag, Cologne, 1994
Rock my Religion. Writings and Art Projects 1965–1990, ed. Brian Wallis, The Massachusetts Institute of Technology, 1993
Walker Evans & Dan Graham, exh. cat. Witte de With, Rotterdam; Whitney Museum, New York, 1992
Dan Graham, Pavilions, exh. cat. Kunstverein München, Munich, 1988

Hans Haacke
* 1936 Cologne, Germany
Lives in New York

Selected Solo Exhibitions
1996 Museum Boijmans Van Beuningen, Rotterdam
1994 John Weber Gallery, New York
1993 *Biennale di Venezia*, German Pavilion, Venice
1989 Musée Nationale d'Art Moderne, Centre Georges Pompidou, Paris
1984 Tate Gallery, London
1972 Museum Haus Lange, Krefeld
1971 Howard Wise Gallery, New York
1965 Galerie Schmela, Dusseldorf

Selected Group Exhibitions
1999 *The Museum as Muse: Artists Reflect*, Museum of Modern Art, New York
1998 *Sculpture*,Chicago Cultural Center, Chicago
1997 *Skulptur. Projekte Münster 1997*, Münster
2nd Johannesburg Biennale, Johannesburg, South Africa
1974 *Interventions in Landscape*, Hayden Gallery, Massachusetts
1971 *earth air fire water: elements of art*, Museum of Fine Art, Boston
1970 *Conceptual Art – Arte Povera – Land Art*, Galleria Civia d'Arte
1969 *Earth Art*, Andrew Dickson White Museum of Art, Cornell University, Ithaca, N.Y.
Live in Your Head: When Attitudes Become Form: Works – Concepts – Processes – Situations – Information, Kunsthalle, Bern
Prospect 69, Städtische Kunsthalle, Dusseldorf

Selected Bibliography
Hans Haacke, *AnsichtsSachen/Viewing Matters*, Dusseldorf, 1999
Peter Friedl and Georg Schöllhammer, 'Der Haacke-Effekt' (Interview), in: *Springer*, October–November 1997, pp. 34–41.
Hans Haacke. Obra Social, exh. cat. Fundació Antoni Tàpies, Barcelona, 1995
Hans Haacke, *Bodenlos*, Stuttgart, Edition Cantz, 1993
Hans Haacke, (Vol. II, Works 1976–1983), exh. cat. The Tate Gallery, London, 1984
Hans Haacke, (Vol. I), exh. cat. Museum of Modern Art, Oxford, 1978
Hans Haacke, 'Vortrag am Museum Folkwang, Essen, June 1973', in: *Selbstdarstellung. Künstler über sich*, ed. Wulf Herzogenrath, Dusseldorf, 1973, pp. 60–71
Edward F. Fry and Hans Haacke, *Hans Haacke – Werkmonographie*, Cologne, 1972
Jack W. Burnham, *Hans Haacke: Wind and Water Sculpture*, Evanston, Illinois, Northwestern University Press, 1967

Henrik Håkansson
*1968 Helsingborg, Sweden
Lives in Stockholm

Selected Solo Exhibitions
1998 Galleri Andreas Brändström
1996 Thomas Nordanstad Gallery, New York, 1996
1994 Olle Olsson Museum, Stockhom
1993 *TRE*, Stockholm

Selected Group Exhibitions
1998 *Crossings*, Kunsthalle Wien, Vienna
After Eden: Garden Varieties in Contemporary Art, Middlebury College Museum of Art
Nuit blanche, Musée, d'Art Moderne de la ville de Paris
1997 *Naturally Artificial*, The Nordic Pavilion, XLVII Biennale di Venezia
Waves in Particles out, CCA, Glasgow
Heaven, P.S. 1 Contemporary Art Center, New York
1996 *Stay on Your Own Slightly Longer (I'm curious)*, Transmission Gallery, Glasgow
1995 *Living Texture*, Ars Futura

Selected Bibliography
Exhibition Catalogues
Tomorrow and Tonight, (texts by Helen Hirsch, Daniel Birnbaum), Kunsthalle Basel, 1999
Natural Reality, Ludwig Forum Aachen, 1999

The Edge of Awareness, WHO 50, Geneva, 1998, pp. 150–151
Joshua Decter, in: *Come Closer*, Liechtensteinische Staatliche Kunstsammlung, 1998, pp. 71–73

Selected Articles
Lucius Burckhardt, 'Kommt der Garten ins Haus?', Basler Magazin, No. 14, 1998, pp. 12/13
'Conversation with Terry R. Myers', in: *Public magazine* 17 Talk, 1998, pp. 51–56
Joshua Decter, 'The Return of Doctor Doolittle,' *SIKSI, The Nordic Art Review*, XII, No. 2, Summer 1997
Daniel Birnbaum, 'Where Has All The Madness Gone?', *Parkett*, No. 50/51, 1997

Siobhán Hapaska
* 1963 Belfast, Northern Ireland
Lives in London

Selected Solo Exhibitions
1999 Bonakdar Jancou Gallery, New York
1997 *Ago*, Entwistle Gallery, London
1995 *St. Christopher's Legless*, ICA, London

Selected Group Exhibitions
1999 *0044*, P.S.1 Contemporary Art Center, New York
1998 *Speed*, The Whitechapel Art Gallery, London
1997 *New Found Landscape*, Kerlin Gallery, Dublin
documenta X, Kassel
Plastik, Württembergischer Kunstverein, Stuttgart
1996 Rhona Hoffman, Chicago
1993 *Wonderful Life*, Lisson Gallery, London

Selected Bibliography
Suzanne Cotter, 'Mach Zero', Make 82 Beastly Issue, December 1998–February 1999, pp. 19–21
Gilda Williams, 'Profile: Blind Alleys, on Siobhan Hapaska', *Art Monthly*, February 1998, pp. 213–214
Ilka Skobie, 'Siobhán Hapaska', *New York Art Magazine*, December 1997/January 1998
Jennifer Higgie, 'Out There', *frieze*, issue 37, 1997
Michael Glover, 'Siobhán Hapaska', *Artnews*, October 1997, pp. 175–176
Matthew Collings, 'Siobhán Hapaska', *frieze*, March/April 1996, pp. 73–74
Juan Cruz, 'Siobhán Hapaska', *Art Monthly*, February 1996

Helen Mayer Harrison/Newton Harrison
Helen Mayer Harrison
* 1929, New York
Newton Harrison
* 1932, New York
They live in San Diego, California and at their project sites

Selected Group Exhibitions
1997 *Aufriss: Künstlerische Position zur Industrielandschaft in der Mitte Europas*, Grassimuseum, Leipzig
1993 *Differentes Natures*, La Defense, Paris
1992 *Fragile Ecologies*, Queens Museum, Queens, New York
1987 *documenta 8*, Kassel, Germany
1976, 1980 *Biennale di Venezia*, Venice

Selected Site Projects
1996 *California Wash: A Memorial for the Disappearing*, Santa
Monica Promenade, California
Future Garden: The Endangered Meadows of Europe, Kunst- und
Ausstellungshalle Bonn, Germany
1995 *The Green Heart of Holland*, Cultural Council of South Holland,
The Hague
1993 *A Serpentine-Lattice*, for the Pacific Northwest Temperate
Coastal Rain Forest of North America
1981 *Baltimore Promenade*, Baltimore

Selected Bibliography
Kim Levin, 'Helen and Newton Harrison: New Grounds for Art', *Arts
Magazine*, Vol. 52, No. 6, 1978
Stephen Eismann, 'Helen Mayer Harrison and Newton Harrison', *Arts*,
Feb. 1981
Susan Platt, 'Helen Mayer Harrison and Newton Harrison: An Urban
Discourse', *Artweek*, Vol. 14, No. 20, May 21, 1981
Linda McGreevy, 'Improvising the Future: the Eco-Aesthetics of
Newton and Helen Harrison', *Arts*, Nov. 1987
Helen Mayer and Newton Harrison, 'Trümmerflora on the Topography
of Terrors', *Whitewalls: A Journal of Language and Art'*, No. 25,
Spring 1990
Patricia Phillips, 'Helen and Newton Harrison at Ron Feldman',
Artforum, May 1991
Eleanor Heartney, 'Fragile Ecologies-Queens Museum', *Art News*,
Dec. 1992
Manuel Cuadra, 'Besseres Bitterfeld: Bitterfeld und die Ästhetik der
Brache', *Fachzeitschrift für Architekten und Bauingenieure, 5 db*,
#127, May 1993
Helen Mayer and Newton Harrison, 'Five Recent Works in Transaction
with the Cultural Landscape', in: *Trilogy – Art – Nature – Science*, ed.
Gertrud Købke-Sutton & Andreas Jürgensen, Copenhagen, 1996
Helen Mayer and Newton Harrison, 'Le Cycle du Lagoon', in: B. Laville
and J. Leenhardt, *Villette-Amazone: Manifeste pour l'Environnement
au XXIe Siècle*, Babel, Paris, 1996
Helen Mayer Harrison and Newton Harrison, 'Knotted ropes, Rings,
Latties and Lace: Retrofitting Biodiversity into the Cultural Land-
scape', in: *Biodiversity: A Challenge for Development Research and
Policy*, ed. Wilhelm Barthlott and Matthias Winiga, Heidelberg,
New York, Tokyo, 1997
John Beardsley, *Earthworks and Beyond, Contemporary Art in the
Landscape*, New York, 1998
Land and Environmental Art, ed. Jeffrey Kastner, Phaidon Press
Limited, London, England, 1998, pp. 142–147, 254
Sculpting with the Environment – A Natural Dialogue, ed. Baile
Oakes, New York, 1995
Arlene Raven, *Art in the Public Interest*, New York, 1993
Alan Sonfist, *Art in the Land – A critical Anthology of Environmental
Art*, New York, 1983

Paula Hayes
* 1958 Concord, Massachusetts
Lives in New York

Selected Solo Exhibitions
1998 Galerie für Landschaftskunst, Hamburg, Germany
1997 AC Project Room, New York
1992/94 Fawbush Gallery, New York

Selected Group Exhibitions
1998 *After Eden: Garden Varieties in Contemporary Art*, Middlebury
College Museum of Art, Middlebury, Vermont
1997 *Land Marks*, The John Weber Gallery, New York
1996 *Shopping*, Deitch Projects, New York
*Power of Suggestion: Narrative and Notation in Contemporary
Drawing*, The Museum of Contemporary Art, Los Angeles
1995 *Paula Hayes and Aki Fujiyoshi*, Galerie Eigen + Art, Berlin
1993 *Just What Is It That Makes Today's Home So Different,
So Appealing?*, Galerie Jennifer Flay, Paris, France
1992 *The Language of Flowers*, Paul Kasmin Gallery, New York
Transgressions in the White Cube: Territorial Mappings, Bennington
College, Bennington
Paper, Fawbush Gallery, New York, Curated by Kiki Smith
The Water Bar, Blum Helman Warehouse, New York
1991 *When Objects Dream and Talk in their Sleep*, Jack Tilton
Gallery, New York

Selected Permanent Garden Installations
1998 *Ghost Planting*, Galerie für Landschaftskunst, Hamburg
1997 *429 Greenwich Street Garden*, New York
1996 *Apple Maze*, KünstlerGärten Weimar, Bauhaus-Universität
Weimar
88 Bleecker Street Lobby, New York
AC Project Room Garden, New York

Selected Bibliography
Bill Arning, 'Review of Exhibitions', *Art in America*, June 1998
Kim Levin, 'Voice Choices', *The Village Voice*, December 1997–
January 1998
Keith Seward, 'Paula Hayes – Fawbush Gallery', *Artforum*, October
1994
Gregory Volk, 'Paula Hayes, Lauren Szold-Lipton Owens', *Artnews*,
1994
Joshua Decter, *Arts Magazine*, March 1992, pp. 85–86
Roberta Smith, 'Art in Review – When Objects Dream and Talk in their
Sleep', *The New York Times*, July 19, 1991

Nikolaus Hirsch/Wolfgang Lorch/Andrea Wandel
Nikolaus Hirsch
* 1964 Karlsruhe, Germany
Wolfgang Lorch
* 1960 Nürtingen, Germany
Andrea Wandel
* 1963 Saarbrücken, Germany

Live in Frankfurt/M. and Saarbrücken, Germany

Selected Projects
1996 Gedenkstätte Börneplatz/Frankfurt/M.
1998 *Gleis 17*, Bahnhof Berlin-Grunewald
1998 (begun) Synagoge Dresden

Selected Exhibitions
1999 *Synagoge Dresden*, Hochschule für Bildende Künste Dresden
Schenkungen und Aquisitionen 1995–1999, Deutsches Architektur-
museum, Frankfurt/M.
1998 *Frankfurter Architekturen*, Deutsches Architekturmuseum,
Frankfurt/M., Germany
BDA-Preis-Berlin, DAZ Berlin

Selected Bibliography
Oliver Elser, 'Respekt vor dem Gegebenen', *Garten + Landschaft*,
No. 4, 1999, pp. 24–25

Peter Herbstreuth, 'Poetik des Faktischen, Registratur als Metapher', *Kunstforum International*, April–June 1998, pp. 485–486
BDA-Preis-Berlin, Berlin, 1998, pp. 20–23
Salomon Korn, 'Die Würde der Bescheidung', in: *DAM Architektur-Jahrbuch*, München, 1996, pp. 100–103
Kasper König, 'Judenmarkt Börneplatz Dominikanerplatz Börneplatz Neuer Börneplatz', in: *Gedenkstätte am Neuen Börneplatz*, Sigmaringen, 1996, pp. 16–23

Damien Hirst
* 1965 Bristol, Great Britain
Lives in Devon

Selected Solo Exhibitions
1998 *Damien Hirst*, Southampton City Art Gallery, Southampton
1997 *The Beautiful Afterlife*, Galerie Bruno Bischofberger, Zurich
1994 *A Bad Environment for White Monochrome Paintings*, Mattress Factory, Pittsburgh
A Good Environment for Coloured Monochrome Paintings, DAAD Galerie, Berlin

Selected Group Exhibitions
1999 *... On the sublime ...*, Roosum Center for Contemporary Arts, Malms, Sweden
1998 *Wild/Life, -or-, The Impossibility of Mistaking Nature for Culture*, Weatherspoon Art Gallery, North Carolina
1994 *Some Went Mad, Some Ran Away*, Serpentine Gallery, London (travelling exhibition)
1993 *Aperto*, Biennale di Venezia, Venice

Selected Bibliography
I want to spend the rest of my life everywhere, with everyone, one to one, always, forever, now, London, 1997
The Beautiful Afterlife, exh. cat. Galerie Bruno Bischofberger, Zurich, 1997
Damien Hirst, exh. cat. Jablonka Galerie, Cologne, 1993
Internal Affaires, exh. cat. Institute of Contemporary Arts, London, 1991

Carsten Höller
* 1961 Brussels, Belgium
Lives in Cologne, Germany

Selected Solo Exhibitions
1999 Kunsthalle, St. Gallen
1998 *Neue Welt*, Museum für Gegenwartskunst Basel
Gift (Poison), Camden Arts Centre, London
1997 Raum für Aktuelle Kunst, Vienna
Moi-Meme, Galerie Air de Paris, Nice
Gift, Galerie Schipper & Krome, Berlin
1996 *Glück*, Kunstverein in Hamburg, Kölnischer Kunstverein, Cologne
1994 *Loverfinches*, Ars Futura, Zurich
Summer Garden (with Lily van der Stokker), Résidence Secondaire, Galerie Air de Paris, Nice

Cooperations (Selected)
1998 *Maison/Häuser*, with Rosemarie Trockel, ARC Musée d'Art Moderne de la ville de Paris
1997 *Ein Haus für Schweine und Menschen*, with Rosemarie Trockel, documenta X, Kassel

Selected Group Exhibitions
1998 *berlin berlin*, 1. Berlin Biennale
Manifesta 2, European Biennial of Contemporary Art, Luxembourg
Es grünt so grün ..., Bonner Kunstverein, Bonn
1997 *Belladonna*, Institute of Contemporary Arts, London
1996 *Hybrids*, de Appel, Amsterdam
Kingdom of Flora, Shoshana Wayne, Los Angeles
1995 *Take Me, I'm Yours*, Serpentine Gallery, London and Kunsthalle Nürnberg
Kwangju Biennale, South Korea
Biennale de Lyon, Maison de Lyon, Lyon
1994 *L'Hiver de l'Amour*, ARC Musée d'Art Moderne de la Ville de Paris
1993 *E*, Künstlerhaus Bethanien, Berlin

Selected Bibliography
Artist's Publications:
'What is Love?', in: Sunshine, *Jahresring* 41, Munich, 1994, pp. 132–157
'Male Masturbation and the Female Orgasm', *Documents sur l'Art Contemporain*. No. 4, 1993, pp. 67–69
Articles:
Helena Kontova, 'From Istanbul with Love and Beauty', *Flash Art*, Nov./Dec. 1997, pp. 47, 55
Max Wechsler, 'Liebesglück kann man auch herbeipfeifen', *Luzern heute*, 21 Aug. 1997
Wolf-Günther Thiel, 'Carsten Höller – Maybe because I can swim, I decided to learn to fly', *Flash Art*, Vol. XXX, No. 194, May–June 1997, pp. 80–84
Yilmaz Dziewior, 'Carsten Höller', *Artforum*, September 1996, p. 120
'De l'homme singe et du bourreau d'enfants', (Interview), *Revue d'Art et de Sciences Humaines*, No. 5, 1995, pp. 36–43
Michelle Nicol, 'Carsten Höller – Getting Real', *Parkett*, No. 43, 1995, pp. 8–17
T. Corvi-Mora, 'Carsten Höller – Interview', *Purple Prose* 5, 1994, pp. 78–81

Jenny Holzer
* 1950 Gallipolis, Ohio
Lives in Hoosick, New York

Selected Solo Exhibitions
1998 Galerie Yvon Lambert, Paris
1997 *Lustmord*, Contemporary Arts Museum, Houston
1994 Art Tower Mito, Contemporary Art Center, Mito, Japan
Lustmord, Barbara Gladstone Gallery, New York
1990 United States Pavilion, *XLIV Biennale di Venezia*, Venice
1989 Solomon R. Guggenheim Museum, New York
Laments 1988–89, Dia Art Foundation, New York
1984 Kunsthalle Basel
1983 Institute of Contemporary Arts, London
1978 Franklin Furnace, New York

Selected Group Exhibitions
1998 *After Eden: Garden Varieties in Contemporary Art*, Middlebury College Museum of Arts, Middlebury, Vermont
1995 *The Age of Modernism: Art in the Twentieth Century*, Martin-Gropius-Bau, Berlin
1996 *Thinking Print: Books to Billboards*, The Museum of Modern Art, New York
Sex and Crime: Von den Verhältnissen der Menschen, Sprengel Museum, Hanover, Germany
1994 *Gewalt/Geschäfte*, Neue Gesellschaft für Bildende Kunst, Berlin

Selected Permanent Installations
1999 *Installation for the Reichstag*, Bundestag, Berlin
1997 *Installation*, Guggenheim Museum, Bilbao, Spain
1994 *Black Garden*, outdoor installation, Nordhorn, Germany
1993 *Green Table*, outdoor installation, University of California,
San Diego

Selected Bibliography
Jenny Holzer – Lustmord, Contemporary Arts Museum, Houston, 1997
Jenny Holzer – Kriegszustand, ed. Klaus Werner, Galerie für Zeitgenös-
sische Kunst, Leipzig, Germany, 1997
Black Garden, ed. Sabine Dylla, Städtische Galerie Nordhorn,
Germany, 1994
Min Nishiwara; 'Interview: Jenny Holzer', *Studio Voice*, April 1994
Doris v. Drateln, 'Jenny Holzer – The Venice Installation', *Kunstforum
International*, No. 109, August/October 1990, pp. 298–303
Donald Kuspit, 'The Only Immortal', *Artforum*, New York, Vol. 28,
Nr. 6, February 1990, pp. 110–118

Peter Hutchinson
* 1930 England
Lives in Provincetown, Massachusetts

Selected Solo Exhibitions
1998 *Utopia*, Holly Solomon Gallery, New York
1995 *Landscapes & Concepts*, Torch Gallery, Amsterdam
1994 *Growth Potential*, Holly Solomon Gallery, New York
1989 *New Land Art*, John Gibson Gallery, New York
1987 American Fine Arts Company Gallery, New York
1974 Stedelijk Museum, Amsterdam
1972 Museum Haus Lange, Krefeld, Germany
1969 John Gibson Gallery, New York

Selected Group Exhibitions
1999 *Works on Paper*, Museum of Modern Art, New York
1997 4e Biennale d'art contemporain de Lyon, France
1996 *Künstlergärten Weimar*, Bauhaus-Universität Weimar
1994 *Green*, Torch Gallery, Amsterdam
1991 *Attitudes*, *Contre Nature*, Centre d'Art Contemporain de
Vassivierre en Limousin, France
1980 *Four-Part Thrown Rope Piece*, Installation for the United States
Pavilion, Biennale di Venezia
1971 *Earth, Air, Fire and Water*, Museum of Fine Arts, Boston,
Massachusetts
1969 *Ecological Art*, John Gibson Museum, New York

Selected Bibliography
Artist's Publications:
Dissolving Clouds; Writings of Peter Hutchinson, Provincetown, Artists
Series Volume III, Provincetown, Massachusetts, 1999
An Art and Gardening Journal, collected essays & correspondence,
1987
Alphabet Cottage Garden Book, 1981
Paracutin Volcano Project, 1979
Catalogues:
Hamish Fulton und Peter Hutchinson, Kunstverein für die Rheinlande
und Westfalen, Dusseldorf, 1998
Peter Hutchinson Selected Works 1968–1977, Galerie Denise René
Hans Mayer, Dusseldorf, 1977

Fabrice Hybert
* 1961 Luçon, France
Lives in Paris

Selected Solo Exhibitions
1999 *At your own risk*, CCAC Institute, San Francisco
1998 *Citoxe*, Fondation De Appel, Amsterdam
Jack Tilton Gallery, New York
1997 *Eau d'or, eau dort, ODOR*, Pavillon français, Biennale di
Venezia, Venice
Galerie Eigen + Art, Berlin
1995 ARC Musée d'Art Moderne de la Ville de Paris
1993 Musée d'art contemporain C.A.P.C., Bordeaux, France
1992 Centre d'art du Creux de l'Enfer, Thiers, France

Selected Group Exhibitions
1999 *At your own risk*, Bergen Museum of Art, Bergen, Norway and
Kunstmuseum Goteborg, Sweden
1998 *Premices*, The Solomon R. Guggenheim Museum, New York,
Musée Zadkine, Paris
1997 *Skulptur. Projekte in Münster*, Münster, Germany
1996 *Manifesta 1*, Rotterdam, Netherlands
Nach Weimar, Kunstsammlungen Weimar, Germany
1995 *Take me (I'm yours)*, Serpentine Gallery, London
Biennale de Kwangju, South Korea
1994 *Hors-limites*, Centre Georges Pompidou, Paris
1993 *Aperto 93*, Biennale di Venezia
1991 Musée d'Art Contemporain, C.A.P.C., Bordeaux
L'amour de l'art, Biennale de Lyon, Lyon
Selected Bibliography
Artist's Publications:
Agenda 1999, Edition Cantz, Stuttgart
Oumeurt I, Hybert-Obrist, édition Le Creux de l'Enfer, 1994
Articles:
Pascaline Cuvelier, Studio Time, *Artforum*, November 1997
Hans-Ulrich Obrist, Interview, *Parkett*, April 1995
Eric Troncy, *Art Scribe*, June 1991

Films
Eau d'or, eau dort, ODOR, 1997
Sans titre (son de cloches), video VHS 3mm, Le Creux de l'Enfer,
1992

Robert Irwin
* 1928 Long Beach, California
Lives and works in Los Angeles

Selected Solo Exhibitions
1998–1999 *Prologue: x 18³*, Dia Center for the Arts, New York
1998 *Robert Irwin: A Selection of Works 1958 to 1970*,
PaceWildenstein Gallery, New York, 1998
1993–1995 *Robert Irwin Retrospective*, The Museum of Contempo-
rary Art, Los Angeles; Kölnischer Kunstverein, Cologne, Germany;
Musée d'Art Moderne de la Ville de Paris and Museo Nacional Centro
de Arte Reina Sofia, Madrid
1987 *Wave Hill Green, Wave Hill Wood, Door Light Window* (gardens &
interior), Wave Hill, Bronx, New York
1971 The Museum of Modern Art, New York

Selected Group Exhibitions
1997–1999 *Sunshine & Noir: Art in L. A., 1960–1997*, Louisiana
Museum of Modern Art, Humlebaek, Denmark; Kunstmuseum

Wolfsburg, Germany; Castello di Rivoli, Museo d'Arte Contemporanea, Italy; UCLA at the Armand Hammer Museum of Art and Cultural Center, Los Angeles
1982 *Form and Function: Proposals for Public Art in Philadelphia*, Pennsylvania Academy of Fine Arts, Philadelphia
1968 *documenta 4*, Kassel, Germany

Selected Site Projects
Central Gardens, The Getty Center, Los Angeles, California, project initiated 1992, planting plan to be completed 2005
9 Spaces, 9 Trees, Public Safety Building Plaza, Seattle, Washington, completed 1983

Selected Bibliography
Bruce Weber, 'Art and Architecture, Dueling on a High Plain', *The New York Times*, April 29, 1998
Christopher Knight, 'An Artwork That Will Grow On You', *Los Angeles Times*, December 17, 1997
Lawrence Weschler, 'When Fountainheads Collide: Robert Irwin and Richard Meier Tangle Over The Getty Center's Garden', *The New Yorker*, December 8, 1997, pp. 60–70
Robert Irwin, exh. cat., The Museum of Contemporary Art, Los Angeles, 1993
Ed Levine, 'Site Sculptors and Landscape Architects', in: exh. cat. Minneapolis College of Art and Design, Minnesota, 1992
Patricia C. Phillips. 'Robert Irwin Wave Hill', *Artforum*, November 1987
Jean Feinberg, 'Perceiving the Garden: Robert Irwin at Wave Hill', Wave Hill, New York, 1987
Robert Irwin, exh. cat. Pennsylvania, 1980

Dominique Kippelen
* 1958 Thann, France
Lives in Strasbourg

Selected Solo Exhibitions
1999 Project for the City of Leicester, England
1997 *Les gouttes de pluie dans la poussière …*, Espace d'Art Contemporain André Malraux, Colmar, France
1995 *Les gouttes de pluie dans la poussière …*, Port du Rhin, Strasbourg

Selected Group Exhibitions
1998 *Jardins*, Brumath, France
Scénographie pour le théatre 'La Paix' d'Aristophane, Strasbourg
1996 *Le Rhin*, Musée d'Art Moderne et Contemporain, Strasbourg

Selected Bibliography
Lucius Burckhardt, 'Kommt der Garten ins Haus?', *Basler Magazin*, No. 14, April 1998
Maia Bouteillet, 'La reveuse du port du Rhin', *Limelight*, April 1997
'La deuxième vie du Port du Rhin', *Steps*, April 1997

Jeff Koons
* 1955 York, Pennsylvania
Lives in New York

Selected Solo Exhibitions
2000 *Jeff Koons: Retrospective*, Guggenheim Museum, New York, NY
1998 *Jeff Koons. Encased Works*, Anthony d'Offay Gallery, London
1995 *Puppy*, Museum of Contemporary Art, Sydney, Australia

Jeff Koons Retrospektive, Staatsgalerie Stuttgart, Stuttgart, Germany
1992 *Jeff Koons Retrospective*, San Francisco Museum of Modern Art, San Francisco, California; Stedelijk Museum, Amsterdam

Selected Group Exhibitons
1997 *Objects of Desire: The Modern Still Life*, The Museum of Modern Art, New York
1992 *Made For Arolsen (Puppy)*, Schloss Arolsen, Arolsen, Germany

Selected Site Project
1997 *Puppy*, (permanent collection), Guggenheim Museum Bilbao, Bilbao, Spain

Selected Bibliography
The American Century, Art and Culture 1950 – 2000, Whitney Museum of American Art, New York, 1999
From Christo and Jeanne-Claude to Jeff Koons, John Kaldor Art Projects and Collection, Museum of Contemporary Art, Sydney, Australia, 1996
Jeremy Gilbert–Rolfe, *Beyond Piety, Critical Essays on the Visual Arts 1986–1993*, Cambridge, Massachusetts, 1996
Jeff Koons, exh. cat. Stedelijk Museum, Amsterdam, The Netherlands, 1993
Angelika Muthesius (ed.), *Jeff Koons*, Cologne, 1992
Veit Loers, *Made for Arolsen*, Schloss Arolsen, Arolsen, Germany, 1992

Till Krause
* 1965 Hamburg, Germany
Lives in Hamburg

Selected Exhibitions
1999 *Falster Versuchsgelände (Das Versuchsgelände der Galerie für Landschaftskunst)*, with Bittermann & Duka, Mark Dion, Anna Gudjónsdóttir, Florian Hüttner and Dan Peterman, Kasseler Kunstverein, Kassel, Germany
1998 *Elemente für eine künstlerische Natur (der Mygindsche Garten)*, Galerie Christian Nagel, Cologne
Mygindscher Garten – Außenstelle Pflanzenwuchs, Künstlergärten Weimar, Bauhaus-Universität Weimar
1996 Galerie für Landschaftskunst, Hamburg, (with Anna Gudjónsdóttir)
1994 Museum Ferner Gegenden, Hamburg, (with Anna Gudjónsdóttir)
1993 *Ultima Thule*, (with Anna Gudjónsdóttir), Friesenwall 120, Cologne, Künstlerhaus Stuttgart
Sonsbeek 93, Arnhem, The Netherlands

Selected Site Project
1999 *Mygindscher Garten, Außenstelle Pflanzenwuchs* (Mygind garden, outpost plant growth), KünstlerGärten Weimar, Bauhaus-Universität Weimar

Selected Bibliography
Mitteilungen des Museums ferner Gegenden, No. 1–9, Hamburg, 1995–99

Samm Kunce
Lives in New York

Selected Solo Exhibitions
1999 Thomas Rehbein Galerie, Cologne, Germany
John Gibson Gallery, New York
1998 Polish Center for Contemporary Art, Oronsko, Poland (installation and permanent work)
1994 *Ich Höre Das Gras Wachsen*, Josh Baer Gallery, Installation, Art Expo Chicago

Selected Group Exhibitions
1999 *Site Specific*, Islip Art Museum, Islip, New York
Botanica, Tween Museum of Art, Deluth, Minnesota
KünstlerGärten Weimar, Bauhaus-Universität Weimar
1998 *Interpreting*, Rotunda Gallery, Brooklyn, New York
1997 *Mother Nature*, John Gibson Gallery, New York
1995 *Configura 2*, Galerie am Fischmarkt, Erfurt
1994 *Life/Boat*, Rotunda Gallery, Brooklyn, New York

Selected Bibliography
Lucius Burckhardt, *Basler Magazin*, No. 14, April 1998, pp. 12–13
Kim Levin, 'Choices: Mother Nature', John Gibson Gallery, *The Village Voice*, May 1997
Holland Cotter, *The New York Times*, October 4, 1996
Susan Harris, *Art in Amercia*, September 1995
Edith Newhall, 'Samm Kunce, Gary Simmons: Installation, Now Growing in SoHo', *New York Magazine*, May 1, 1995
Roberta Smith, 'Nineties', John Gibson Gallery, *The New York Times*, January 15, 1993

Gordon Matta-Clark
* 1943 New York City
died 1978 in New York City

Selected Solo Exhibitions
1997 *Reorganizing Structure By Drawing Through it – Zeichnung bei Gordon Matta-Clark*, Generali Foundation, Vienna
1974 John Gibson Gallery, New York
1972 *Rosebush*, St. Mark's Church, New York
Bronx Floors, Manhattan, Bronx and Brooklyn, New York
1971 *Cherry Tree, Winter Garden and Time Well*, 112 Greene Street, New York

Selected Group Exhibitions
1984 *Flyktpunkter/Vanishing Points*, Moderna Museet, Stockholm
1980 *Architectural Garden*, Los Angeles Institute of Contemporary Art, Los Angeles
1975 *Art in Landscape*, Illinois State University, Normal (trav. exh.)
1972 *documenta 5*, Kassel, Germany
1969 *Earth Art*, Cornell University, Ithaca, New York

Selected Bibliography
Reorganizing structure by drawing through it: Zeichnung bei Gordon Matta-Clark, catalogue raisonné, ed. Sabine Breitwieser, Generali Foundation, Vienna, Cologne, 1997
Gordon Matta-Clark, IVAM Centre Julio González, Valencia, 1992
Gordon Matta-Clark: A Retrospective, Museum of Contemporary Art, Chicago, 1985
Cindy Nemser,'The Alchemist and the Phenomenologist', *Art in America*, No. 59, March 1970, pp. 100–103
Robert Pincus-Witten, 'Review', *Artforum*, 9, September 1970, p. 75

Mathieu Mercier
* 1970 Conflans-Sainte Honorine, France
Lives in Paris

Selected Solo Exhibitions
1999 Galerie Mehdi Chouakri, Berlin
Galerie Chez Valentin, Paris
1998 Institut français de Berlin, avec K. Solomoukha, Berlin
1997 *Austerlitz Autrement*, Galerie Chez Valentin, Paris
1996 Galerie du commerce, Marseilles

Selected Group Exhibitions
1998 *Berlin-Berlin*, Berlin Biennale für Zeitgenössische Kunst (cat.)
Le dessin en procès, Galerie la box, Bourges (cat.)
GS2 Domesticity, Mehdi Chouakri, Berlin
1997 *Post-diplôme*, CRDC, Nantes
1996 *Images, objets, scènes, espace vidéo*, Le Magasin, Grenoble
Précipités 1, La Flèche d'or, Paris
1994 Galerie la box, Bourges

Selected Bibliography
Mathieu Mercier – Un Manual, ed. Gilles Drouault, Paris, 1999
Le dessin en procès, Galerie la box, Bourges, 1998
Berlin/Berlin, Biennale für zeitgnössische Kunst, Berlin, 1998

Teresa Murak
* 1949 Kielczewicach, Poland
Lives in Warsaw, Poland

Selected Solo Exhibitions
1996 Polnisches Institut, Leipzig, Germany
1991 *Ziarno*, performance, P.S. 1 Contemporary Art Center, New York

Selected Group Exhibitions
1996 *Kunst und Natur*, Lindenau Museum, Altenburg, Germany
1998 *Body and the East*, Museum of Modern Art, Ljubljana, Slovenia
1989/90 *Ressource Kunst – Die Elemente neu gesehen*, Künstlerhaus Bethanien, Berlin; Museum Budapest

Selected Site Project
Sculpture for the Earth, Collection Hoffmann, Berlin

Selected Bibliography
Teresa Murak, exh. cat.Galeria Bielska, Bielsko – Biala, Poland, 1998
Dämmern und Werden, exh. cat. Polish Institute, Leipzig, 1996
Despite/Difference. Polki, exh. cat. Herbert Read Gallery, Kent, England Institute of Art and Design, Canterbury, 1996
J'ai cultive mon premier 'Semis', exh. cat. Galerie Faust Rosa Turetsky, Geneva, 1992
Georg Jappe (ed.), *Ressource Kunst – Die Elemente neu gesehen*, Cologne, 1989

N55
Rikke Luther
*1970 in Denmark
John Sørvin
*1964 in Denmark
Cecilia Wendt
*1965 in Sweden
Ingvil Aarbakke
*1970 in Norway
Live in Copenhagen, Denmark

Selected Exhibitions
1999 *I never promised you a rosegarden*, Kunsthalle Bern, Switzerland
Next Stop, Lofoten Arts festival, Norway
LKW. Things between Life, Art & Work, O.K. Center of Contemporary Art, Linz, Austria
New Life, P-House, Tokyo
Formule 2.1, Künstlerhaus Bethanien, Berlin
1998 *Cool Places*, Baltic Young Artist Triennial, Contemporary Art Center, Vilnius, Lithuania
Bicycle Thieves, Tough Gallery, Chicago, USA
The Campaign Against Living Miserably, RCA, London
1996 *NowHere*, Louisiana Museum of Modern Art, Denmark

Selected Bibliography
Like Virginity, Once Lost – Five Views on Nordic Art Now, Prospexus, Sweden 1999
LKW. Things between Life, Art & Work, O.K. Center of Contemporary Art, Linz, Austria, 1999
Cream – Contemporary Art in Culture, Phaidon Press, London, 1998
'Aperto: Copenhagen', in: *Flash Art International*, No. 201, Summer 1998
Lars Bang Larsen, 'Review: Home Hydroponic Unit', *frieze*, London, No. 35, June–August 1997

David Nash
*1945 Esher, Surrey, Great Britain
Lives in Blaenau Ffestiniog, North Wales

Selected Solo Exhibitions
1998 *Red and Black*, LA Louver, Los Angeles
David Nash Sculpture, Galerie Lelong, New York
1996 *Forms into Time 1971–96*, Museum van Hedengaase Kunst, Antwerp
Annely Juda Fine Art, London
1991 *Kunst Europa 1991*, Kunstverein Heidelberg, Germany
1990 S*culpture 1971–90*, Serpentine Gallery, London
1989 Centre d'Art Contemporain de Vassiviere, Limousin, France
1984–1985 Moriyama City, Shiga, Japan. Exhibition travelled to: Tochigi Prefectural Museum of Fine Arts, Tochigi-ken; Miyagi Museum of Art, Sendai; Fukuoka Art Museum; Sogetsu Kaikan, Tokyo
1982 *Wood Quarry*, Rijksmuseum Kröller-Müller, The Netherlands

Selected Group Exhibitions
1998 *Landscapes*, Meyerson and Nowinskai Gallery, Seattle, Crown Point Press, USA
Nature, Art, Architecture, Landscape, Tweede Natuur, Antwerp, Belgium
1996 *Trilogy: Art-Science-Nature, Confrontation with Creation*, Kunsthalle Brandts Klaedefabrik, Odense
1995 *Here and Now*, Serpentine Gallery, London
1993 *Differentes Natures*, Espace Art Defense, Paris

1988–1989 *Artists in National Parks*, Victoria and Albert Museum, London (and subsequent tour of England)

Selected Planted Works
Since 1988 *Above the Waters of Leith*, Scottish National Museum of Modern Art, Edinburgh
Since 1987 *Serpentine Sycamores*, Cae'n-y-Coed, North Wales
Since 1985 *Divided Oaks and Turning Pines*, Hoge Veluwe, Rijksmuseum Kröller Müller, Otterlo
1983 *Sod Swap*, Cae'n-y-Coed, North Wales and Kensington Gardens, London
Since 1977 *Ash Dome*, Cae'n-y-Coed, North Wales

Selected Bibliography
David Nash – Forms into Time, Academy Editions, London, 1996
Julian Andrews, *The Sculpture of David Nash*, ed. The Henry Moore Foundation, Lund Humphries Publishers, London, 1996
James Scarborough, *Flash Art*, February 1996
William Feaver, Reviews 'David Nash, Annely Juda', *ARTnews*, September 1993
Janet Koplos, 'Rooted', *Art in America*, April 1993
Alan McPherson, 'Interview with David Nash', *Artscribe*, No. 12, June 1978, pp. 30–34

Artist's Publications
At the Edge of the Forest, Annely Juda Fine Art, London, 1993
David Nash, Sculpture 1971–90, Serpentine Gallery, London, 1990

Barbara Nemitz
*1948 Göttingen, Germany
Lives in Berlin and Weimar, Germany

Selected Solo Exhibitions
1997 *Das schöne Leben*, Heidelberger Kunstverein, Heidelberg
1995 Kunstsammlungen zu Weimar, Landesmuseum, Weimar
1987 *Nachtlandschaften – promenades nocturnes*, mise en scene, Tiergarten ; Production, Berliner Festspiele, Berlin
1985 *Beauty and Pain*, mise en scene, S.O. 36, Berlin, (trav.) die börse, Wuppertal, Zakk, Dusseldorf, Stollwerckfabrik, Cologne
1982 *Perlen im Sande der Mark*, Künstlerhaus Bethanien, Berlin
1980 Wilhelm-Lehmbruck-Museum, Duisburg
1979 Neue Galerie-Sammlung Ludwig, Aachen

Site project
Since 1993 *KünstlerGärten Weimar* (Artists' Gardens Weimar), Bauhaus-Universität Weimar

Selected Bibliography
Barbara Nemitz, *Kunstforum International*, No. 146, Cologne, 1999, pp. 95–96, 198–199
Barbara Nemitz, 'Künstlergärten Weimar' and 'Der Garten ist der Ort der Handlung', *Kunstforum International*, No. 145, Cologne, 1999, pp. 145–154, pp. 207–212
Peter Sager, 'Kunstrasen', *Die Zeit/Zeitmagazin*, No. 47, Hamburg, 1998, pp. 16–26
Hans Gercke, 'Cultivating the Field of the Absurd – On the installation *Living the Beautiful* by Barbara Nemitz', in: *das Schöne leben*, exh. cat. Kunstverein Heidelberg, Heidelberg, 1997, pp. 5–20
Siegrid Feeser, 'Barbara Nemitz – das Schöne leben', *Kunstforum International*, No. 137, Cologne, 1997, pp. 409–410
Barbara Nemitz, 'KünstlerGärten Weimar', *Weimar Kultur Journal*, Weimar, 1996, pp. 28–29

Barbara Nemitz, exh. cat. Kunstsammlungen zu Weimar, including essays by Gerda Wendermann and Gerhard Kolberg, Weimar, 1995, pp. 5–18

Lucius Burckhardt, 'Landschaft im Schaukeln', *Kassel Kulturell*, No. 5, Kassel, 1991

Dirk Schwarze, 'Schönheit und Schmerz', Eine Rauminszenierung, *Kunstforum International*, No. 114, Cologne, 1991

Bernhard Buderath, 'Wirf Dich der Nacht in die Arme – Die Syntax der Romantik', in cat. *Nachtlandschaften – promenades nocturnes*, Berliner Festspiele, Heinrich Winterscheid, Dusseldorf, 1987, pp. 33–37

Barbara Nemitz, 'Pearls in the Sand of the Mark Brandenburg', exh. cat. *Barbara Nemitz*, Künstlerhaus Bethanien, Berlin, 1982, p. 35

Wolfgang Becker, 'Die Seelenstreichler', in exh. cat. *Barbara Nemitz – Malereien*, Neue Galerie – Sammlung Ludwig, Aachen, 1979, pp. 33–35

Artist's Publications
wachsen – Work at the Artists' Gardens Weimar, No. 1–4, ed. Barbara Nemitz, Bauhaus-Universität Weimar 1995–1998
Schönheit und Schmerz (Beauty and Pain), Berlin, 1985

Olaf Nicolai
* 1962 Halle/Saale, Germany
Lives in Berlin

Selected Solo Exhibitons
1999 *Labyrinth*, Galerie für Zeitgenössische Kunst Leipzig, Germany
1998 *Modul*, Galerie EIGEN + ART, Berlin
1997 *Blind date* (with Ann Lislegard), Werkstatt Lothringer Straße, Munich

Selected Group Exhibitons
1999 P.S. 1 Contemporary Art Center, New York
Empty Garden, Watari-Um Museum, Tokyo
Natural Reality, Ludwig Forum für Internationale Kunst, Aachen
Skulpturenbiennale 1999, Münster
After the Wall, Moderna Museet Stockholm
Empty Gardens, Watari-Um Museum, Tokyo
1998 *post naturam – nach der Natur*, Geologisch-Paläontologisches Museum Münster/Hessisches Landesmuseum, Darmstadt
etre nature, Fondation Cartier, Paris
La Ville, le Jardin, la Mémoire: 1998, 1999, 2000, Villa Medici, Rome
1997 *documenta X*, Kassel
new space, P.S. 1 Contemporary Art Center, Long Island City, NY (USA)
Interieur/Landschaft, with Matthias Hoch, Galerie Nagel, Cologne
Interieur/Souvenir, Galerie EIGEN + ART, Berlin
1993 *Hortus/Präparat*, Galerie Fabian Walter, Basle

Selected Bibliography
Olaf Nicolai, *show case*, Nürnberg, 1999
'future nostalgia?', Conversation with Frank Eckart, in: *Natural Reality*, exh. cat. Ludwig Forum für Internationale Kunst, Aachen, Stuttgart, 1999, pp. 86–95
Olaf Nicolai, *Kunstforum International*, No. 146/1999, pp. 96, 200
Olaf Nicolai, 'Landschaft/Interieur' in: *Politics-Poetics – das Buch zur documenta X*, Ostfildern, 1997
Olaf Nicolai, *Pflanze/Interieur*, Cologne and Leipzig, 1996

Nils-Udo
* 1937 Lauf, Bavaria, Germany
Lives in Riedering, Bavaria, Germany

Selected Projects and Exhibitions
1999 *Nils-Udo – Kunst mit Natur*, Ludwig Forum für internationale Kunst, Aachen, Germany, (travelling exhibition)
Centre d'Art Contemporain, Vassivière en Limousin/Beaunont du Lac, France
Parfums en Sculptures – Sculptures de Parfums, Jardin des Plantes, Paris and Château de Laàs, Pyrénées Atlantiques, France
1998 *Novalis-Hain – Die blaue Blume, Großinstallation*, Juristische Fakultät der Universität Augsburg, Germany
Galerie Guy Bärtschi, Geneva
1996 *Across the River*, Music-Video, Project with Peter Gabriel for the worldwide WWF-Campaign *The Living Planet*, Vancouver Island, Canada
1994 *Art Grandeur Nature II*, Parc de la Courneuve, Saint Denis, Paris
Project *Maïs*, AGPM Pau, Ministère de la Culture, DRAC, Conseil Général, Laás, France
Pro Natura Baltica, Helsinki, Stockholm, Lübeck and Tallinn
Selected Site Projects
1978 *Das Nest*, Galerie Falazik, Neuenkirchen, Germany
1973 *Hommage à Gustav Mahler*, Chiemgau, Oberbayern, Germany

Selected Bibliography
Nils-Udo – Kunst mit Natur, ed. Wolfgang Becker, exh. cat. Ludwig Forum, Aachen, Cologne, 1999
Vittorio Fagone, *Art in Nature*, Milan, 1996
Dieter Ronte, 'Nils-Udo, ein Künstler der Natur', in: exh. cat. *Nils-Udo/ Bob Verschueren*, ed. Atelier 340, Brussels, 1992
Colette Garraud, 'Art et Nature: L'Ephémère', in: Recherches Poétiques 2, Presses Universitaires de Valenciennes, 1995
Ruth Falazik/Lothar Romain, *Kunst-Landschaft*, Neuenkirchener Symposien, 1974 – 1987, Bremen, 1987
Natur – Skulptur, exh. cat. Württembergischer Kunstverein, Stuttgart, 1981

Brigitte Raabe
* 1961 Höxter, Germany
Lives in Hanover and Hamburg, Germany

Selected Exhibitions
1999 *Gärten der Flora*, Kunstmuseum Kloster Unser Lieben Frauen, Magdeburg, Germany
Berg – Äther, Einsiedlerbibliothek, p.t.t.red, Brennerpass
1998 *Pflanzen Liebe*, Projektraum Voltmerstraße, Hanover
1996 *Pflanzen im Dom*, Braunschweiger Dom, Braunschweig, Germany
1995 *Der Blumenladen*, Brutto Gusto, Rotterdam
1993 *Lange, Raabe, Wewer*, Kunstverein Hannover, Hanover
Drei Birken, Hjertöya, Norway
1992 *Ein Treppenhaus für die Kunst II*, Ministerium für Wissenschaft und Kultur, Hanover

Site Project
since 1996 *Duftveilchenpflanzung* (Fields of scented violets), KünstlerGärten Weimar, Bauhaus-Universität Weimar

Selected Bibliography
Gärten der Flora, Kunstmuseum Kloster Unser Lieben Frauen, Magdeburg 1999

Peter Sager, 'Kunstrasen', *Die Zeit/Zeitmagazin*, No. 47, Hamburg, 1998, pp. 17, 22, 23
Befragung der Räume, exh. cat., Kunstmuseum Kloster Unser Lieben Frauen, Magdeburg, 1997
Raimar Stange, 'Die Blumenhändlerin Brigitte Raabe', in: *wachsen – Work at the Artists' Gardens Weimar*, No. 2, ed. Barbara Nemitz, Universitätsverlag Weimar, 1996
Brigitte Raabe – Pflanzen im Dom, exh. cat. Braunschweig, 1996
J. Schweinebraden Frhr. v. Wichmann Eichhorn, *Brigitte Raabe*, Textheft mit Zeichnungen von Brigitte Raabe, Barkenhoff-Stiftung, Worpswede, 1994
Brigitte Raabe, exh. cat. Kunstverein Hannover, Hanover, 1993
Brigitte Raabe, exh. cat. Ministerium für Wissenschaft und Kunst, Hanover, 1992

Nikolaj Recke
* 1969 Copenhagen, Denmark
Lives in Copenhagen

Selected Solo Exhibitions
1998 Akershus Artcenter. Oslo
1995 *Masters at Work*, Århus

Selected Group Exhibitions
1999 *Signs of Life*, 1st Melbourne International Biennial
New Life, Nagamia projects, Tokyo
Nasubi Gallery, *Cities On the Move*, Louisiana, Humlebaek
I love nature, OTTO, Copenhagen
1998 *Out of the North*. Württembergischer Kunstverein Stuttgart (cat.)
Wrapped, West Zealand Art Museum (cat.)
1997 Louisiana Museum, Humlebaek (cat.)

Selected Bibliography
Juliana Engberg, 'Nikolaj Recke', Melbourne International Biennal, 1999
'Nikolaj Recke', *Siksi*, Autumn 1996

Tobias Rehberger
* 1966 Esslingen/Neckar, Germany
Lives in Frankfurt/M.

Selected Solo Exhibitions
1999 Transmission Gallery, Glasgow
1998 Moderna Museet, Stockholm
Kunsthalle Basel, Basle
1997 *brancusi*, Galerie neugerriemschneider, Berlin
anastasia, Friedrich Petzel Gallery, New York
1996 Portikus, Frankfurt/M.

Selected Group Exhibitions
1998 *Manifesta 2*, Luxembourg
1997 *Truce: Echoes of Art in an Age of Endless Conclusions,* Site Santa Fe, Santa Fe, USA
future-present-past, Biennale di Venezia, Venice
Skulptur. Projekte in Münster '97, Münster, Germany
Rooms with a View: Environments for Video, Guggenheim Museum Soho, New York
1996 *Manifesta 1*, Rotterdam
1995 *Bed & Breakfast*, Ifor Evans Hall, London
1992 *Qui, quio, où?*, Musée d' Art Moderne de la Ville de Paris

Selected Bibliography
Jerry Saltz (ed.), *An Ideal Syllabus*, London, 1998
Daniel Birnbaum, 'A Thousand Words', *Artforum*, November 1998, pp. 100–101
Francesco Bonami, 'Tobias Rehberger', in: *cream. contemporary art in culture*, Phaidon, London, 1998, pp. 336–339
Joshua Decter, 'Tobias Rehberger', *Artforum*, February 1998, pp. 93–94
Martin Pesch, 'Sculpture. Projects in Münster', *frieze*, issue 36, September/October 1997, pp. 82–83
Carl Freedman, 'Things in Proportion', *frieze*, March/April 1997, pp. 66–69
Yilmaz Dziewior, 'Tobias Rehberger', *Artforum*, January 1997, pp. 74–75
Martin Pesch, 'Tobias Rehberger', *artist*, No. 25.4/1995, pp. 16–19

Gary Rieveschl
* 1943 Cincinnati, Ohio
Lives in East Hampton, N. Y.

Selected Solo Exhibitions
1991 *Rites of Spring*, Vered Gallery, East Hampton, New York
1981 *Artists' Gardens and Parks*, Hayden Gallery, M.I.T., Cambridge, Massachusetts and Museum of Contemporary Art, Chicago, Illinois
1980 Project series *Kreuzberger Lifeforms*, Berlin
1979 Project *Breakout*, for the exhibition *Künstlergärten*, Wissenschaftszentrum, Bonn, Germany
1977 *Bremer Lifeforms*, Galerie der Gruppe Grün, Bremen, Germany
Material aus der Landschaft/Kunst in der Landschaft, Galerie Falazik, Neukirchen, Germany
1975 *Lifeform Banners*, Contemporary Art Center, Cincinnati, Ohio
1973 *D'Aug Days*, Contemporary Art Center, Cincinnati, Ohio
1971 *Elements of Art*, Museum of Fine Arts, Boston, Massachusetts
1967–1970 Center for Advanced Visual Studies, M.I.T., Cambridge, Massachusetts

Selected Bibliography
Gary Rieveschl, in: *Kunstforum International*, No. 146, July/August 1999, pp. 100, 212–213

Erik Samakh
* 1959 St. Georges de Didonne, France
Lives in Serres, France

Selected Exhibitions
1999 Centre d'art contemporain de Colmar, France
1998 Centre d'Art Contemporain, Le Creux de l'Enfer, Thiers, France
1996 Galerie des Archives, Paris
1995 *Biennale de Johannesburg*, Selection du FRAC Réunion, South Africa
1994 *Differentes Natures*, visions de l'art contemporani, Barcelona Museum Het Kruithuis, 's-Hertogenbosch, The Netherlands
1993 Théâtre du Cercle de l'Arsenal, Biennale di Venezia, Venice
1992 Galerie des Archives, Paris
Acquisition du Parc de la Villette, Paris
1991 *Ars Electronica*, Linz, Austria
1987 *Steirischer Herbst*, Graz, Austria

Selected Bibliography
Maria le Mouëllic, *'Erik Samakh, écoutez voir … '*, Beaux-Arts Magazine, No. 127, October 1994

Erik Samakh, exh. cat. and CD, ed. La Culture pour Vivre, Grand Prix d'Art Contemporain de Flaine, 1993
La Parabole du Bambou, Anny Milovanoff, La Lettre de la Chartreuse No. 13, Festival d'Avignon, 1987

Charles Simonds
* 1945 New York City
Lives in New York City

Selected Solo Exhibitions
1994 *Charles Simonds, Retrospective*, Fundació 'la Caixa', Barce-lona; Galerie nationale du Jeu de Paume, Paris
1988 *Spectrum: Charles Simonds*, Corcoran Gallery of Art, Washington, D.C.
1984 *House Plants and Rocks*, Leo Castelli Gallery, New York
1978 *Floating Cities and Other Architectures*, Westfälischer Kunst-verein, Münster

Selected Group Exhibitions
1993 *Différentes Natures – Visions de L'art contemporain*, Galerie Art 4 et Galerie de l'Esplanade Dèfense, Paris
1988 *Big Little Sculpture*, Williams College of Art, Williamstown, Pennsylvania
Gordon Matta-Clark and Friends, Galerie Lelong, New York
1977 *documenta 6*, Kassel
1974 *Interventions in Landscape*, Massachusetts Institute of Tech-nology, Hayden Gallery, Cambridge

Selected Bibliography
Charles Simonds, exh. cat. Galerie nationale de Jeu de Paume, Paris, 1994
Gilles A. Tiberghien, 'Sculptures inorganiques, Land Art et architec-ture', *Cahiers du Musée national d'Art moderne*, Paris, No. 39, spring 1992, pp. 98–115
Wolfgang Bessenich, 'Wachsendes Baumhaus – Der Amerikaner Charles Simonds im Basler Architekturmuseum', *Basler Zeitung*, June 11, 1985, p. 38
Markus Brüderlin, 'Charles Simonds – The Three Trees', *Kunstforum International*, Cologne, October–November 1985, pp. 244–245
Lucy R. Lippard, 'Public Sculpture: The Pursuit of the Pleasurable and Profitable Paradise', *Artforum*, New York, March 1981, pp. 64–73
Lucy R. Lippard, 'Public Sculpture II: Provisions for the Paradise', *Artforum*, New York, Summer 1981, pp. 37–42
Colette Garraud, *L'Idée de nature dans l'art Contemporain*, Paris, Flammarion, 1994, pp. 25, 27, 77, 78, 86
John Beardsley, *Earthworks and Beyond. Contemporary Art in the Landscape*, New York, Abbeville Press, 1984, pp. 50–57, 110–118

Robert Smithson
* 1938 Rutherford, N.Y.
Died 1973 in Texas

Selected Solo Exhibitions
1999 *Robert Smithson: Retrospective*, Moderna Museet, Stockholm
1997 *Robert Smithson: Issues of Entropy*, John Weber Gallery, New York
1993–1994 *Robert Smithson: Une Retrospective: le paysage entropi-que*, IVAM, Centre Julio Gonzalez, Valencia, Spain (international travelling exhibition)
1989–1990 *Robert Smithson: Zeichnungen aus dem Nachlaß*, West-

fälisches Landesmuseum für Kunst und Kulturgeschichte Münster, Germany
1982–1983 *Robert Smithson Rétrospective*, ARC, Musée d'Art Moderne de la Ville de Paris
1980–1982 *Robert Smithson – Sculpture*, Herbert F. Johnson Museum of Art, Cornell University, Ithaca, N.Y. (travelling exhibition)
1976 John Weber Gallery
1974–1977 Robert Smithson: Drawings, New York Cultural Center, (travelling exhibition)
1968–1969 Galerie Konrad Fischer, Dusseldorf, Germany

Selected Group Exhibitions
1990 *The Experience of Landscape: Three Decades of Sculpture*, Whitney Museum of American Art
1980 *Mythos & Ritual*, Kunsthalle Zürich, Switzerland
1974 *Earth, Air, Fire, Water*, University of Wisconsin, Milwaukee
1972 *documenta 5*, Kassel
1969 *When Attitudes Become Form*, Kunsthalle Bern, Switzerland
1968 *Art of the Real*, Museum of Modern Art, New York
Prospect '68, Kunsthalle Düsseldorf, Germany

Selected Bibliography
Robert Smithson: The Collected Writings, ed. Jack Flam, Berkeley and Los Angeles, 1996
Robert Smithson – Une rétrospective, Le paysage entropique 1960–1973, MAC, galeries contemporaines des Musées de Marseille, Marseille, 1994
Robert Smithson: Zeichnungen aus dem Nachlaß, Westfälisches Landesmuseum für Kunst und Kulturgeschichte Münster, Germany, 1989/90
Robert Hobbs, *Robert Smithson: Sculpture*, Ithaca, New York, 1981
Lucy Lippard, 'Gardens: Some Metaphors for a Public Art', *Art in America*, November 1981, pp. 136–150

Alan Sonfist
* 1946 New York
Lives in New York

Selected Solo Exhibitions
1996 *Retrospective*, University of Iowa Art Museum, Iowa City, Iowa (USA)
1995 *Natural/Cultural Landscapes*, Tampa Art Museum, Tampa, Florida (USA)
1994 *Landscapes*, Nancy Drysdale Art Gallery, Washington, D.C.
1992 *Sculpture*, Public Art Fund, Doris Freedman Plaza, New York
Drawings of La Defense, EPAD Contemporary
1975 *Time Landscape™*, Finch College Museum of Art, New York

Selected Group Exhibitions
1999 *Natural Reality*, Ludwig Forum, Aachen, Germany
1996 *Trilogy: Art, Nature, Science*, Kunsthallen Brandts Klaede-fabrick, Tickon, Denmark/travelling exhibition
1993 *Différentes Natures*, Galerie Art 4 et Galerie de l'Esplanade Dèfense, Paris
1992 *Fragile Ecologies: Contemporary Artists Interpretations and Solutions*, Queens Museum, Queens, New York
1991 *Green Art*, Max Protech Gallery, New York
1989 *Nature as Art*, Akademie der Künste, Berlin

Selected Site Projects
Natural/Cultural Landscape™ Commissions:
2000 *Historical Islands* – EXPO 2000, Dessau, Germany

1999 *Nature Theatre*, KünstlerGärten Weimar, Bauhaus-Universität Weimar, Germany
1998 *Natural/Cultural Landscape™* of Tampa, Tampa, Florida
1989 *Circle of Life*, Kansas City, Missouri
1987 *Circles of Time*, Villa Celle, San Tomaso, Florence, Italy
1970 *Native Seed Mounds*, Central Park, New York
1965 *Time Landscape™* – Greenwich Village Plan, New York

Selected Bibliography
Natural Reality – Artistic Positions between Nature and Culture, exh. cat. Ludwig Forum für Internationale Kunst, Aachen, Germany, 1999, pp. 128–131
Jeffrey Kastner, ed., *Land and Environmental Art*, Phaidon Press Ltd., London, 1998
Barbara C. Matisky, *Fragile Ecologies*, The Queens Museum of Art, New York, 1992
Rosabianca Skira, ed., *L'art contemporain et l'axe historique*, Paris, 1992
Joshua C. Taylor, *The American Land*, W. W. Norton and Co., New York, 1979
Lawrence Alloway, *Autobiography of Alan Sonfist*, Herbert F. Johnson Museum of Art, Ithaca, 1975
Robin Cembalest, 'The Ecological Art Explosion', *Art News*, Summer 1991
Robert Rosenblum, 'Interview with Alan Sonfist', in: *Alan Sonfist 1969–1989*, exh. cat. Hillwood Art Museum, Long Island University, Brookville, N.Y., 1990, pp. 3–28
Gunnar Jale Sorte, ed.,'Site-specific Sculpture', *Parks for the Future*, Alnarp, Sweden, 1990
'Oaks and Catbirds, Forever', *The New York Times*, July 18, 1989
Jonathan Benthall, 'Haacke, Sonfist and Nature', *Studio International*, March 1971

Artist's Publication
Autobiography of Alan Sonfist, Cornell University Press, Ithaca, New York, 1975

Daniel Spoerri
*1930 Galati, Romania
Lives in Seggiano/Grosseto, Italy

Selected Solo Exhibitions
1991/90 Musée National d'Art Moderne, Centre Georges Pompidou, Paris, (trav. exh.), Museum Moderner Kunst, Vienna; Städtische Galerie im Lenbachhaus, Munich; Musée Rath, Geneva; Kunstmuseum Solothurn, Switzerland
1973 Eat Art Gallery, Dusseldorf
1963 Galerie Zwirner, Cologne
1961 Galleria Schwarz, Milan

Selected Group Exhibitions
1990 *Von der Natur in der Kunst*, Wiener Festwochen, Vienna
1989 *Magiciens de la terre*, Musée National d'Art Moderne, Centre Georges Pompidou, Paris
1986 *1960: Les Nouveaux Réalistes* (trav. exh.), Musée d'Art Moderne de la Ville de Paris
1985 *Berlin durch die Blume oder Kraut und Rüben: Gartenkunst in Berlin-Brandenburg*, Schloß Charlottenburg, Berlin
1977 *documenta 6*, Kassel
1961 *The Art of Assemblage*, (trav. exh.), The Museum of Modern Art, New York

Selected Site Projects
since 1998 *Il Giardino di Daniel Spoerri*, Seggiano/Grosseto, Italy
since 1998 *Liegewiese – Betreten verboten!*, KünstlerGärten Weimar, Bauhaus-Universität Weimar, Germany

Selected Bibliography
Il Giardino di Daniel Spoerri, ed. Anna Mazzanti, Florence, 1998
Giancarlo Politi, 'Daniel Spoerri', Flash Art, No. 154, 1990
Petit lexique sentimental autour de Daniel Spoerri, exh. cat. Kunstmuseum Solothurn, Solothurn, 1990
Ben Vautier, *Fluxus and Friends going out for a drive*, Berlin, 1983
Dorothy Iannone, *The Story of Berne*, Dusseldorf, 1970
William. S. Rubin, *Dada and Surrealist Art*, London, 1969
Pierre Restany, *Les nouveaux réalistes*, Paris, 1968

Selected Artist's Publications
100 Kochrezepte, Verona, 1985–89
Mythology and Meatballs, Berkeley, 1982
Gastronomisches Tagebuch, Neuwied, Berlin, 1970
Ja, Mama das machen wir. Modernes Schweizer Theater, Egnach, 1964

Laura Stein
*1964 East Patchogue, N.Y.
Lives in New York

Selected Solo Exhibitions
1997 *On the inside*, School of the Museum of Fine Arts, Boston, Massachsetts
Basilico Fine Arts, New York
1996 *Frankfurt, a Story, and a Song*, Frankfurt/M., Germany

Group Exhibitions
1999 *Nature is Not Romantic*, Hunter College Art Gallery, N. Y.
1998 *Wild/Life or The Impossibility of Mistaking Nature for Culture*, Weatherspoon Art Gallery, Greensboro, North Carolina
1997 *Organically Grown*, Yerba Buena Gardens, San Francisco
1995 *Human/Nature*, New Museum, New York
1994 Kunstraum Wien, Vienna, Austria
Animal Farm, James Cocoran Gallery, Santa Monica, California

Selected Site project
1998 *All About Eden*, KünstlerGärten Weimar, Bauhaus-Universität Weimar, Germany

Selected Bibliography
Nature is Not Romantic, exh. cat. Hunter College Art Gallery, New York, 1999
Peter Sager, 'Kunstrasen', *Die Zeit/Zeitmagazin* (Hamburg), No. 47, November 12, 1998
Alix Pearlstein, 'Laura Stein', *wachsen – Work at the Artists' Gardens Weimar*, ed. Barbara Nemitz, Spring 1998, No. 4, pp. 13–16, Bauhaus-Universität Weimar, 1998
Gregory Volk, 'Laura Stein at Basilico', *Art in America*, June 1998, p. 114
Lucius Burckhardt, 'Arbeiten mit Lebewesen – Wissenschaft oder Kunst?', *Basler Zeitung*, April 11, 1998, pp. 12–13
Ken Johnson, 'Laura Stein: On the Inside', *The New York Times*, December 5, 1997
Dike Blair, 'Laura Stein: Basilico Fine Arts', *Flash Art*, March–April 1996, pp. 111–112
Kirby Gookin, 'Laura Stein at Basilico Fine Arts', *Artforum*, October 1994, p. 105

Laura Stein 'plant to plant', in: Barbara Steiner, *Lost Paradise*, Vienna, 1994, pp. 39–41

Michael Stephan
*1961 Vechta, Germany
Lives in Hanover and Hamburg, Germany

Selected Exhibitions
1999 *Der fremde Garten*, Württembergischer Kunstverein Stuttgart, Germany
1998 *PflanzenLiebe*, Projektraum Voltmerstraße, Hanover
weint bei Musik, Kunstraum Wohnraum, Hanover
1997 *Grüne Bilder – blau behandelt*, Kunstraum Neue Kunst, Hanover
1996 *Vorübergehend behandelt*, Galerie Andresson, Reykjavik, Iceland
1995 *Grünes Licht*, Kunstraum G7, Mannheim, Germany
Preis des Kunstvereins Hannover, Hanover, Germany
Gelbe Bilder, Kunstraum Neue Kunst, Hanover, Germany

Site Project
since 1997 *Alles sieht bläulich aus – die Blaue Blume*, Künstler-Gärten Weimar, Bauhaus-Universität Weimar

Selected Bibliography
Catalogues:
20 behandelte Arbeiten, Kunstraum G7 and Kunstraum Neue Kunst, Mannheim/Hanover, 1995
unterschiedlich behandelt, Niedersächsisches Ministerium für Wissenschaft und Kultur, Hanover, 1996
Michael Stephan, Kunstverein Hannover, Hanover, 1995
Der fremde Garten, Württembergischer Kunstverein Stuttgart, Stuttgart, 1999
Articles:
Bernd Dittrich, 'Die blaue Blume blüht rot', in: *wachsen – Work at the Artists' Gardens Weimar*, No. 4, ed. Barbara Nemitz, Bauhaus-Universität Weimar, 1998
Joachim Kreibohm, 'Über Michael Stephan', *Artist Kunstmagazin*, Bremen, No. 14/15, February 1993, pp. 24–27

Didier Trenet
*1965 Beaune, France
Lives in Trambly, France

Selected Solo Exhibitions
1997 *Le jardin de ma mère, Etudes et Ruines*, Cabinet d'arts graphiques, Centre Georges Pompidou, Paris
1996 *Elégante et Claire*, Galerie Claire Burrus, Paris
1993 *Mille Merdis Madame*, Migrateurs, Musée d'Art Moderne de la Ville de Paris
Selected Group Exhibitions
1997 *A(a)mitiés et autres catastrophes. La carte du tendre*, Centre d'art, Crestet
1996 *Manifesta 1*, Museumspark, Rotterdam
Le Passage des Fées, (with Paul-Armand Gette), Le Creux de l'Enfer, Thiers

Selected Bibliography
Gérard Lapalus, 'Heureux qui, comme Ulysse …', in: *Le jardin de ma mère – Études et Ruines*, Centre Georges Pompidou, Paris, 1997
Necmi Sönmez, 'Des espaces imaginaires', in: exhibition brochure, Kunstruimte alliance francaise, Rotterdam, 1997

Ingo Vetter/Annette Weisser
A. Weisser
*1968, Villingen, Germany
Lives in Berlin
I. Vetter
*1968, Bensheim, Germany
Lives in Berlin

Selected Solo Exhibitions
1998 Künstlerhaus Bethanien, Berlin
1996 *controlled atmosphere #2 – Der Garten*, Akademiegalerie München, Munich

Selected Group Exhibitions
1998 *Videonale 8*, Kunstverein Bonn
1997 *Controlled Atmosphere #8 – Falsche Freunde*, Botanischer Garten München, Munich
Disturban, Kunstraum, Munich
1996 *Park Fiction 4*, Hamburg
art is not enough, Shedhalle Zürich, Zurich

Selected Bibliography
Artist's Publications:
Falsche Freunde, Installationen im Botanischen Garten München, Munich, 1997
controlled atmosphere #4 – The Garden, Cologne, 1996
Articles:
Dorit Margreiter, 'Was zählt, ist nicht die Gegensätze aufzulösen, sondern gleichzeitig einzunehmen', in: *Springerin*, June/Aug. 1998
Stefan Römer, 'Natürlich wollen wir alle reich, schön und berühmt sein – über künstlerische Arbeitsbedingungen im Dienstleistungs-ambiente', in: *Springerin*, September/November 1998

Sandra Voets
*1967 Bonn, Germany
Lives in Dusseldorf, Germany

Selected Solo Exhibitions
1999 *Mikrowelle*, Förderverein Aktuelle Kunst, Münster, Germany
1997 *Drunken Flowers*, Biljana Tomic, Galerie Studentencenter, Belgrade, Yugoslavia
1996 *Body and Plants*, lecture and performance, KünstlerGärten Weimar, Bauhaus-Universität Weimar
Korrekturen an Pflanzen und Menschen, Galerie Laden 33, Dusseldorf
1993 *forever young*, Formatgalerie, Basle, Switzerland

Selected Group Exhibitions
1999 *Warten*, Kunstwerke Berlin
Sympathikus, Museum Abteiberg, Mönchengladbach
1999 *Secret Life of Plants*, Galerie Conrads, Dusseldorf
1998 *Bon-Direct*, Bonner Kunstverein
1997 *o.T., Privatraum Beispiel 1*, Galerie S, Aachen
1995 *Arte Viva*, Senigallia, Italy

Selected Bibliography
Meisterschule, exh. cat. Galleria Salvatore Ala, Milan, 1998
'Sandra Voets', in: Kunstforum International, No. 146, July/August 1999, pp. 109–110, 240–241
Bon direct, exh. cat. Bonner Kunstverein, Bonn, 1998
Michael Voets, 'The Beauty of Flowers and the Coldness of Idols –

On the works of Sandra Voets', *wachsen – Work at the Artists' Gardens Weimar*, ed. Barbara Nemitz, Bauhaus-Universität Weimar, No. 3, summer 1997, pp. 11–17

Herman De Vries
* 1931 Alkmaar, Netherlands
Lives in Knetzgau/Eschenau, Germany

Selected Solo Exhibitions
1998 Susan Inglett Gallery, New York
vergangeligkheid, Kunstvereinigung Diepenheim, Netherlands
aus der Wirklichkeit, Stadthaus Ulm, Germany
1995 *Herman De Vries – aus der Wirklichkeit*, Städtische Galerie Erfurt, Germany
1993 *von den Pflanzen*, Städtische Galerie, Würzburg, Germany

Selected Group Exhibitions
1997 *Skulptur. Projekte 1997*, Münster
1996 *Triology, Kunst-Natur-Videnscap*, Copenhagen
1994 *Naturkunden*, Kunsthochschule Budapest
1992 *Shamanism, Plants and Altered States of Consciousness*, with symposium, San Luis Potosi, Mexico
1990 *Von der Natur in der Kunst*, Messepalast, Vienna
1982 *Natur-Landschaft-Kunst*, Kunsthalle Bremen, Germany

Selected Site Projects
Since 1986 *die wiese/paradiesfeld* (The meadow/field of paradise), Eschenau, Germany
Since 1997 *sanctuarium*, Münster, Germany

Selected Bibliography
herman de vries – oeuvreprijs 1998, ed. The Netherlands Foundation for Fine Arts, Design and Architecture, Amsterdam, 1998
herman de vries – de tuindorpcollecties, Stichting Bronzen Beverfonds & Woningcorporatie TBV, Tilburg/Amsterdam, 1998
herman de vries. from earth – von der erde, exh. cat. Städtische Galerie, Schwäbisch-Hall, 1998
C. De Boer, 'Over de vergankelijkheid van de tekens', in: *herman de vries*, exh. cat. Kunstverein Diepenheim, Diepenheim, 1998
'herman de vries. temple of the western buddha', in: *Unbuilt Roads, 107 Unrealized Projects*, ed. Hans Ulrich Obrist and Guy Tortosa, Ostfildern, 1997
Vittorio Fagone, Art in Nature, Milan, 1996
herman de vries: to be. texte – textarbeiten – textbilder, ed. Andreas Meier, Ostfildern, 1995

Shelagh Wakely
Lives in London

Selected Solo Exhibitions
1997 Galerie Le Monde de l'Art, Paris
1994 South London Gallery, London
1986 *A fountain garden*, Northwick Park Hospital, Harrow, London
1985 *The representation of a Baroque Garden*, Portland Sculpture Park, England
1982 *Five Tables in a Courtyard garden*, (permanent outdoor installation), St George's Hospital, London
1979 ICA, London
1977 *Summer Show 1*, Serpentine Gallery, London

Selected Group Exhibitions
1996 *Life/Live*, Musée d'Art Moderne de la Ville de Paris and Centro Cultural do Belem, Lisbon
1987 *Flowers*, Anne Berthoud Gallery, London
1980 *British Art 1940–80 from the Arts Council Collection*, Hayward Gallery, London

Selected Artist's Publications
The representation of a Baroque garden, postcard work, 1988
It is so green outside it is difficult to leave the window, Coracle Press, 1980

Video
Tunga's garden 1991–97, shown with *Tunga 1977–97* at Bard College, New York, Museum of Contemporary Art Miami, Caracas Museum, 1997/98

Meg Webster
* 1944 San Francisco, California
Lives in New York

Selected Solo Exhibitions
1998 P.S. 1 Contemporary Arts Center, Long Island City
1997 *Blue Sky*, Morris-Healy Gallery, New York
1996 *Installation and Drawings*, Hiram Butler Gallery, Houston, Texas
1992 *Kitchen Garden*, Contemporary Arts Museum, Houston, Texas
Running, Brooklyn Museum, Brooklyn, New York
1990 Milwaukee Art Museum, Milwaukee, Wisconsin
Barbara Gladstone Gallery, New York

Selected Group Exhibitons
1999 *Powder*, Aspen Art Museum, Aspen, Colorado
Drip, Blow, Burn, Hudson River Museum, Yonkers, N.Y.
Hiriya Project Proposals Exhibiition, Tel Aviv Museum of Art, Israel
Botanica, Tween Museum of Art, Deluth, Minnesota
1995 *The Material Imagination*, Solomon R. Guggenheim Museum, New York
1994 *Landscape as Metaphor*, Denver Art Museum, Colorado
Urban Paradise: Gardens in the City, Pubic Art Fund, *Paine Webber Gallery*, New York
1993 *Dialogue with Nature*, The Phillips Collection, Washington
1992 *The Nature of Science*, Pratt Manhattan Gallery, New York
1990 *Terra Incognita: New Approaches to Contemporary Landscape*, Museum of Art, Rhode Island School of Design, Providence
Botanica: The Secret Life of Plants, Lehman College Art Gallery, Bronx, New York
1989 *Les Graces de la Nature*, Sixiemes Ateliers Internationaux des

Pays de la Loire, Lemot, France
The Experience of Landscape: Three Decades of Sculpture, Whitney Museum of American Art, New York

Selected Bibliography
Catalogues:
Meg Webster, *Sculpture Projects*, Greensboro: Weatherspoon Art Gallery, University of North Carolina, Greensboro, 1992
The Last Decade: American Artists of the 80's, New York: Tony Shafrazi Gallery, 1990, pp. 212–218
1989 Biennial Exhibition, New York, Whitney Museum of American Art, 1989, pp. 156–159
American Art of the Late 80's: The Binational, Boston: The Institute of Contemporary Art and Museum of Fine Arts, Boston, 1988, Interview by Trevor Fairbrother, pp. 212–218
Art at the End of the Social, Rooseum: Rooseum, Collins & Milazzo, 1988, pp. 319–323
Articles:
Linda Yablonsky, 'Meg Webster', *Time Out*, April 17–24, 1996
Ann Wilson Lloyd, 'Art as Nature', *Garden Design*, March/April 1992, pp. 14–17
Jan Axgikos, 'Green Piece', *Artforum*, April 1991, Vol. XXIX, No. 8, pp. 104–110
Scott Gutterman, 'Natural and Unnatural Causes', *Art International*, No. 12, Autumn 1990, pp. 57–58
Elanor Heartney, 'Meg Webster at Barbara Gladstone', *ARTnews*, Vol. 89, No. 8, October 1990, p. 187
Nancy Spector, 'Meg Webster/Barbara Gladstone Gallery', *Contemporanea*, September 1990, pp. 98–99
Joshua Decter, 'Meg Webster: Barbara Gladstone', *Flash Art*, Vol. XXIX, No. 153, Summer 1990, p. 147
Roberta Smith, 'Sculpture in the City, From Blankets to Bronze', *The New York Times*, April 20, 1990, pp. C1, C28

Annette Wehrmann
* 1961
Lives in Hamburg, Germany

Selected Solo Exhibitions
1992 Künstlerhaus Weidenallee, Hamburg
1991 Produzentengalerie, Kassel

Selected Group Exhibitions
1999 *Mondo Immaginario*, Shedhalle Zürich, Zurich
1998 *Artainment – Kunst und Unterhaltung*, Sprengelmuseum, Hanover
1995 *Erste Wahl*, Kunstverein in Hamburg
1994 *Agent Artists*, P.S. 1 Contemporary Art Center, New York

Lois Weinberger
* 1947 Stams, Austria
Lives in Vienna, Austria

Selected Solo Exhibitions
1999 *Watari- um*, Watari Museum of Contemporary Art, Tokyo
Museum des 20. Jahrhunderts Stiftung Ludwig, Vienna
1997 Galerie König ET Lettner, Vienna

Selected Group Exhibitions
1999 *Hirya Dump*, Tel Aviv Museum of Art, Tel Aviv, Israel
1998 *La Ville, Le Jardin, La Mémoire*, Académie de France,

Villa Medici, Rome
Urban Realities, Kunsthalle Szombathely, Hungary
Es grünt so grün …, Bonner Kunstverein, Germany

Selected Site Project
1997 *Das über die Pflanzen/ist eins mit ihnen* (That about the plants/is one with them), documenta X, Kassel

Selected Bibliography
'Lois Weinberger', Kunstforum International, No. 146, ('Das Gartenarchiv') July/August 1999, pp. 110, 242–243
Christoph Tannert, 'Unkraut im Freizeitpark – Über die Bemühungen des Gärtner-Künstlers Lois Weinberger', *Neue Bildende Kunst*, No. 6, 1997
Lois Weinberger, *Notizen aus dem Hortus*, Ostfildern, 1997
Lois Weinberger, exh. cat. Wiener Secession, 1995/96, Vienna, 1995

Luc Wolff
* 1954 Luxemburg
Lives in Berlin

Selected Projects and Exhibitions
1999 *KünstlerGärten Weimar*, Bauhaus-Universität Weimar
1998 *Biotop*, public garden, Martin-Luther-Universität Halle/Saale
Park, Galerie Erna Hécey, Luxembourg
1997 *Magazzino*, Grenai delle Zitelle (Giudecca), Biennale di Venezia
1995 *oikos & Eigenbau*, Berlin
1993 *Plans Complexes*, Galerie de Luxembourg
Out of Place – Fehl am Platz, Bunker am Anhalterbahnhof, Berlin

Selected Bibliography
Catalogues:
Exposure, exh. cat. on occasion of the XLVII Venice Biennale 1997, ed. Ministry for Culture in Luxembourg, Luxembourg, 1997
Magazzino, exh. cat. Venice Biennale 1997, ed. Ministry for Culture in Luxembourg, Luxembourg, 1997
oikos und Eigenbau, exh. cat., Berlin, November 1995
Out of Place – Fehl am Platz, text by Peter Funken, exh. cat. Berlin, 1993
Articles:
'Luc Wolff', *Kunstforum International*, No. 146 ('Das Gartenarchiv'), July/August 1999, pp. 112–112, 146–147
Annette Quast, 'Ausgesetzt/Exposed', *wachsen – Work at the Artists' Gardens Weimar*, No. 4, March 1998, Universitätsverlag Weimar
Phyllis Braff, 'Installation Art at Documenta and the Biennale', *Cover Magazine*, Vol. II, New York, September 1997
Armin A. Wallas, 'Von der Zukunft in die Vergangenheit', *Mnemosyne* (No. 22), Klagenfurt, 1997
Ina Nottrot, 'Leerstellen', *neue bildende Kunst*, Berlin, June/July 1997
Elisabeth Vermast, *Artistes Luxembourgeois d'aujourd'hui*, Publ. Editions M. Theis, Luxembourg, 1995

GENERAL BIBLIOGRAPHY

Books

William Howard Adams, *Grounds for Change – Major Gardens of the Twentieth Century*, Boston, Toronto, London, 1993
Diana Balmori, Margaret Morton, *Transitory Gardens – Uprooted Lives*, Yale University Press, New Haven and London, 1993
John Beardsley, *Earthworks and Beyond*, New York, 1984
Madison Cox, *Artist's Gardens*, New York, 1993
Vittorio Fagone, *Art in Nature*, Milan, 1996
Brigitte Franzen, *Die vierte Natur – Gärten in der zeitgenössischen Kunst*, Cologne, 2000
Colette Garraud, *L'idée de nature dans l'art contemporain*, Paris, 1994
John K. Grande, *Balance – Art and Nature*, Montréal, Quebec, New York, 1994
Anne Hoormann, *Land Art – Kunstprojekte zwischen Landschaft und öffentlichem Raum*, Berlin, 1996
Jeffrey Kastner (ed.), *Land and Environmental Art*, Phaidon Press, London, 1998
Phillippe Ledieu, Michel Vilain, *Le jardin du futur*, Éditions d'art Somogy – Cité des Sciences et de l'Industrie, Paris, 1997
Maurizio Nannucci, *Hortus Botanicus*, Ostfildern, 1992
Gilles A. Tiberghien, *Land Art*, Paris, 1993
Patrick Werkner, *Land Art USA – Von den Ursprüngen zu den Groß-raumprojekten in der Wüste*, Munich, 1992

Catalogues

Naturally Art/Kunst in der Stadt, Kunsthaus Bregenz, Bregenz, Austria, 1999
I Never Promised You a Rosegarden, Kunsthalle Bern and Botanischer Garten der Universität Bern, Bern, 1999
Formule 2.1, Künstlerhaus Bethanien, Berlin, 1999
Natural Reality – Künstlerische Positionen zwischen Natur und Kultur, ed. Ludwig Forum für Internationale Kunst, Aachen, Stuttgart, 1999
être nature, Fondation Cartier pour l'art contemporain, Paris, 1998
natürlich künstlich. Besichtigung eines hybriden Gebildes, O.K. Cent-rum für Gegenwartskunst, Linz, 1998
Lausanne Jardins – Une envie de ville heureuse, Editions du Péribole et Ecole Nationale Supérieure du Paysage de Versailles, Lausanne, 1998
Zeitgenössische Skulptur. Projekte in Münster 1997, eds. Klaus Bußmann, Kasper König, Florian Matzner, Ostfildern, 1997
Es grünt so grün ..., Bonner Kunstverein, Bonn, 1997
Landschaft mit dem Blick der 90er Jahre, eds. Kathrin Becker and Klara Wallner, Cologne, 1995
Barbara Steiner (ed.), *Lost Paradise – Positionen der 90er Jahre*, Munich, Stuttgart, 1995
Visions of America – Landscape as Metaphor in the Late Twentieth Century, Denver Art Museum and Columbus Museum of Art 1994, Harry N. Abrams, New York, 1994
East of Eden, Museum Schloß Mosigkau, Dessau, 1994
Green, Torch Gallery, Amsterdam, 1994
Ocean Earth – 1980 bis heute, Neue Galerie am Landesmuseum Joanneum, Graz, Stuttgart, 1993
Arte Ambientale, La Collezione Gori nella Fattoria di Celle, Turin, 1993
Différentes Natures, Galerie Art 4 and Galerie de l'Esplanade Défense, Paris, 1993
Denatured Visions – Landscape and Culture in the Twentieth Century, Museum of Modern Art, New York, 1991
Theatergarden bestiarium – The Garden as Theater as Museum, The Institute of Contemporary Art, New York, P.S. 1 Museum, 1989, Cambridge, Mass., 1990

Von der Natur in der Kunst – Eine Ausstellung der Wiener Fest-wochen, ed. Wiener Festwochen, Vienna, 1990
Magiciens de la terre, ed. Jean-Hubert Martin, Centre Georges Pompidou, Paris, 1989
Landschaft in der Erfahrung – Eine Ausstellung mit Werken des 19. und 20. Jahrhunderts, ed. Kölnischer Kunstverein, Cologne, 1989
Ressource Kunst – Die Elemente neu gesehen, ed. Georg Jappe, Künstlerhaus Bethnien, Berlin, Cologne 1989
Der Baum, ed. Hans Gercke, Kunstverein Heidelberg, Heidelberg, 1985

Articles

Paolo Bianchi (ed.), 'Das Gartenarchiv', *Kunstforum International*, No. 146, July–August 1999, pp.48–253
Paolo Bianchi (ed.), 'Künstler als Gärtner', *Kunstforum International*, No. 145, May–June 1999, pp. 40–233
Thomas von Taschitzki, 'Der Künstler war immer der Gärtner', *der bogen – Journal der Bauhaus-Universität Weimar*, No. 5, May 1999, pp. 1–5
Sabine Kunz, 'Die Vegetation wird zum Kunstwerk', *art – Das Kunst-magazin*, Januar 1999, p. 39
Peter Herbstreuth, 'Eine Rose ist keine Rose', *Der Tagesspiegel*, 25 November 1998
Lucius Burckhardt, 'Kommt der Garten ins Haus?', *Basler Magazin*, No. 14, 11 April 1998
Barbara Nemitz (ed.), *wachsen – Work at the Artists' Gardens Weimar*, No. 1–4, Universitätsverlag Bauhaus-Universität Weimar, 1995–1998
Peter Sager, 'Kunstrasen', *Die Zeit/Zeitmagazin*, No. 47, Hamburg, 1998, pp. 16–26
Robert Smithson, 'A Sedimentation of the Mind: Earth Projects', *Artforum*, September 1968. Reprinted in: *Robert Smithson. The Collected Writings*, ed. Jack Flam, Berkeley and Los Angeles 1996, pp. 100–113
Barbara Nemitz, 'Künstlergärten Weimar', *Weimar Kultur Journal*, No. 11, 1996
Guy Tortosa, 'Minimalist gardens', *Topos – European Landscape Magazine*, No. 11 ('New Gardens'), München, June 1995, pp. 96–104
Lucy R. Lippard, 'Gardens: Some Metaphors for a Public Art', *Art in America*, No. 69, New York, November 1981, pp. 136–150

Peter Herbstreuth
born in 1959, lives in Berlin and writes regularly on contemporary art and architecture for the magazines *Kunst-Bulletin*, *Kunstforum International*, *Flash Art* and the newspaper *Tagesspiegel* (Berlin). Numerous catalogue contributions. He lectures at the Art Academy Berlin on art and architecture and curated the exhibitions *Real* at the Nordic Art Center Helsinki 1993, *Startblock* at Kunst-Werke Berlin 1995 and *s/light* at Konstmuseet Malmö 1997. He was guest curator for the exhibitions *Prix Wanki* at Wanki Museum Seoul 1998 and *A Brief Story of the Synagogue* at the Ethnographic Museum in Dresden (1999). He is co-author (with Annegret Nippa) of a recently published book about synagogues, *Eine kleine Geschichte der Synagoge*, and is currently at work on a book about trees.

Kim Levin
lives in New York. She is a regular contributor to *The Village Voice*, New York, and president of AICA, The International Association of Art Critics. Her writing on art has appeared in numerous magazines and journals in the United States and other countries, including *neue bildende kunst*, *Artscribe*, *Parkett* and *Kunstforum International*. She is author of *Beyond Modernism: Essays on Art from the '70s and '80s* and editor of *Beyond Walls and Wars: Art, Politics, and Multiculturalism*.
Educated at Vassar College, Columbia University, and New York University's Institute of Fine Arts, she has taught at the Philadelphia College of Art, Parsons School of Design and School of Visual Arts and has lectured at several universities in the USA. In 1986, she received the Art/World Award for Distinguished Newspaper Criticism. In 1993, she was awarded the SECA Fellowship for Criticism by the San Francisco Museum of Modern Art. She was an advisor at the 1995 *Kwangju Biennial* in Korea and has curated exhibitions at museums in Korea, Japan, Poland, Norway, Denmark and Germany.

Barbara Nemitz
born in Göttingen in 1948, studied at the Hochschule für Bildende Künste in Hamburg from 1968 to 1974. Her work in art is interdisciplinary, and she employs a broad range of different media. In addition to extensive work groups in the field of painting, she has also realised staged works incorporating elements of music. Her work has been exhibited at several museums and the Berlin Festival. Barbara Nemitz has been a professor of art at the Bauhaus-Universität Weimar since 1993. There she is currently realising her project *KünstlerGärten Weimar*, a complex work of art encompassing multiple levels of creative activity devoted to the central theme of art with living plants, in cooperation with guest artists, scholars, students and university staff members. Barbara Nemitz is editor of the journal *wachsen* (growing) and other publications.

GENERAL INDEX

This book is published as a part of *KünstlerGärten Weimar*

With kind support of *Aventis CropScience*, Lyon, France
and *Bauhaus-Universität Weimar*, Germany

Thanks to

Vito Acconci Studio, New York; Galerie Air de Paris, Nice; American
Fine Arts, Co., New York; Galerie des Archives, Paris; Galerie Art:Con-
cept, Paris; Knut Åsdam, Copenhagen; Stefan Banz, Luzern; Basilico
Fine Arts, New York; Lothar Baumgarten, Dusseldorf; Michel Blazy,
Paris; Roland Bersdorf, Berlin; Bonakdar Jancou Gallery, New York;
Galleri Andreas Brändström, Stockholm; Cosima von Bonin, Cologne;
Galerie Bugdahn und Kaimer, Dusseldorf; Annemarie and Lucius
Burckhardt, Basel; Daniel Buren, Paris; Castello di Rivoli – Museo
d'Arte Contemporanea, Rivoli; Maurizio Cattelan, Milan; Mel Chin, New
York; Galerie Mehdi Chouakri, Berlin; DAAD Galerie, Berlin; Agnes
Denes, New York; Bernd Dittrich, Großschwabhausen; Galerie
Eigen+Art, Berlin/Leipzig; Josef Filipp, Leipzig; Ian Hamilton Finlay,
Lanarkshire; Nina Fischer and Maroan el Sani, Berlin; Peter Fischli and
David Weiss, Zurich; Irene Fortuyn, Amsterdam; Patrick Frey, Zurich;
Gloria Friedmann, Paris; Colette Garraud, Paris; Generali Foundation,
Vienna; Paul-Armand Gette, Paris; Avital Geva, Ein Shemer; John
Gibson Gallery, New York; Massimilioni Gioni, Busto Arsizio; Barbara
Gladstone Gallery, New York; Gerrit Gohlke, Berlin; Dan Graham, New
York; Stiftung Dr. Georg Haar, Weimar; Hans Haacke, New York; Henrik
Håkansson, Stockholm; Siobhán Hapaska, London; Helen Mayer
Harrison and Newton Harrison, San Diego; Paula Hayes, New York;
Galerie Max Hetzler, Berlin; Caroline Higgitt, Edinburgh; Enver Hirsch,
Hamburg; Nikolaus Hirsch/Wolfgang Lorch/Andrea Wandel, Frankfurt/
Main; Jenny Holzer, Hoosick Falls; Peter Hutchinson, Provincetown;
Fabrice Hybert, Paris; Robert Irwin, San Diego; Annely Juda Gallery,
London; Dominique Kippelen, Strasbourg; Ruth Koenig, Kassel; Till
Krause, Hamburg; Samm Kunce, New York; Lebenshilfe, Weimar;
Mathieu Mercier, Paris; Günther Metken, Paris; Teresa Murak, Warsaw;
N55, Copenhagen; Galerie Christian Nagel, Cologne; David Nash,
Cae'n-y-Coed; Maria and Heinz Nemitz, Mühltal; Galerie neugerriem-
schneider, Berlin; Olaf Nicolai, Berlin; Nils-Udo, Riedering; Städtische
Galerie, Nordhorn; Maria Nordman, California; PaceWildenstein Gal-
lery, New York; Brigitte Raabe, Hamburg; Nikolaj Recke, Copenhagen;
Lucinda Renisson, Berlin; Gary Rieveschl, East Hampton; Erik Samakh,
Paris; Galerie Schipper und Krome, Berlin; Monika Seelbach, Berlin;
Charles Simonds, New York; Alan Sonfist, New York; John S. Southard,
Groß-Umstadt; Daniel Spoerri, Seggiano; Laura Stein, New York;
Raimar Stange, Hanover; Michael Stephan, Hamburg; Christoph
Tannert, Berlin; Friedrich Tietjen, Secession, Vienna; Susanne Titz,
Aachen; Didier Trenet, Trambly; Ingo Vetter and Annette Weisser,
Berlin; Sandra Voets, Dusseldorf; Herman De Vries, Knetzgau; Shelagh
Wakely, London; Walker Art Center, Minneapolis; John Weber Gallery,
New York; Meg Webster, New York; Annette Wehrmann, Hamburg;
Luc Wolff, Berlin

Editor
Barbara Nemitz

Book concept
Barbara Nemitz

Editing
Barbara Nemitz, Thomas von Taschitzki

Copy editing
Cornelia Plaas, John S. Southard

Translations into English
John S. Southard
except pp. 32–34, 92, 116 (Caroline Higgitt); p. 58 (Ruth Koenig);
p. 138 (Lucinda Rennison)
Translations into German
p. 163–170 Nikolaus G. Schneider, Thomas von Taschitzki

Graphic design, Type setting
Graphisches Atelier Sternstein, Stuttgart

Colour separations
Weyhing digital, Ostfildern-Ruit

Printed by
Dr. Cantz'sche Druckerei, Ostfildern-Ruit

© 2000 by Hatje Cantz Publishers, the editor and authors
© 2000 for works reproduced by the artists or their legal successors;
for Lothar Baumgarten, Daniel Buren, Nina Fischer, Gloria Friedmann,
Paul-Armand Gette, Hans Haacke, Carsten Höller, Robert Irwin,
David Nash, Olaf Nicolai, Charles Simonds, Robert Smithson, Daniel
Spoerri, Luc Wolff by VG Bild-Kunst, Bonn, 2000

Published by
Hatje Cantz Publishers
Senefelderstraße 12
73760 Ostfildern-Ruit
T. +49 (0) 711/44 05-0
F. +49 (0) 711/44 05-220
Internet: www.hatjecantz.de

Distribution in the US
D.A.P., Distributed Art Publishers
155 Avenue of the Americas, 2nd Floor
USA-New York, N.Y. 10013-1507
T. (001) 212-627 19 99
F. (001) 212-627 94 84

ISBN 3-89322-971-X

Printed in Germany

Front cover
Laura Stein, *Sylvester Tomato*, 1996, color photograph
Back cover
Michel Blazy, *La vie des choses* (The life of things), 1997, installation,
Musée d'Art Moderne de la Ville de Paris